This project was made possible through the generosity of the following companies:

Adobe

OLYMPUS

LEXAR
Media

EPSON

snapfish

jetBlue
AIRWAYS

WEBWARE

Google

NEW YORK, NEW YORK
Manhattan, 12:16 A.M.: New York's
famed Woolworth Building.
Photo by Michael Lee

LONDON, NEW YORK, MUNICH, MELBOURNE, and DELHI

Created by Rick Smolan and David Elliot Cohen
24/7 Media, LLC
Po Box 1189
Sausalito, CA 94966-1189
www.america24-7.com

First American Edition, 2003
03 04 05 06 07 10 9 8 7 6 5 4 3 2 1

Published in the United States by
DK Publishing, Inc.
375 Hudson Street
New York, NY 10014

DK Publishing, Inc. offers special discounts for bulk purchases for
sales promotions or premiums. Specific, large-quantity needs can be met
with special editions, personalized covers, excerpts of existing guides,
and corporate imprints. For more information, contact:
Special Markets Department
DK Publishing, Inc.
375 Hudson Street
New York, NY 10014
Fax: 212-689-5254

Cataloging-in-Publication data is available
from the Library of Congress
US ISBN 0-7894-9975-4

A CIP catalogue for this book is available
from the British Library
UK ISBN 1-4053-0012-4

Printed by Toppan Printing Co. Ltd., Japan

First printing, October 2003

The western skies from a Cessna 182
Skylane, above northwestern
Washington State.
Photo by Nathan P. Myhrvold

AMERICA 24/7

24 Hours. 7 Days.
Extraordinary Images of
One American Week.

Created by Rick Smolan and David Elliot Cohen

DK Publishing

MENTONE, ALABAMA
Sweet Home Alabama: The forests and fields of rural northern Alabama are home to the fairies and elves of Stella Knowlton's imagination. Weekend visits to the family cabin, which has no water or electricity, give Stella a taste of what life was like a hundred years ago, when entertainment consisted of picking wildflowers, catching fireflies, and chasing dreams.
Photo by Hal Yeager, The Birmingham News

Table of Contents

An American Time Capsule

A hundred years from now, historians may pose questions such as these: What was America like at the beginning of the third millennium? How did life change after the 9/11 attacks and the ensuing war on terrorism? How was America affected by its corporate accounting scandals and the high-tech boom and bust? Was it still the land of opportunity? Could Americans still express themselves freely?

We created *America 24/7*, the largest collaborative photography project in history, to address these questions and countless others. Since so many Americans seem concerned about how their country is portrayed by Hollywood, Madison Avenue, the media, and government, we decided this would be a propitious time to invite Americans to tell their own stories, unfiltered, with digital photographs of their families, friends, and communities.

Over the course of a seven-day period, May 12–18, 2003, more than 25,000 professional and amateur photographers, including 36 Pulitzer Prize winners, were issued an unusual challenge: Go out and create a visual time capsule. Make extraordinary images of everyday American life.

Like any week, this particular week's momentous and mundane events were reflected in headlines: *Record Number of Tornadoes in the Texas and Oklahoma Panhandle; Candidate Bush Files Papers for 2004 Race; Trapped in Heat in Texas Truck, 18 Immigrants Die; Lawsuit Seeks to Ban Sale of Oreos to Children; Gramps a Grad at Age 95.* Other events, that didn't make the headlines, were reflected in the quotidian statistics of American life: 78,000 Americans were born, 45,000 married, 48,000 died. Hundreds of thousands more graduated from high school or college. Millions celebrated birthdays.

But America isn't merely the sum of its headlines and statistics. America is a super-sized idea—a dreamspace—where individuals are free to practice Catholicism or Buddhism, read Karl Marx or Nora Roberts, protest a war or join the military, work for a giant corporation or launch a new venture in

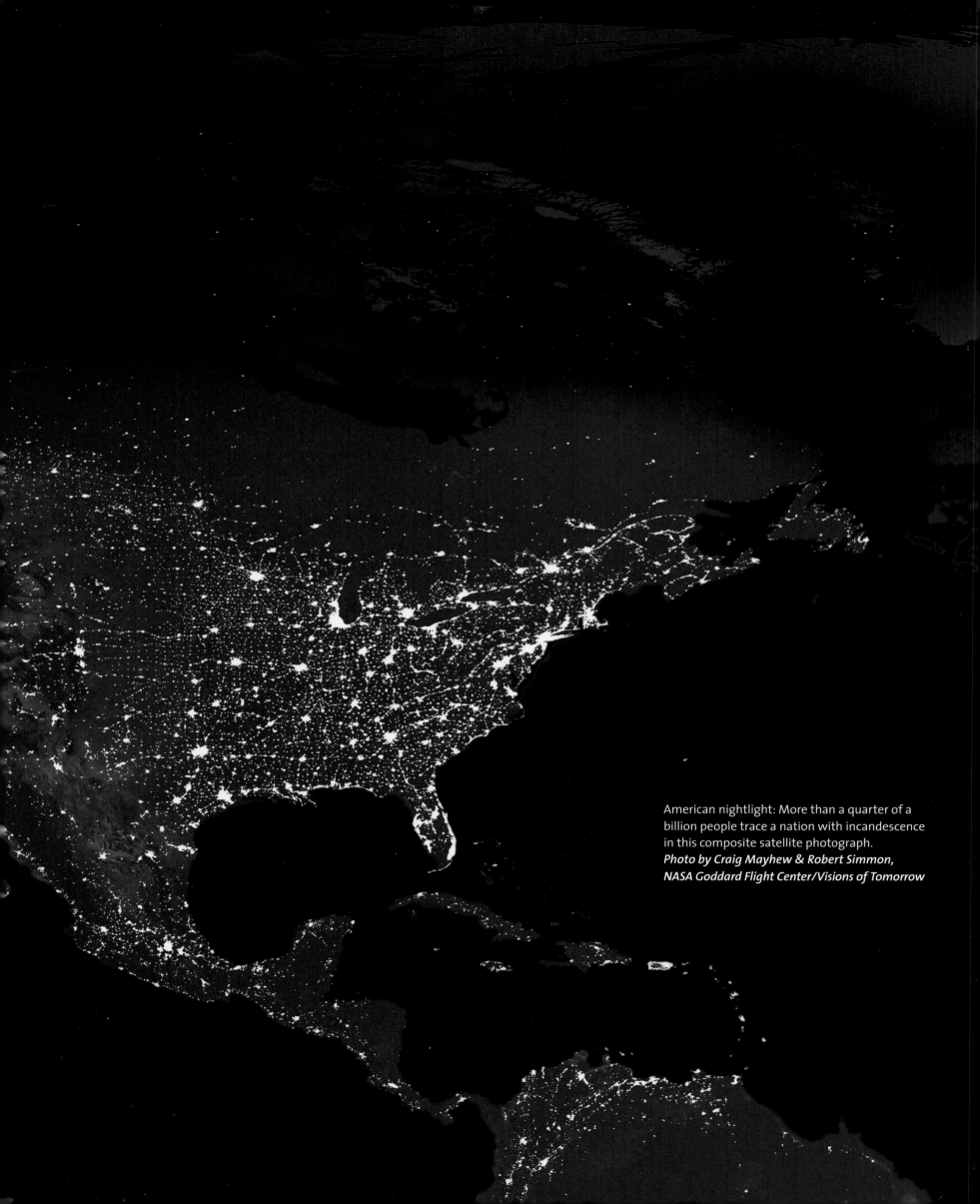

American nightlight: More than a quarter of a billion people trace a nation with incandescence in this composite satellite photograph.
Photo by Craig Mayhew & Robert Simmon,
NASA Goddard Flight Center/Visions of Tomorrow

their garage. Within its wide margins, the American nation manages to encompass an inexplicably complex yet workable whole.

The hundreds of thousands of digital images that poured into *America 24/7*'s website comprise an unprecedented view of Americans in celebration and sadness; in action and contemplation; at work, home, and school. Our decision to make this an all-digital project reflects a critical tipping point in the history of photography: 2003 is the first year that Americans purchased more digital cameras than film cameras. For the first time since its invention more than 150 years ago, photography is being transformed—from chemicals to bits—and the transformation is profound. Taking, utilizing, and particularly sharing photographs will never be the same.

To mark this sea change, all of the *America 24/7* professional, amateur, and student photographers shot with digital cameras. Their pictures were stored, transmitted, edited, and laid out digitally. We have created large-scale collaborative photography projects for two decades, but the digital technology behind *America 24/7* enabled a new inclusiveness. For the first time, we could combine amateur and student photographs with the work of leading journalists. This exuberant democracy of images, reflected on the following pages, is a revelation.

Nearly every *24/7* photographer stayed close to home and chose his or her own subjects. We asked our shooters to capture the essence of daily life in their communities. And we encouraged them to find a household where they could hang their hats for a week and record the texture of modern family life. We also asked them to address larger

NEW YORK, NEW YORK
Dawn over Manhattan: The morning view
from the top of the Empire State Building.
Photo by Joe McNally

themes of work, recreation, faith, community, and the natural landscape.

Then we recruited picture editors from America's leading magazines and newspapers, including *National Geographic, Time, Newsweek,* the *New York Times,* and the *Washington Post.* They had to select the best 300 images from the hundreds of thousands submitted. This was an incredibly difficult task. At times we all felt as if we were forced to choose which of our children would make it into the lifeboat. Partially to assuage that feeling, we added a running strip of small images along the tops of many pages. These photographs, similar in subject to the larger images on the same page, give the reader a taste of the editing process. We realize that many readers will think we chose the wrong images to enlarge, and they'll be happy to know that the smaller "strip images" will get the space they deserve when we publish individual *24/7* books for each state in fall of 2004.

America 24/7 is not intended to be fair. Not every state, race, religion—or photographer—is represented; nor is every point of view included. This is not a book for tourists or one created by a public-relations firm to explain America to the world. It's a visual patchwork, woven by Americans from every walk of life. Just as Roy Stryker's landmark Farm Security Administration photography project shaped our collective memory of the 1930s, we hope the compelling photographs in *America 24/7* will help shape future generations' understanding of this poignant and pivotal period in American history. We expect that this family album will inspire, amuse, and on occasion, disturb you. As a mirror of everyday American life, this is as it should be.

—*Rick Smolan and David Elliot Cohen*

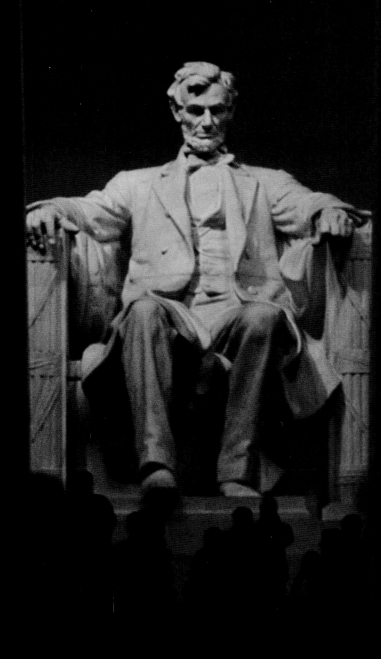

WASHINGTON, D.C.
On a May evening, tourists flock to the Lincoln Memorial at the west end of Washington's Reflecting Pool. Completed in 1922, each of the neoclassical monument's 36 columns represent the states in the Union at the time Lincoln died. Above his statue, it says: "In this Temple, as in the hearts of the people, for whom he saved the Union, the memory of Abraham Lincoln is enshrined forever."
Photo by Chris Usher, Apix

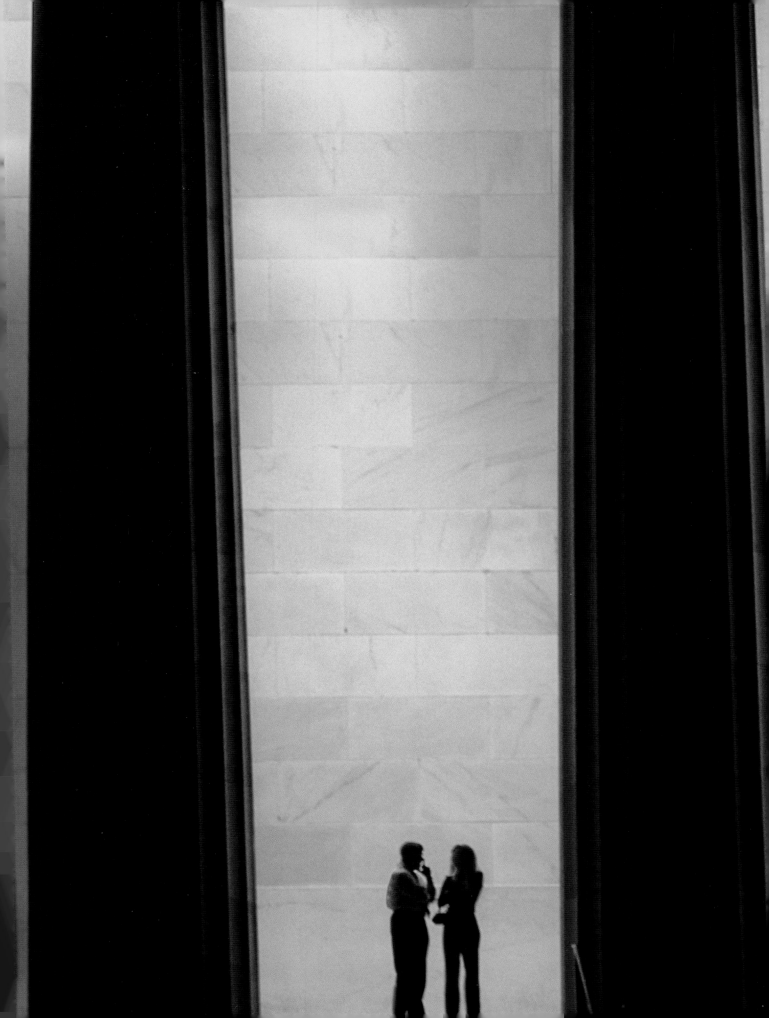

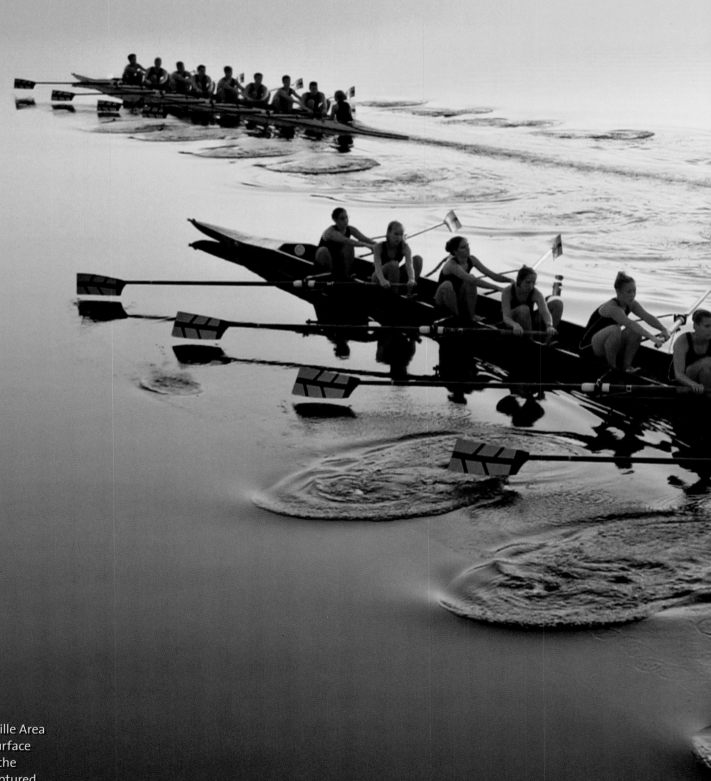

GAINESVILLE, FLORIDA
At sunrise, two "eights" from Gainesville Area
Rowing barely agitate the mirrored surface
of Newnan's Lake. A few days earlier, the
women's varsity crew, foreground, captured
third place in the Florida Scholastic Rowing
Association's State Championship regatta.
Photo by John Moran

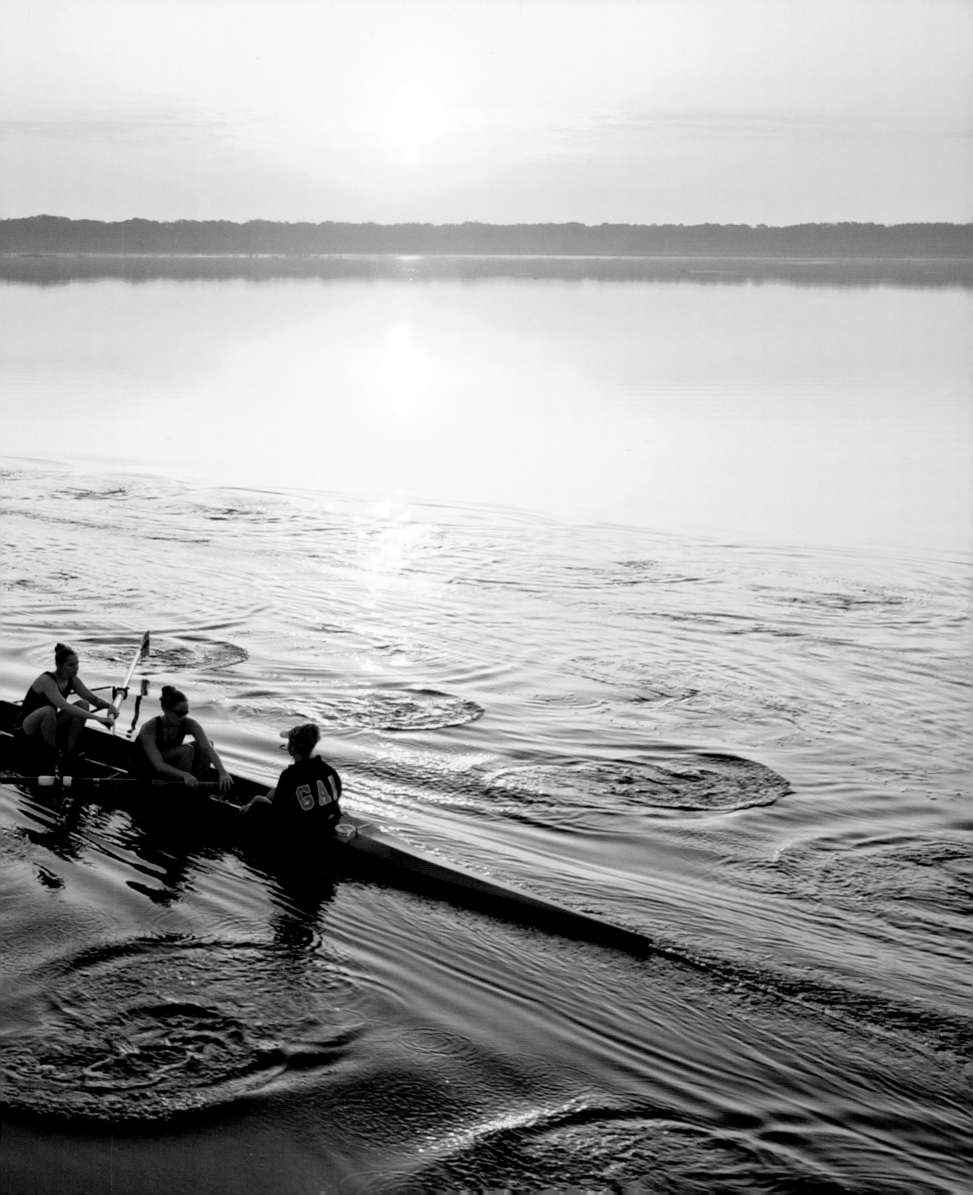

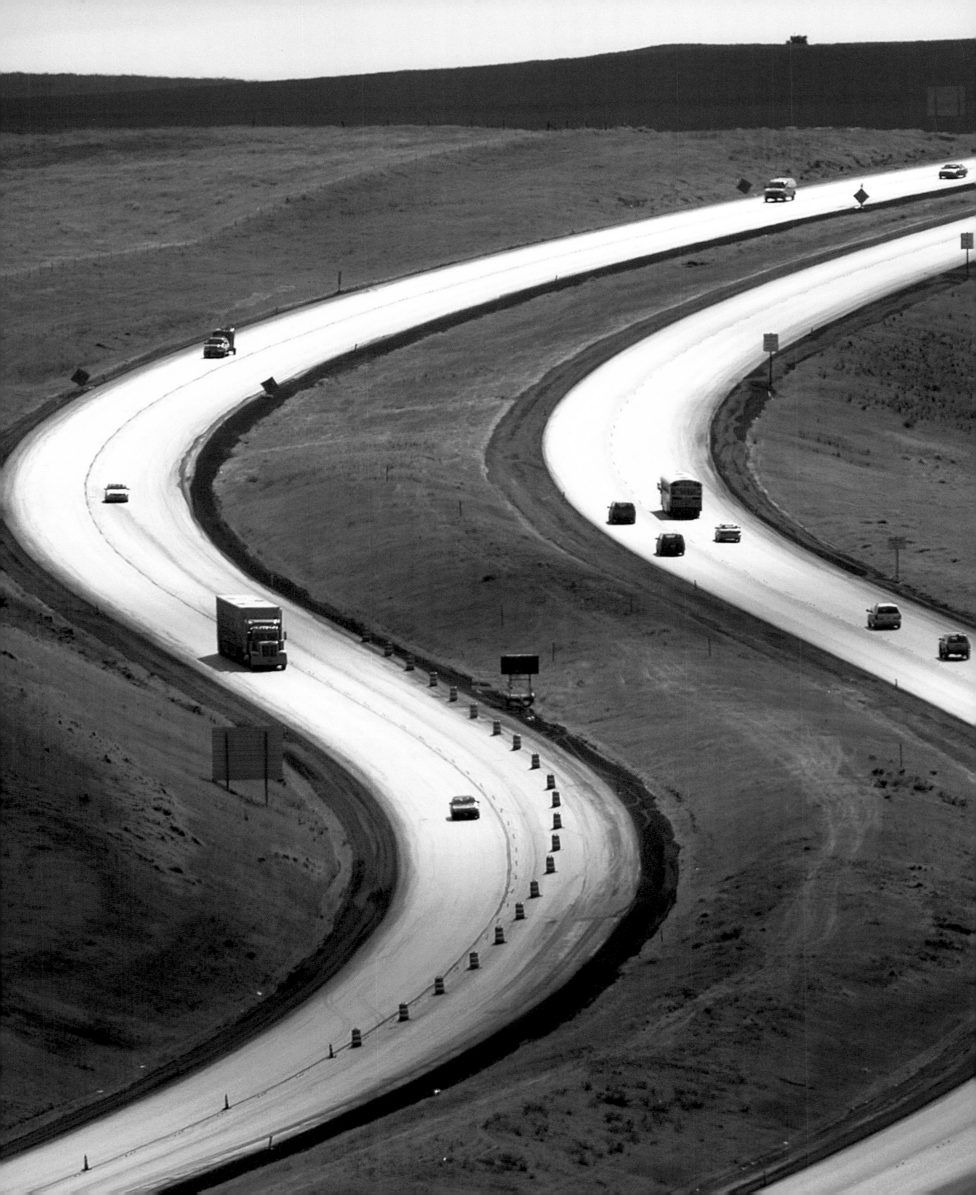

PENDLETON, OREGON

Interstate 84 snakes northwest toward Portland, where it concludes its 770-mile journey from Salt Lake City, Utah. One of thousands of routes in the vast network of American roadways, Interstate 84 transports station wagons over much the same territory the Oregon Trail pioneers crossed in covered wagons on their journey from Missouri to Oregon more than 160 years ago.
Photo by C. Bruce Forster

NORTH EAST, PENNSYLVANIA
Paradise found: Rural landscape watercolorist
Vitus J. Kaiser, 74, hones his craft come rain
or shine. Today he's set up his canvas in the
pristine apple, peach, and pear orchards of
Seifert's Fruit Farm.
Photo by Jack Hanrahan, Erie Times-News

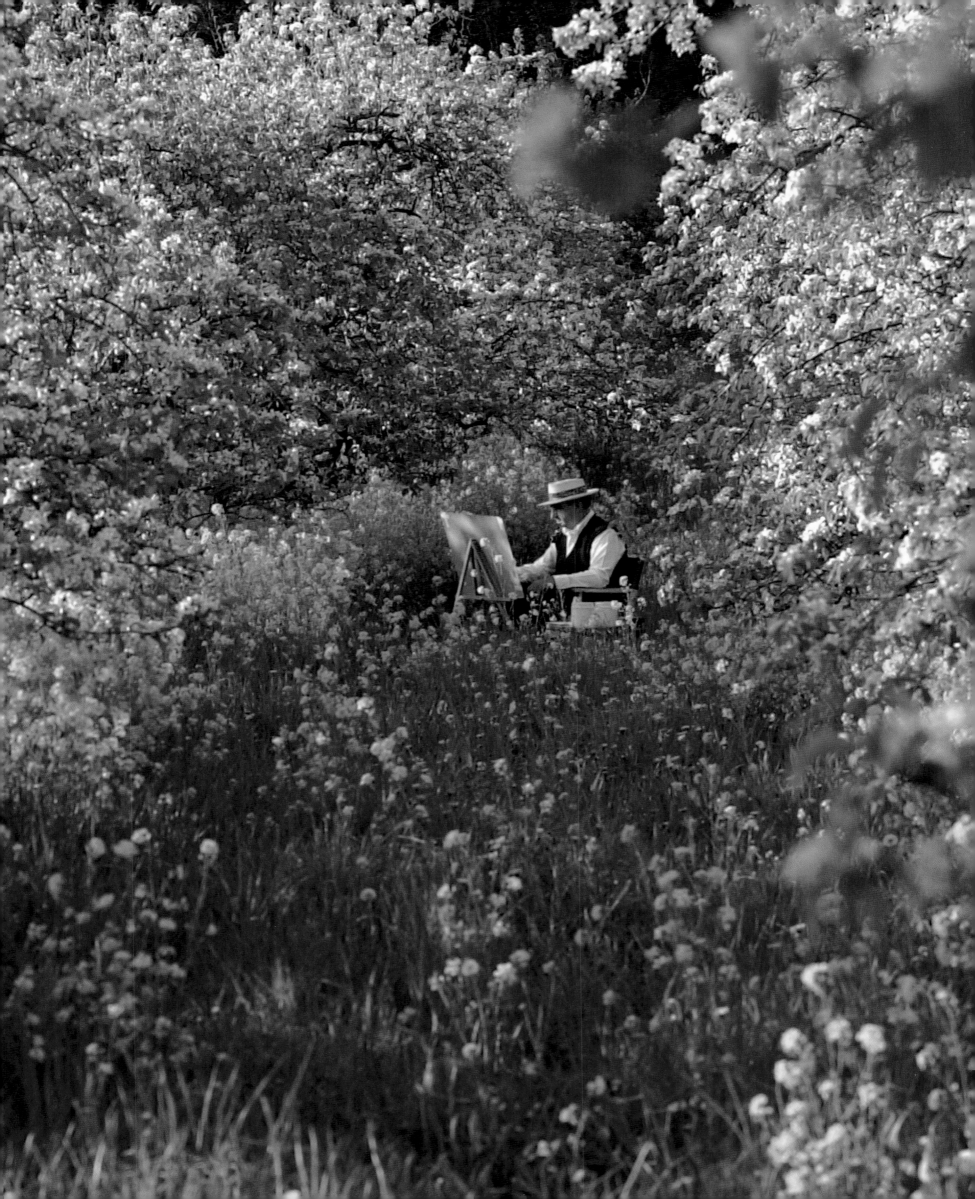

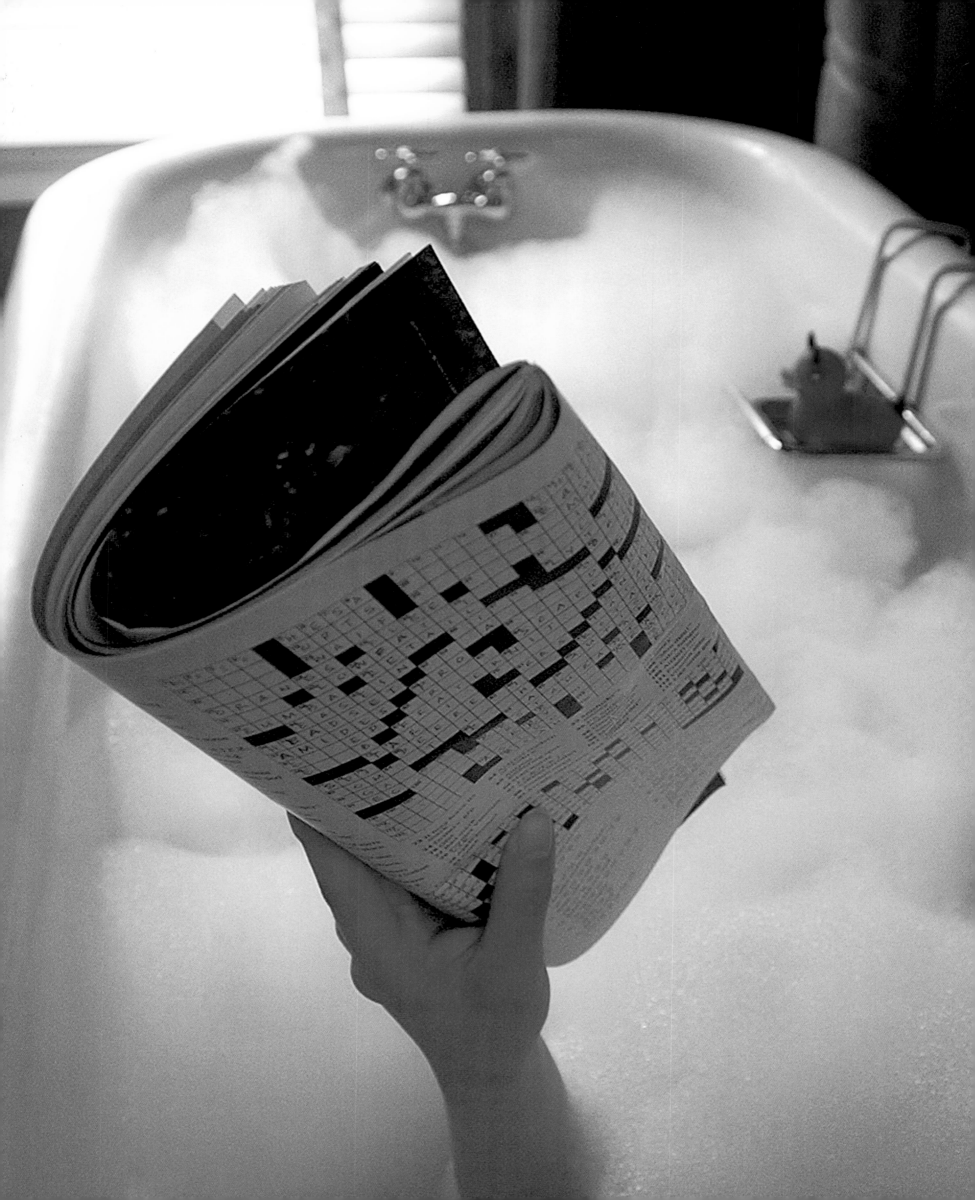

Hearth & Home

I am fascinated by the images on the following pages. They are part of a deep human impulse to capture forever and to interpret the gestures, both large and small, of our daily lives. This impulse has been with us in many forms for a long time.

For many years I've been collecting early 20th century antique postcards for both the images on the fronts and the messages written on the backs. One example, from 1913, is an original photograph, taken by someone with a Brownie camera and then printed onto cardboard with a postcard back. This was a common practice in the early 20th century in America. People took photos of every aspect of their daily lives and exchanged them through the mail.

This particular image is of an achingly fragile biplane, in the perilous early days of aviation, flying solitary before an empty sky. If you look closely you can see the right end of the upper wing beginning to tear away. The message on the back of the card simply reads: "This is Earl Sandt of Erie Pa. in his aeroplane just before it fell."

ATLANTA, GEORGIA Lilli Kim Ivansco melts into a daytime bath while musing over 11 Down (answer: "Elmer"). *Photo by Joey Ivansco*

I am enchanted with these messages. These fragments of voices of Americans who have long since passed away are profoundly resonant not only of the individual lives pulsing behind the words but also of the preoccupations and character of this nation, both then and now.

On the Fourth of July in 1906 an anonymous young man sent an image of the White Mountains of New Hampshire to his father in Massachusetts. The postmark indicates the young man was staying at a grand resort hotel there, the Crawford House. "This is a quiet 4th," he wrote. "There are 220 in the house. When the flag was raised this morning they gathered on the piazza and took off their hats and gave three cheers. Going to pitch tomorrow." The card is very moving to me in its understatement. Nearly a hundred years ago everyone in this hotel came out into the yard, mostly strangers to each other, and cheered their devotion to an America that so closely bound them together.

In another private photo card, a woman sits beside a female friend in a 1906 Mitchell automobile and she has written a poem beneath the image: "No chord of music has yet been found/ to even equal that sweet sound/ which to my mind all else surpasses/ an auto engine and its puffing gasses." She added, writing to the friend who sat beside her, "Don't this recall many pleasant rides over the beautiful Drive Way?" This card captures an early 20th century moment in the further opening of American society. A woman delights with another woman in the technology of a male-dominated society, perhaps sensing that this very technology would one day help transform that society into something even more egalitarian.

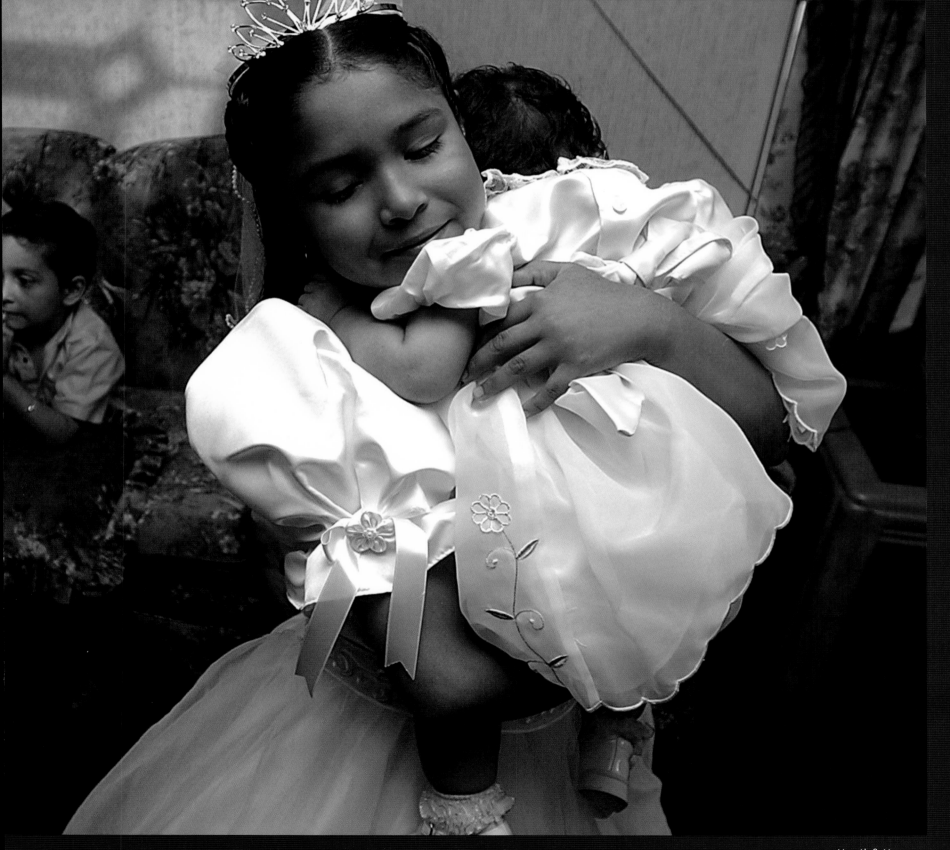

CHARLOTTE, NORTH CAROLINA Nine-year-old Nora Garcia cuddles her little sister, Vanessa, one, before they share their first communion at the La Iglesia de Guadalupe Catholic Church. It is a momentous day for the family from Jalisco, Mexico, which has lived in the United States for five years.
Photo by Gayle Shomer Brezicki

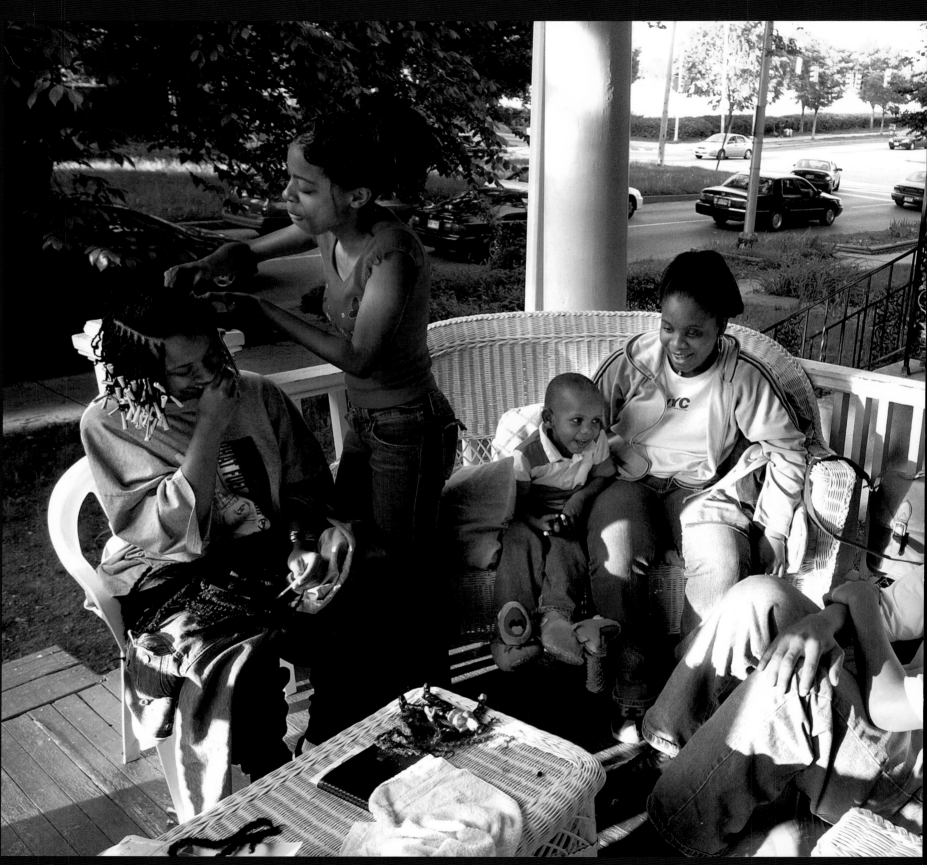

When I bought that postcard of the biplane, I knew that one day I would write a short story inspired by it. I'd always assumed, however, that the story would be in the voice of Earl Sandt, the doomed pilot. But after September 11, 2001, I knew that I had to write the story in the voice of the man who watched.

Because on 9/11, we were all the ones who watched. In writing the story about America of the early 20th century I realized something crucial about that terrible day in America of the early 21st century. The man who snapped the photo and wrote the postcard ninety years earlier felt the same thing that we all did on September 11, and I came to understand that the most profound and abiding effects of that day have very little to do with international politics or worldwide terrorism or homeland security or our unity as a nation.

Those issues are real and important too, of course, but it seems to me that the deepest experience of 9/11 happened for us one soul at a time in an entirely personal way. We each of us viewed the fall of an aeroplane under stunning circumstances for which we had no frame of reference, and as a result, the event got around certain defenses that we all necessarily carry within us. And we confronted—one by one by one—in a way most of us never have—our own mortality.

By Robert Olen Butler

ROBERT OLEN BUTLER *won the 1993 Pulitzer Prize for Fiction. He is writing a book of stories, called* Had a Good Time, *based on his antique postcard collection.*

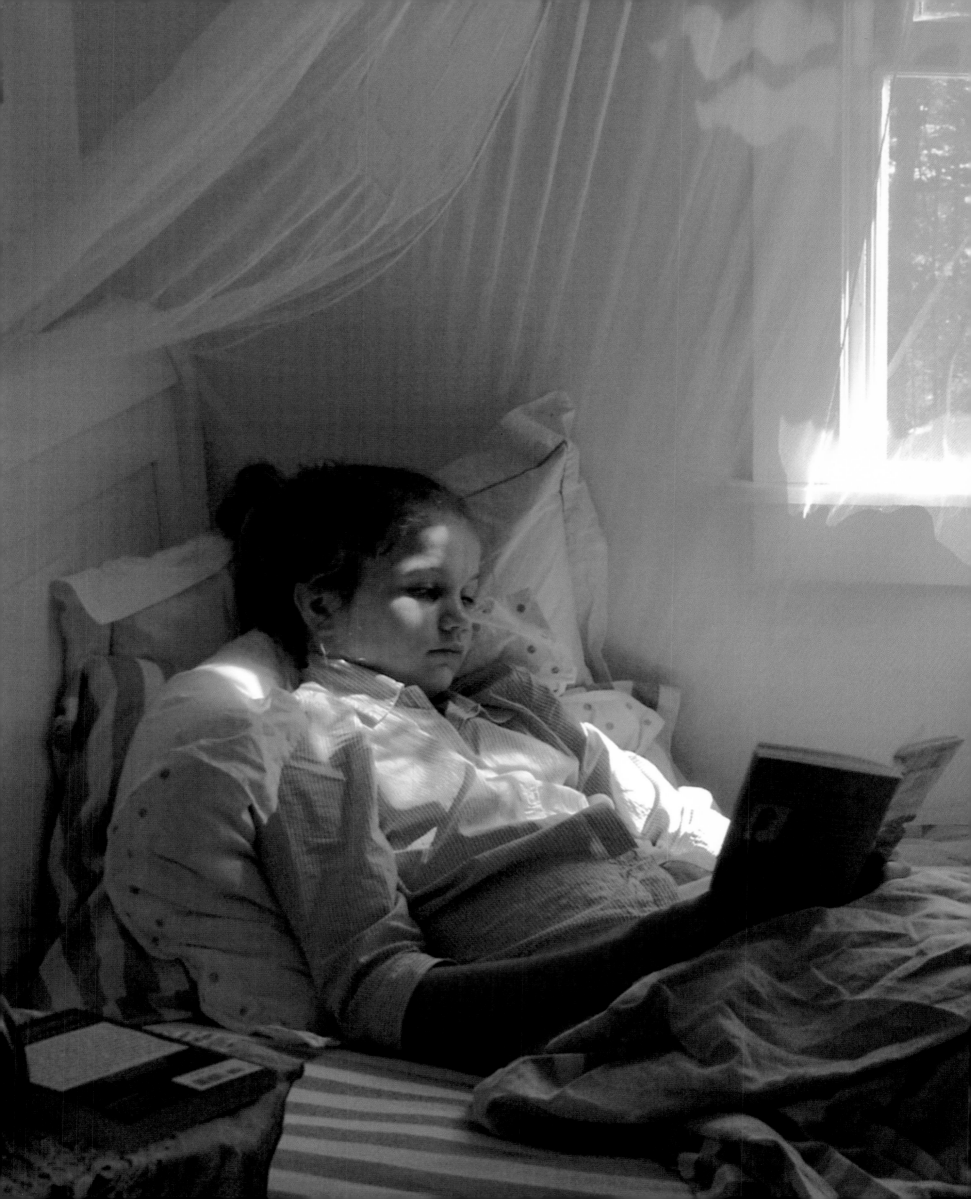

LAKEVILLE, CONNECTICUT
The average American child watches three hours of television per day, but Charlotte Day-Reiss, 11, prefers the company of books. Her parents, both journalists, report that Charlotte devours five books a week during the summer months.
Photo by Anne Day

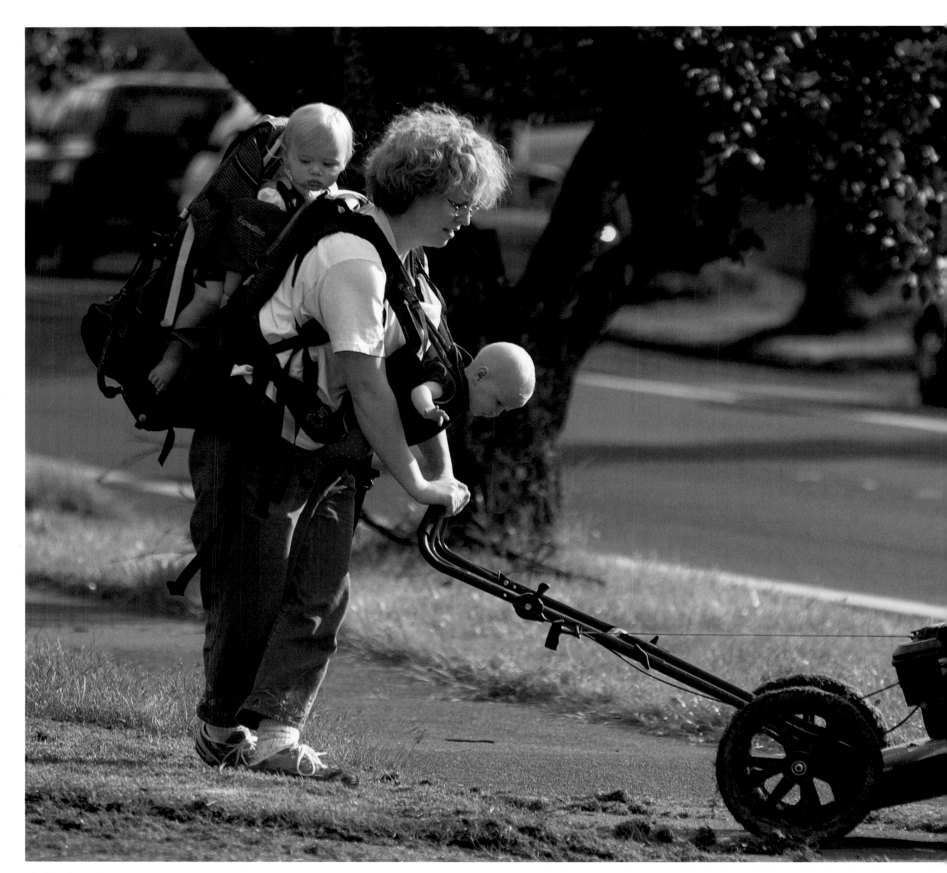

CORVALLIS, OREGON
Alicen Bartholomeusz noticed that Sofia,
18 months, and Rachel, 6 months, calmed down
when her husband mowed the lawn. Faced with
two crying babies and a husband at work, she
cuts the grass with babies on board. Hopefully,
she has an equally clever solution for back pain.
Photo by Karl Maasdam

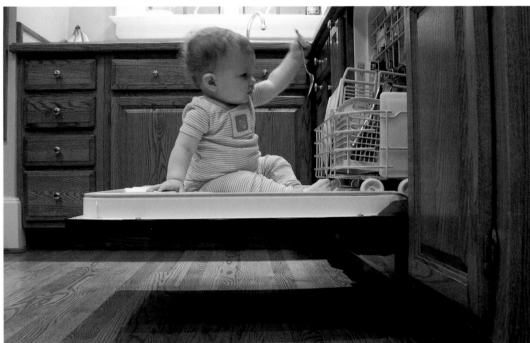

GROSSE, MICHIGAN

Mother's little helper: 13-month-old Emma
learned early on that the dishwasher was center
stage in the Johnston kitchen and a safe haven
from the family's overly affectionate family dogs.
Photo by Andrew Johnston

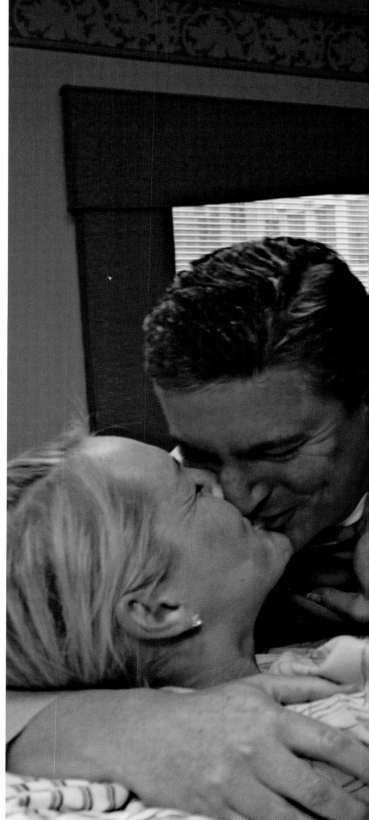

BURLINGTON, VERMONT

Lisa Bilowith and Sue Schmidt adopted both of their African-American sons, 19-month-old Kai and 8-year-old Sha'Ron. Bilowith says their two-mom, multiracial family could only exist in a progressive state such as Vermont, the first in the country to grant same-sex partnerships the full rights and privileges of marriage (1999). The first state to allow full joint adoption for lesbians and gays? Alaska, in 1985.
Photo by Karen Pike, Karen Pike Photography

HE'EIA, HAWAII

Scuba diving instructor Keli'i Wagner hangs with his newborn identical twins 'Aulani and Kainani. The babies have a remarkable multicultural lineage: Hawaiian, Japanese, African American, Irish, and German. The children's names, though, are strictly Hawaiian. 'Aulani means "heavenly messenger of the sea." Kainani means "beautiful ocean."
Photo by Brett Uprichard

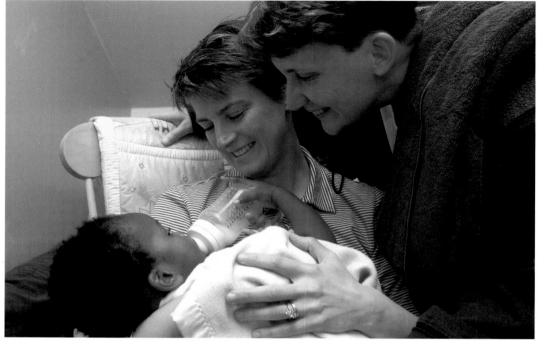

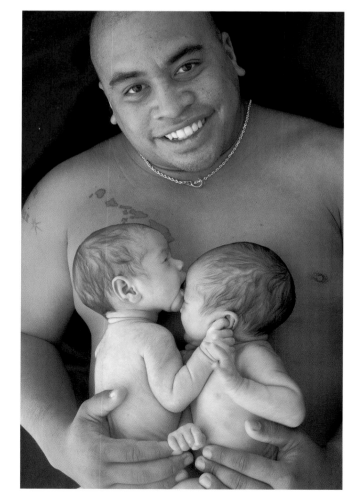

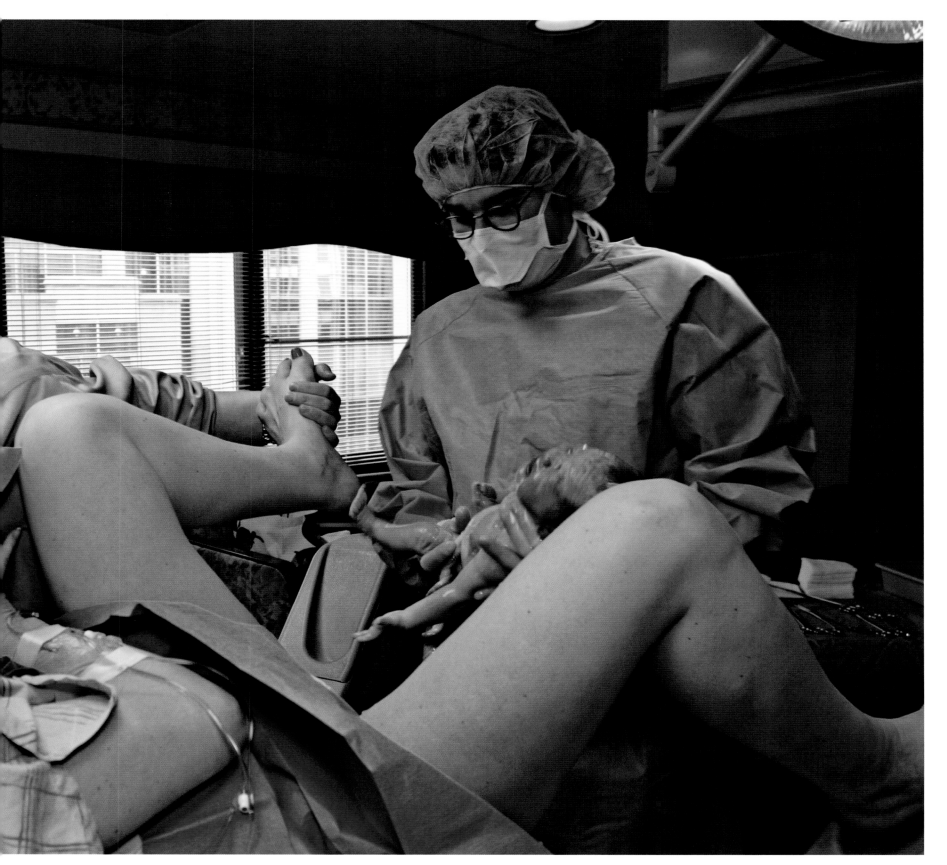

CHICAGO, ILLINOIS
Labor of Love: Gretchen and Brian Baker welcome 15-second-old Lily into the world at Prentice Women's Hospital in Chicago. Fashionably late to arrive, Lily's birth was induced. To accommodate medical necessity or busy schedules, 20 percent of deliveries in American hospitals are induced.
Photo by Michael Hettwer

NERSTRAND, MINNESOTA
During a class visit to Nerstrand Big Woods
Dairy, Seth, Emily, and Jeremy of Prairie Creek
Community School in Castle Rock play in
the barn after learning about environment-
friendly farming practices. To protect local
water supplies, the dairy does not use
pesticides or commercial fertilizers.
Photo by Renée Jones,
Owatonna People's Press

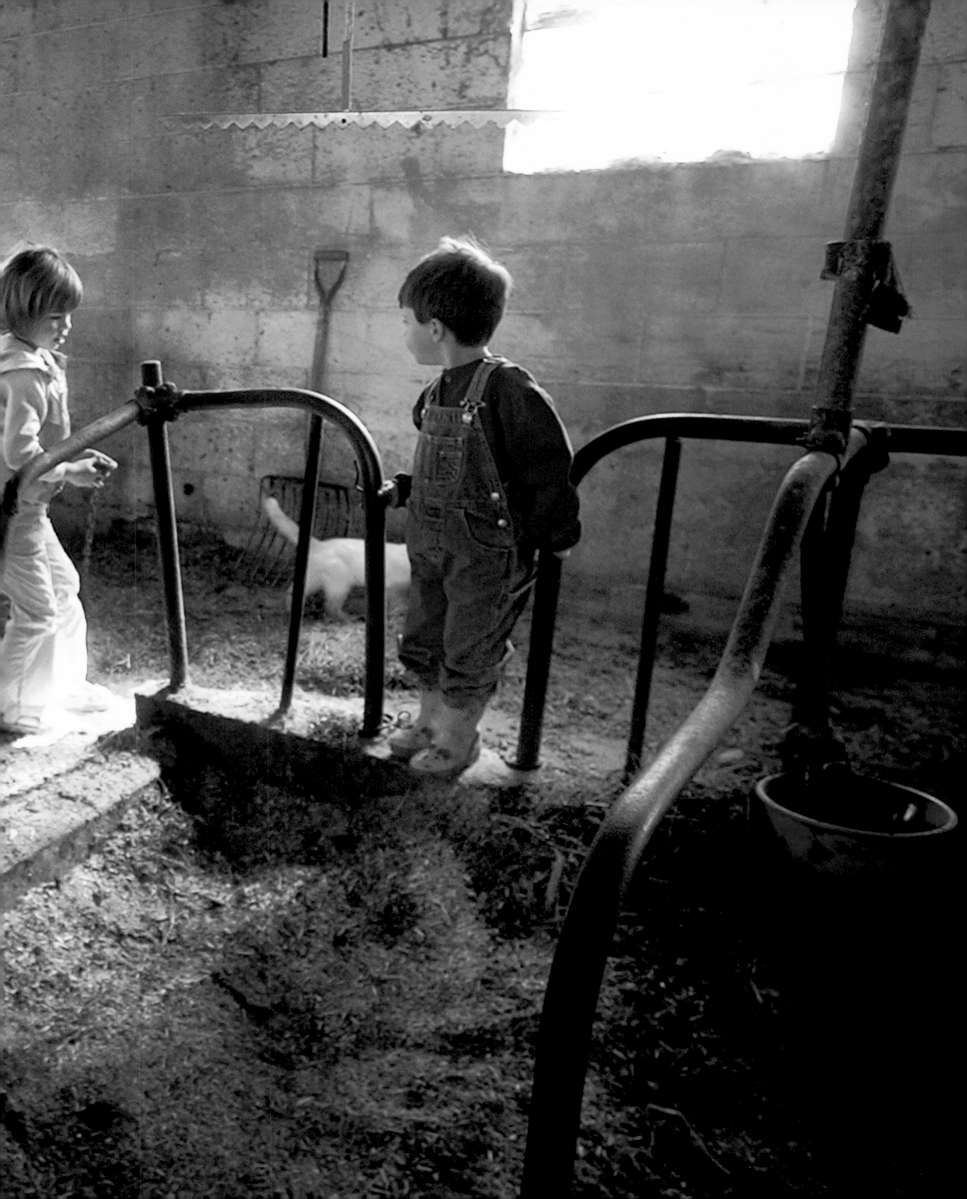

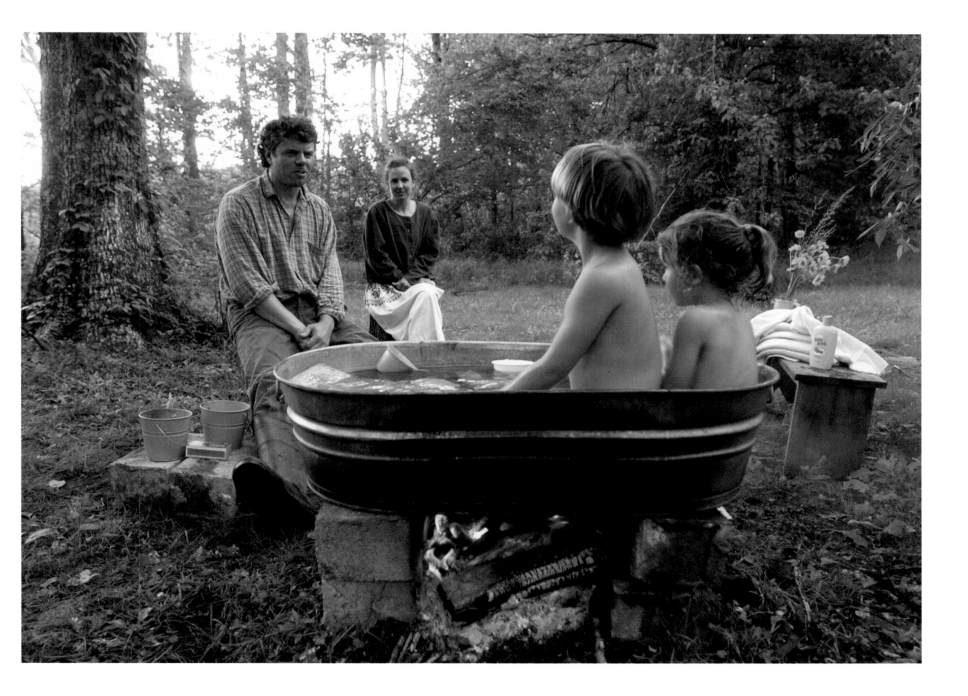

NEW YORK, NEW YORK

When Allan Ludwig, nine, wakes up in NoLita, a gentrified section north of New York's Little Italy, his dad, Allan Sr., will take him across the street to Buffa's Coffee Shop for pancakes and orange juice. Then it's off to school on the bus.

Photo by Gwen Akin

MENTONE, ALABAMA

Everett and Stella Knowlton take their bath the old-fashioned way: in a galvanized steel tub heated by a campfire. Weekends with mom Helene at her boyfriend, Tres Taylor's, woodsy cabin is their favorite time of the week.

Photo by Hal Yeager, The Birmingham News

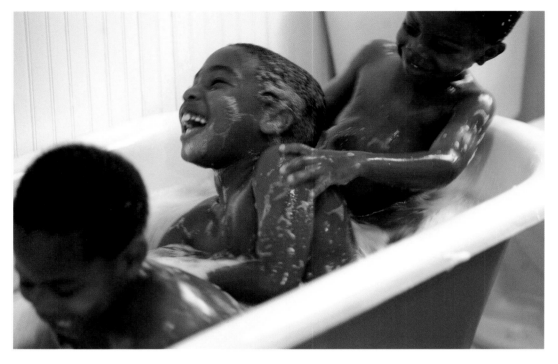

UNDERWOOD, MINNESOTA
Rub-a-dub-dub! Bathing is a major production in the LaFond household where the family of nine requires an elaborate tub schedule. The little ones wash up first, and are ready for bed by the time Joseph, seven, Benjamin, six, and Martin, three, soap up. Parents Jim and Laure LaFond have adopted all nine of their African-American children.
Photo by Stormi Greener

COVINGTON, LOUISIANA
Cheeky three-year-old Mary Magill Grunfeld in a photo her parents will share with everyone they know—and everyone she dates—for the rest of her life.
Photo by David Grunfeld, The Times-Picayune

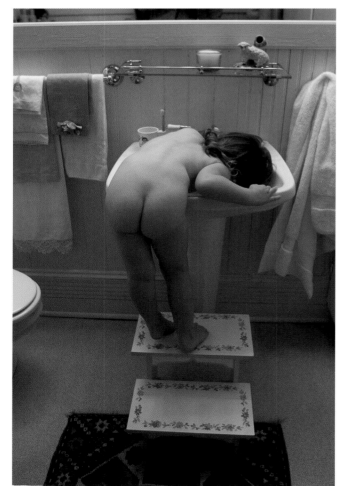

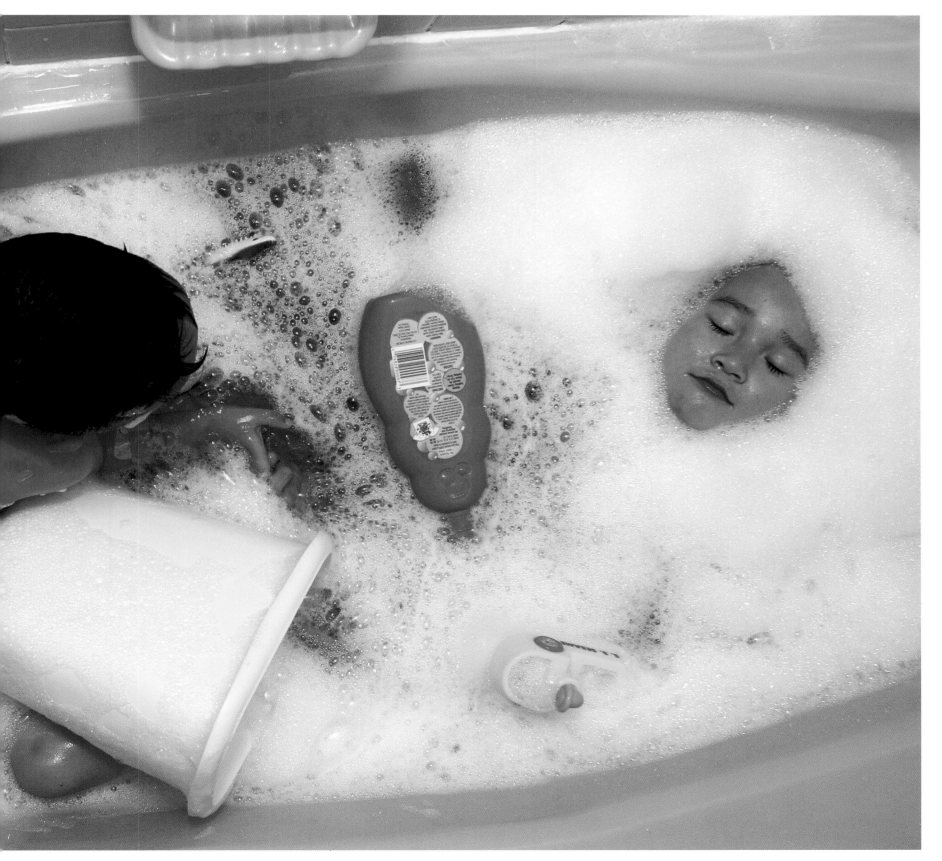

CHICAGO, ILLINOIS

Matt, 5, and Ben, 3, are the adopted Chinese sons of Garey Schmidt, 45, a single dad and healthcare benefits manager for whom fatherhood has been a revelation. "The boys are dependent on me for everything," Garey says, "The love and emotion they have, it's overwhelming." In 2002, Americans adopted nearly 5,000 children from the People's Republic of China.
Photo by Tim Klein

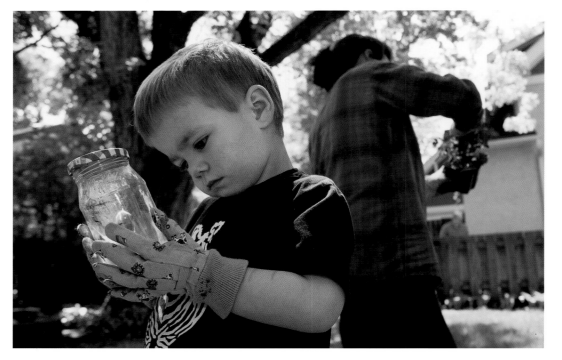

WHEATON, ILLINOIS
Budding entomologist Timothy Hudson, three,
admires his new pet caterpillar.
Photo by Michael Hudson

NORTHFIELD, MINNESOTA

Bottoms up: Believe it or not, the legs belong to college junior Ted Johnson, enthusiastically celebrating the last day of finals at St. Olaf College, a liberal arts institution affiliated with the Evangelical Lutheran Church.

Photo by Renée Jones, Owatonna People's Press

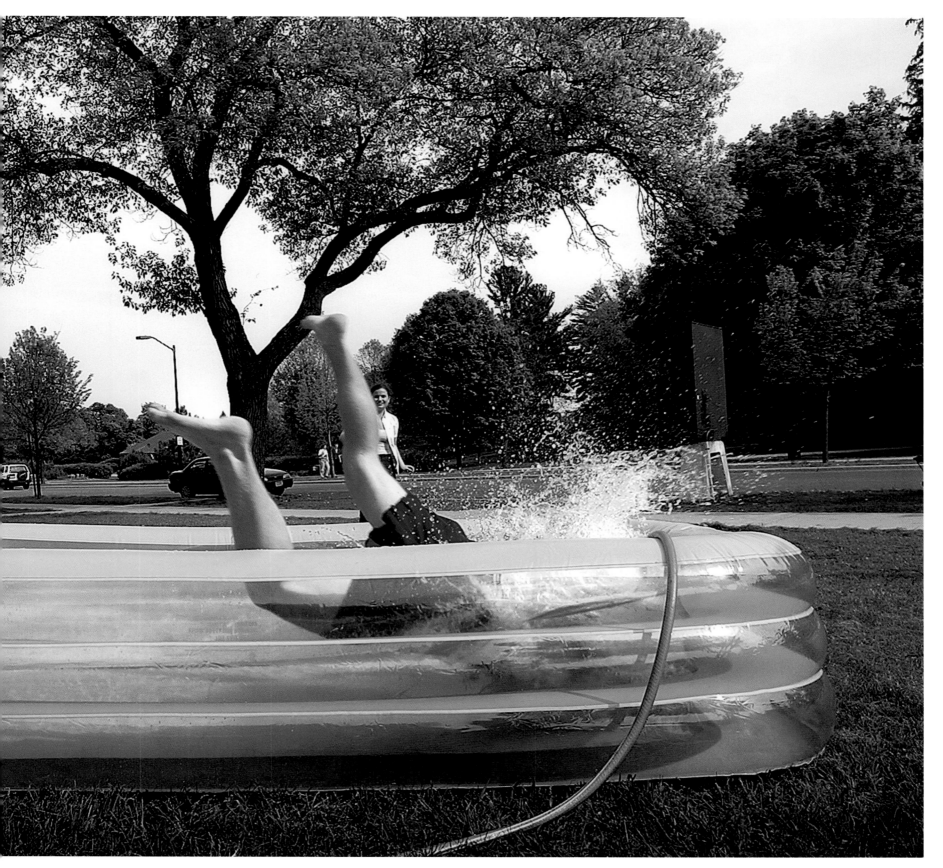

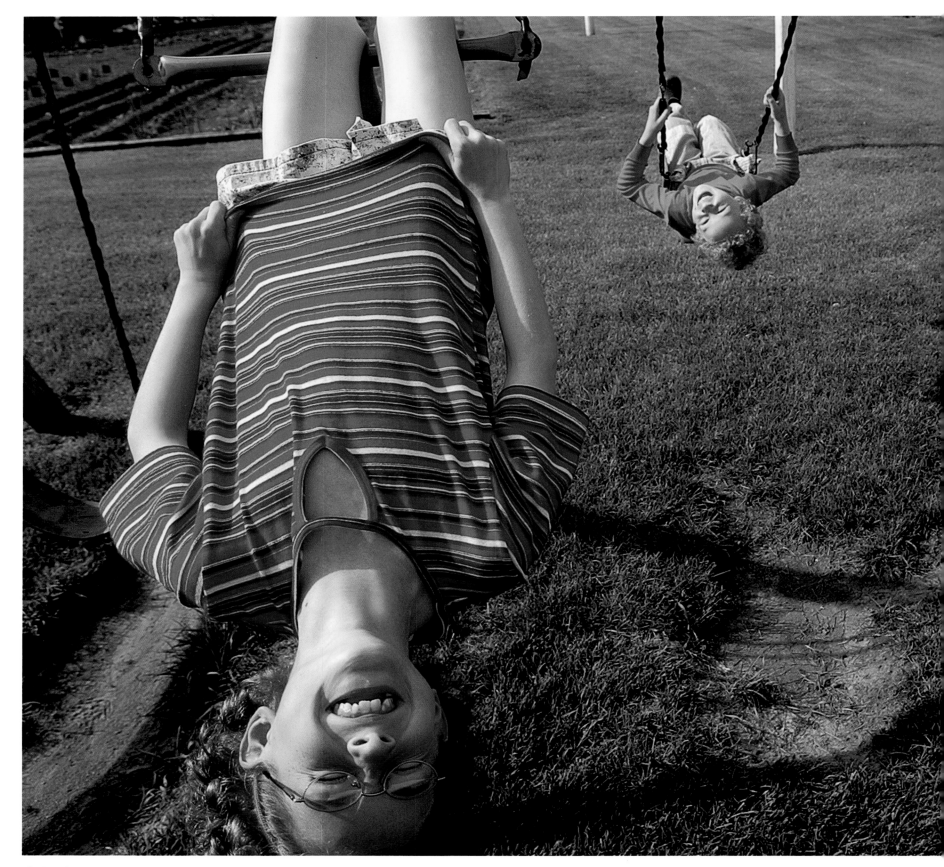

BERNARD, IOWA
Swing time: Kayleen Turnis, nine, and sister Jessica, six, go for the gusto on their backyard swing set. Their dad, Mike, works the family farm tending dairy cows, corn, alfalfa, and soybeans. In addition, he works as a bus driver and part-time gravedigger.
Photo by Dave Kettering,
Telegraph Herald Newspaper

ROCHESTER, NEW YORK
Future luge Olympian Michael Garside, four, hones his skill on the giant jungle slide at the annual Lilac Festival in Highland Park. After 15 thrilling runs, Mom had to pry him away.
Photo by Carlos Ortiz, Democrat and Chronicle

DUBOIS, ILLINOIS
Tammy Jahnke has her hands full. Besides taking care of Todd, two, and Tyler, four, she works at a local bank and helps manage the family farm in southern Illinois. The Jahnkes are the fifth generation to raise Angus cows on this land. They live in the house that her husband, Chris's, great-great-grandparents built by hand in the 1800s.
Photo by Steve Jahnke

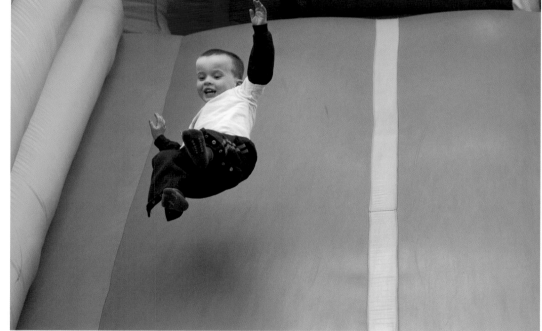

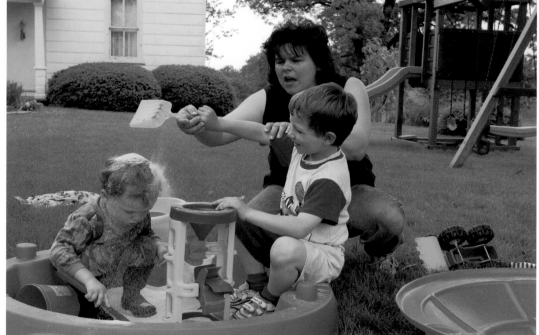

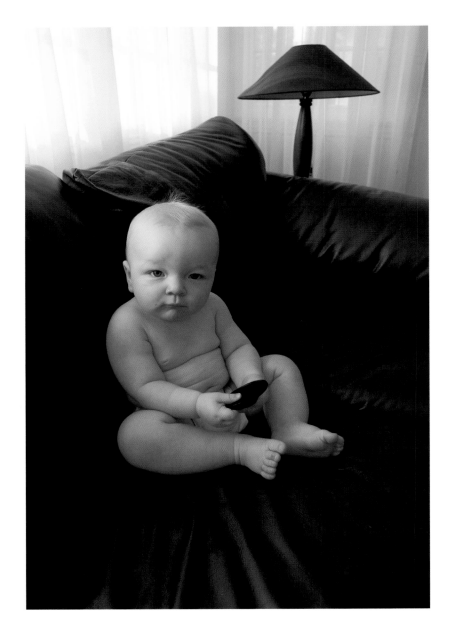

PASADENA, CALIFORNIA
Patient beyond his age, Stephen Krider, 11 months,
waits for his mother to awaken.
Photo by David Krider

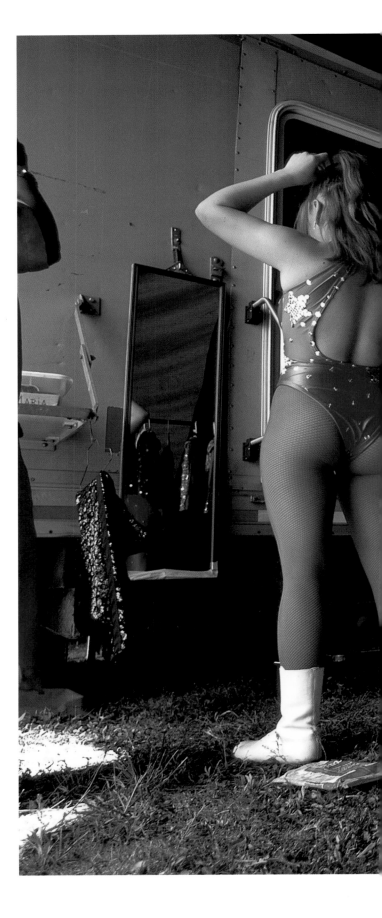

LINCOLN, NEBRASKA

Juggling Vicente Jr.'s needs with the demands of their daily aerial performances is a balancing act for Peruvian trapeze artists Vicente and Deonicia Ventura, seen here beneath the bleachers at the Nebraska State Fairgrounds. Like most of the performers in the traveling Carson & Barnes Five-Ring Circus, the Venturas split their year between South America, where they train, and America, where they tour. Next stop: Wayne, Nebraska.
Photo by Ken Blackbird

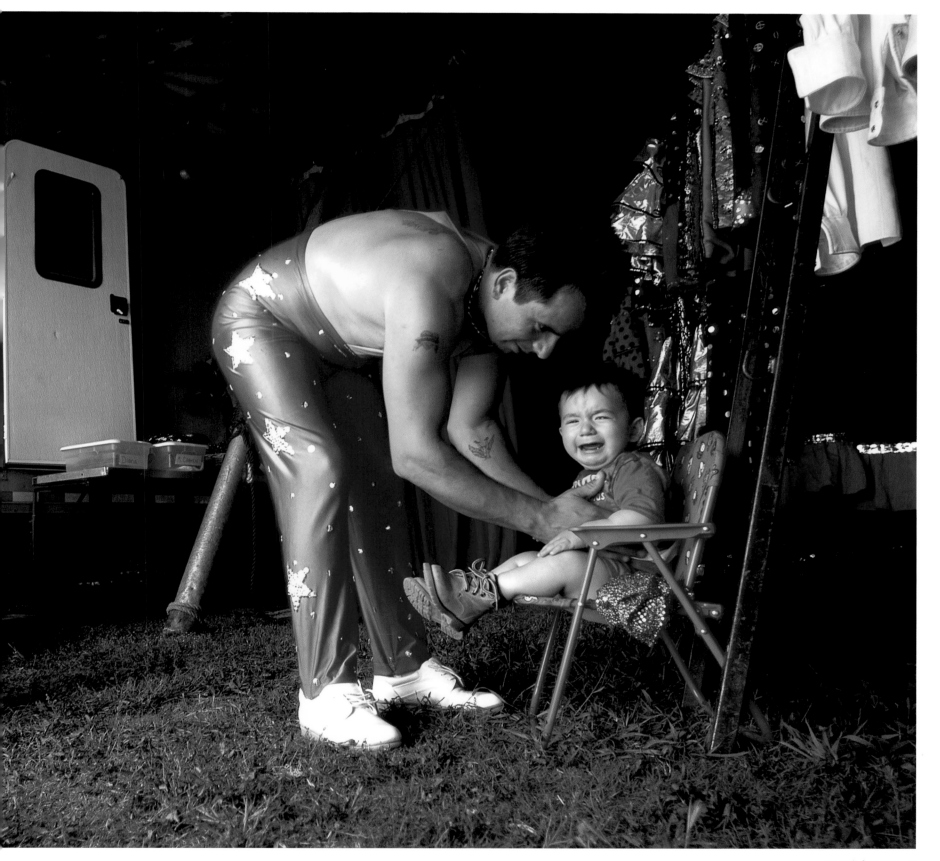

DEARBORN, MICHIGAN

Groom Mohamad Zaarour (in gold vest) dances his wedding night away at the Bint Jebail Cultural Center in Dearborn (near Detroit), home of America's largest, most influential Arabic-speaking community, with nearly 300,000 members. Zaarour and his bride, Nadia Noureddine, a hairstylist, are part of the 100,000-member Lebanese community.
Photo by Sylwia Kapuscinski

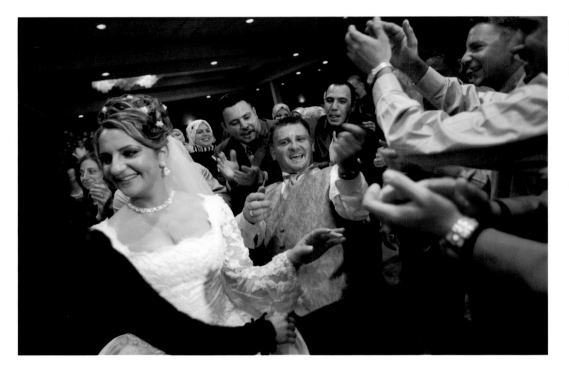

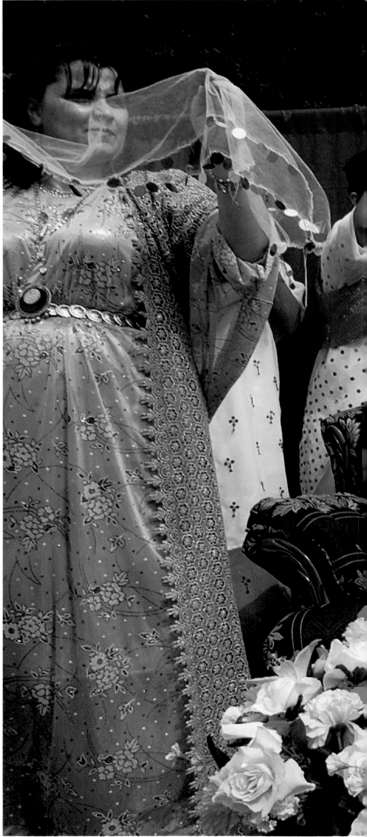

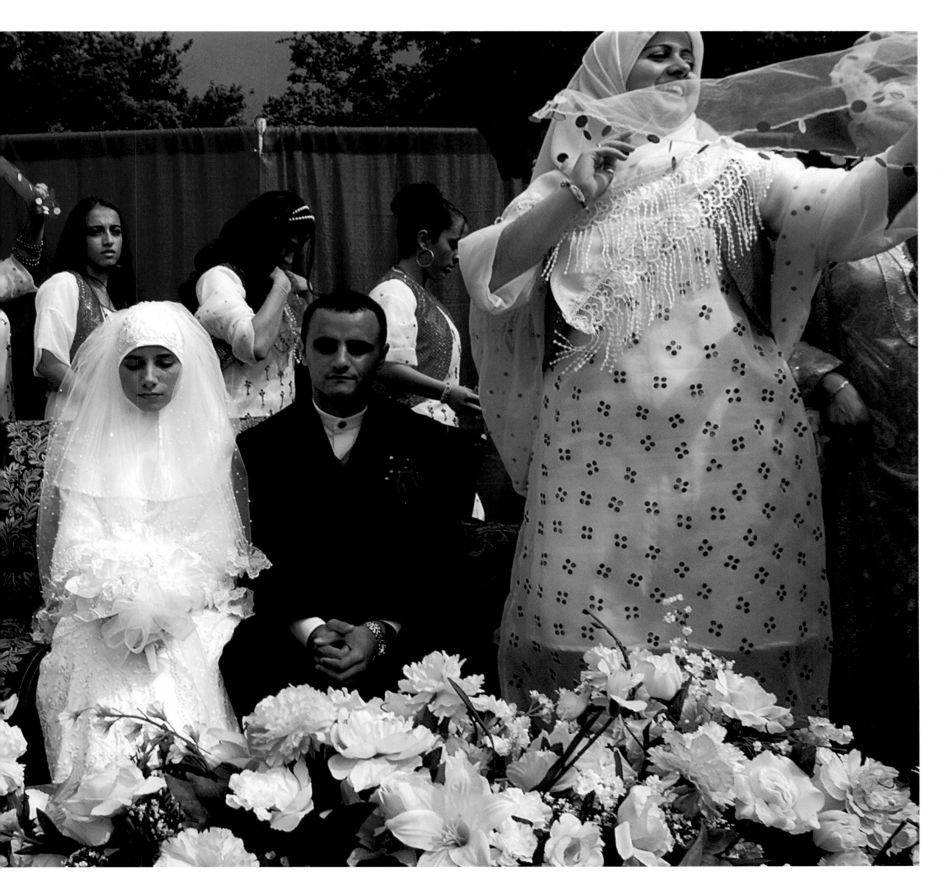

NASHVILLE, TENNESSEE

In 1988, years before they met and fell in love, Nehayet Abdulkadar and Gohdar Abdulkadir both fled Saddam Hussein's Iraq. They spent more than two years in Turkish refugee camps, and both arrived in America in 1991. Like many Kurds, they made a new home in Nashville, site of America's largest Kurdish population (approximately 8,000).

Photo by John Partipillo, The Tennessean

NAPERVILLE, ILLINOIS
Mr. Mom: Little Logan is none too pleased with
sister Madison's attention. But he is probably
delighted that his dad, Mike Becker, takes care of
him. As a stay-at-home father, Mike is part of a
growing number of men (16 percent in 2003) who
have chucked the commute and embraced
shopping, cleaning, and cooking.
Photo by Stuart Thurlkill

SARATOGA, CALIFORNIA

Baby you can drive my car: It doesn't take much coaxing to get Jacob Gensheimer, 16 months, to Gene's Fine Foods, an upscale grocery store in northern California. Parents and kids love these kiddy carts dubbed "Shoppers in Training." The only downside is the inevitable meltdown in the checkout line when it's time to leave.
Photo by Jim Gensheimer,
The San Jose Mercury News

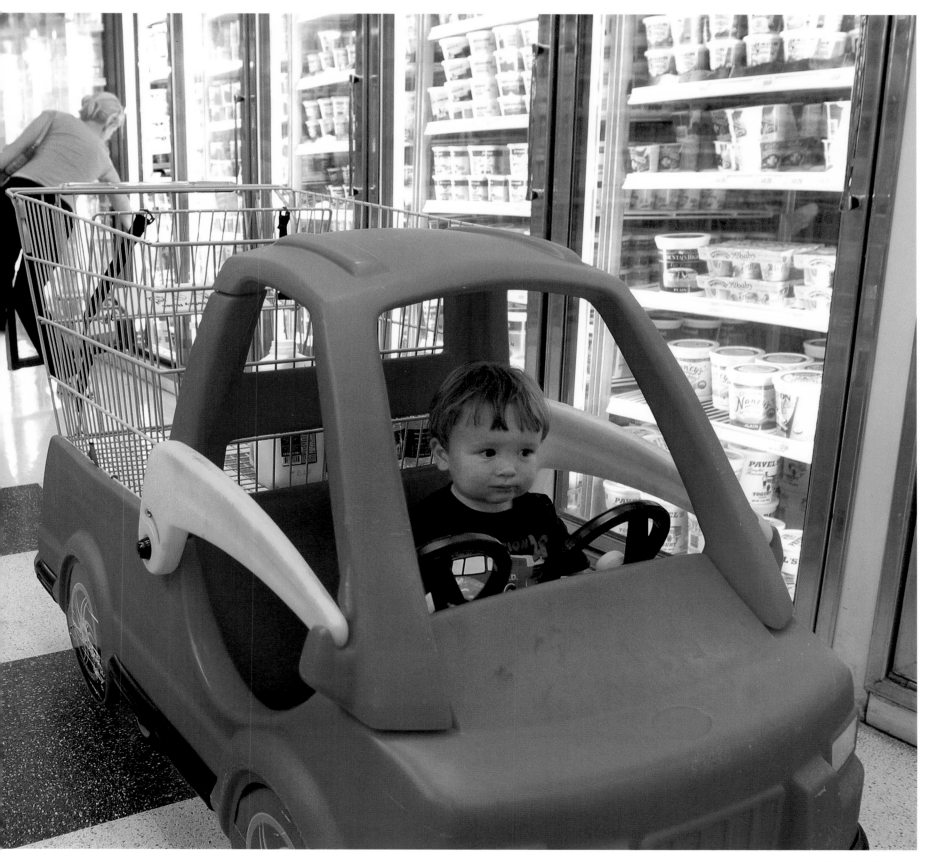

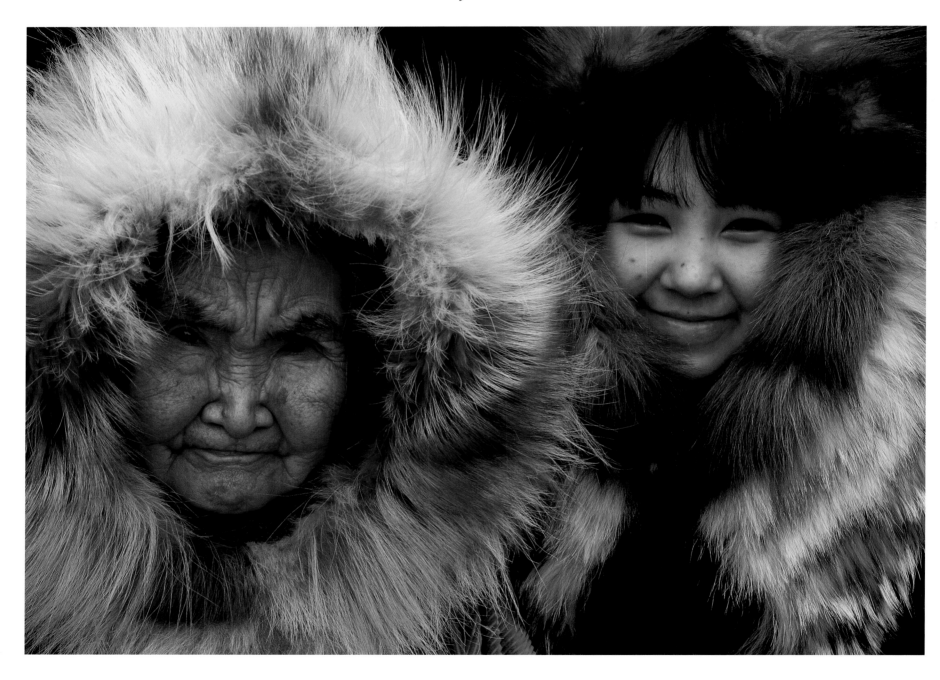

KWETHLUK, ALASKA

Then and now: As a Yupik girl growing up in a small village, Olinka Nicolai, 80, lived in a mud house, trapped rabbits, and traveled by dogsled. Today, she lives in the river town of Kwethluk, close to her great-granddaughter Josephine, 17, who surfs the Internet and listens to gospel CDs on her Walkman. But Olinka made sure Josephine learned essential survival skills like dressing fish, birds, and caribou.

Photo by Clark James Mishler

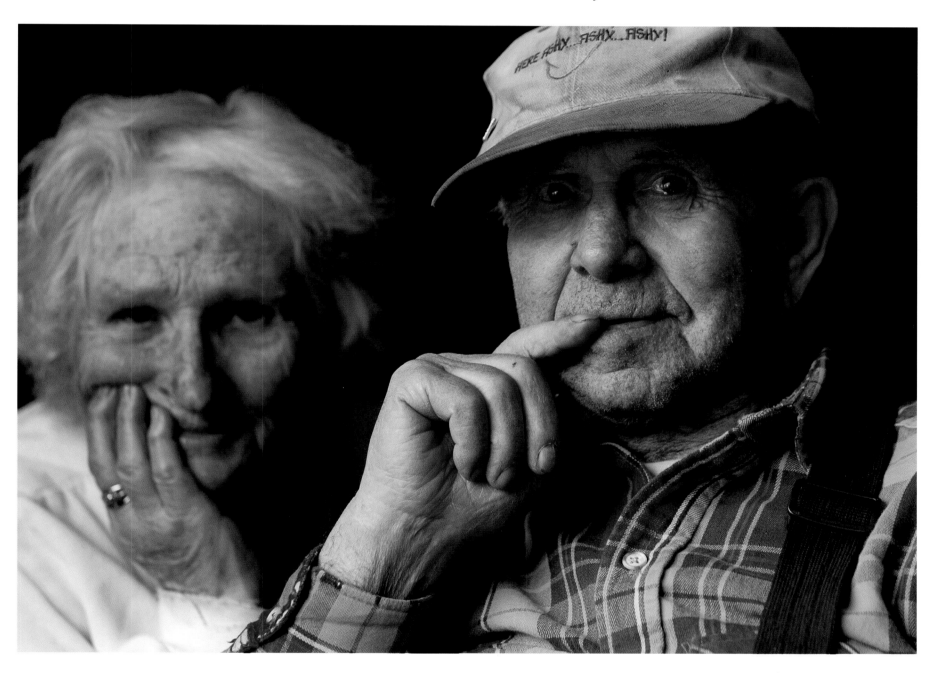

GRAND PORTAGE, MINNESOTA
Fern and Lloyd Hendrickson raised eight children while running their commercial fishing business on the shores of Lake Superior. A sprightly, plainspoken 81, Lloyd says he doesn't think his son, Edward, 61, is quite ready to take over the reins. Besides, says Lloyd, "I still love it—except, of course, for the overeducated idiots at the Department of Natural Resources who're destroying fishing and farming in this state."
Photo by Stormi Greener

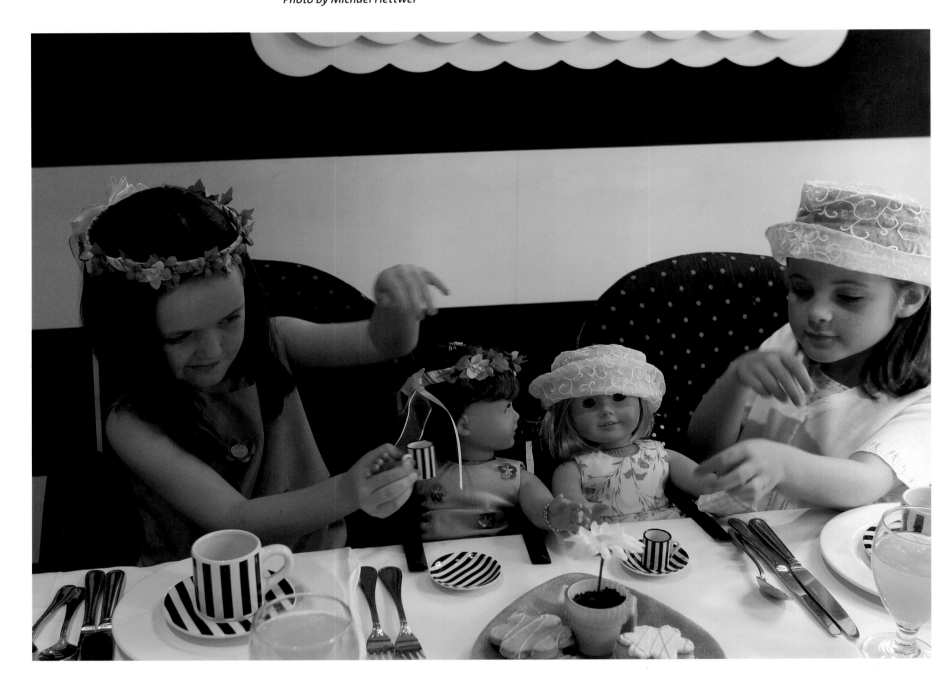

CHICAGO, ILLINOIS
A top tourist attraction, American Girl Place is
a three-story retail experience. American Girl's
pricey dolls come in various complexions and
hair colors to match nearly any girl's appearance.
Also on the premises: a doll hair salon, a doll
theater, and a dress shop that sells girls' clothes
to match the dolls'. At the cafe, Caroline Cronin
and Madeline Sheridan, both six, take tea with
their mini-me's.
Photo by Michael Hettwer

HAMILTON, MONTANA

June Howe, 92, and her sister Zelma Hartley, 98, share laughs over a cup of tea at June's house in Hamilton (pop. 4,000). The sisters, who live across the street from each other, fondly remember their first tea parties nearly nine decades ago. That's when they formed the Happy Hearts Club with three other girls who lived on what was then a dirt road.

Photo by Jeremy Lurgio

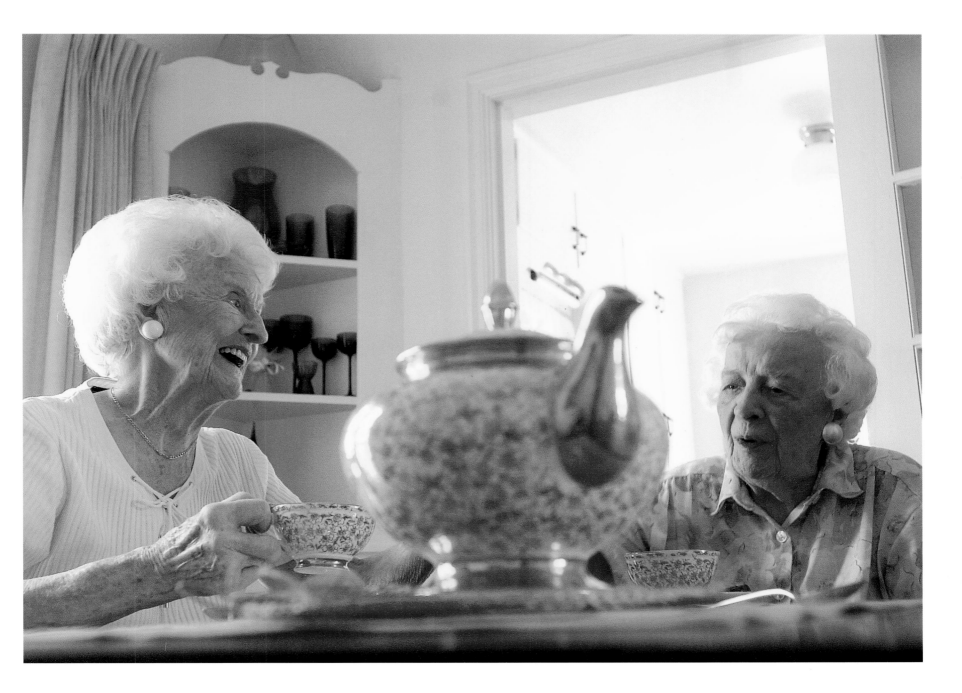

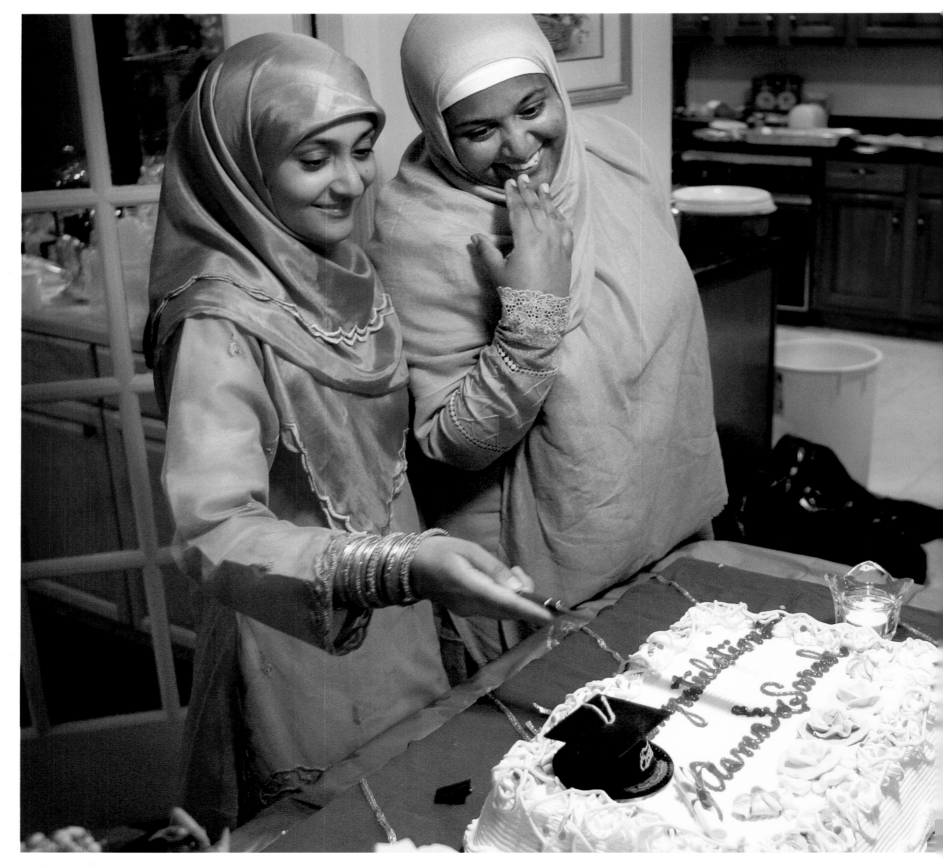

TEQUESTA, FLORIDA
First-generation Pakistani-Americans Asma and Sarah Azimi celebrate their college graduation. Asma, 22, received her degree in education from the University of Michigan, and Sarah, 26, graduated from Eastern Michigan University with a B.A. in communications. The sisters say they'll honor the Muslim tradition of arranged marriages, but will be the first women in their family to pursue careers outside the home.
Photo by Jacek Gancarz, Palm Beach Daily News

HILLSIDE COLONY, MONTANA

Pacifist Christians who trace their roots to 16th-century Switzerland, the 30,000 Hutterites who live on 350 communal farms across rural North America are known for leading a separate and quiet existence. "Boss cook" Rachel Hofer prepares meat-and-cheese pies, dinner for her 135 brethren who live and work at the farm, close to the Canadian border.

Photo by Todd Korol

SAN FRANCISCO, CALIFORNIA

San Francisco roommates for five years, Alex Holod and Nicole Kahl knew they were going their separate ways—Alex to grad school across the Bay in Berkeley, Nicole home to Sacramento—so they made a big deal of Alex's 30th birthday.

Photo by Sheila Masson

BURNSVILLE, MINNESOTA

With summer vacation weeks away and prom around the corner, 18-year-old Sarah Peterson gets ready for another day at Burnsville Senior High School in Northern Minnesota. Someday archaeologists may regard the posters, cards, slogans, and other paraphernalia covering Sarah's walls as the equivalent of ancient cave paintings.

Photos by Brian Peterson,
The Minneapolis Star-Tribune

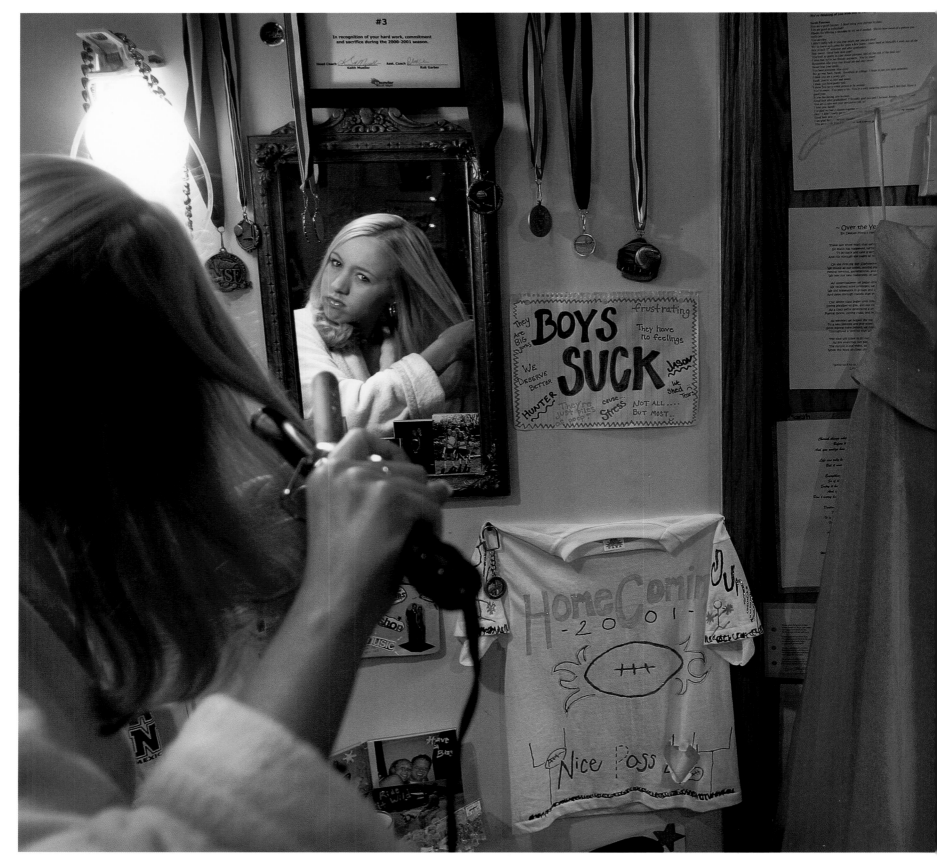

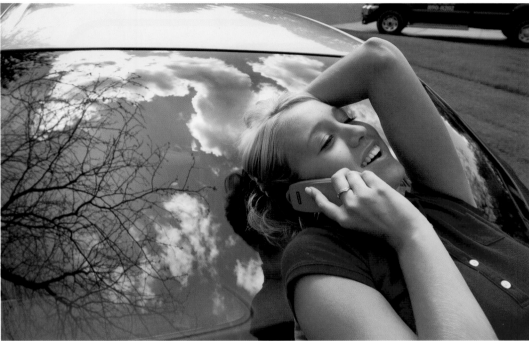

BURNSVILLE, MINNESOTA

Later that same day, Sarah makes evening plans with her friend Eric: maybe basketball in the driveway, maybe hanging out at home, maybe a movie. Her longer-range plans include studying dental hygiene at Minnesota State University in the fall.

JEKYLL ISLAND, GEORGIA
A day filled with memories and someone to share them with: Joel and Lucille Barnett return to the island they visited as a young couple 55 years ago.
Photo by Flip Chalfant

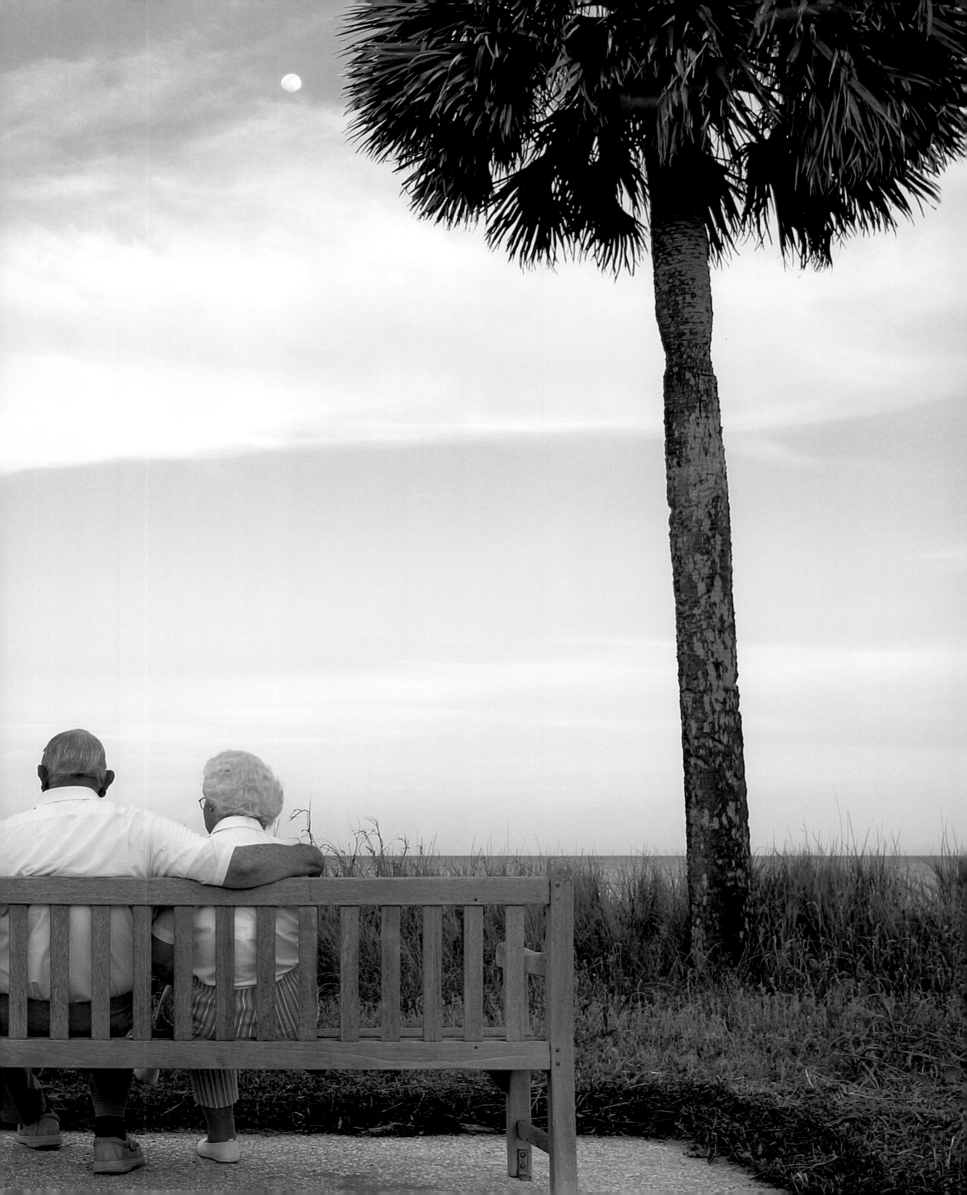

The year 2003 marks a turning point in the history of photography: This is the first year that digital cameras will outsell film cameras. And, as tiny digital cameras become standard components on cell phones, the digital-image revolution, which has already swept Japan and begun in Europe, will only accelerate. To celebrate this unprecedented sea change, the *America 24/7* team invited amateurs—along with students and professionals—to shoot and submit images for inclusion in this book. Think of it as audience participation. More than 25,000 amateurs submitted images and many of them are interspersed throughout this book. The following four pages comprise a gallery created exclusively by amateur photographers.

ROWLETT, TEXAS School can wait. Boys can wait. For now, nothin' beats just being seven in Grandma's backyard. *Photo by Vickie Belcher*

HOUSTON, TEXAS "My 3-year-old son takes a nap on the couch with his arms thrown back, just like his daddy," notes his mom Amy Gullet. *Photo by Amy Gullett*

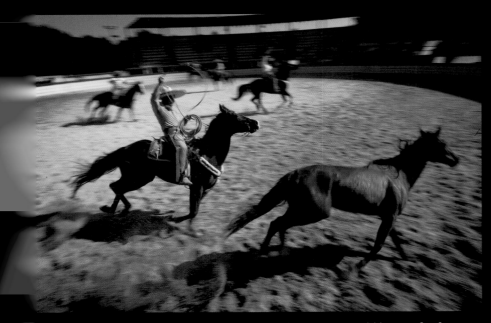

SAN ANTONIO, TEXAS Charros—Mexican cowboys—rope wild horses for fans at the San Antonio Charro Association, the oldest such organization in America.

SAN CLEMENTE, CALIFORNIA Abandoned at night, the San Clemente Pier bustles with surfers, fishermen, and tourists during the day.

LAND O'LAKES, WISCONSIN Ritarose Battin, two years old, can't swim yet, but she's fascinated by the minnows in Moccasin Lake in Wisconsin. *Photo by Suzi Battin*

DOBBS FERRY, NEW YORK Every May, the Kennys' five cherry trees dump a dazzling carpet of pink petals in the backyard. Chava Kenny, 13, coaxed sister Rachel, 11, to pose for a picture, becoming the youngest *America 24/7* photographer. *Photo by Chava Kenny*

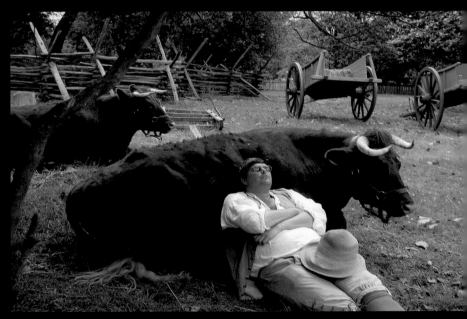

NEW YORK, NEW YORK Mid-canyon on New York's famous Fifth Avenue, St. Patrick's Cathedral shows its colors. *Photo by Craig Gordon*

WILLIAMSBURG, VIRGINIA Early American cowch: Ox wrangler Darin Tschopp, 36, usually demos how ox carts provided transportation in Colonial Williamsburg, but

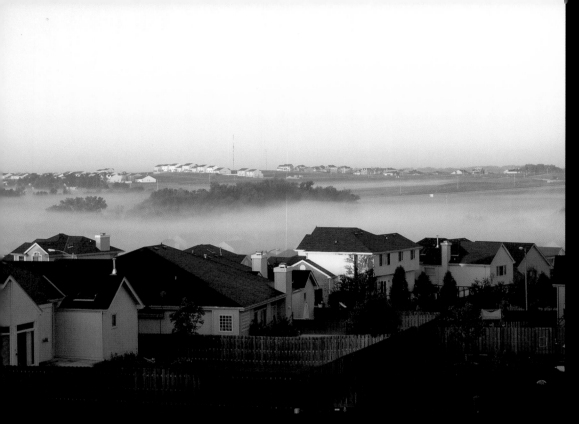

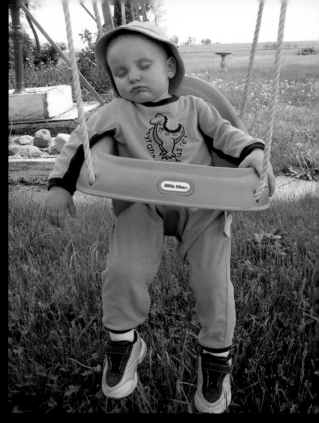

OMAHA, NEBRASKA The world from his window: Morning fog lies low over cornfields and orchards near the Elk Creek Crossing subdivision, developed in the mid-1990s. *Photo by Randy Zuke*

RANKIN, ILLINOIS After a tough day of *Sesame Street* and fingerpainting, Gable Edwards, 20 months, crashes in his favorite swing. *Photo by Heather Edwards*

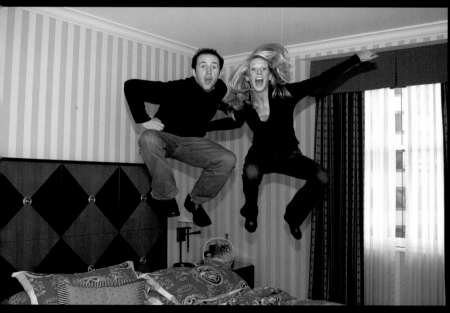

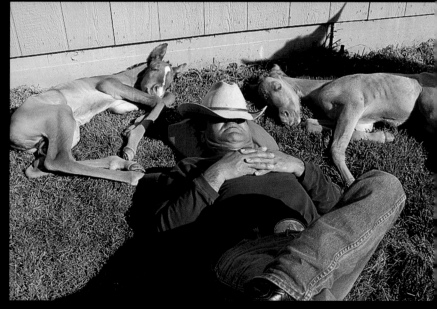

SALT LAKE CITY, UTAH Newlyweds Justin and Josie Fish jump for joy. During one week in America, more than 22,000 couples tie the knot, some very enthusiastically. *Photo by Michael West*

SUMMERVILLE, OREGON Rancher Louie Ochoa takes a well-earned rest after delivering twin foals earlier that morning. Twin foals are extremely rare; rarer still that both foals and mother survive the birth. *Photo by Susan Ochoa*

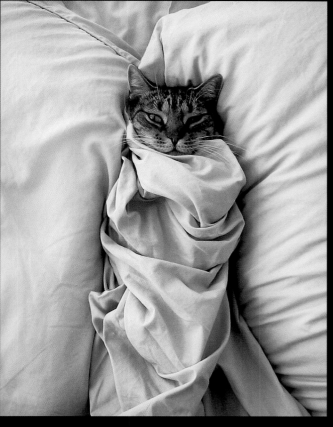

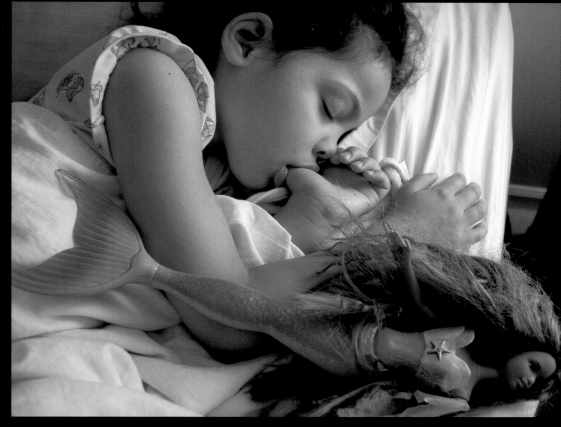

DETROIT, MICHIGAN Move over Milo: Like any self-respecting feline, Chad Warner's tabby, Milo, prefers to sleep in the bed. *Photo by Chad Warner*

ITHACA, NEW YORK Madeline, four, calls her Barbie "Queen of All Mermaids in the Sea." The doll was purchased with her piggy-bank money, which she divides equally: some to spend, some to save, and some to give away. *Photo by Irene Horrigan*

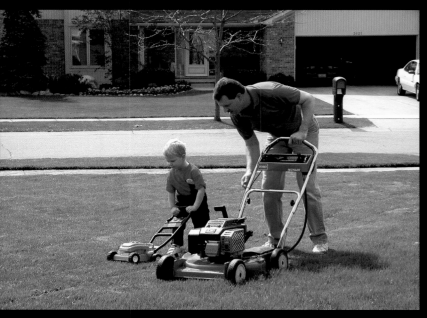

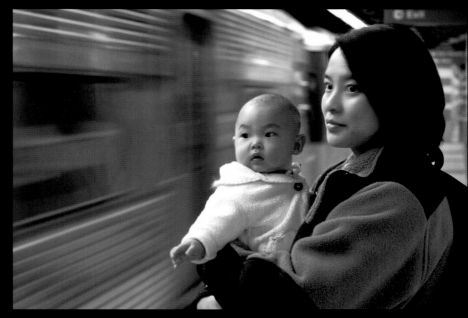

WIXOM, MICHIGAN Among the many things fathers teach sons: On Sunday morning, Andy Neller and his son Bradley, two, mow the lawn. *Photo by Barbara Neller*

PHILADELPHIA, PENNSYLVANIA Debra Shick and her daughter, Chenjing, crossed the Delaware to visit friends in New Jersey. And for the first time, five-month-old Chenjing stayed awake for the entire ride. *Photo by Yischon Liaw*

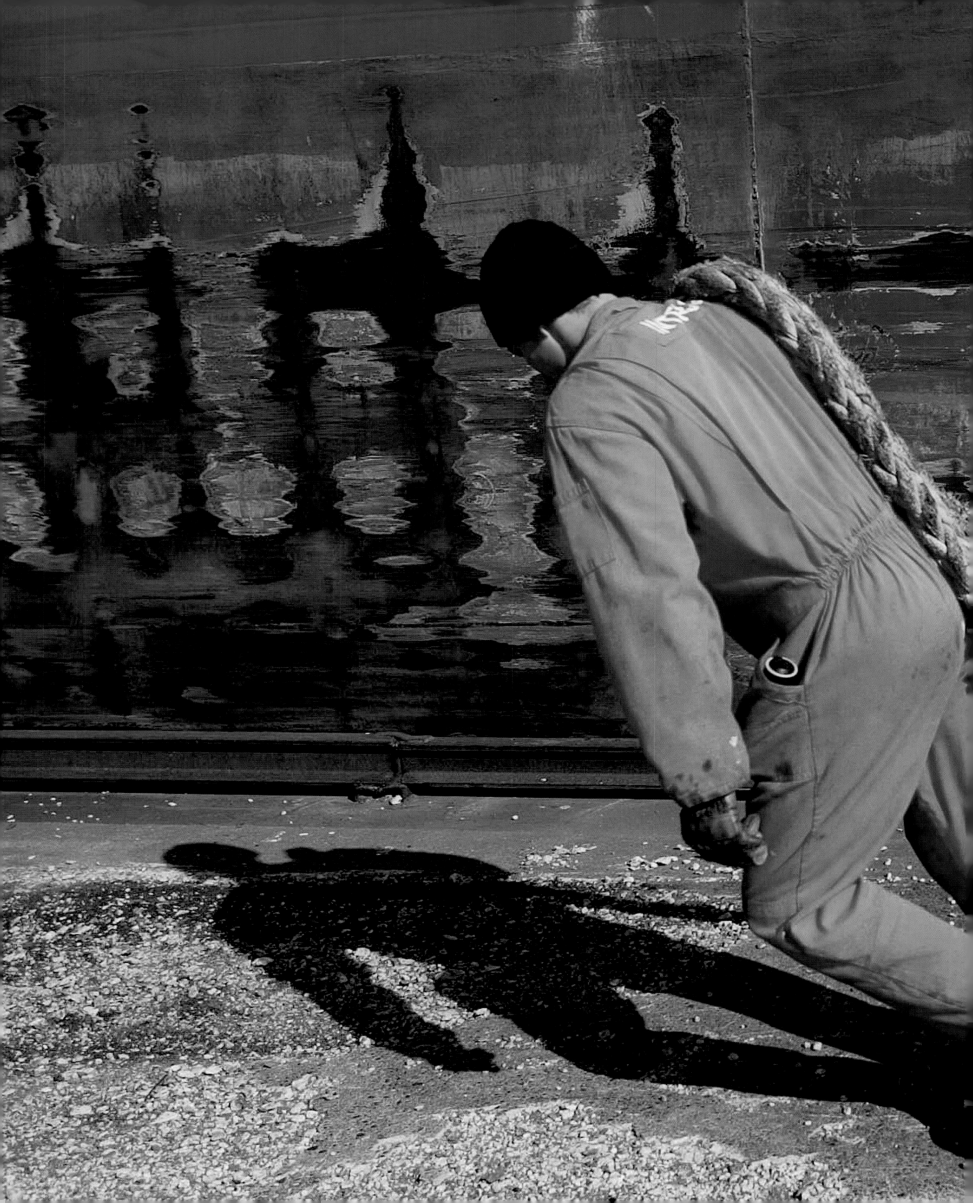

<div style="writing-mode: vertical-rl">Hard at Work</div>

Under a glass globe in my living room there is a remnant of my family's four centuries of history on the North American continent. I'm sure everyone who has visited my home must feel it is the strangest of heirlooms, an indecipherable piece of the American past, a tissue of time and forgotten lives. I try to imagine (as archaeologists do with tools from Pompeii or shards of pottery from the Incas) the African-American world of hope, struggle, heroism, and long-deferred possibilities that background this 80-year-old object.

What rests under glass is a thick, cloudy milk bottle, very scarred, that bears in relief the inscription "One Pint. This Bottle Property of and Filled by JOHNSON DAIRY CO., Evanston, Il. Wash and Return."

The venerable Johnson who owned that bottle was my late great-uncle William. He was born in 1892 in rural South Carolina at the end of Reconstruction, near the little town of Abbeville, just three years before Booker T. Washington's Atlanta Compromise address. His people lived close to the

DULUTH, MINNESOTA Colonists called them to action with shouts of "Men 'long shore." And once this Lake Superior longshoreman ties off the 21,000-ton bulk carrier, Federal Weser, he will help load 850,000 bushels of North Plains grain bound for Spain. *Photo by Richard Hamilton Smith*

They call it the bull pen: Billionaire Mayor
Michael Bloomberg busted out of the traditional
mayoral office and substituted trading-floor-
type cubicles for himself and his deputies in the
heart of New York's historic City Hall (circa 1812).
The founder of financial data giant Bloomberg
L.P., he thinks the setup "makes for a more open
and efficient flow of information."
Photo by Mark Peterson

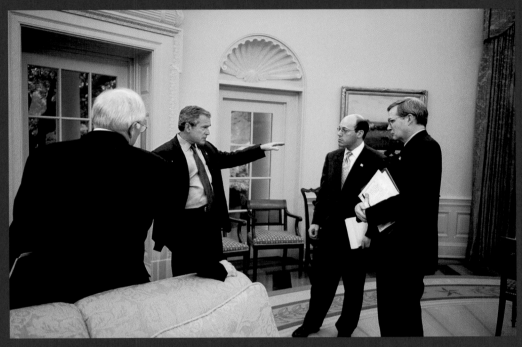

WASHINGTON, D.C. George W. Bush holds court with Dick Cheney, Ari Fleischer, and Steve Hadley after a meeting with Norway's Prime Minister Kjell Magne Bondevik. Even if you're prime minister, you'd better not be late to the Oval Office. Known as the "on-time administration," meetings start and conclude precisely as scheduled.
Photo by Paul Morse, The White House

land. They farmed, spent their winters hunting, and produced everything they needed. Their water came from a well. They put their children to work at age five, making them fetch things for the adults as they worked. In their daily lives nothing came easily, or was taken for granted.

Like many black people who migrated to the north after World War I, he traveled to Chicago and settled in Evanston, a quiet suburb, bringing with him nothing more than a strong back and a burning desire to succeed against staggering racial odds during the era of Jim Crow segregation. In Evanston, he discovered that white milk companies did not deliver to blacks. Always a man who preferred hard work and getting his hands dirty to complaining, building to bellyaching, Uncle Will responded to racism by founding the Johnson Dairy Company, an enterprise that did very well delivering milk each morning to black Evanstonians.

When the Great Depression brought his company to an end, Uncle Will worked on a construction crew until he learned the ropes, then he

started his second venture, the Johnson Construction Company, which lasted into the 1970s and was responsible for raising churches (Springfield Baptist Church), apartment buildings, and residences all over the North Shore area —places where today, long after my great-uncle's death in 1989 at the age of 97, people still live and worship their god.

I grew up in a town where every day I saw or entered buildings that were produced by the ingenuity, sweat, and resourcefulness of my great-uncle's all-black construction crew, which once employed my father and uncles. And so, as a child, I never doubted—not once—the crucial role my people have played since the 17th century colonies in the building of America on all levels—physical, cultural, economic, and political.

Whenever I walk through my living room, passing Uncle Will's milk bottle, I can hear the urgency that entered his voice when he counseled his great-nephews and nieces to "Get an education." Sometimes when I'm working late at night, and walk from my second-floor study down-stairs to the kitchen for a fresh cup of tea, I see his milk bottle on an end-table, and I wonder how tightly the dreams of this tall, handsome, industrious black man were tied to these tiny pint containers.

Did other black men tell him he was foolish to try competing with the white milk companies? Did he stay up nights wondering, like any entrepreneur (or artist), if he might fall on his face with nothing to show for his sweat and sacrifices except spilled milk? If so, then that was just all right. For America guaranteed that he would have the chance to dream again.

By Charles Johnson

CHARLES JOHNSON *has won the National Book Award and the Academy Award for Literature from the American Academy of Arts and Letters.*

cessed at Foremost Farms, one of America's
top 10 dairy cooperatives.
Photo by Mark Hirsch, Telegraph Herald

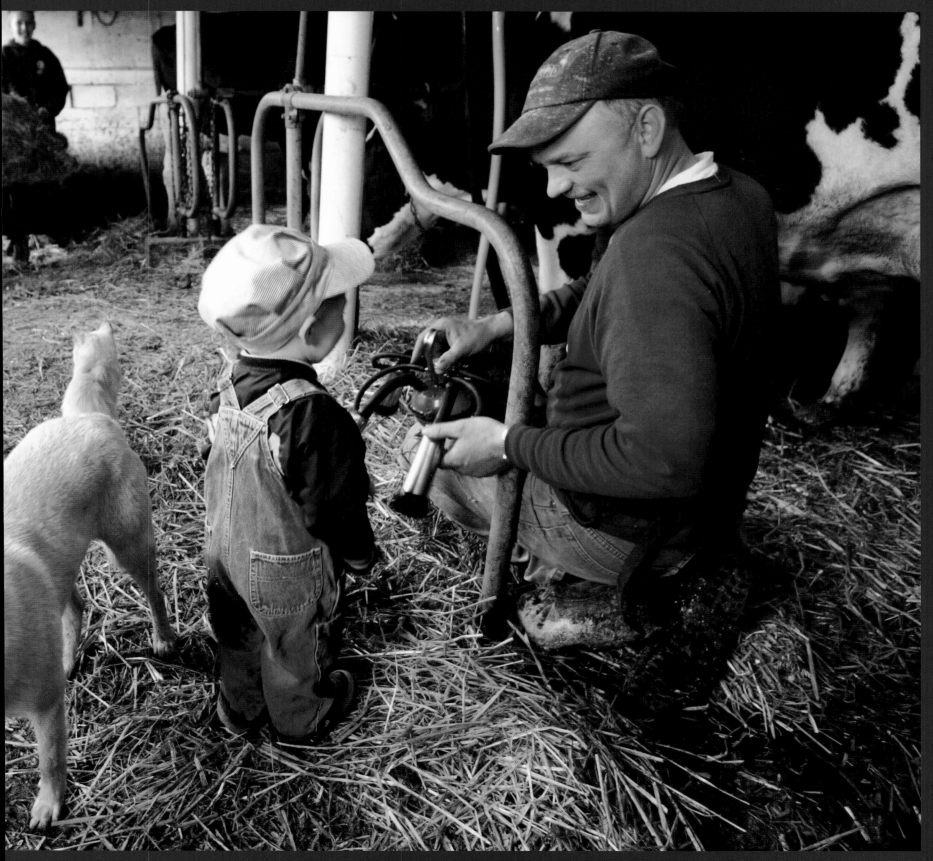

WASHINGTON, D.C.
Morning commuters cram into cars at Washington's downtown Metro Center Station. Washington consistently ranks among the most traffic-congested metropolitan areas in America, which enhances Metrorail's popularity (more than 180 million tickets are sold annually).
Photo by Andy Nelson

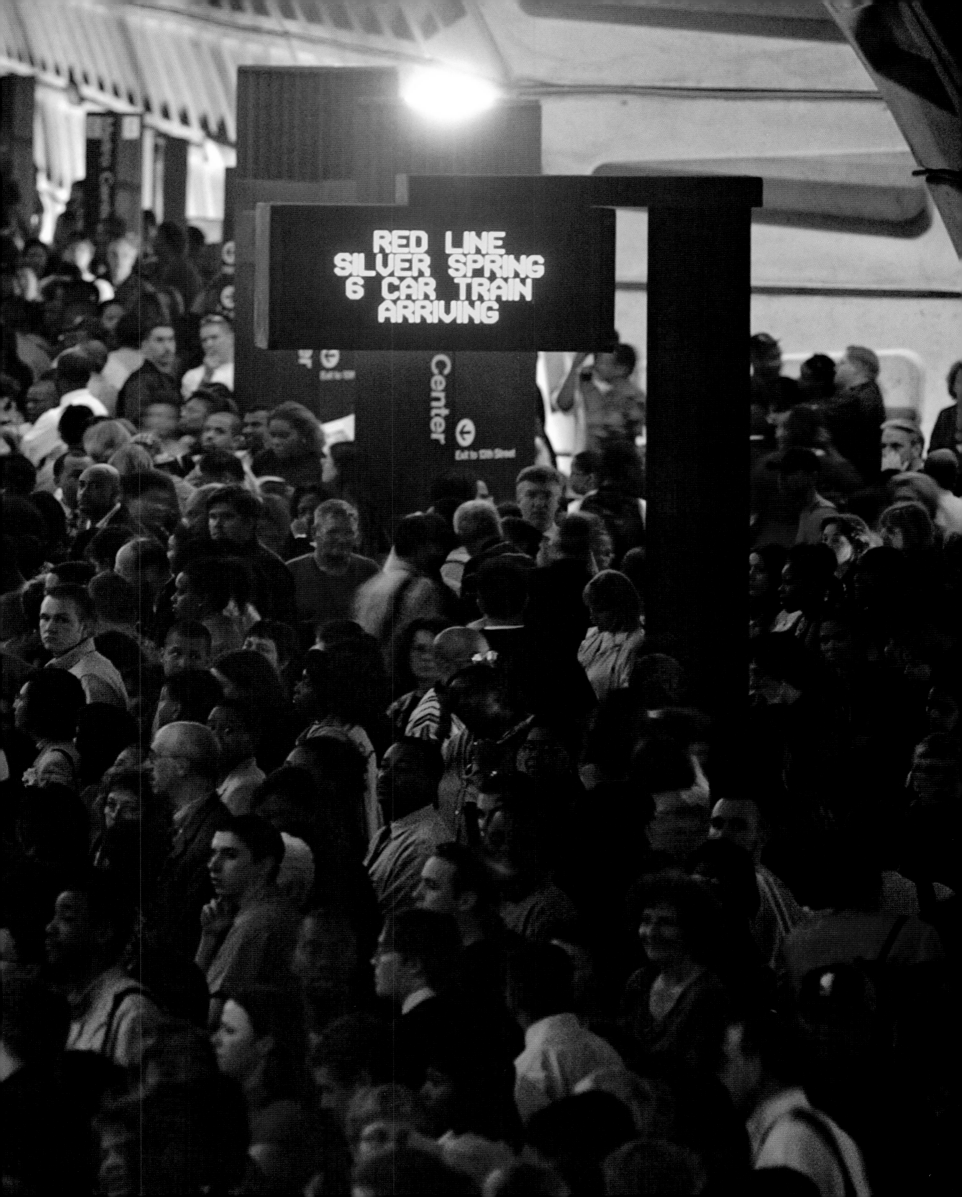

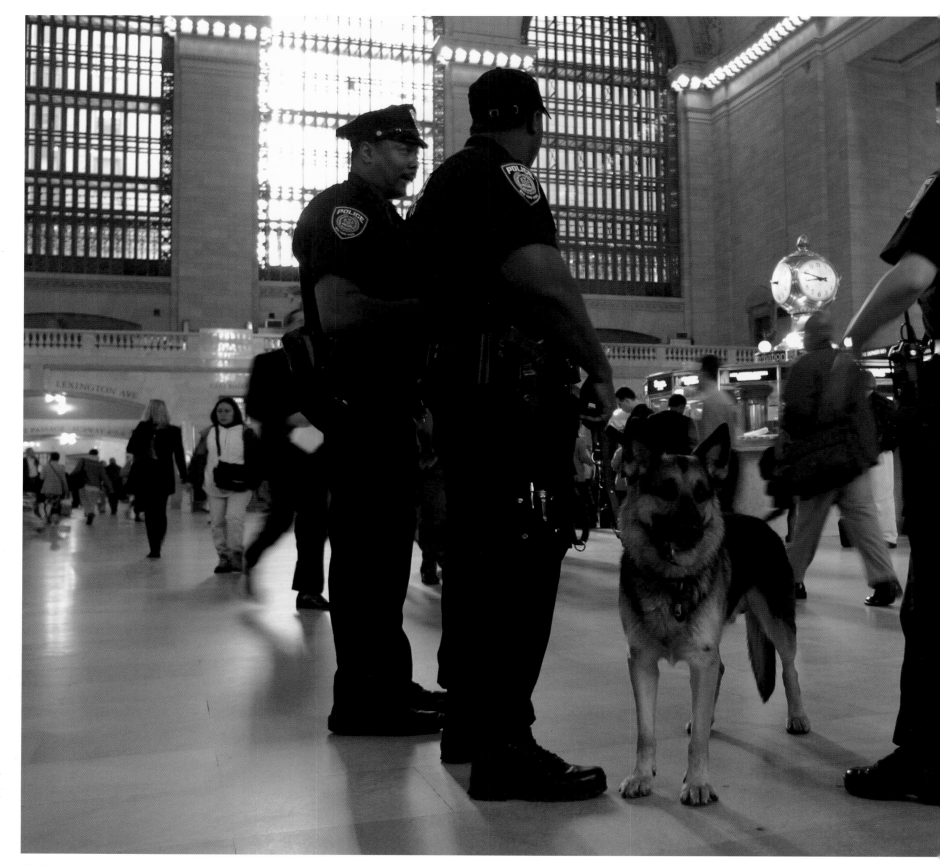

NEW YORK, NEW YORK
Operation Atlas, New York City's antiterrorist program instituted during the American war on Iraq, was still in effect months after combat ended, with undisclosed thousands of law enforcers deployed. At Grand Central Terminal, Metropolitan Transportation Authority officers guard the Grand Concourse, crossroads for a half-million commuters daily.
Photo by Lori Grinker, Contact Press Images

LONG BEACH, CALIFORNIA

Although she works for JetBlue at Long Beach Airport, customer-service agent Sally Witt must go through the same security procedures passengers do. Many travelers find the checks slow and frustrating, which is why the Transportation Security Administration's stated objective is to get 95 percent of passengers to security screening in 10 minutes or less.
Photo by PF Bentley, PFPIX.com

NEW YORK, NEW YORK

Shoes are to New Yorkers what cars are to Angelenos: really important. At Grand Central Station, commuters like George Rosenberg (left) and Pete Edwards keep shoe shiner Jose Chicaira in business at the Cobble and Shine stand. Charging a reasonable $3 for shoes and $3.50 for boots, Chicaira shines more than a dozen pair of New York shoes every rush hour.
Photo by Lori Grinker, Contact Press Images

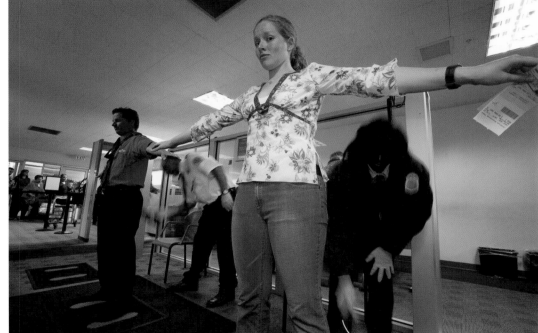

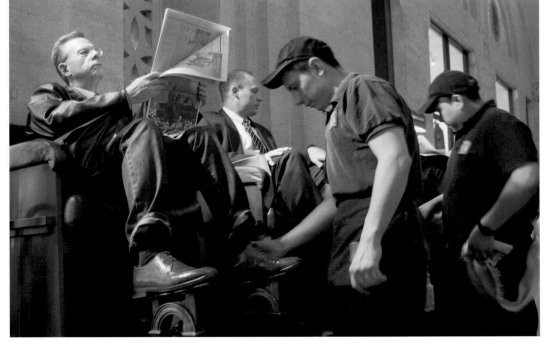

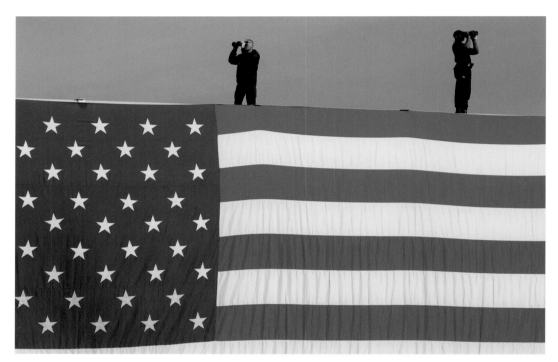

BERNALILLO, NEW MEXICO
Secret Service countersnipers provide cover from the rooftop of MCT Industries, a government defense contractor and waste transporter, where President Bush spoke to factory workers about his jobs-creation program. During the four-day trip, Bush also gave the commencement address at the University of South Carolina, visited with tornado victims in Omaha, Nebraska, and spoke about his jobs program again in Indianapolis.
Photo by Khue Bui

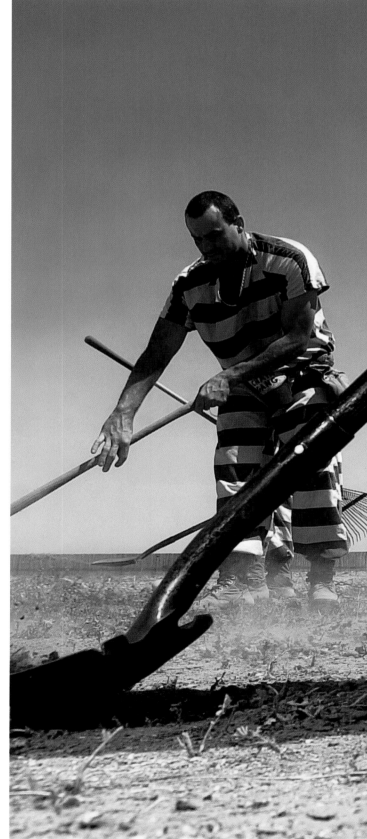

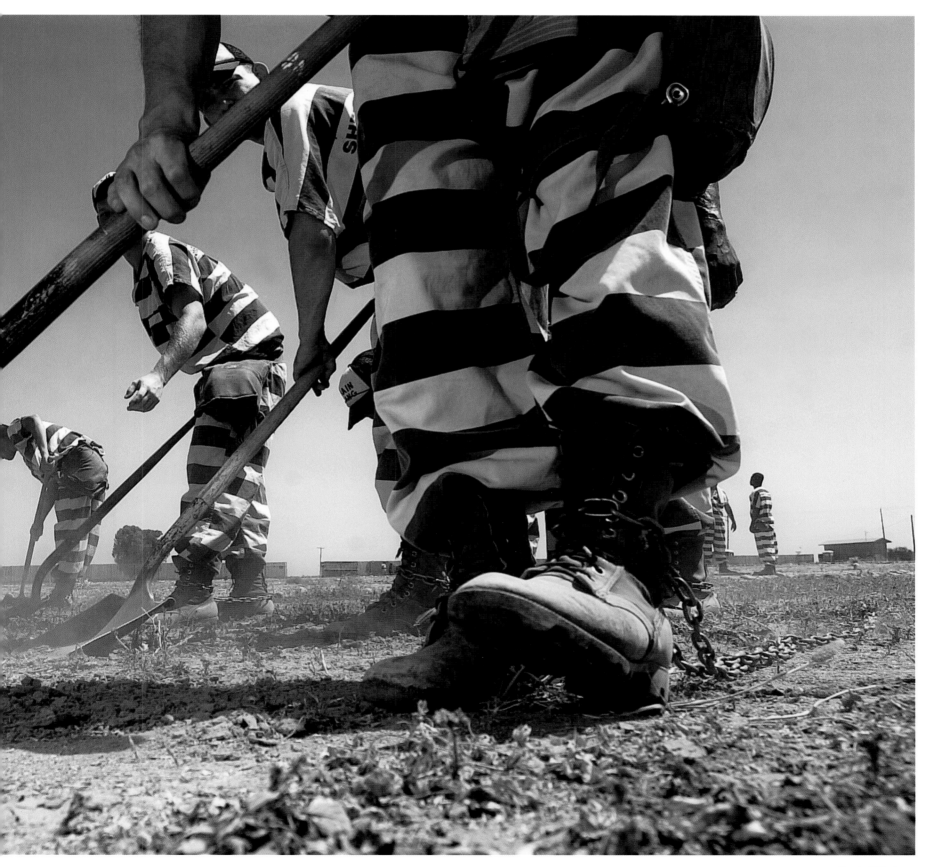

PHOENIX, ARIZONA
Sheriff Joe Arpaio's chain gangs work six days
a week cleaning streets, painting over graffiti,
and in this case, tending the county cemetery.
Arpaio is known in these parts as "America's
Toughest Sheriff." But Maricopa County also has
the only accredited high school in an American
jail and an effective drug and alcohol rehabili-
tation program. A high percentage of Arpaio's
inmates leave clean and sober and few return.
Photo by Pat Shannahan, The Arizona Republic

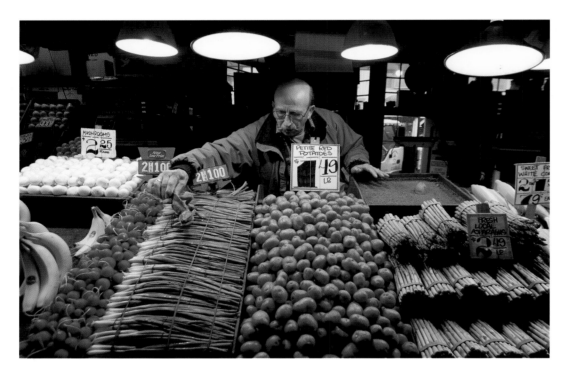

SEATTLE, WASHINGTON
In the predawn hours, Dan Manzo (with stuffed iguana), prepares his family stand at Pike Place Market, perched above the Seattle waterfront. The stall, established 100 years ago, occupies a prime location in one of America's most popular city markets. A living embodiment of America's diversity, the market has been home to a range of merchants including Sephardic Jews, and Americans of Japanese, Italian, and Filipino descent.
Photo by Alan Berner

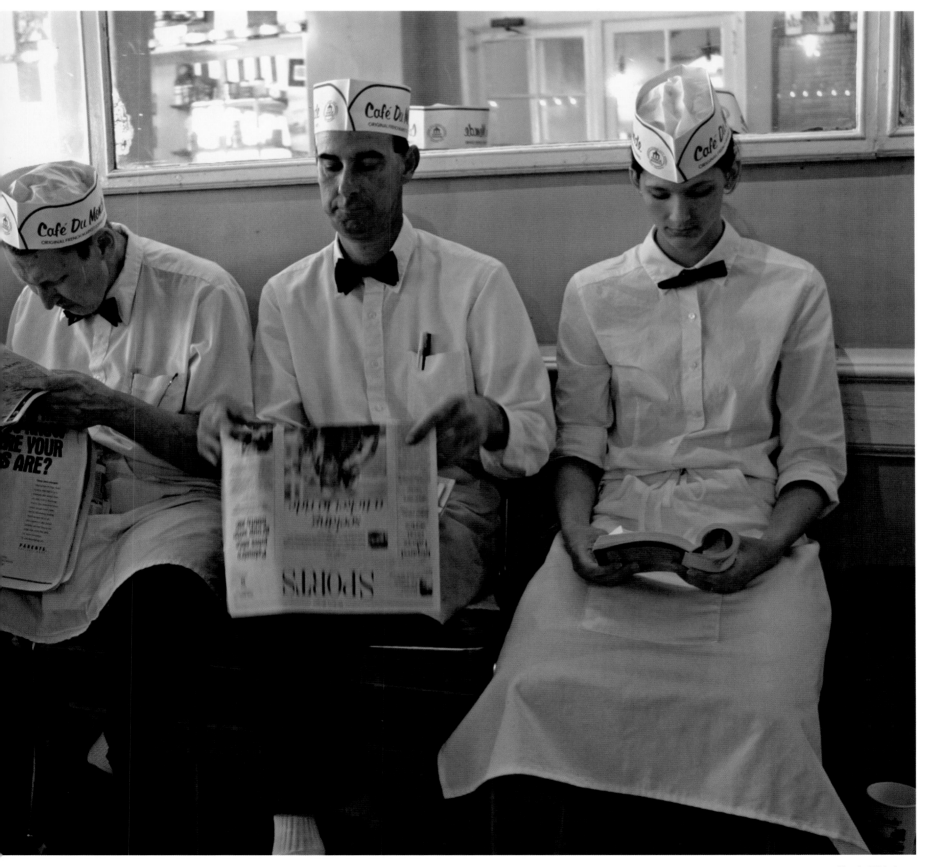

NEW ORLEANS, LOUISIANA
Employees of the historic Café du Monde take a break before new hungry customers amble in. Established in 1862, the old French-market coffee stand attracts both locals and tourists from around the world with its famous *beignets*, fried dough covered in powdered sugar, served up hot 24 hours, seven days a week (except Christmas).
Photo by Andy Levin

MERIDIAN, INDIANA
Students of Northwest Lineman College learn the ins and outs, or in this case, the ups and downs, of power-delivery systems. Climbing power poles in safety class helps keep future prospects from becoming one of the 30 electrical linemen who die each year from falls in the field.
Photo by Troy Maben

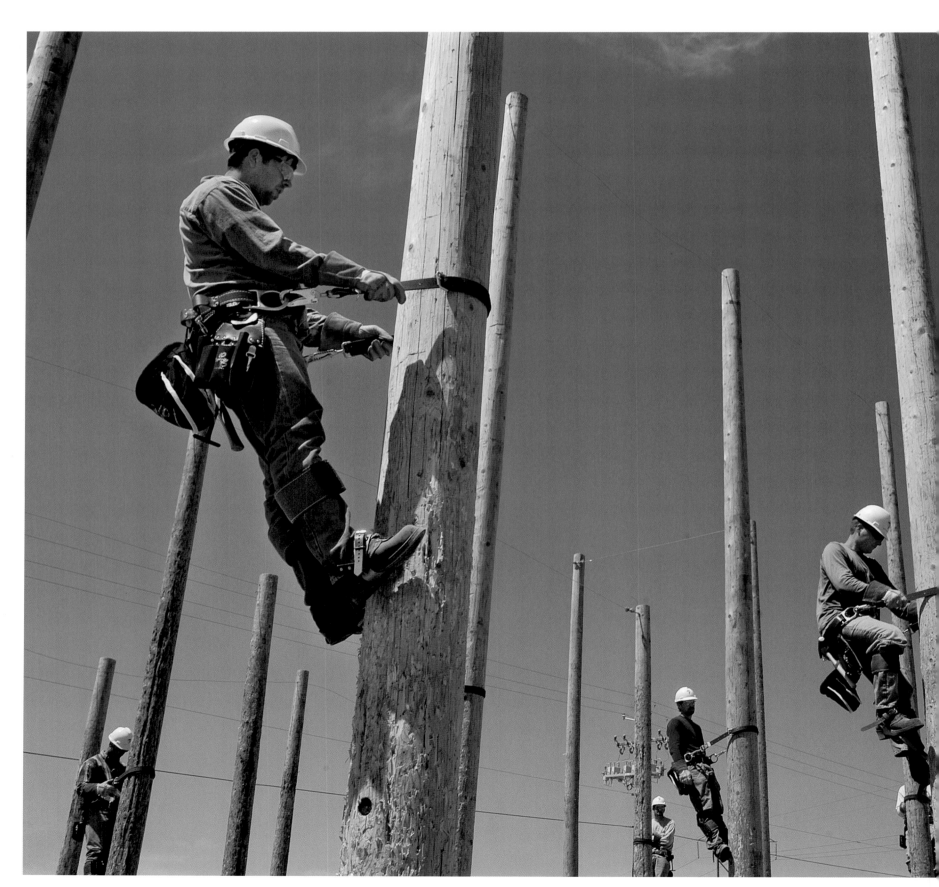

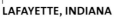

LAFAYETTE, INDIANA
Get the point? Tony Ybarra of Ambia, Indiana does as he prepares to paint a newly paved road in Lafayette. Ybarra's job can be dangerous: A semi almost hit him recently while he was replacing mileage markers on a three-lane highway in Indianapolis.
Photo by Michael Heinz

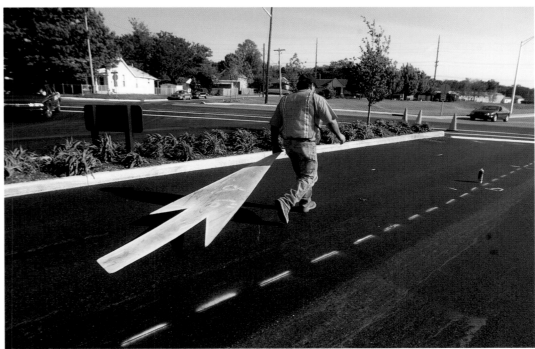

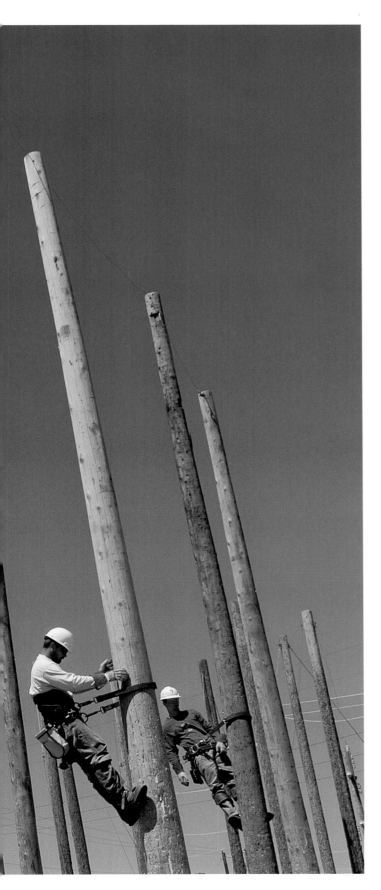

NEW YORK, NEW YORK

Erected in 1930—during an ego-driven New York skyscraper war—the 1,046-foot Chrysler Building was the tallest building in the world for exactly four months. Although dethroned by the 1,250-foot Empire State Building, many still consider the Chrysler Building to be the world's most beautiful skyscraper. Kevin Kiernan makes sure the art deco masterpiece glows through the night, changing one of its 10,000 bulbs.

Photo by Philip Greenberg

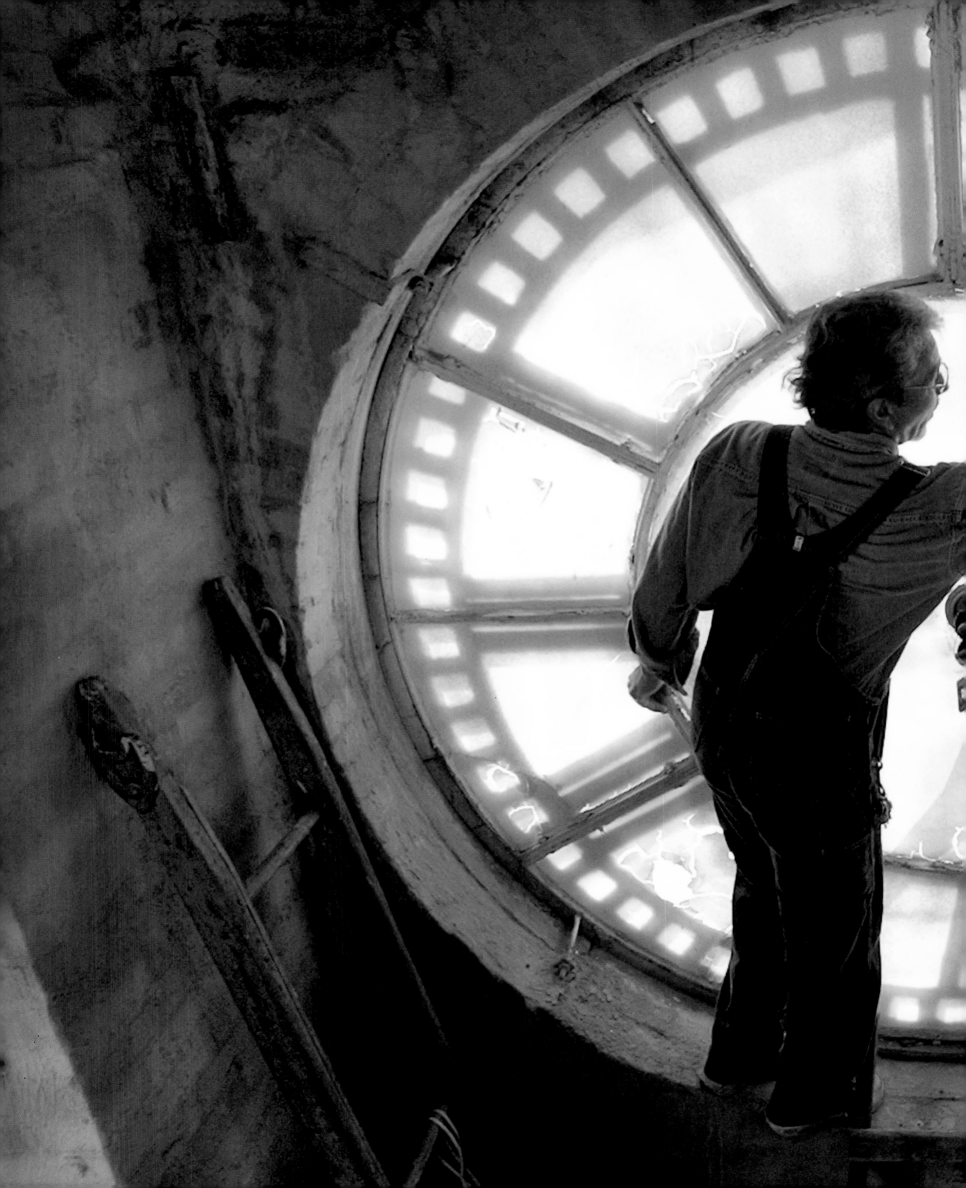

ADEL, IOWA
The 100-year-old clock tower of the
Dallas County Courthouse paces the lives of
the 3,200 people of Adel, Iowa. Inside the
tower, custodian William Clark checks the
clock's translucent western face for cracking
and peeling. The clock's weighted works were
electrified only 30 years ago.
Photo by Charlie Neibergall, Associated Press

VENTURA, CALIFORNIA
Ventura icon Johnny "Tony" Barrios, 77, says
running a hopping business makes him feel half
his age. Tony's Pizzaria has been baking pies and
filling stomachs for more than 40 years.
Photo by PF Bentley, PFPIX.com

LAKE LEELANAUT, MICHIGAN
Six years ago, sisters Christen Landry, 33, and
Sarah Landry, 29, converted a dilapidated pizza
parlor in northwest Michigan into Kejara's Bridge,
a community hub that features fresh organic
fare and local artwork. The sisters' motto:
"Feed your senses."
Photo by J. Carl Ganter, MediaVia

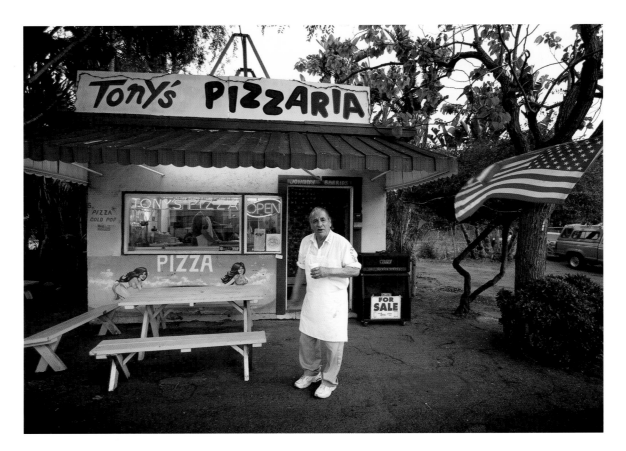

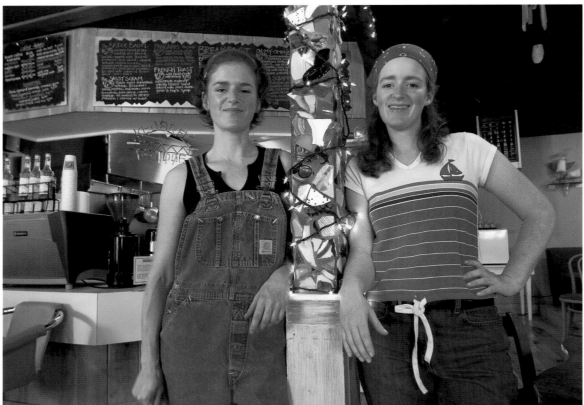

HOBOKEN, NEW JERSEY

Ireno Rodriquez's Antique Bakery relies on daily
coal deliveries to produce its renowned Hoboken
bread. Baked over the coals for five hours, the
bread has a unique flavor and crisp crust. One
of only three bakeries left in the area that bake
these Italian-style baguettes, Antique Bakery
sells more than 1,000 loaves a day.
Photo by Thomas E. Franklin

SEAL ROCK, OREGON

Takaya and Kiyo Hanamoto emigrated from
Osaka, Japan, to the Oregon coast in 1989. Both
chefs, they opened their restaurant, Yuzen, in
1990 and set about fusing their native cuisine
with the Pacific Northwest's shellfish, mush-
rooms, and strawberries (not to mention cream
cheese and Chinese spices).
Photo by Brian Lanker

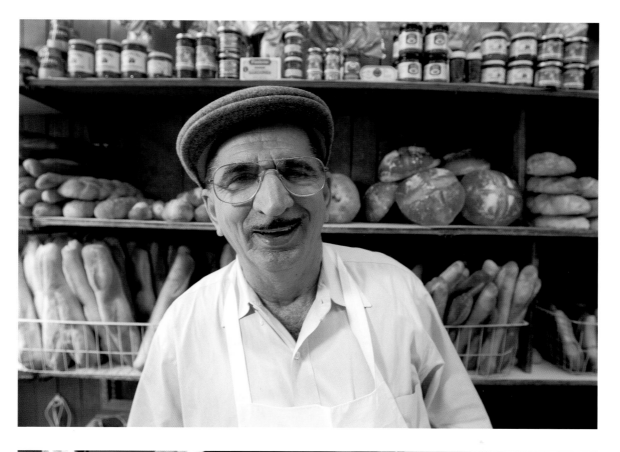

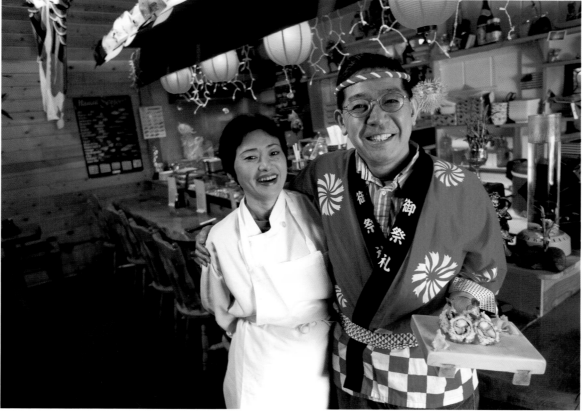

COLUMBIA, SOUTH CAROLINA

Hong Cheng's family moved from New York City to South Carolina in 2001 to open the Great China Restaurant. The only English-speaking member of his family, Hong became the public face of the restaurant—and a local celebrity. But two weeks after *America 24/7* photographer Kim Kim Foster visited Hong, the restaurant burned to the ground, and the Cheng family left town with no forwarding address.

Photo by Kim Kim Foster

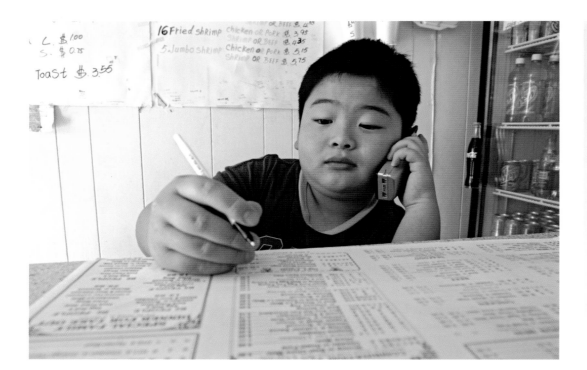

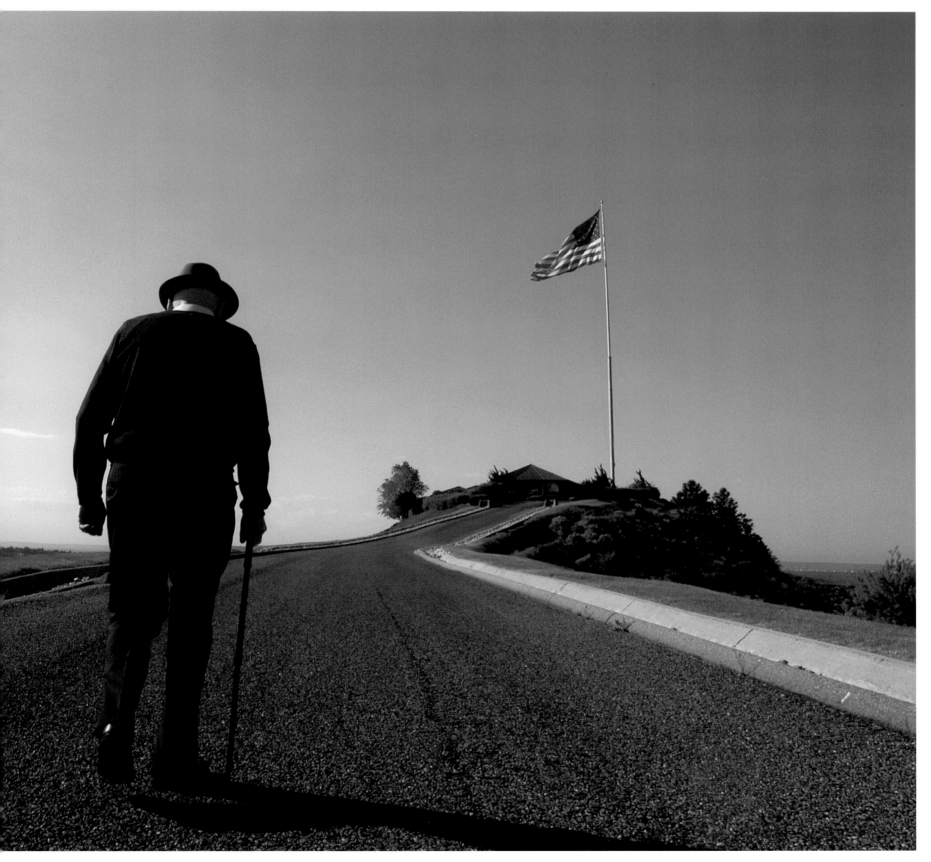

BOISE, IDAHO

Billionaire J.R. Simplot, 94, quit school at 14 and started shipping onions and potatoes. In the mid-1960s, he contracted with McDonald's Ray Kroc to supply him with frozen french fries. Today J.R. Simplot Co. is a multibillion-dollar agribusiness. The flag above Simplot's house is "a reminder," he says, "that we live in a country that allows a barefoot farmboy the opportunity to become a captain of industry."

Photo by Gerry Melendez

LAKE BUENA VISTA, FLORIDA
Today may be the happiest day in the life of
Lucy Coates of Lindenhurst, Illinois, but for
Richard Gerth, official Fairy Tale Wedding
greeter at Walt Disney World's Grand
Floridian Resort, it's just another day in the
kingdom. Gerth, 77, brings wedding dresses to
life with the "dress fluff" he perfected more
than 11 years ago. He estimates he's lifted the
dresses of at least 3,400 women.
Photo by Preston Mack

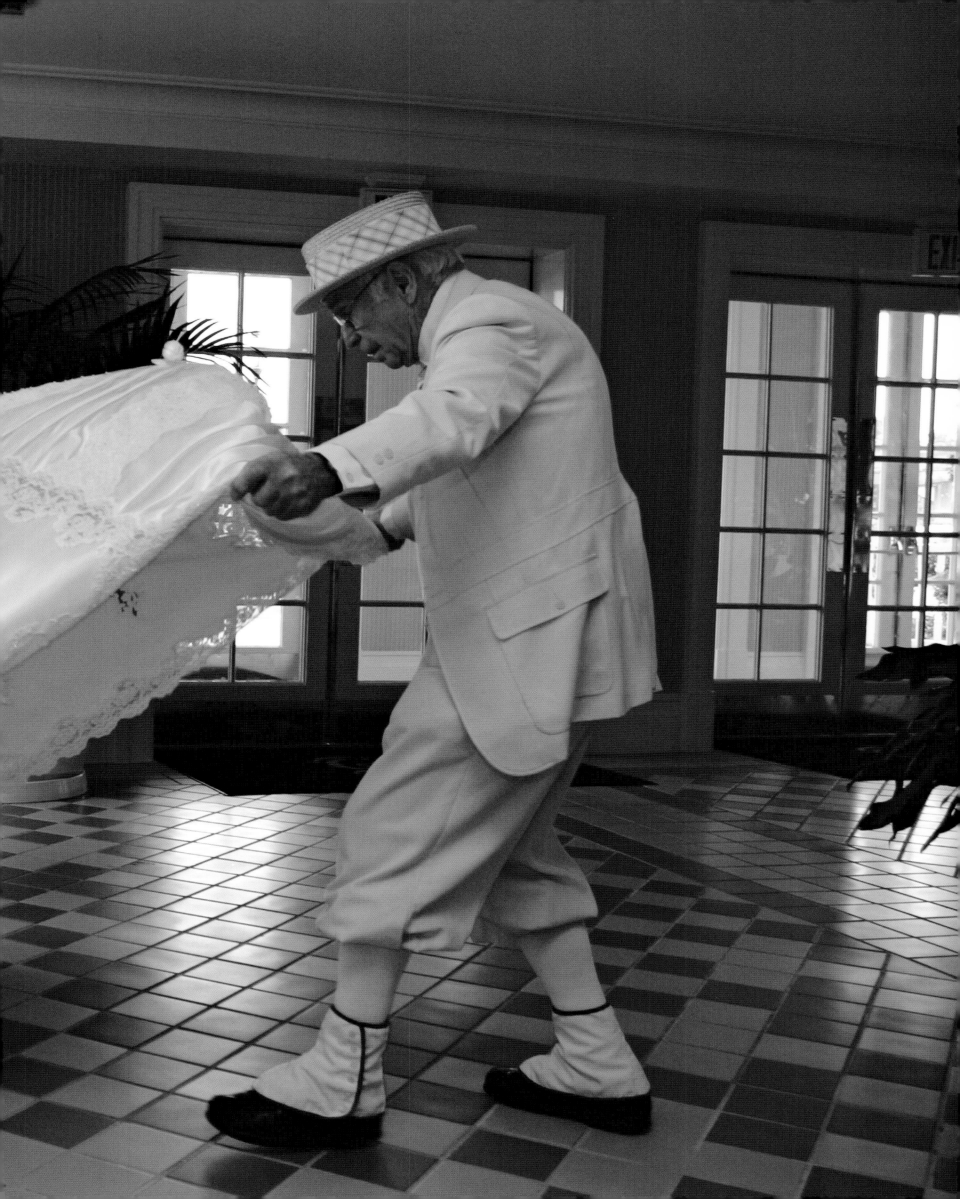

RIGBY, IDAHO

As seen on TV: Marjorie Scott, curator of the Jefferson County History Museum, oversees an exhibit about Philo T. Farnsworth's invention: television. In 1921, when he was just 14, Farnsworth realized that an electron beam could scan images much the same way as he tilled a potato field, row-by-row. This led to Farnsworth's invention of the first workable picture tube, seven years later, in San Francisco.
Photo by Robert Bower, Post Register

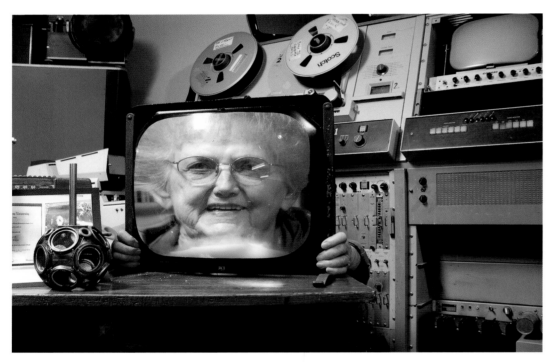

HARTFORD, CONNECTICUT

When Alphanso "Chippy" Edwards, 60, started his restaurant, Chippy's, 20 years ago he was one of only a handful of African-American business owners in Hartford. Today, his domain also includes the Laundromat next door, which is handy when it comes time to wash the tablecloths.
Photo by Marc-Yves Regis II, The Hartford Courant

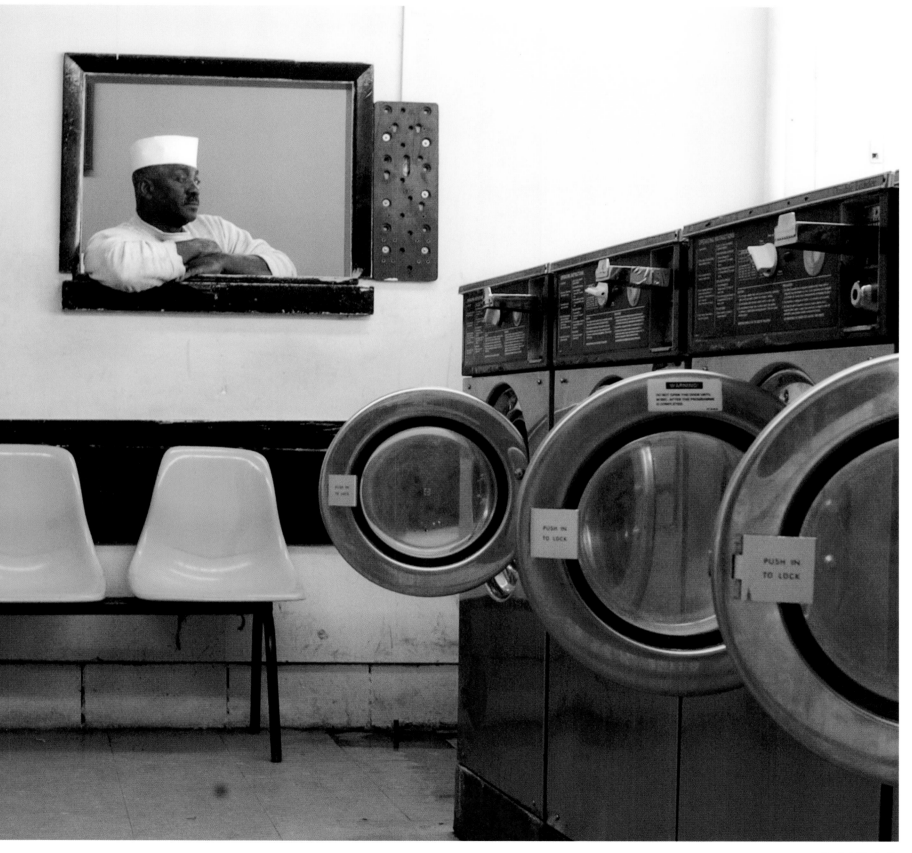

WAR, WEST VIRGINIA

Seventy-nine-year-old identical twin barbers
Riley and Rush Justice have been snipping
together since the Depression, when the
school principal asked the 12-year-olds to give
free haircuts to impoverished coal miners
in the school's basement. After serving in
World War II, they returned to West Virginia,
married, and opened their shop in 1947.
They're training a new man to take over
when they retire next year at 80.

Photo by F. Brian Ferguson

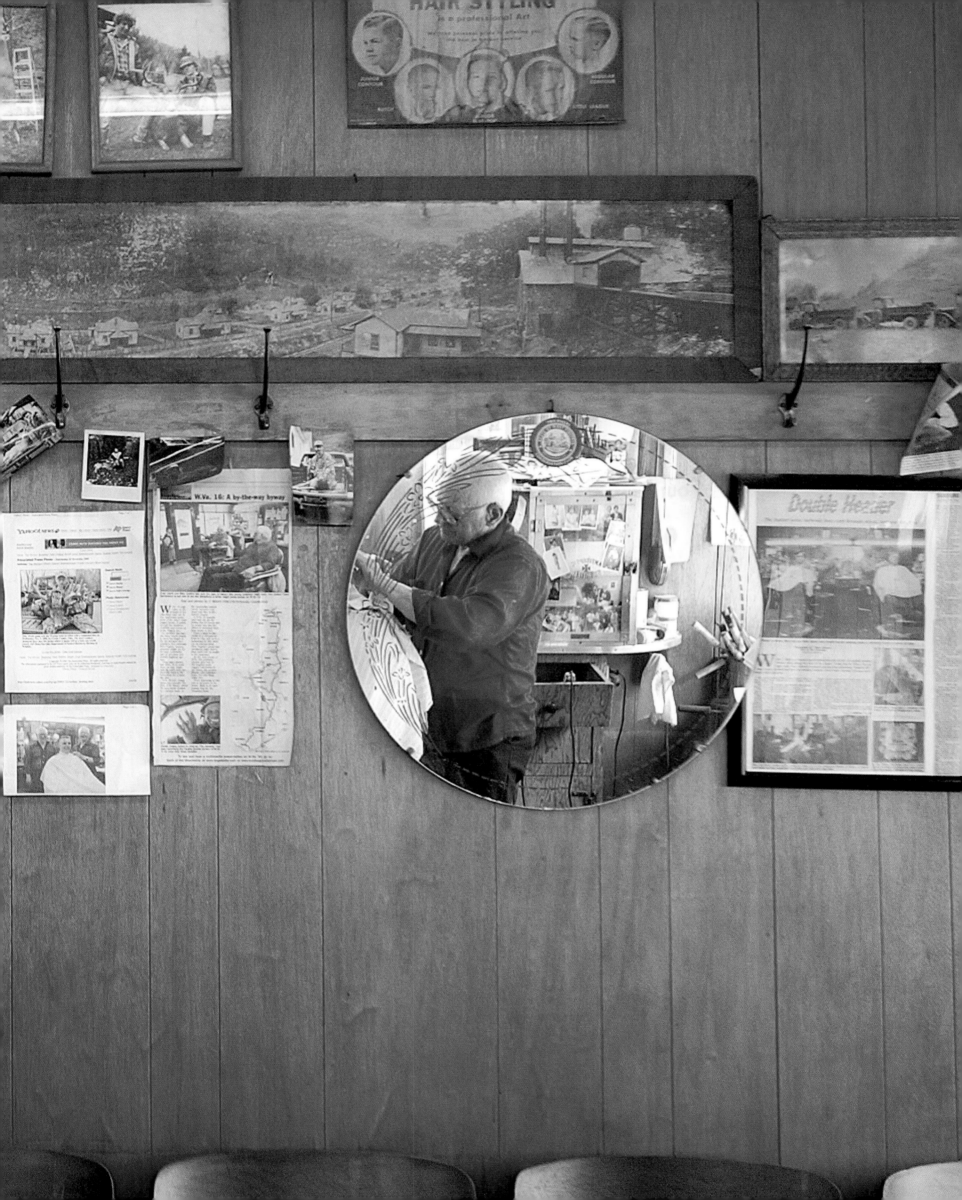

CALAIS, VERMONT

The Full Montpelier: The Men of Maple Corner (four miles north of Montpelier) bared all for a good cause: to raise money for the fire-damaged Maple Corner Community Center. The calendar generated half-a-million dollars, but not everyone approved. After much discussion, the Maple Corner Men for Decency posed for their own picture—fully clothed—which was also included in the calendar.

Photo by Craig Line

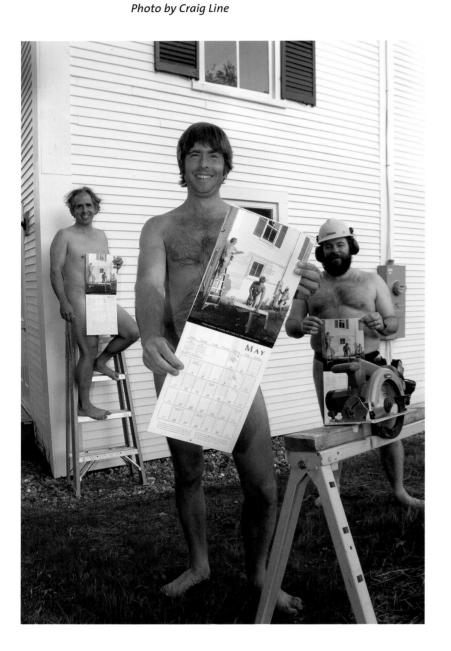

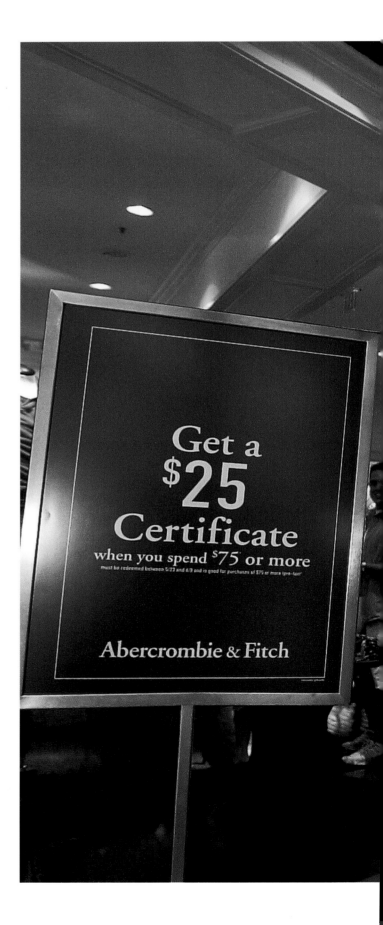

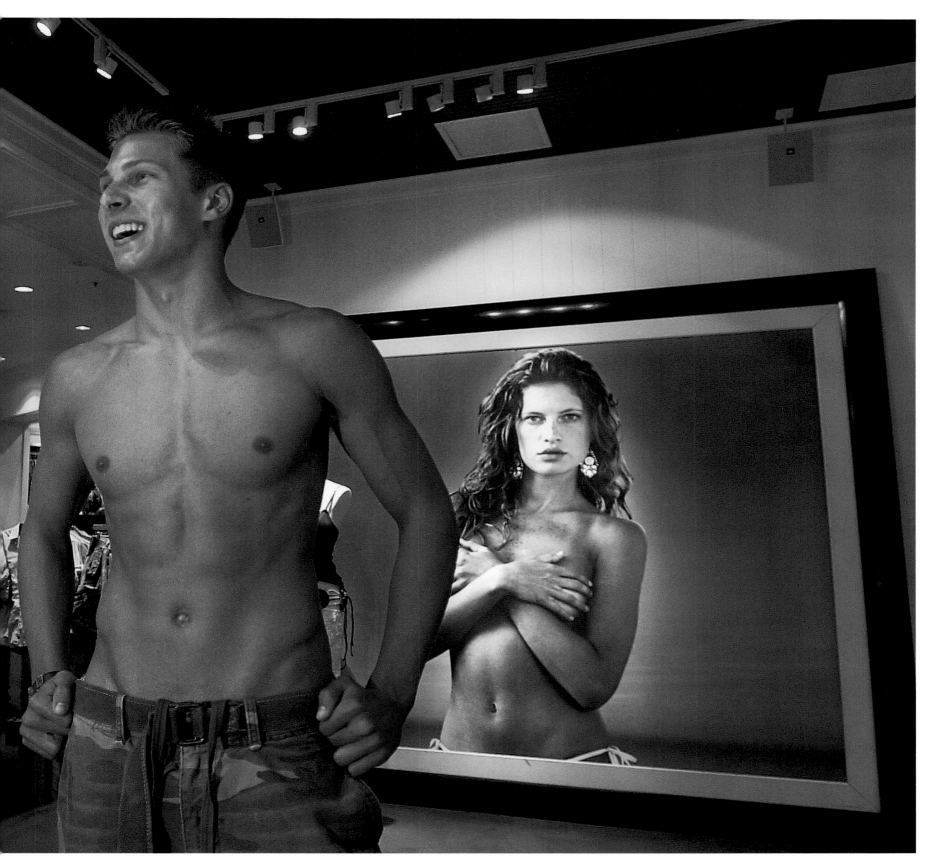

BLOOMINGTON, MINNESOTA

Skin sells: "It's not exactly like being a greeter at Wal-Mart," says Ryan Schultz, 18, "but people love it. They're always stopping to take my picture." Schultz's weekends-only gig as a greeter at Abercrombie & Fitch in Minnesota's giant Mall of America will help pay for college, where he hopes to continue his football career as a defensive back.
Photo by Richard Marshall

CHICAGO, ILLINOIS
At the Lyric Opera House in Chicago, runway models receive their assignments for an Oscar de la Renta fashion show later that evening. Competition for this event was fierce—only one out of every 35 applicants was selected.
Photo by Tim Klein

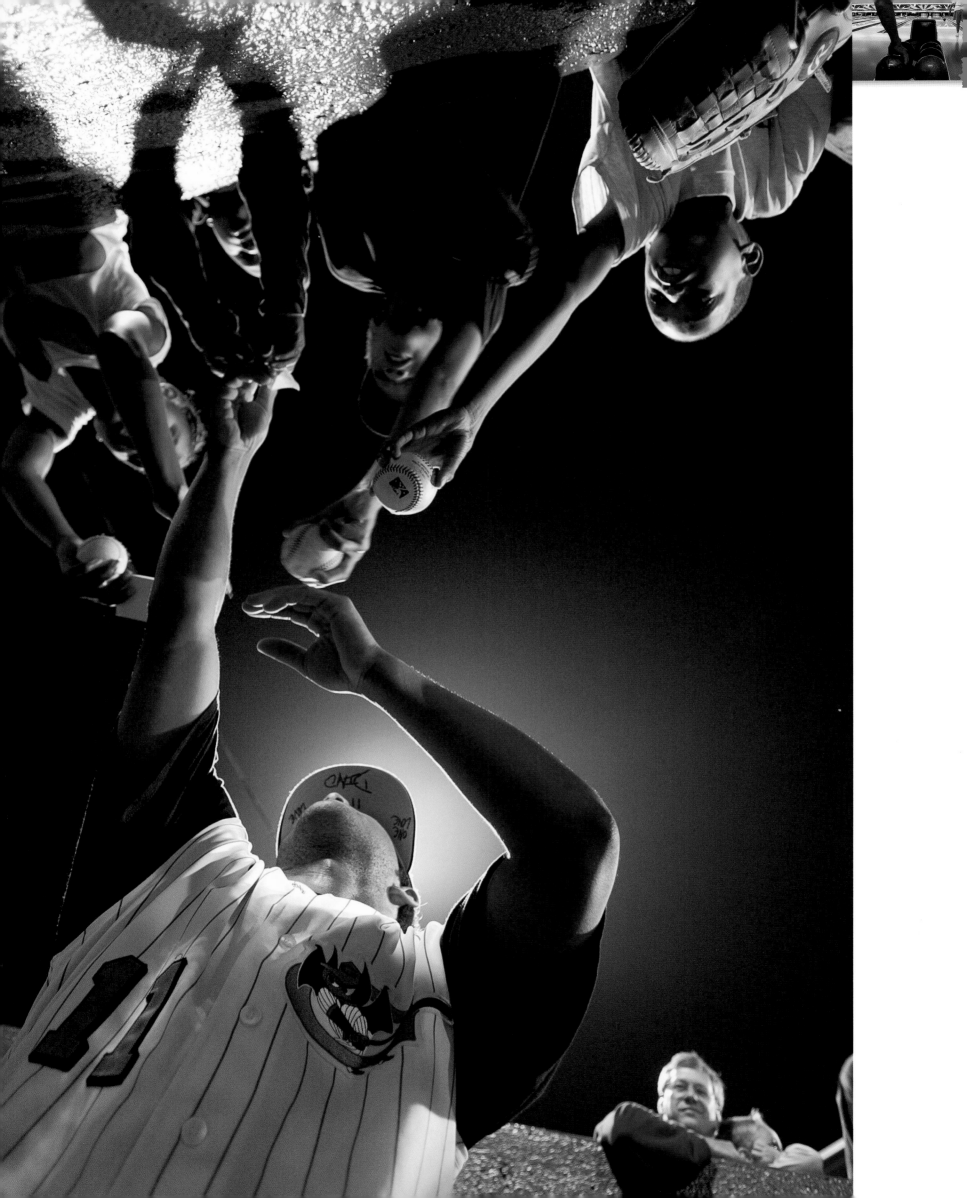

GREENSBORO, NORTH CAROLINA

Shortstop Robert Andino, 19, signs balls for adoring fans after his Greensboro Bats beat the Hickory Crawdads 8 to 4. Picked in the 2002 Amateur Draft, Andino opted to play for the Bats, a Class A Florida Marlins farm club, instead of pursuing a college career.
Photo by Patrick Davison,
The University of North Carolina

FAIRBURN, GEORGIA

When he was 10 years old, Evander Holyfield walked into a gym, heard the slap of leather on leather and knew what he wanted to do with his life. Thirty years later, the four-time world heavyweight boxing champion is newly married and luxuriously ensconced in a 51,000-square-foot mansion on 400 acres in the countryside outside Atlanta.
Photo by Greg Foster

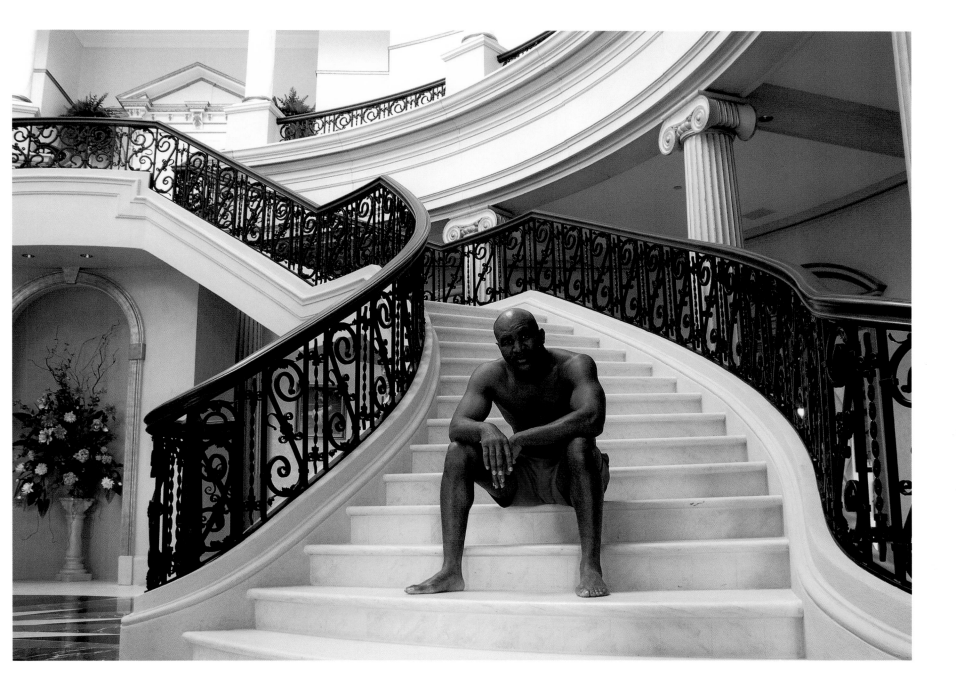

UNIVERSAL CITY, CALIFORNIA
In the global village, few personalities are as oversized as movie star Jim Carrey. At the May 14 Hollywood premier of his latest film *Bruce Almighty*, Carrey stepped off the red carpet and into the crowd to sign autographs and pose with fans.
Photos by Jeffrey Aaronson, Network Aspen

HOLLYWOOD, CALIFORNIA
During Antonio Hernandez's 12 years with the Top End Company, he's embedded more than 100 stars on Hollywood's Walk of Fame. His favorite star? Elvis Presley's, which he repaired and relocated. Five categories—Motion Picture, Television, Radio, Recording, and Live Theater— allow certain celebs to earn multiple stars. Hernandez places Harrison Ford's Motion Picture star in front of 6665 Hollywood Boulevard.

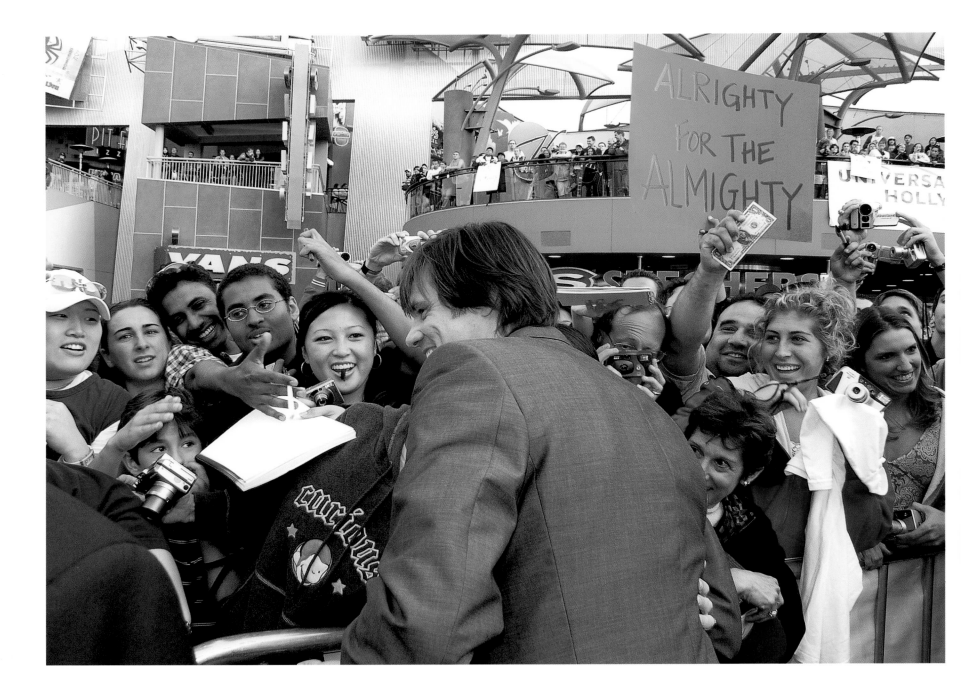

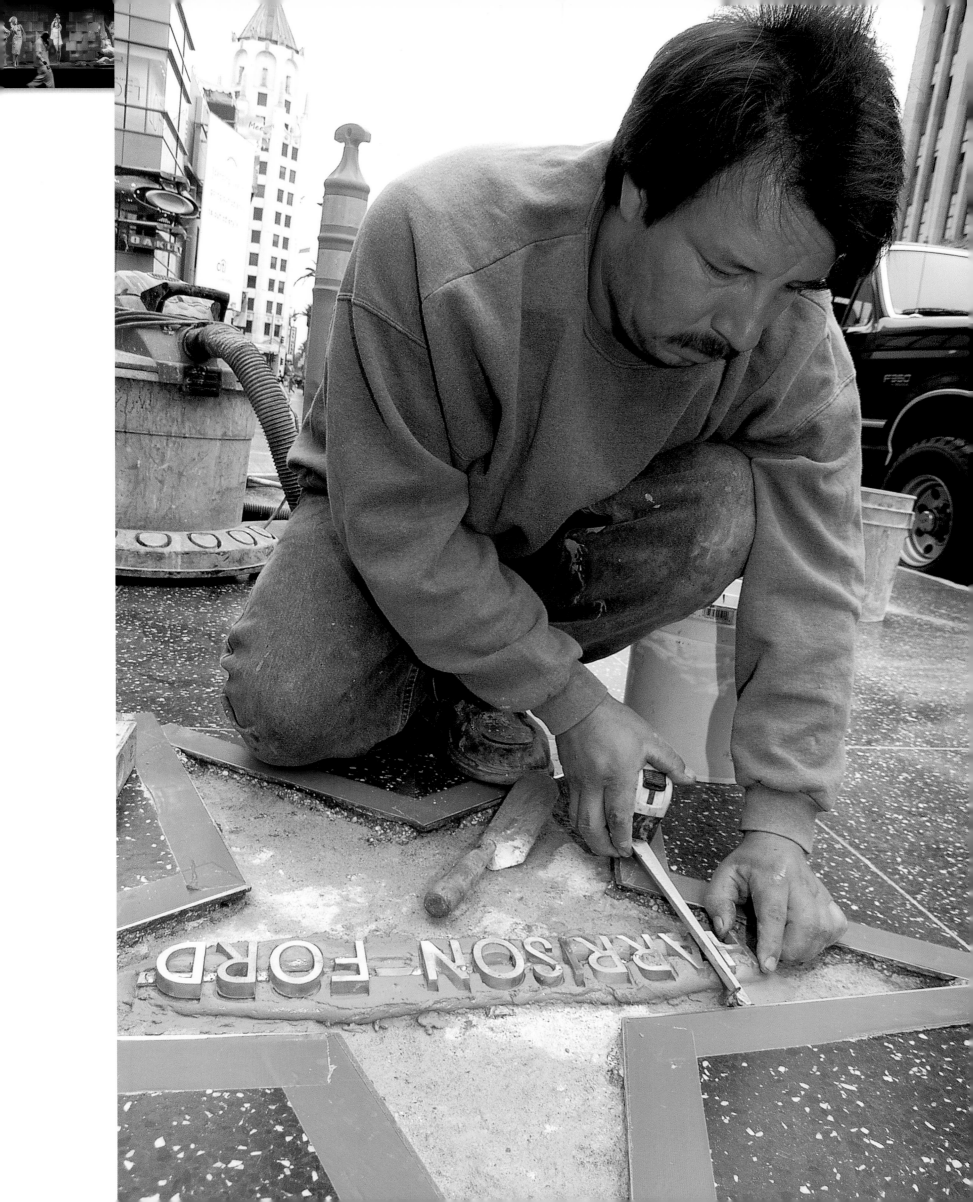

MIDDLEFIELD, CONNECTICUT
John Kurze, Jr. (cowboy hat in booth) realized a lifelong dream when he became an auctioneer five years ago at Middlesex Livestock Auction. A horse trainer by trade, Kurze got his start auctioning antiques on weekends. Farmland has slowly given way to residential development in Connecticut, and Middlesex is now the last livestock auction in the state.
Photo by Cloe Poisson, The Hartford Courant

Not-so-lazy girl: Mary Davis throws herself into her work at Best Chairs, Inc. in southern Indiana. Davis, 50, has been sitting down on the job for nearly three years, testing as many as 300 sofas and loveseats every day. Her greatest occupational hazard? Slippery new vinyl.
Photo by David Pierini, The Herald

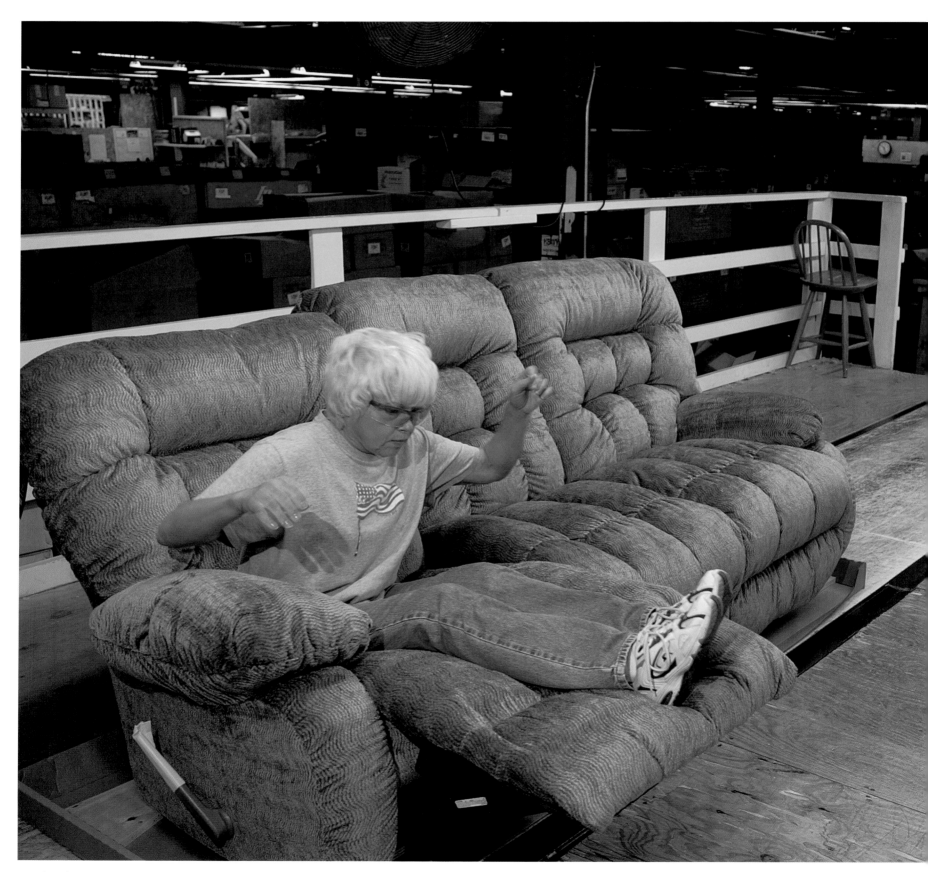

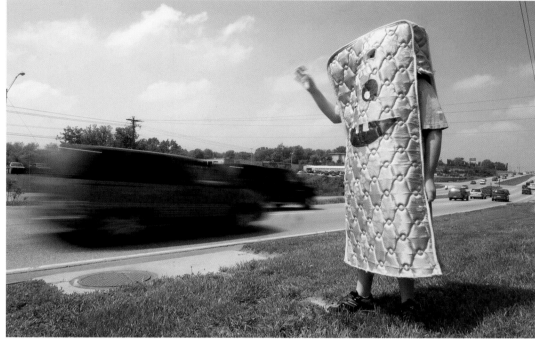

DUBUQUE, IOWA

Bed head: Business at the Verlo Mattress Store
on Dodge Street jumps 30 percent on Saturdays,
when 12-year-old Cameron Hall clocks in for
his $6 per hour shift. How'd he get the gig?
Networking. Cameron's father Rich referred
the boy after borrowing a mattress from
the store for a community theater production
of *Once Upon A Mattress*.
Photo by Mark Hirsch, Telegraph Herald

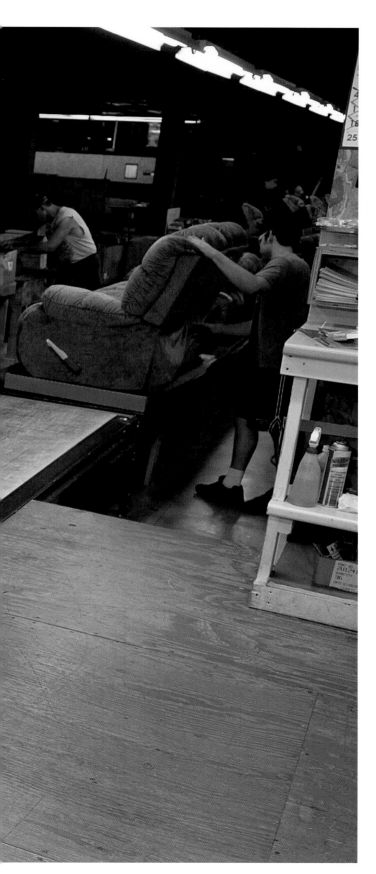

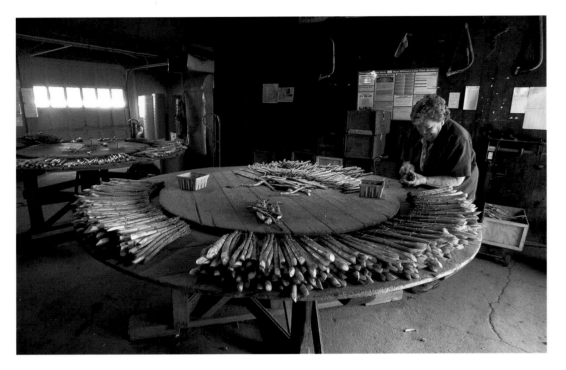

HADLEY, MASSACHUSETTS
Asparagus processing hasn't changed much in the 60 years since Erna Korenwesky, 81, started farm work. Asparagus, a fast-growing member of the lily family (up to 10 inches a day!) must still be handpicked and carefully packed to avoid damaging tender stalks. Korenwesky sets the pace at Hibbard Farm, packing up to 240 pounds of asparagus during each 12-hour shift.
Photo by Nancy Palmieri

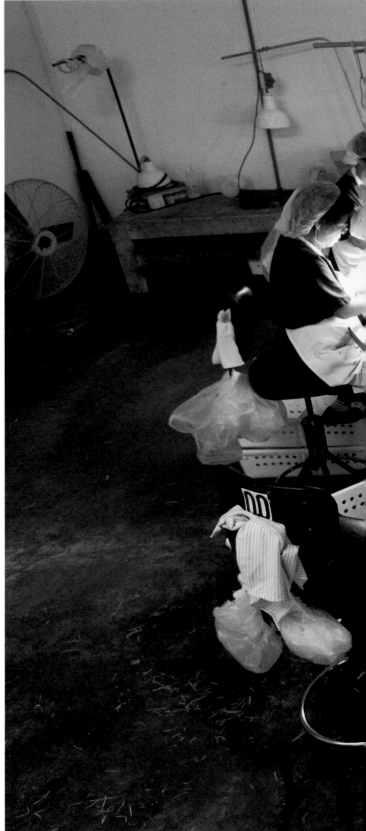

CLINTON, NORTH CAROLINA

Prestage Farms Turkey Hatchery employs nine Korean-American women for a very specific task: to determine the sex of 12,000 chicks per hour. In South Korea, where there are chickens but very few turkeys, women spend years learning the delicate skill, which involves manipulating the tiny balls of fluff in such a way that the sex is made apparent.

Photo by Janet Jarman, Contact Press Images

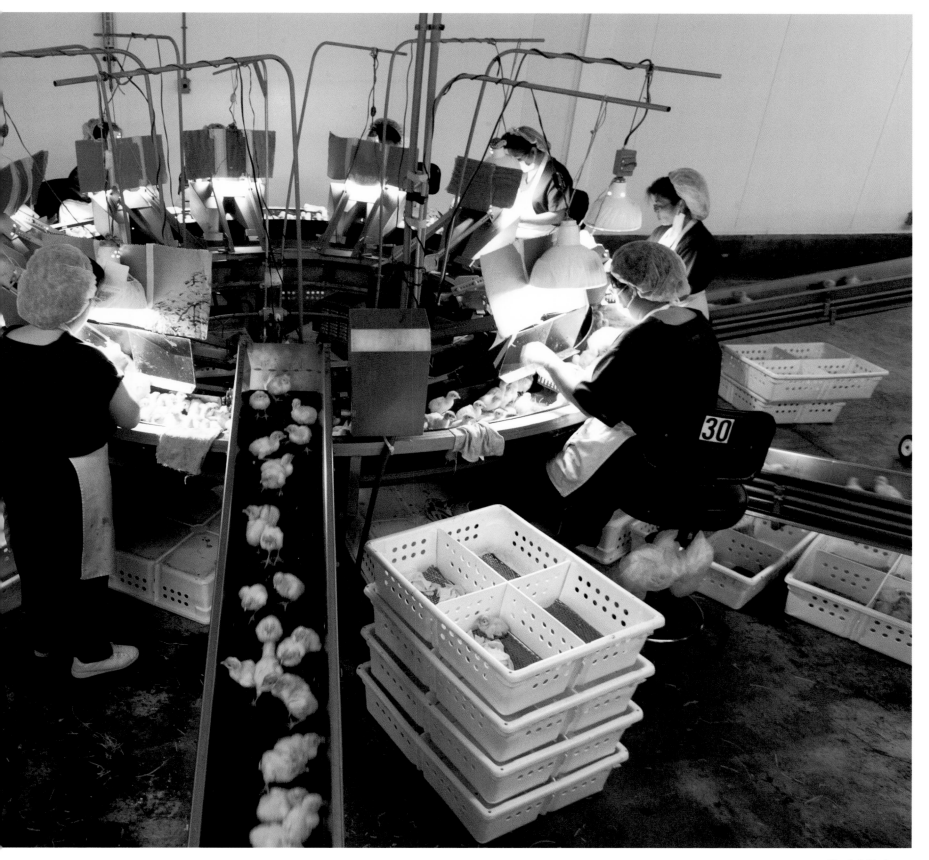

Who brought the cards? After an evening
obedience class, dog trainer Celeste Meade briefs
Breaker, Zipper, and Zoom on the dessert specials
at American K9 Country's Canine Cafe.
Photo by Bob Hammerstrom

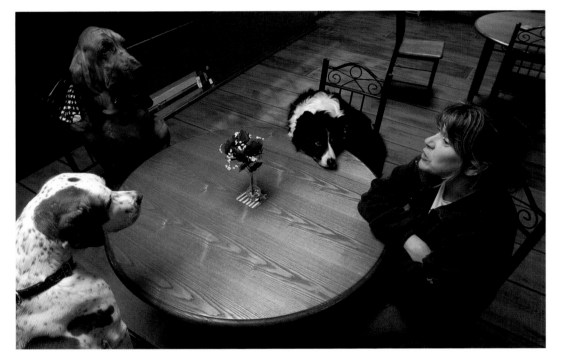

LOUISBURG, NORTH CAROLINA

Tonto, a miniature "seeing-eye" horse is introduced to restaurant etiquette by trainers Don and Janet Burleson (seated left). Horses are natural guide animals. If one horse in a herd goes blind, another horse will serve as its guide for life. Miniature horses live much longer than dogs (up to 50 years) and, yes, they can be housebroken.

Photo by Ami Vitale

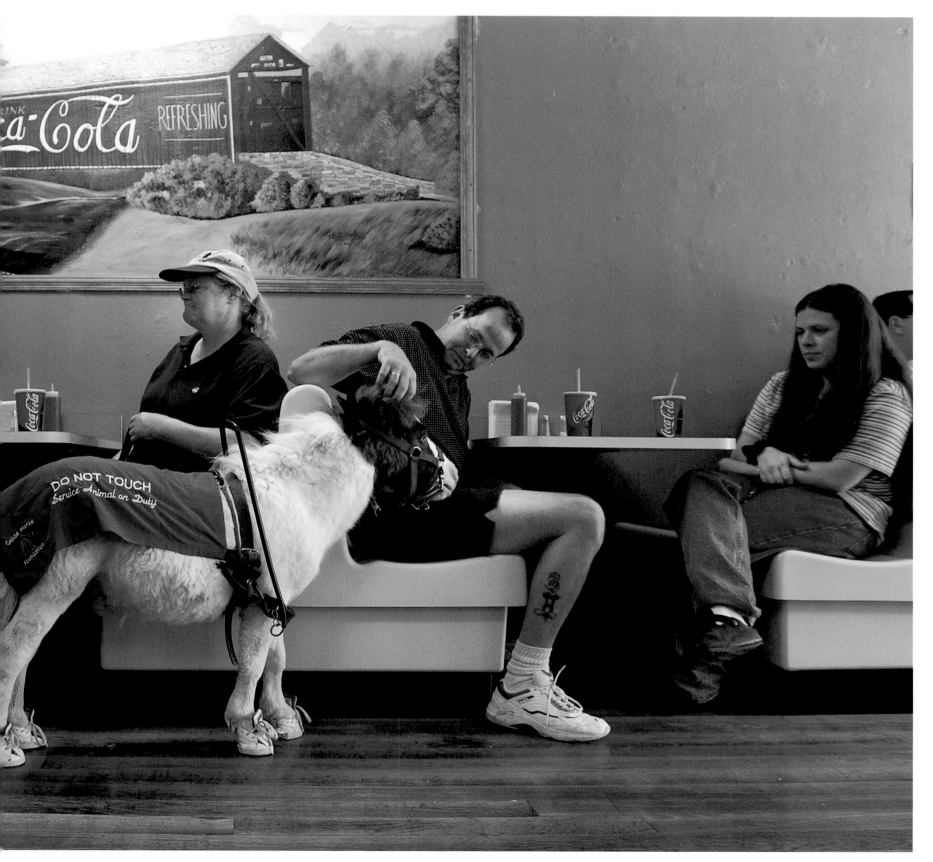

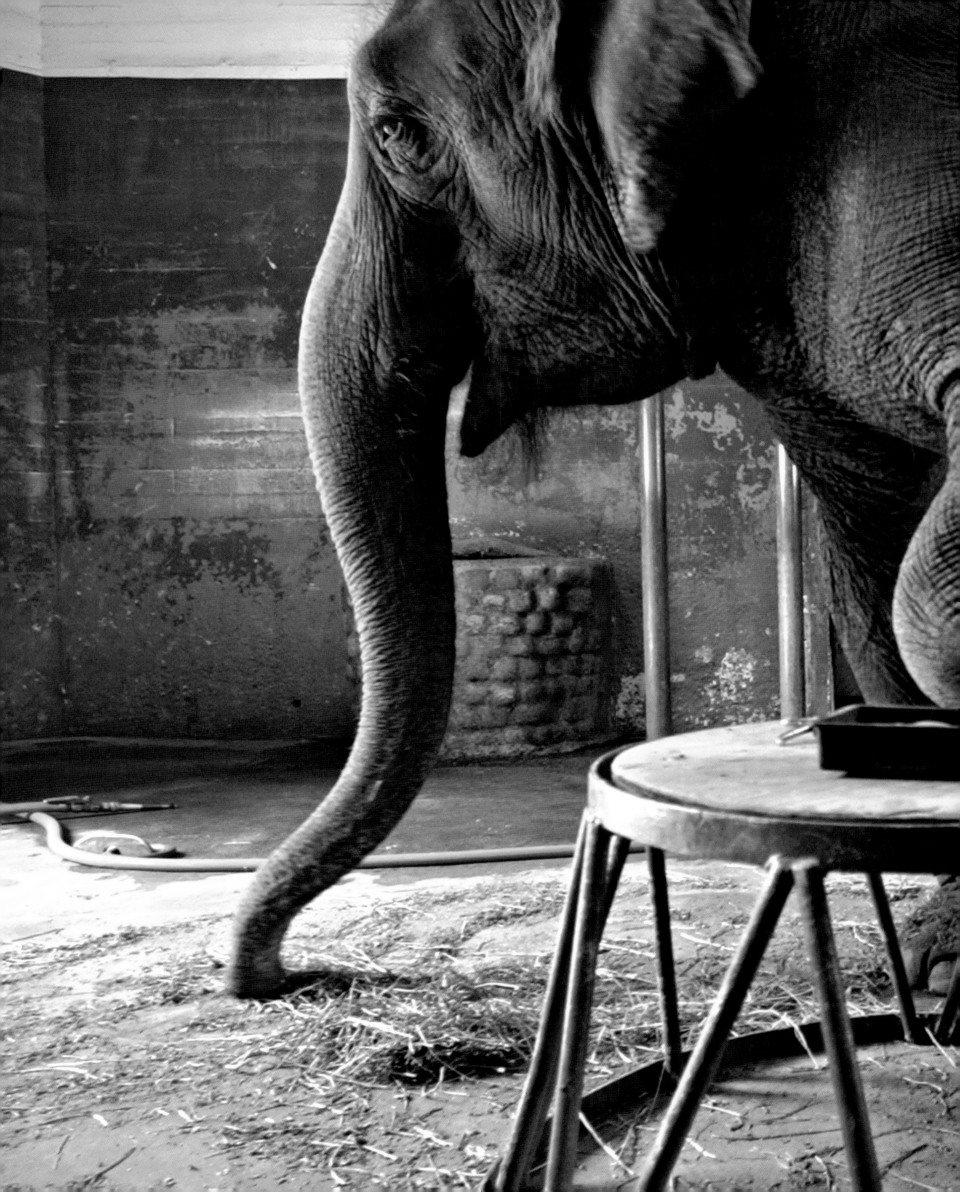

NEW ORLEANS, LOUISIANA
Pachyderm pedicure: Ellen Frosch, one of the Audubon Zoo's elephant handlers, trains and cares for Jean, a 30-year-old, 6,800-pound Asian elephant. Frosch, whose degree is in zoology, says Jean was bought by the zoo 20 years ago and is very gentle. She sees a baby elephant in her future if plans to artificially inseminate Jean are successful.
Photo by Chris Granger

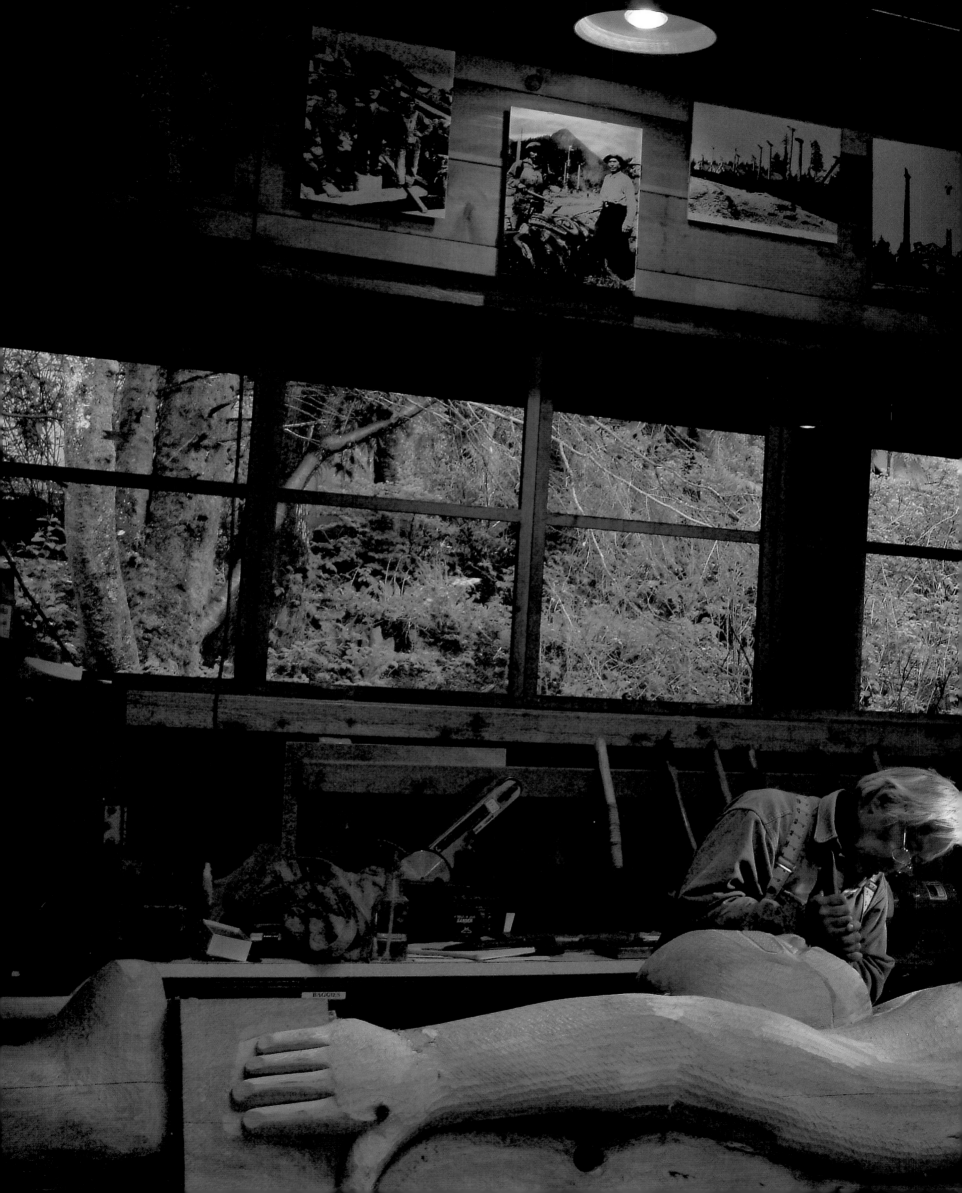

SAXMAN, ALASKA
Tlingit master-carver Nathan Jackson hews a 30-foot red cedar log into a totem pole he has named *Opening the Box of Wisdom*. A year in the making, the totem will be painted by Jackson's wife, Dorica, before it's shipped 800 miles north to the Alaska Native Heritage Center in Anchorage.
Photo by Hall Anderson

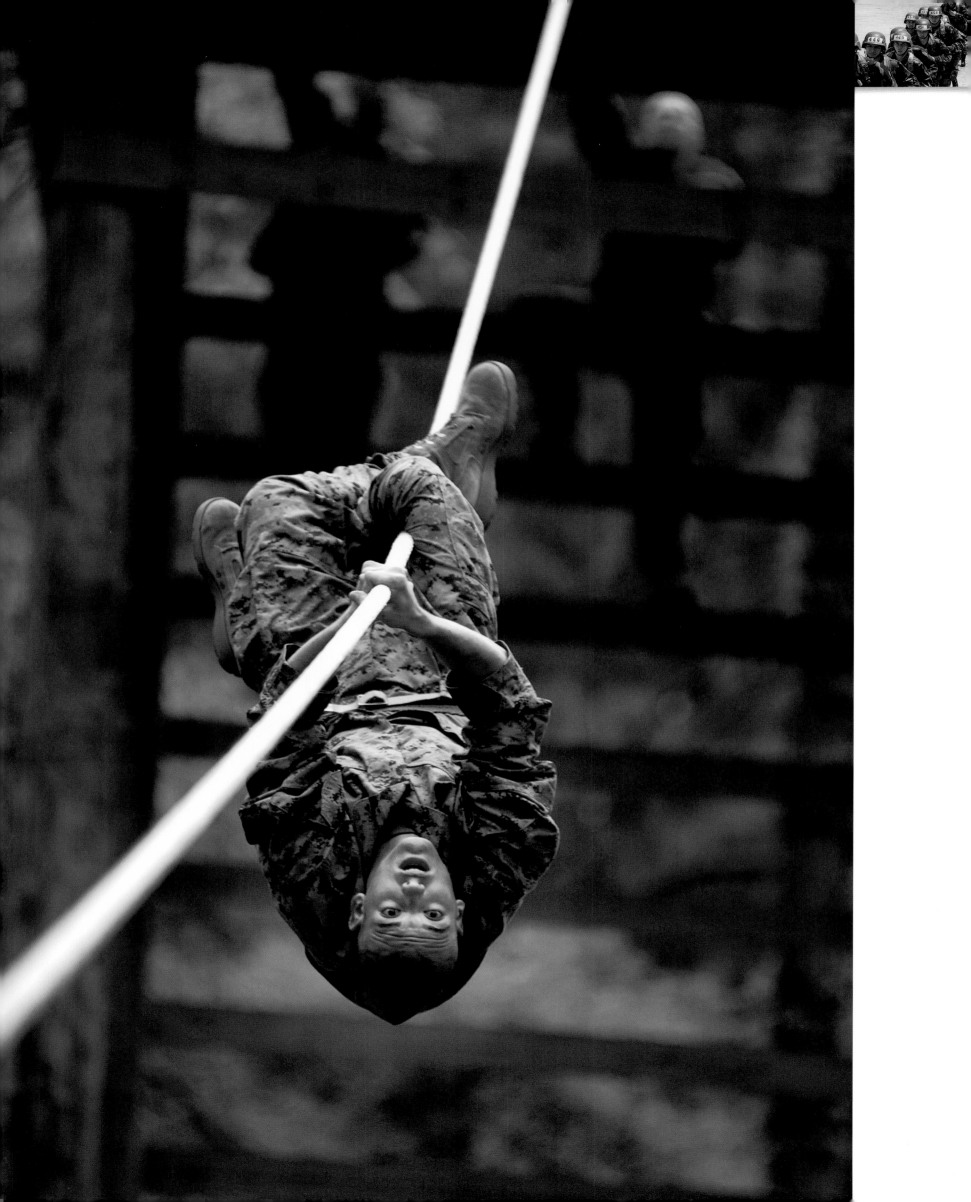

PARRIS ISLAND, SOUTH CAROLINA
Nearing the end of his rope, Marine recruit Jason Vanslambrouck prepares to execute an acrobatic, midair maneuver. New recruits must flip themselves over 50 feet of water to complete this confidence test at the Corps' Recruit Depot, also known as "Boot Camp."
Photo by Stephen Morton, stephenmorton.com

ANNAPOLIS, MARYLAND
Teammates extract Mandy Minikus of Raleigh, North Carolina, from a prickly situation during the U.S. Naval Academy's Sea Trials, a grueling 11-hour ordeal that tests the mettle of first-year midshipmen, a.k.a. plebes. There are more than 150 women in the Naval Academy's class of '06.
Photo by Doug Kapustin, The Baltimore Sun

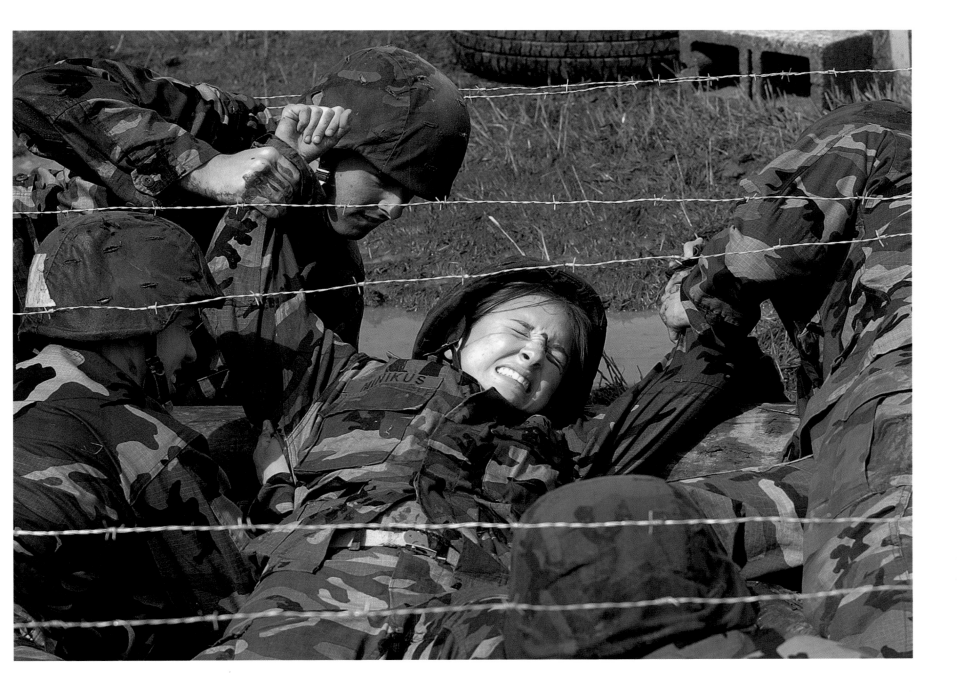

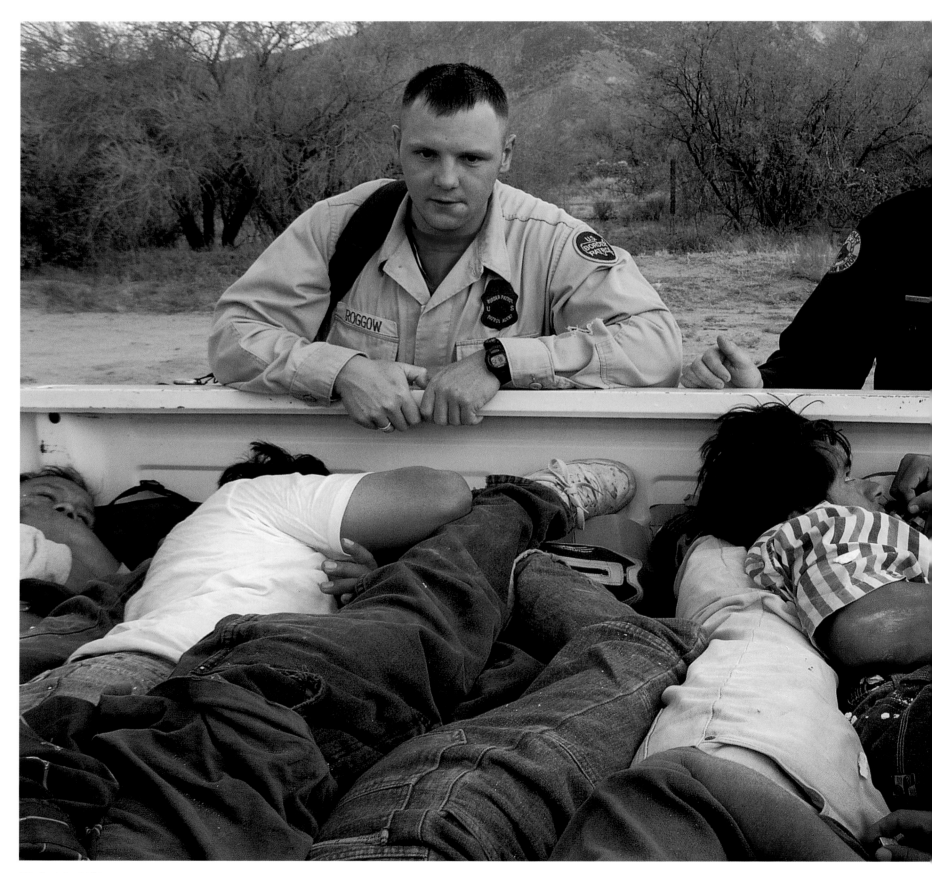

TUCSON, ARIZONA
Ride to nowhere: U.S. Customs agents in a Blackhawk helicopter spotted this pickup truck headed east on Highway 86 toward Tucson. A single sheet of drywall covered the bed. The team alerted local police, who stopped the truck and found 20 border crossers jammed inside— ten in the cab and ten under the sheetrock. The undocumented immigrants were processed and bused back to the Mexican border.
Photo by John Annerino

SELLS, ARIZONA

Exit here: Sisters from Mexico City, Mariana, one, and Fernanda, two, are sent back to Mexico with their parents, Almadelia and Jose Gutierrez, along with 45 other undocumented immigrants. Collected in the Sonoran desert southwest of Tucson, the captives will be photographed and fingerprinted, then released at the border for return to Mexico. In May of 2003, 14 people died while trying to cross into Arizona.
Photo by Tricia McInroy, Tucson Citizen

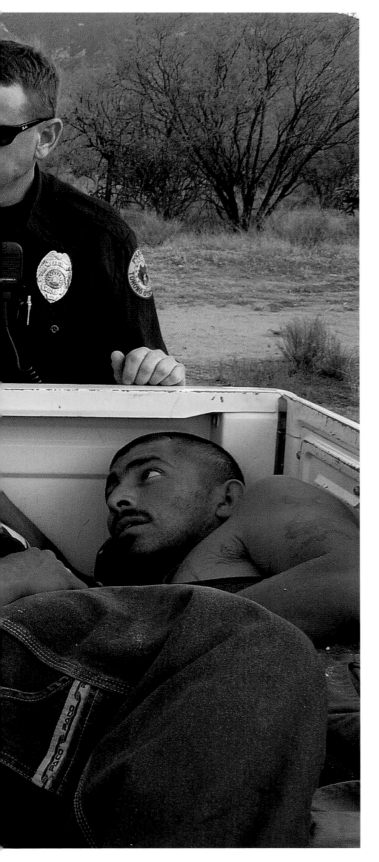

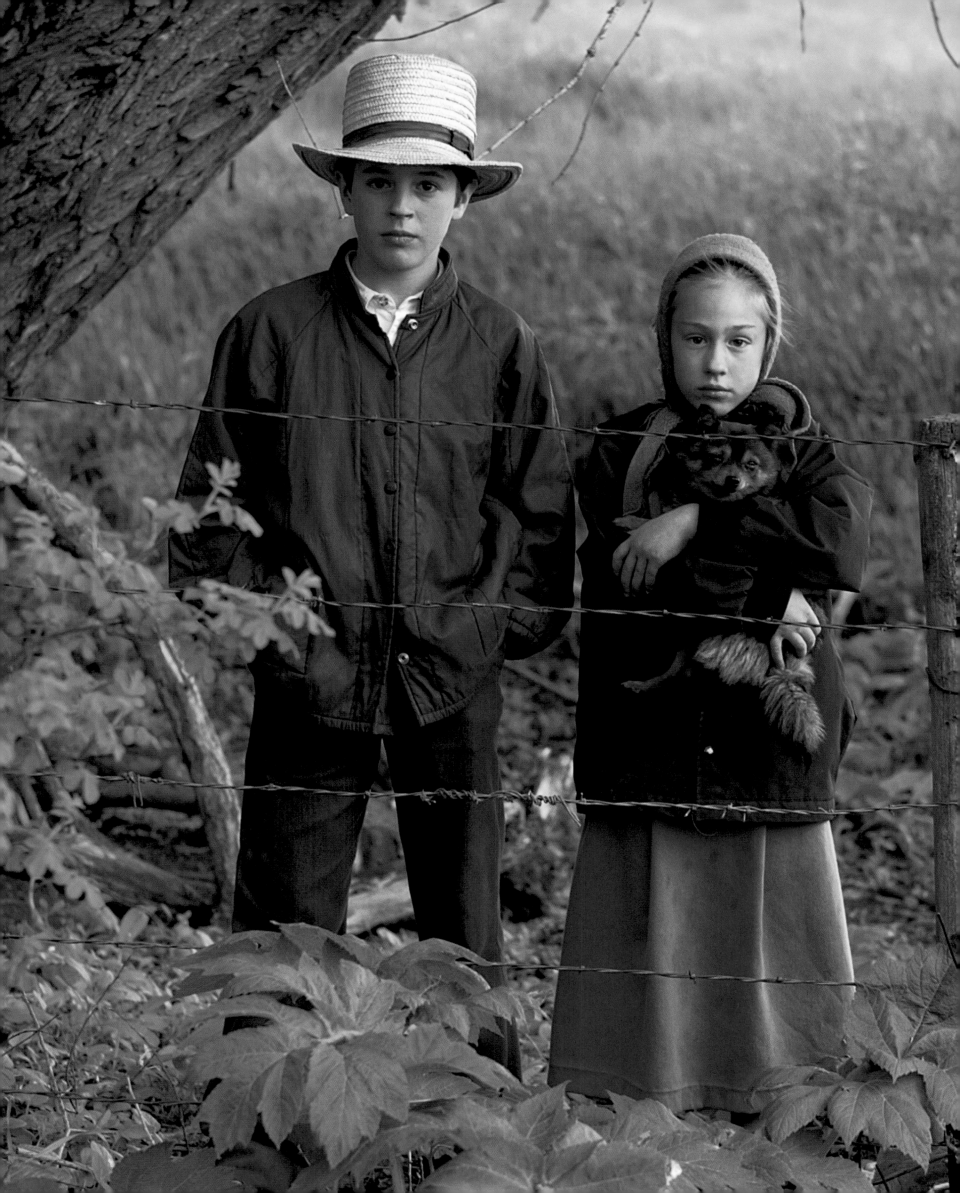

ST. IGNATIUS, MONTANA

Conrad Beachy, 10, and his sister Melanie, 7, belong to a 20-family Amish community in western Montana's Mission Valley. The children, whose religous beliefs prohibit the use of computers, TV, or video games, attend a church school through the eighth grade, after which it is assumed they will work and marry within the Amish community.

Photo by Kurt Wilson

EL PASO COUNTY, COLORADO

Nine-year-old Sam Frost and his neighbors secure a calf on Sam's dad's ranch in rural El Paso County during branding season. Families from seven neighboring ranches take turns helping each other during the monthlong spring branding season. This morning, 250 calves were rounded up for branding, earmarking, dehorning, castration, and vaccination.

Photo by Mark Reis, The Colorado Springs Gazette

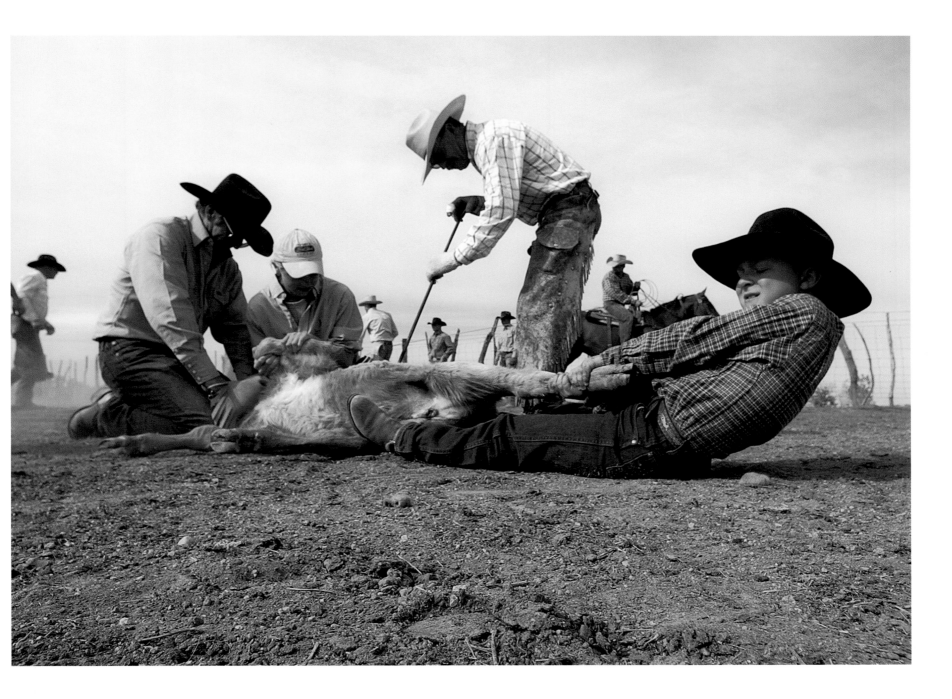

EAST FORT, FLORIDA
Timothy Spiller, 14 (left) and Ty Pigott, 11, meet
three times a week to practice roping steer
for rodeo competitions. Both boys compete in
Florida and have won many competitions and
thousands of dollars in prize money. Timothy
is moving to the national level and is currently
ranked number one in team roping. He plans
to be a professional rodeo rider when he
grows up.
Photo by Dan Wagner

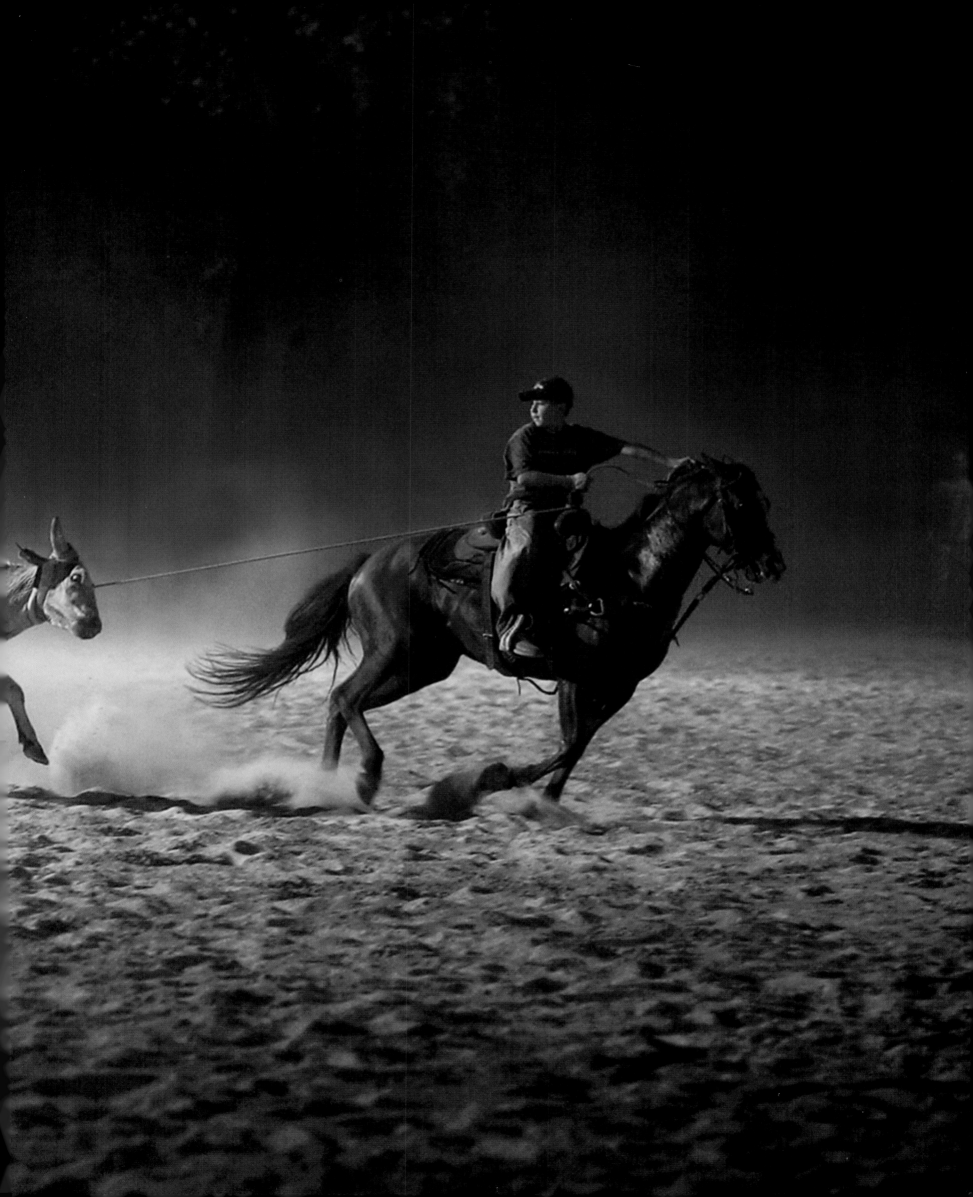

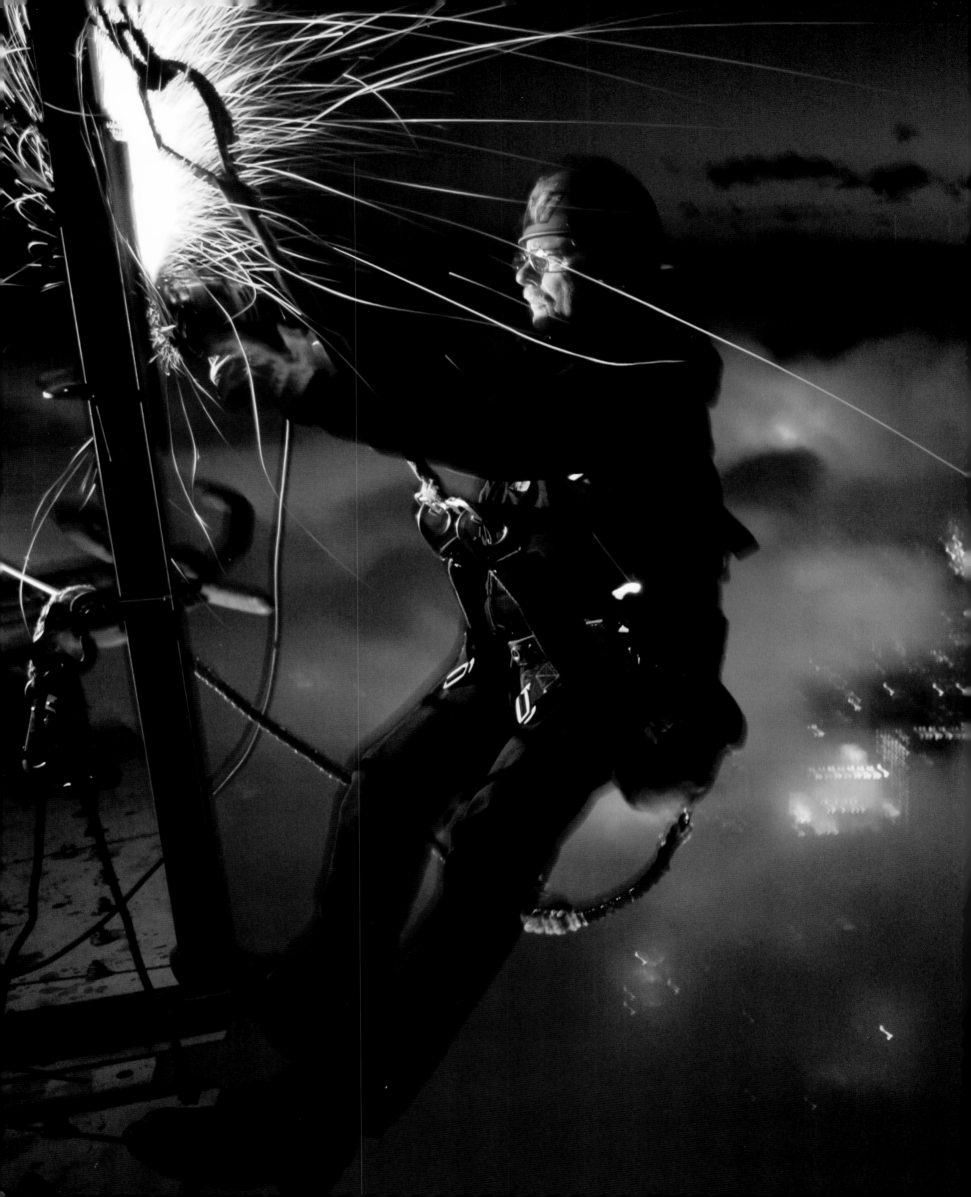

NEW YORK, NEW YORK
After the destruction of the World Trade Center in September 2001, broadcasters relocated their transmission antennae to the top of the Empire State Building, which, at 1,250 feet, has reclaimed its title as the tallest building in New York. At dawn, dangling at the equivalent of the 104th floor, machinist Tom Silliman of Electronics Research, Inc. preps the towers' superstructure for new equipment.
Photo by Joe McNally

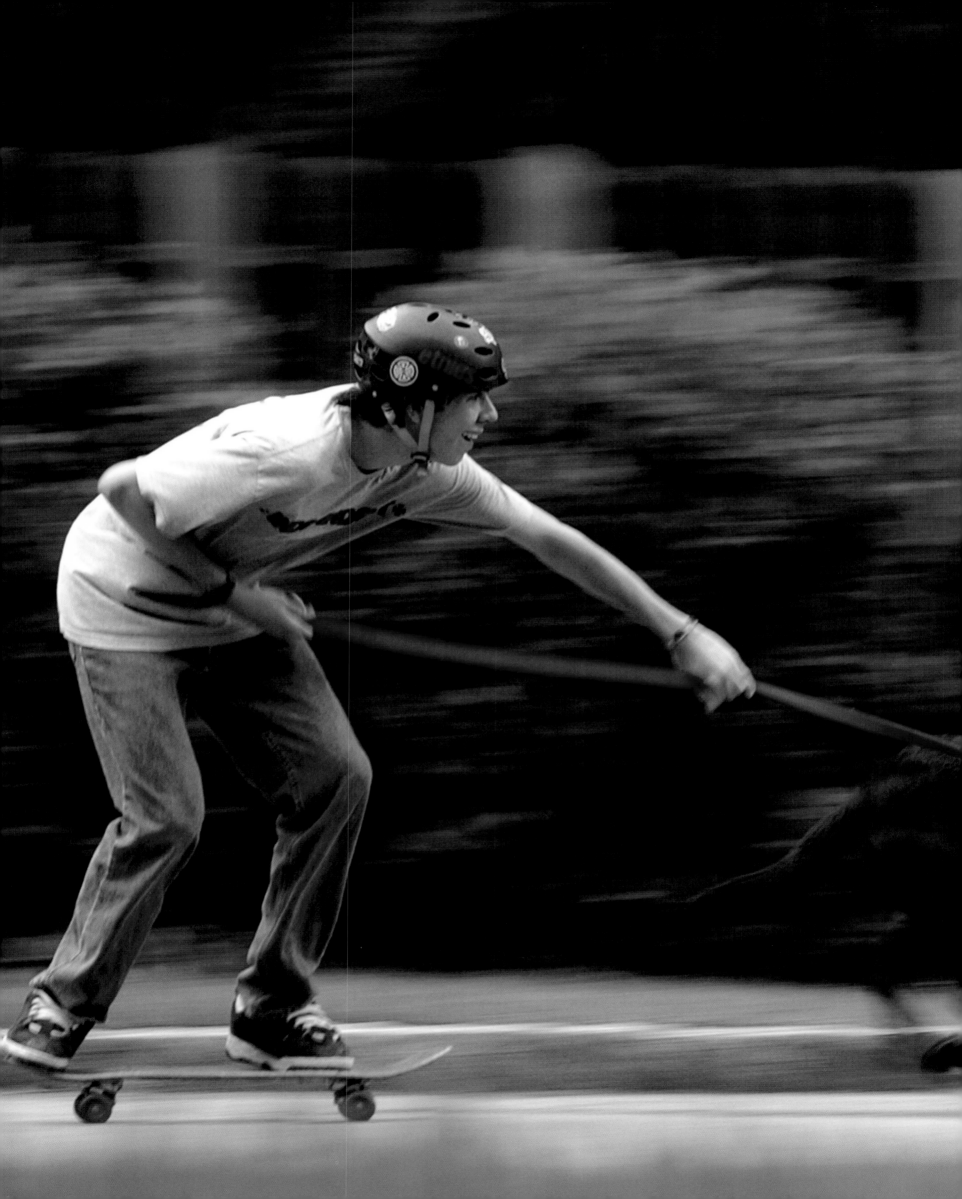

America at Play

We played like any other American kids between those rough-and-tumble ages of five and nine; that is to say, hard. A child's work is pure imagination and adventure; it is all about skateboards and swimming pools, Big Wheels and baseball cards, trampolines and pogo sticks. From dawn 'til dusk, when we weren't in school, we played. We were typical kids. But as a group we shared in our differences too.

It's a stranger coincidence to me now than it ever was then: All seven kids in my small neighborhood were children of adoption. We had normal American names, like John and Diane, Matt and Peter, but we were immigrants in our own families— different in an elusive, hazy way—but still accepted and loved without exception. We kids were like mismatched toys in a toy box, each a piece of a larger set that had been lost somewhere and then found again, by our families and, serendipitously, by each other.

ATLANTA, GEORGIA Speed isn't the problem for fearless 15-year-old Nash Addicks and his noble steed, Chipper. Rather, it's how to stop.
Photo by Rich Addicks,
The Atlanta Journal-Constitution

milk-feeding the calves and graining the cows.
The Demmer family has owned the 160-acre
dairy farm southwest of Dubuque since 1957.
Photo by Mark Hirsch, Telegraph Herald

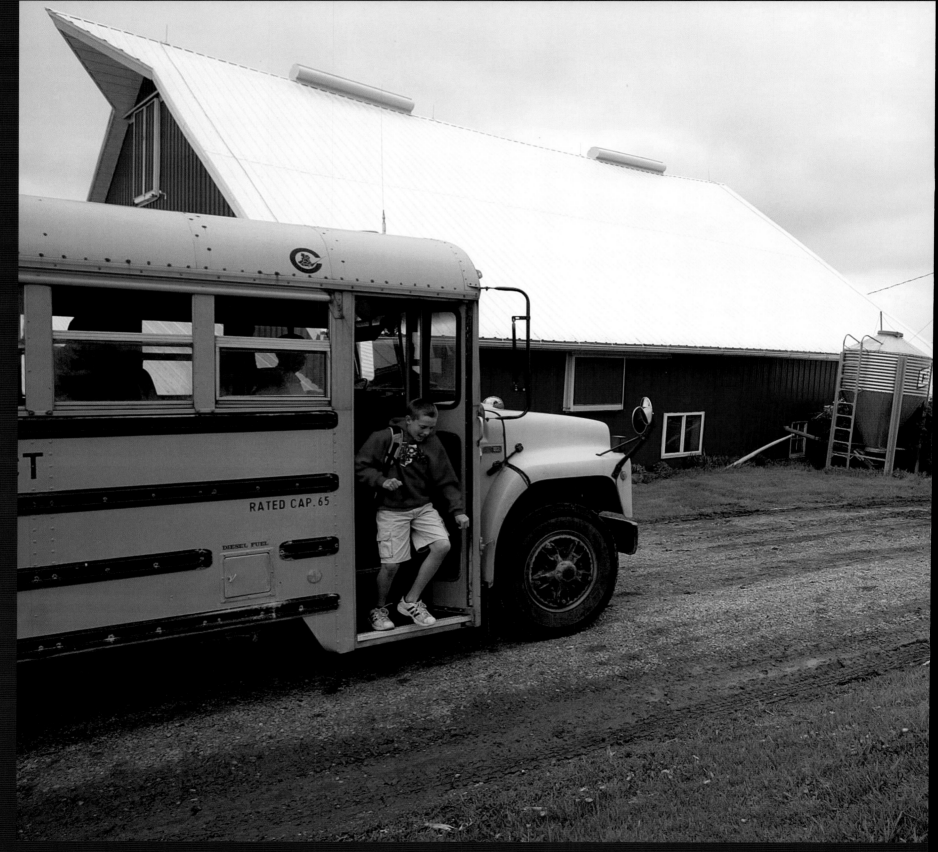

We all lived on what we called the "Loop"—a small, tilting hillside neighborhood built around a circular quarter-mile road. The Loop realized every child's playground dream. None of the houses around it had a front lawn, a back yard, or even a fence. Instead, they had orchards of apricot trees, whose sun-warmed fruit we picked and ate between games of hide-and-seek, and persimmons, which we didn't eat but threw as far as we could, watching them land and explode, leaving irregular, mashy stains on the uneven asphalt road. The Loop was full of things to throw—dirt clods, sticks, rocks—and targets to throw them at, some live (a lizard sunning on a woodpile) and some long gone, like the hollowed-out tree we often gathered around to invent new rules. Our dogs roamed free, following us from one home to another, sniffing spoiled pomegranates along the way.

Driveways radiated from the center of the Loop like the curvy rays of the sun we drew in crayon on popsicle-stick houses we made for our parents. Five of the driveways led to the homes of seven kids no older than nine. Two older boys, tyrants in their early teens, lived along a dirt road just off the Loop, far enough to not be voting members and separate enough by age and distance to be banished by our parents. I'm sure those earliest days when we did join the "big kids" and subsequently returned home with wounds from noogies, snapping rubber bands, and BB guns had something to do with the older boys' banishment.

The seven of us played well together despite our odd number, which usually meant that no matter what game we decided to play, we were bound to have uneven teams. Our games, then, tended more

toward those that pit one person against everyone else (Marco Polo and kick-the-can) or free-for-alls like sit-down skateboard races along the Loop's sharpest decline, during which we wore through the rubber heels of our sneakers.

We could never seem to agree on rules. And thus we formed mini-countries, establishing systems for play based on borders projected invisibly outward from our homes. A more-or-less implied home-field advantage. Being the eldest, I held the largest territory and was granted the authority to resolve disputes over most of the Loop's land. John, the second eldest, shared control of Loop water. After all, his family had the pool.

When we encountered the most severe conflicts in play, say, when someone shot ten imaginary bullets into a kid who refused to fall down dead, we closed a border for a few days to let things cool down. Even then, however, borders softened quickly, and we eventually resolved any conflict as kids, not countries: with a game of pick-up-sticks or by tossing nickels against a wall.

I still return to the Loop for a walk now and then. Each time the scenery changes a little bit more. The old homes are gone, and so are the orchards, having long ago been leveled for rows of new housing. But the memories remain. Especially those of how a group of kids embraced each other, through that universal art of play, thoroughly enough to under-mine any notions of separateness. *By Sean T. Kelly*

Author and America 24/7 *Senior Editor* SEAN T. KELLY *lives, works, and, especially plays, not far from the Loop in California's San Francisco Bay Area.*

CONRAD, MONTANA You go girl! With her matching pink hat and boots, Sheridan Johnson, three, rides in style at the 45th annual Whoop-Up event, which signals the start of the rodeo season in Montana. Kids can start riding sheep at three years old and graduate to steers when they're six.
Photo by John W. Liston, Great Falls Tribune

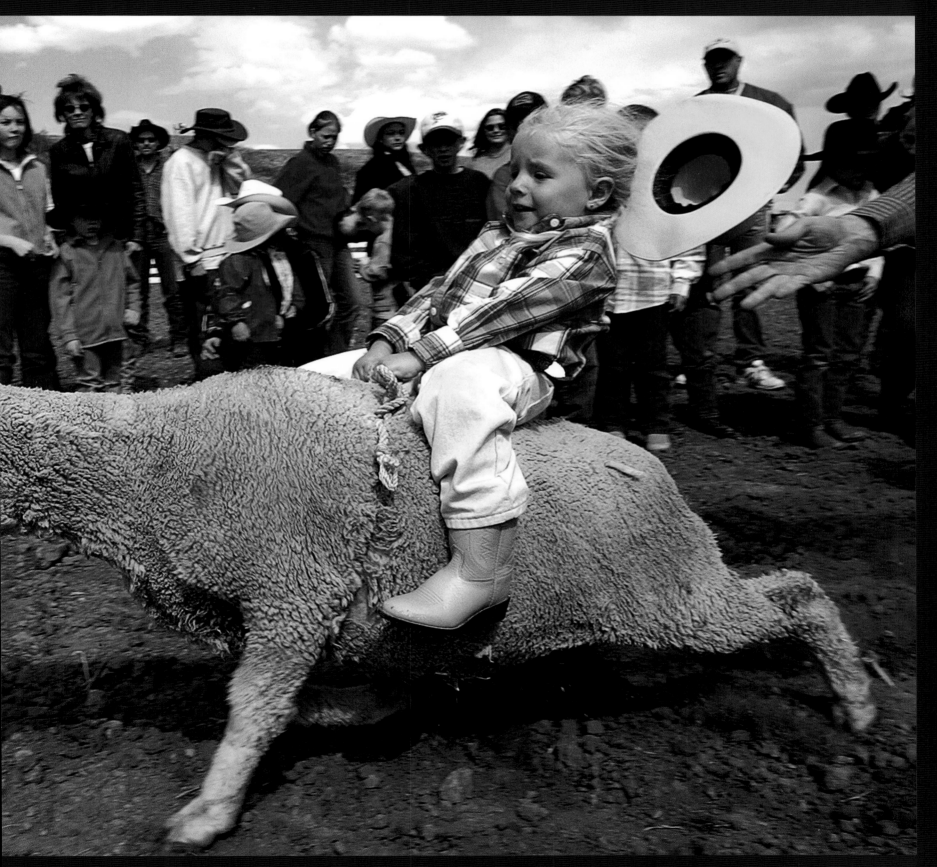

TEANECK, NEW JERSEY
Girls at the co-ed 220-student Muslim
junior-senior high school, Al-Ghazaly, jump rope
during lunch break. Muslim religious and cultural
beliefs prohibit girls from appearing in public
without their headcover, or "hijab."
Photo by Danielle P. Richards

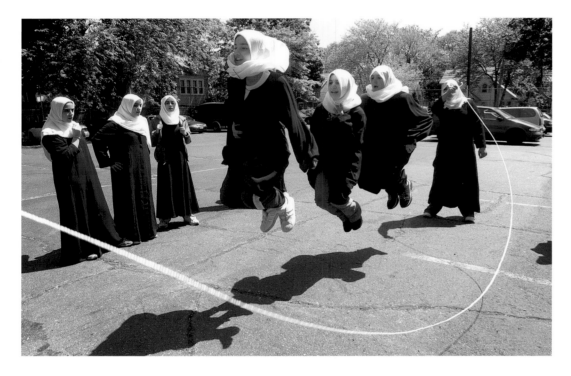

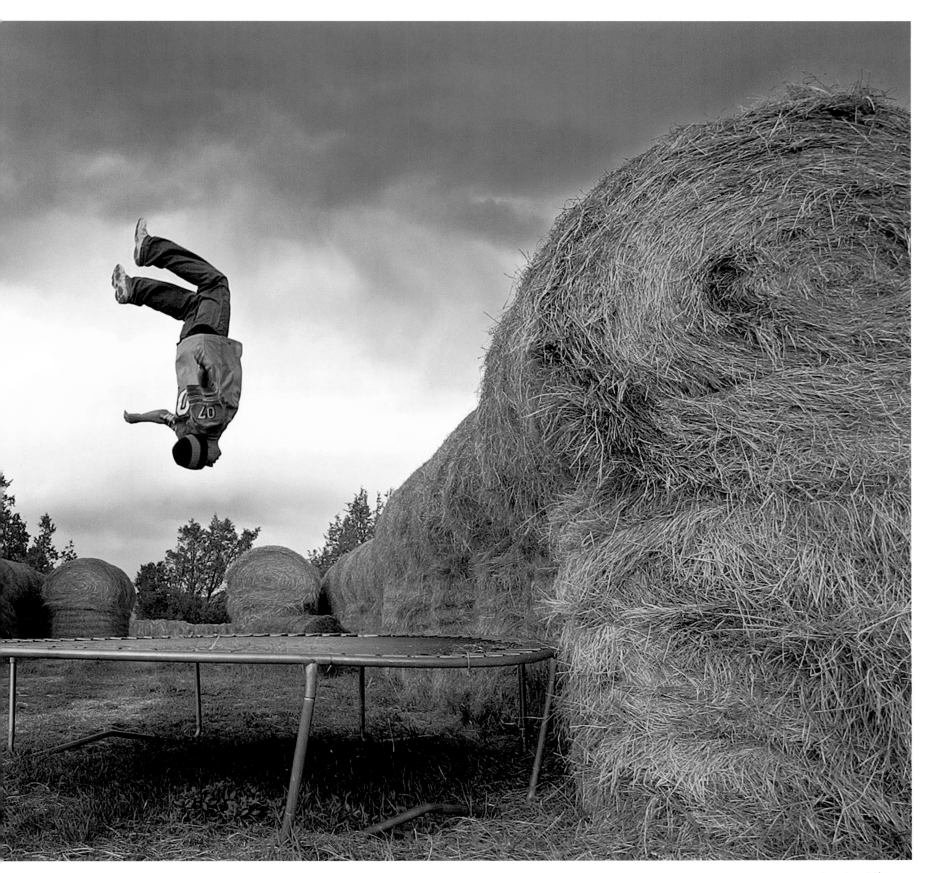

LIVINGSTON, MONTANA
Head over heels: Minutes before the storm clouds open up, Matt Gray, 15, flips for his friend Heidi Skattum at her parents' farm in Paradise Valley.
Photo by Erik Petersen

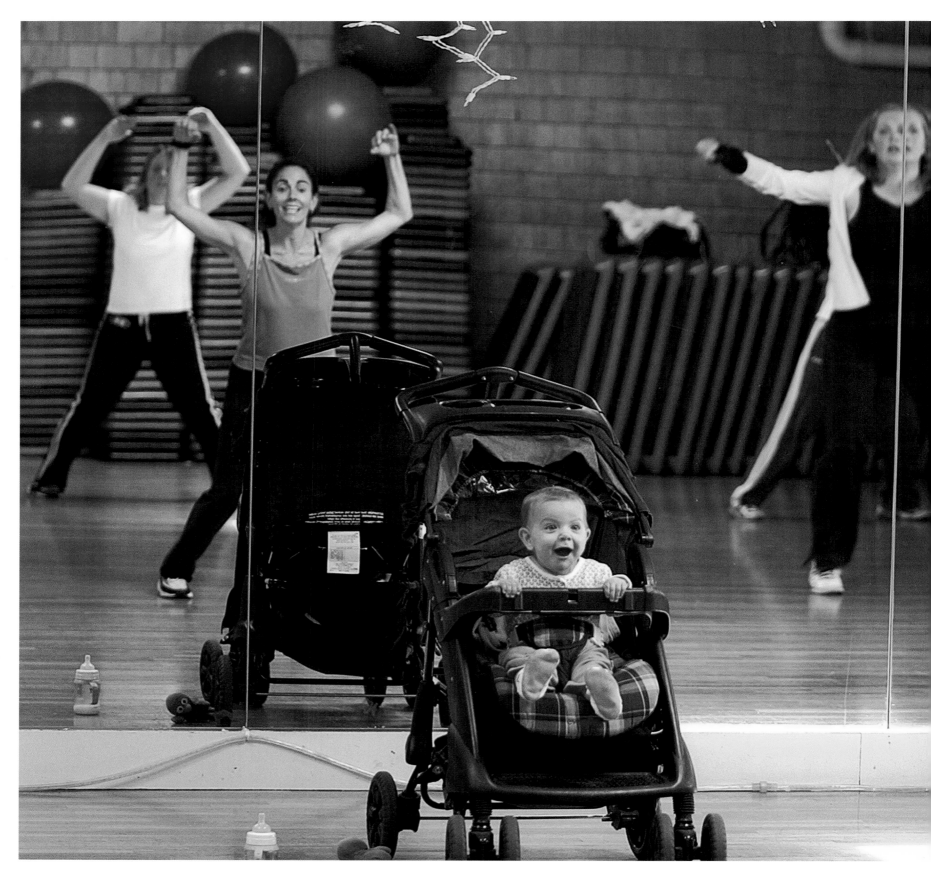

MIDDLETOWN, RHODE ISLAND
Here's looking at you, mom: Fitness instructor
Lynda West and 10-month-old daughter, Chloe,
keep multitasking mothers in shape—and their
babies amused—during Strollercise class at the
Newport County YMCA.
Photo by Dave Hansen

WARM SPRINGS, OREGON
Three-month-old Taya Holliday may not agree, but Native American mothers at the Early Childhood Education Center on the Warm Springs Reservation find that traditional beaded cradleboards reassure newborns by providing a secure, womb-like sensation. Individually handcrafted for each child, baby carriers were historically strapped to horses during hunting-season migrations.
Photo by Brian Lanker

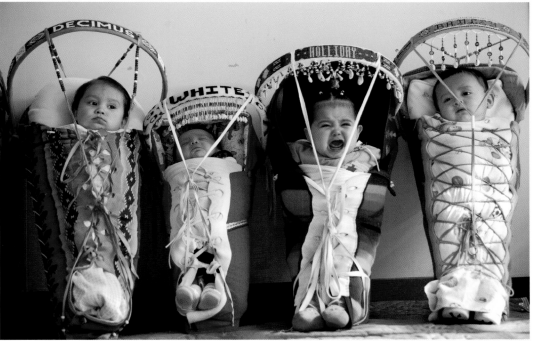

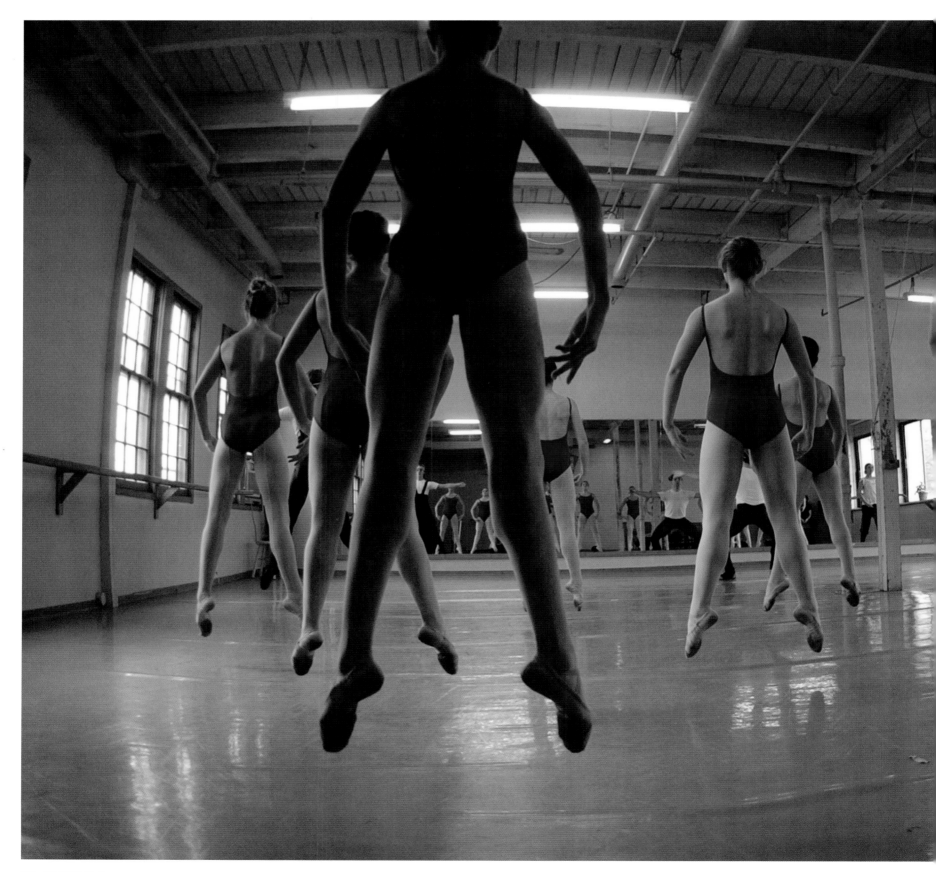

ROCHESTER, NEW YORK
Dancers with the Rochester City Ballet perform a series of *échappés* at the Draper Center for Dance Education. Founder Tim Draper is celebrated for bringing world-class dance to central New York.
Photo by Carlos Ortiz, Democrat and Chronicle

OWATONNA, MINNESOTA

Five-year-old Senja Elsie Koski may be
wearing cowboy boots with her tutu, but there
is no doubt where her heart lies. Taking lessons
since the age of three, Senja's a natural and loves
the limelight. Here, Senja and mom pick up her
costume for the spring show, "Dance Mania," at
Jill Hoggard's Academy of Dance.
Photo by Renée Jones, Owatonna People's Press

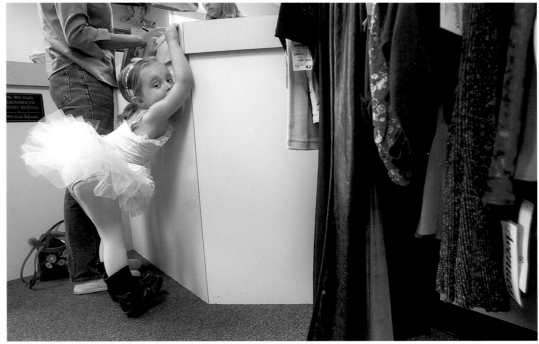

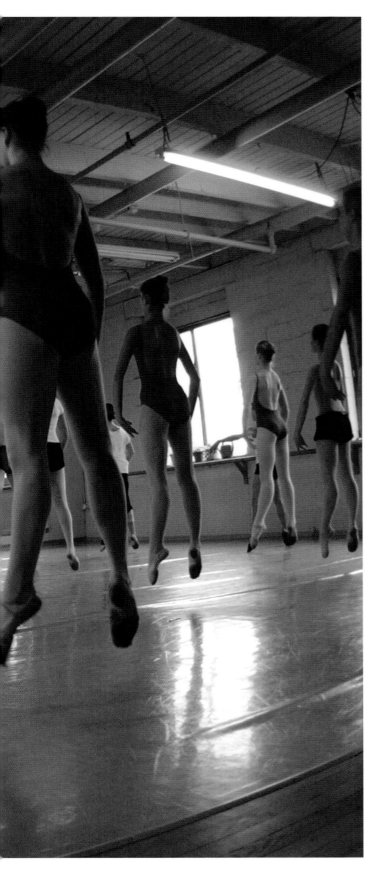

AUSTIN, TEXAS
Gods and monsters drift away as 15-year-old
Owen O'Brien glides through the night, alone
with her thoughts, in her own backyard.
Photo by Michael O'Brien

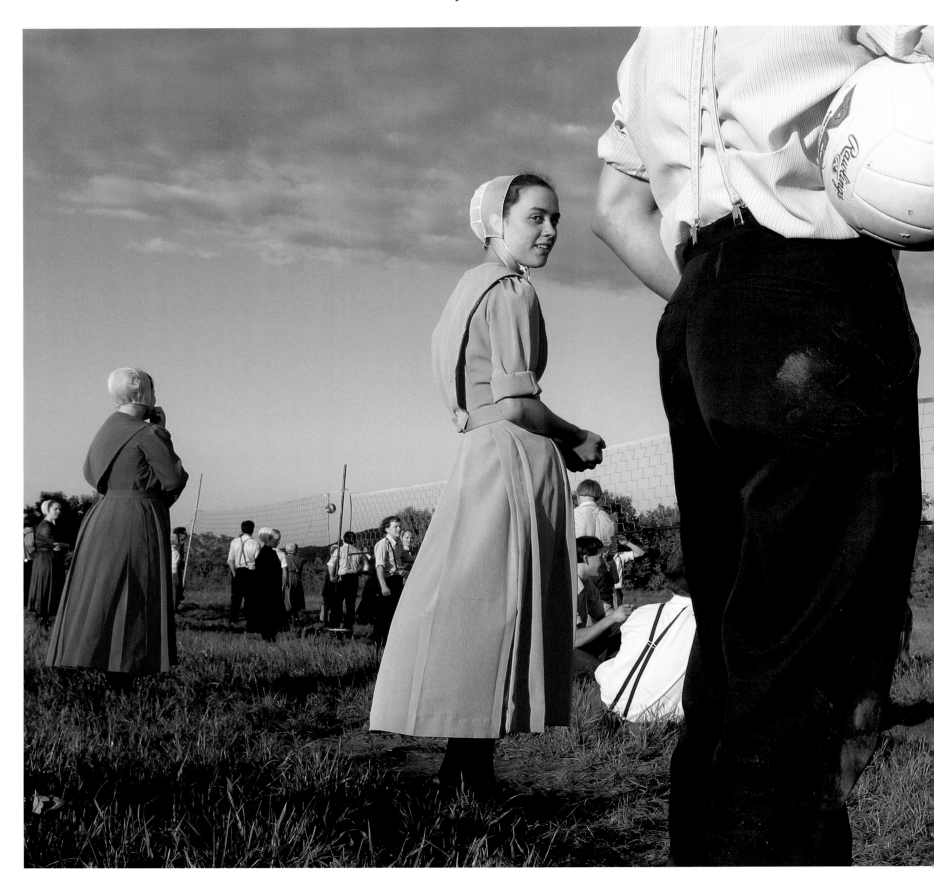

PORT TREVORTON, PENNSYLVANIA
Christian Mennonites in rural Port Trevorton (pop. 451) meet weekly for outdoor activities. Outsiders have trouble distinguishing between Mennonites and Amish because of their similar attire, but the Mennonites are not as reclusive as the Amish, nor do they shun all modern technology. They are known for their involvement in hunger and disaster relief and even maintain their own website.
Photo by Yoni Brook

OTSEGO, MICHIGAN

Kelly Kujawa, a tight end with the Toledo Spitfires, cools off at halftime during a game against the Southwest Michigan Jaguars. The National Women's Football Association, formed in 2000 by sports-entertainment entrepreneur Catherine Masters, fielded 30 teams in 2003 with more franchises in the works. Long story short: Toledo lost the game, 41–0.

Photo by Mark Bugnaski, Kalamazoo Gazette

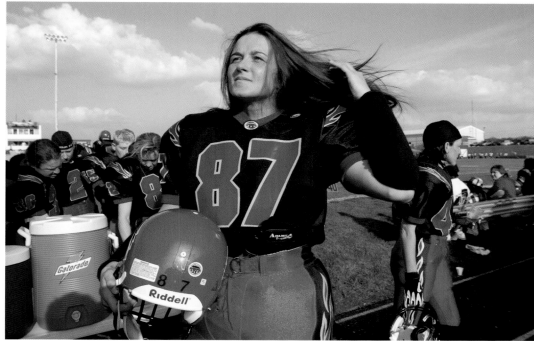

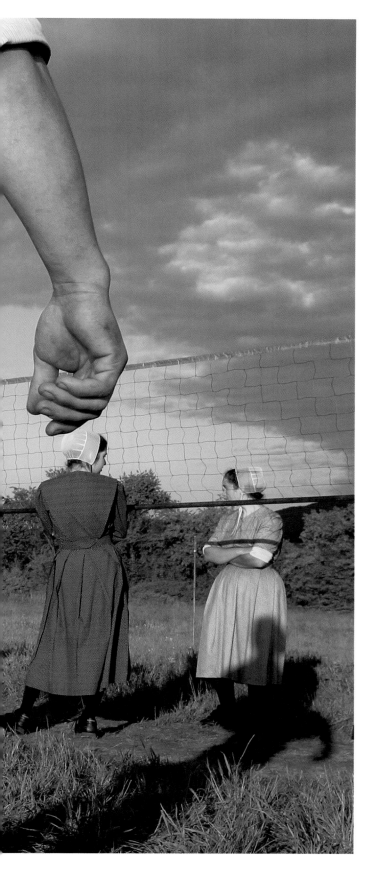

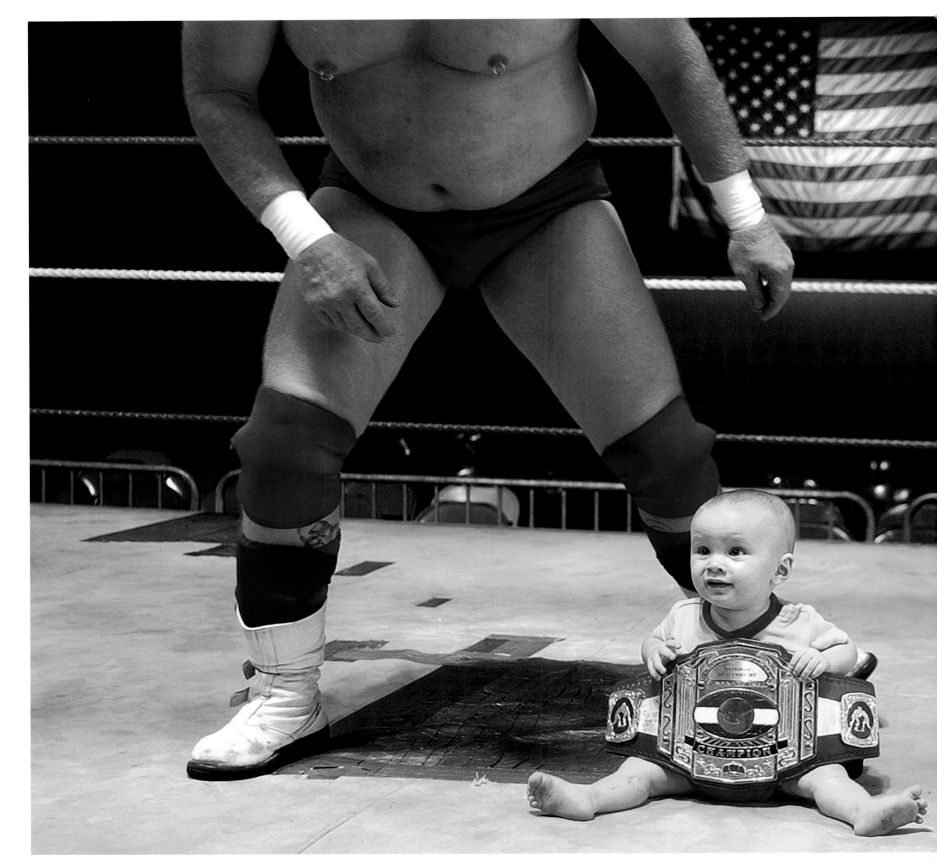

HUMBOLDT, TENNESSEE

During the week, Donnie Cook lays and repairs cable for Humboldt Cablevision. But on the weekend, he transforms himself into "Ricky Murdock," one of Tennessee's top professional wrestlers. Cook's 11-month-old son Tristan poses with his father at the end of a two-hour wrestling event. One of America's most popular spectator sports, there are 12 USA Wrestling chartered clubs in Tennessee alone.

Photo by Jim Weber

KAIMUKI, HAWAII
Kari Lloyd-Jones and her son, Ian, demonstrate a modified version of the plough in Yoga Hawaii's baby-yoga class. The class helps moms and dads build the strength and tranquility they need to bring up baby—and babies like Ian get to enjoy their parents from a new perspective.
Photo by Sergio Goes

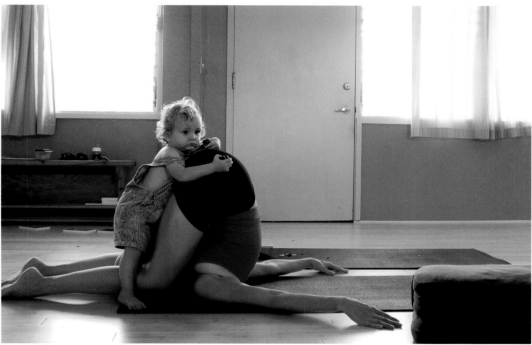

ANCHORAGE, ALASKA

At his post-work workout at Powerhouse Gym, machinist Dan Mayhak, 54, takes his triceps to the edge with 60 pounds on the E-Z curl bar. Dan's goal is a national Masters championship—then to turn his success into a new career as a motivational speaker. Years ago, he suffered from alcoholism and depression. Bodybuilding, he says, helped him to climb out of it.

Photo by Marc Lester, Anchorage Daily News

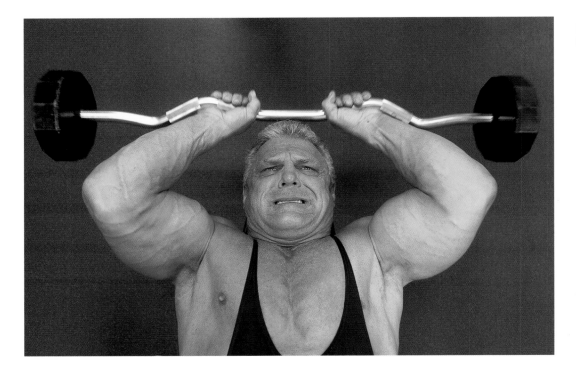

FORT LAUDERDALE, FLORIDA

Hey, what's everybody lookin' at? Shooters, a bar on Florida's Intracoastal Waterway, reaches maximum capacity during Sunday's hot body contest, which gives contestants a shot at cash, prizes, adoration, and applause.
Photo by Melissa Lyttle

SPRINGFIELD, ILLINOIS
Striking out seems like the end of the world for any little leaguer. Now slugger Roman Ballenger must wait for the eight batters that stand between him and a shot at redemption.
Photo by T.J. Salsman, The State Journal-Register

WATERFORD, CONNECTICUT
Waterford High's softball squad circles up for luck before every game. But the ritual didn't lead to victory today. The team suffered a loss to Eastern Connecticut Conference rival Montville High.
Photo by Sean D. Elliot, The Day

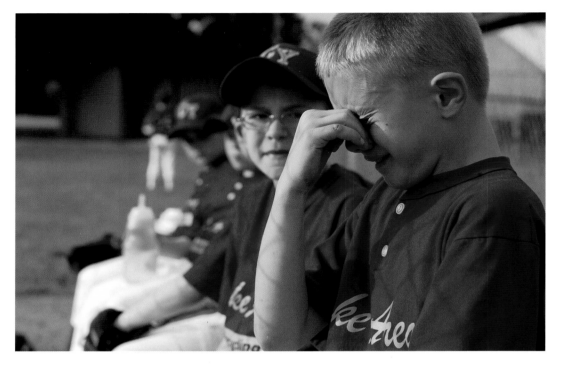

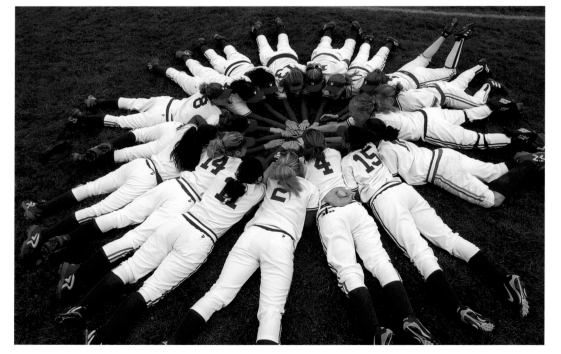

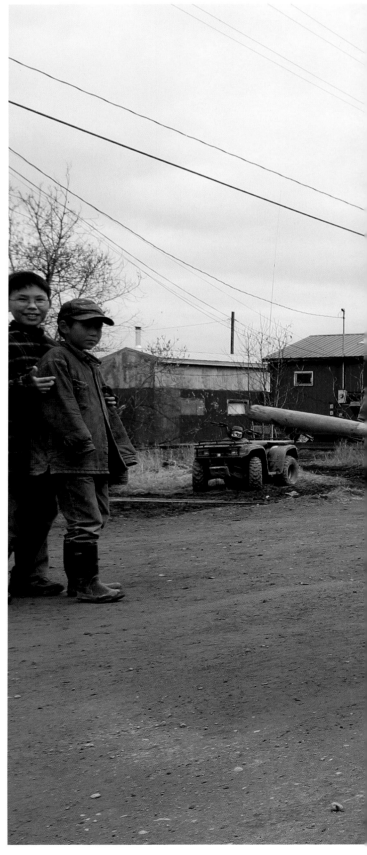

KWETHLUK, ALASKA

In Kwethluk (pop 703), an old, predominantly Yupik settlement on the Kuskokwim River in western Alaska, third graders play stickball during recess. About 60 of the towns' residents hold commercial fishing licenses, but in recent years declining fish populations have seriously affected the largely subsistence economy. Salmon, moose, and caribou are the staples of the local diet.
Photo by Clark James Mishler

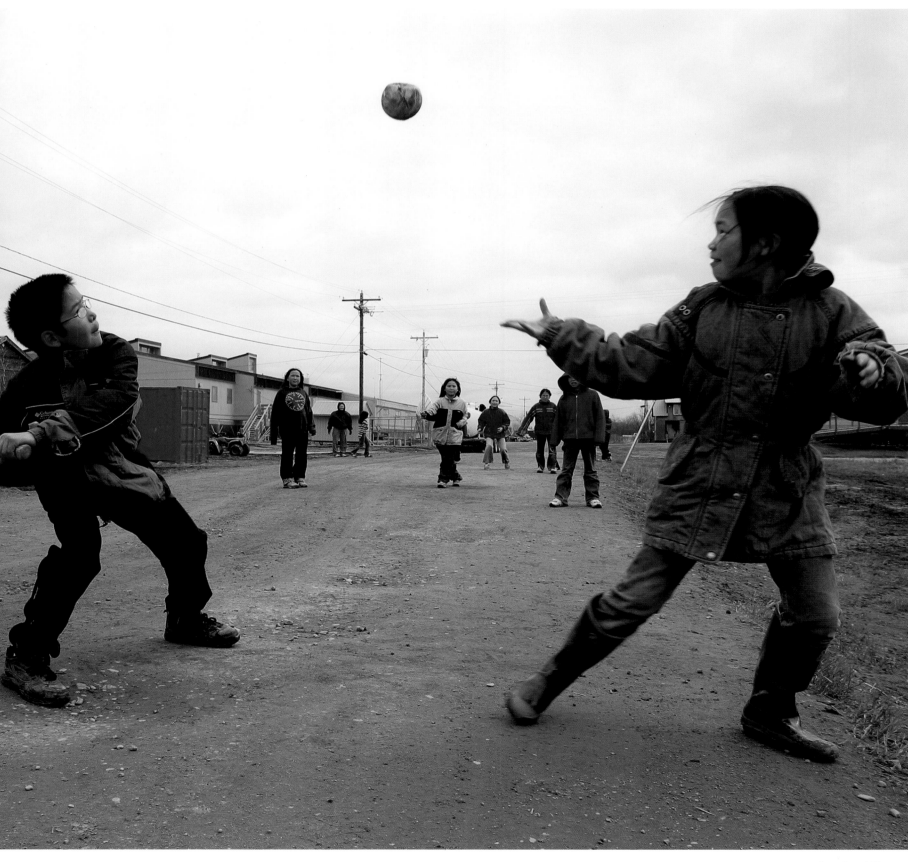

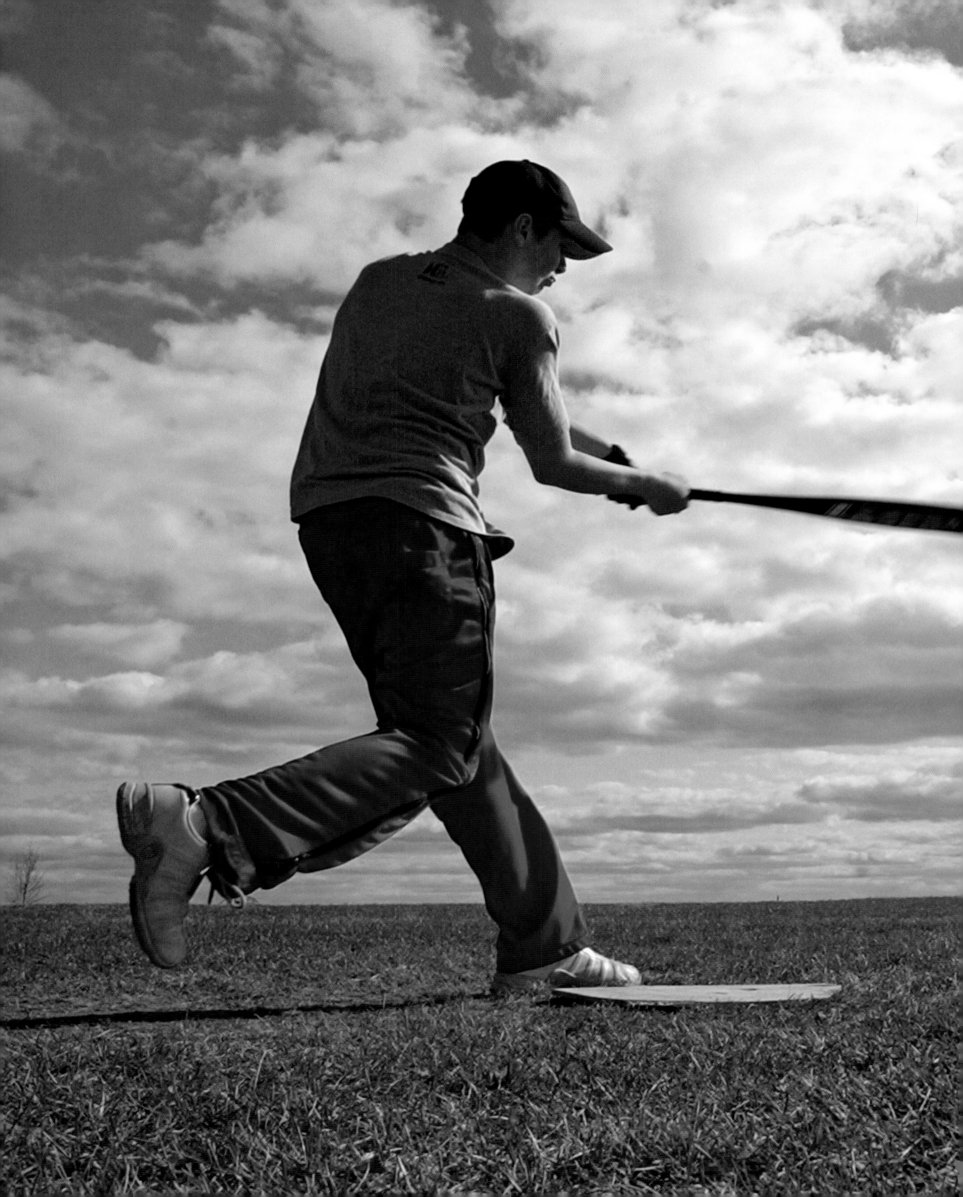

CARIBOU, MAINE
Two out. Bottom of the ninth. Bases loaded.
Fourteen-year-olds Justin Bouchard (swinging
for the fences) and Jordan Haines (throwing
the heat) play in their own field of dreams.
Photo by Kevin Bennett

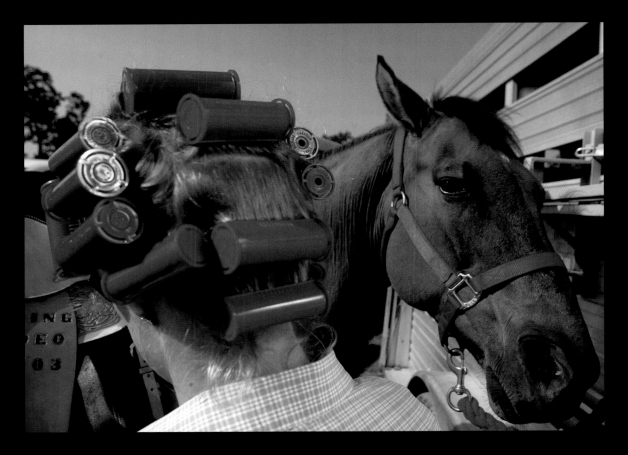

REDDING, CALIFORNIA 2003 Redding Rodeo Queen Rochelle Taylor, 20, gets her hair—and her horse Bandit—ready for the opening ceremonies of this year's rodeo. *Photo by Jim Merithew*

CAMILLUS, NEW YORK Foot traffic: Alison Owens, riding shotgun with her mom, waits for her sister to get out of school. *Photo by Laurie Owens*

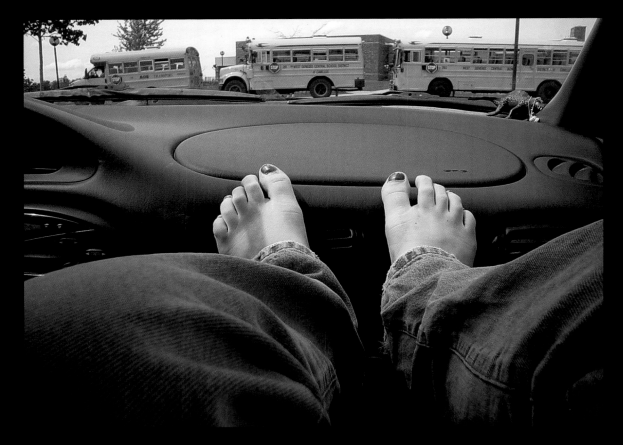

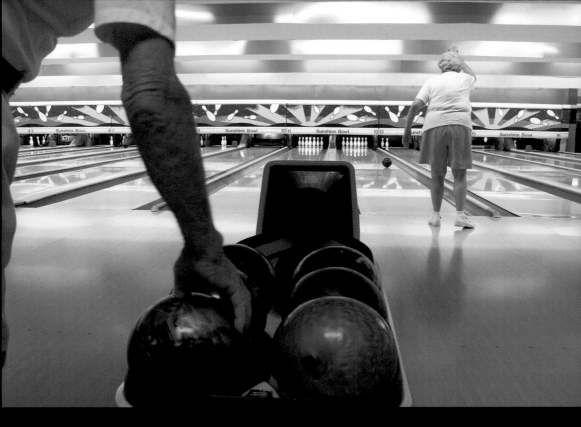

PINELLAS PARK, FLORIDA Widow Betty Flynn bowls for the Pirates. She reports that the guys on her team are "crazy, but nice." *Photo by Cheryl Anne Day-Swallow*

OCEAN CITY, MARYLAND With a woolly Atlantic storm pushing ashore, the Cruisin' Ocean City classic car rally still managed to draw more than 3,000 hot rods and 25,000 spectators to the venerable beach resort. *Photo by Shannon Bishop*

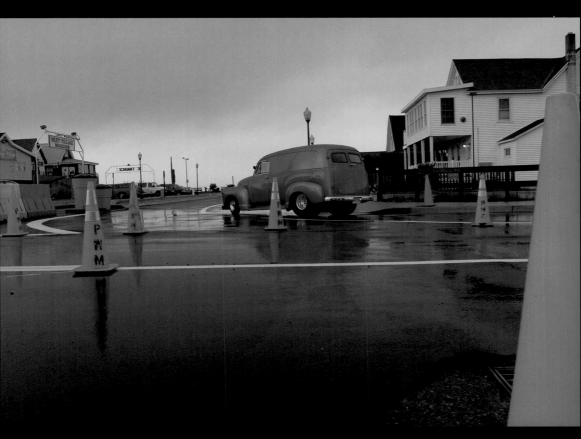

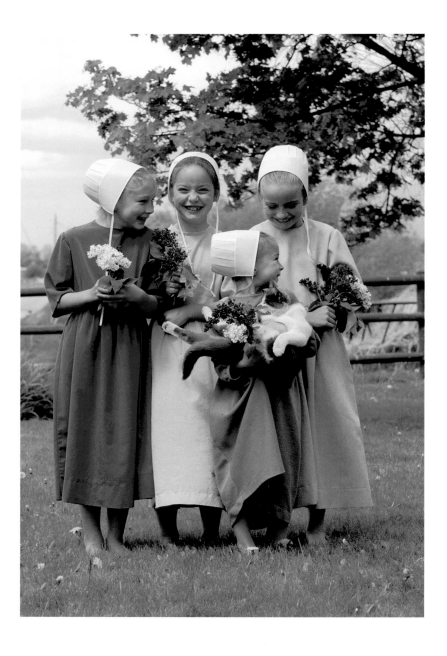

ST. IGNATIUS, MONTANA

The Amish usually marry within their own communities, which tends to reduce the pool of surnames. Heidi Miller, Hannah Miller, Naomah Miller, and Emily Miller (holding cat) are actually from three separate families. Their solid-colored dresses and white caps are designed to encourage humility and separateness from the outside world.

Photo by Kurt Wilson

NEW YORK, NEW YORK
Rollin' on the River: Ikon models (L-R) Merily
Jurna, 21, Shye Jones, 18, and Lynda Daisley, 20,
skate over the East River to Manhattan on the
1.13-mile-long Brooklyn Bridge. Today the crossing
is free, but on opening day in 1883, it would have
cost each girl a penny.
Photo by Alicia Hansen

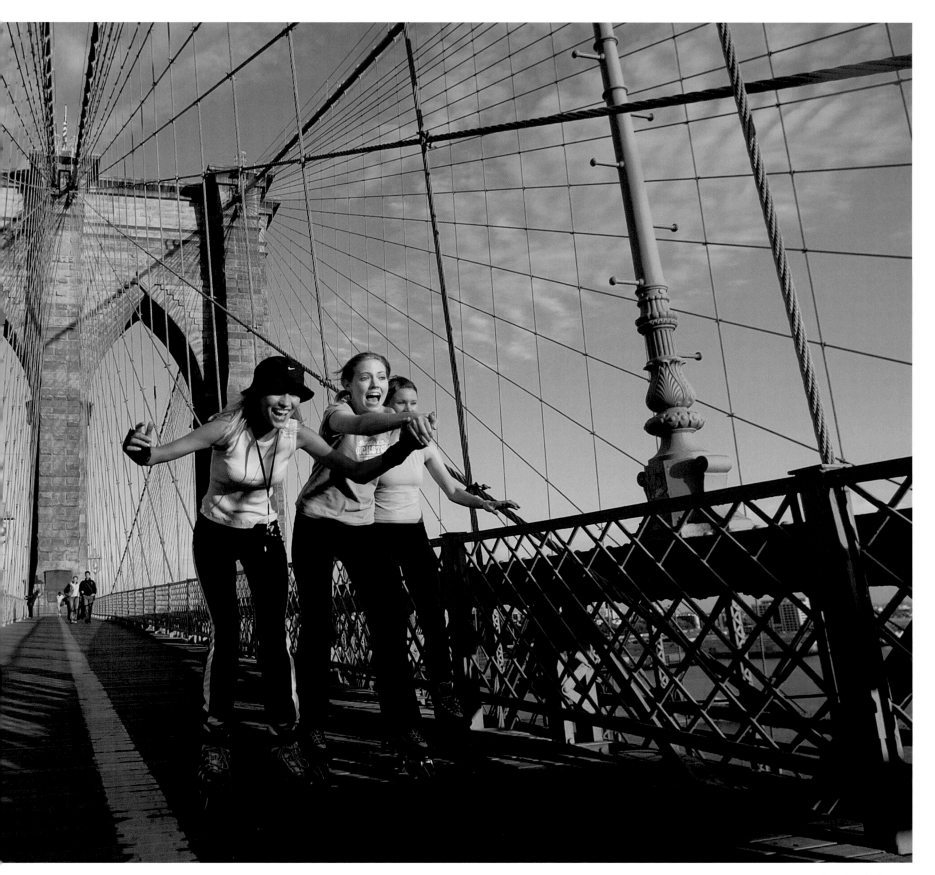

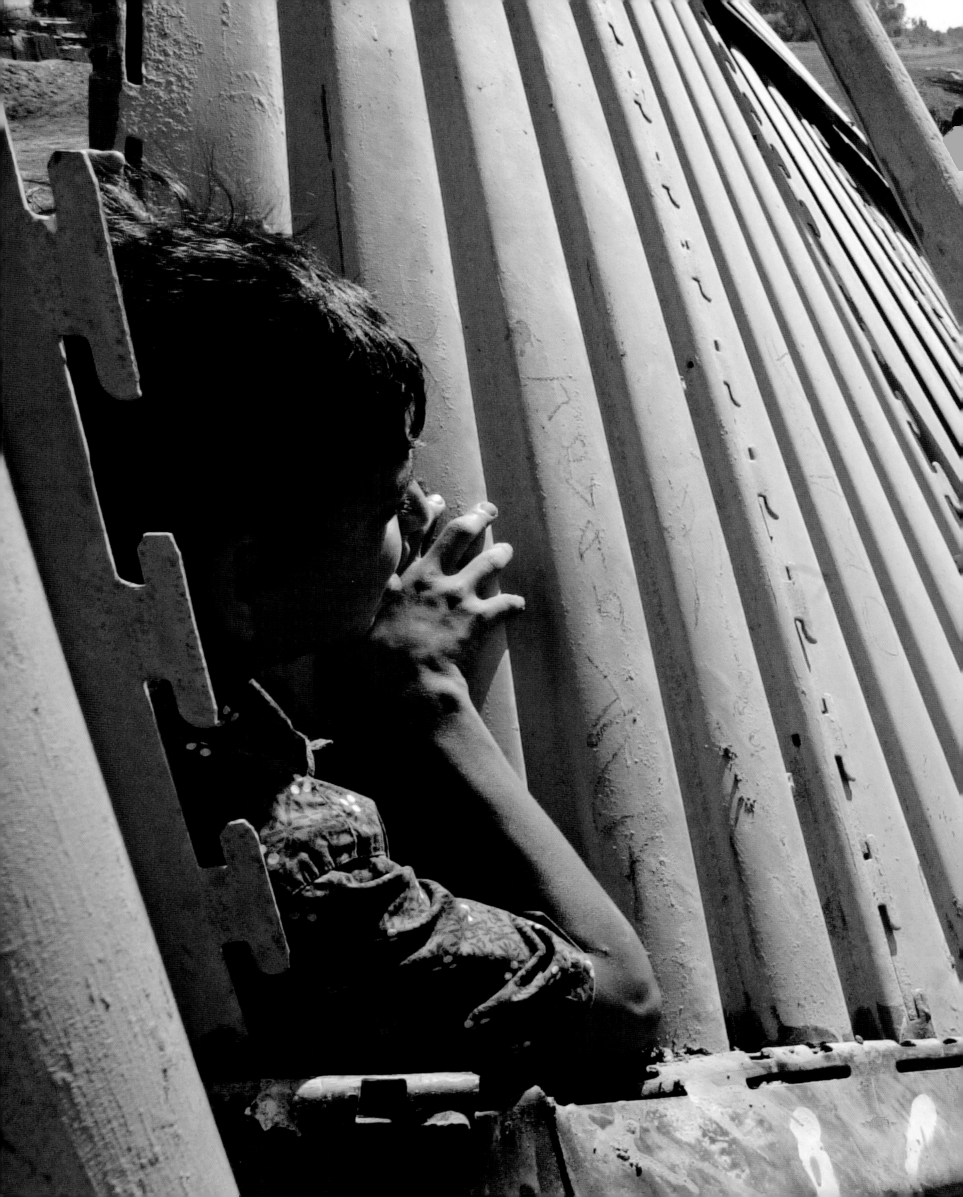

CALEXICO, CALIFORNIA
The 80-mile All-American Canal not only irrigates California's Imperial Valley, it's also a perfect swim spot along the Mexican border. Although climbing through the westernmost edge of the border fence from Mexico into America is technically illegal, on particularly hot days the Border Patrol tends to look the other way.
Photo by Peggy Peattie,
The San Diego Union-Tribune

GARDNER, MASSACHUSETTS
Members of the Gardner Wildcats High
School Girl's Swim Team train twice a day
at the indoor Greenwood Memorial Pool,
the oldest municipal swim facility in
Massachusetts. The team's gifted athletes
find that their winning track record makes
them desirable candidates for prestigious
universities across America.
Photo by Sean Dougherty

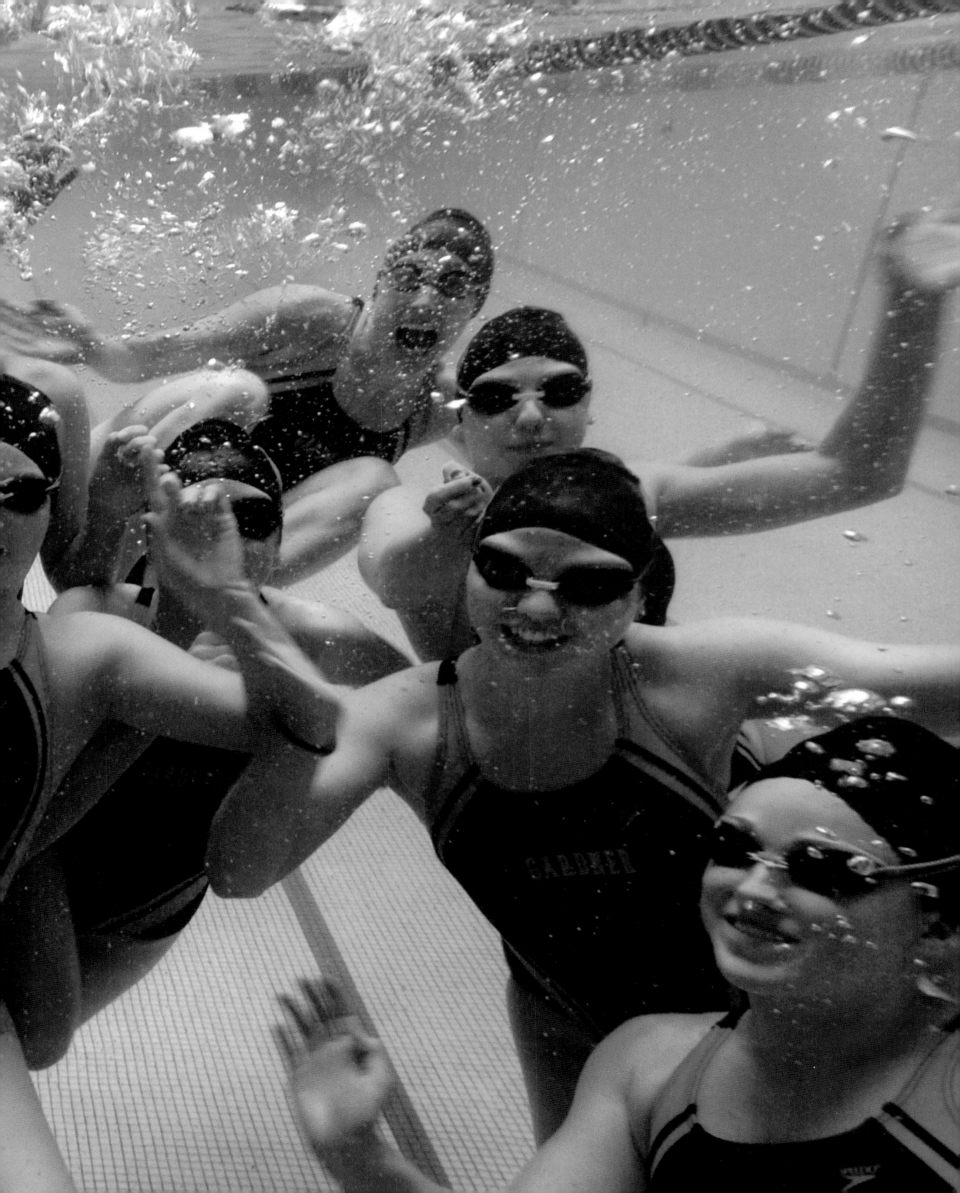

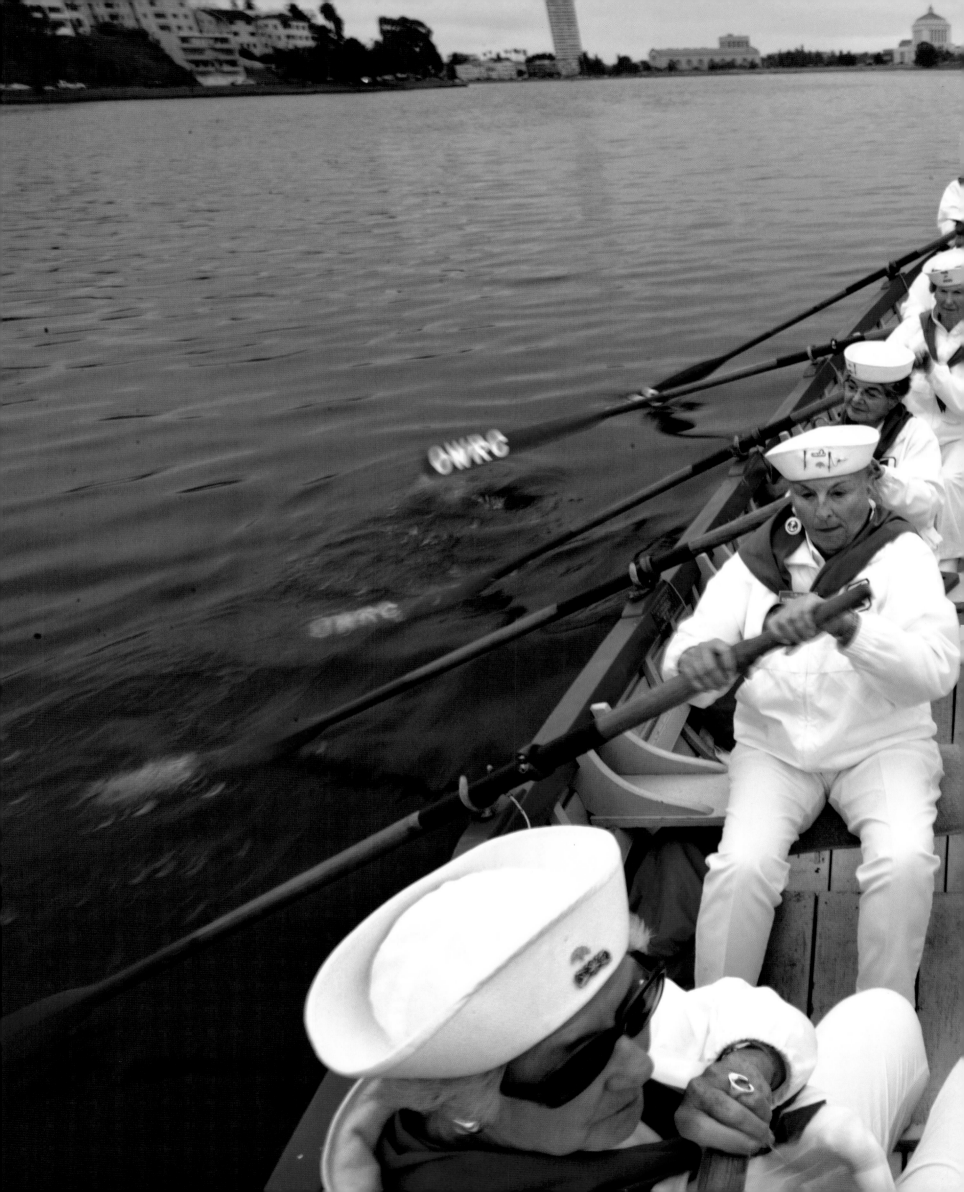

OAKLAND, CALIFORNIA
The Oakland Women's Rowing Club gathers every Wednesday at 11 A.M. for an hourlong excursion on Lake Merritt near downtown Oakland. The club's 48 mothers and grandmothers, ranging in age from 53 to 96, still adhere to the dress code established by the founders in 1916.
Photo by Jean Jarvis

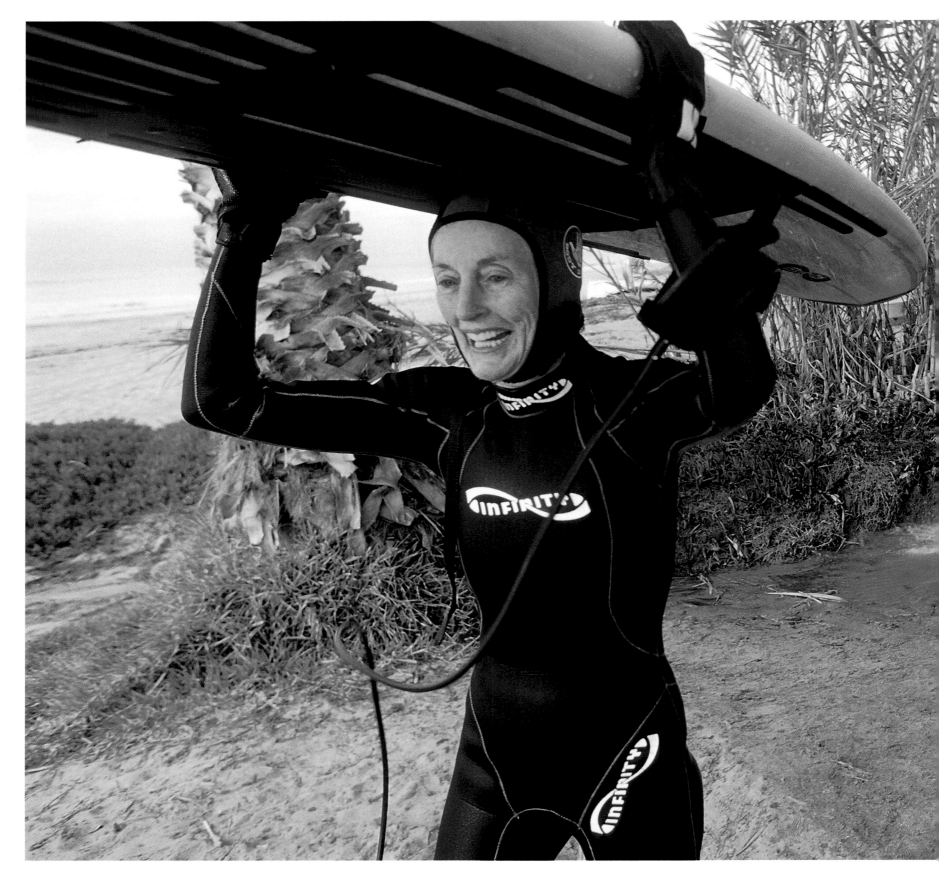

SAN CLEMENTE, CALIFORNIA
Must be the negative ions: Eve Fletcher, 76, after an "expression" session at San Onofre State Beach. Eve must be the oldest Roxy Girl in the world. Hale, hearty, and widely admired, she's been surfing San Onofre's Trestles break three times a week for 50 years.
Photo by Rick Rickman

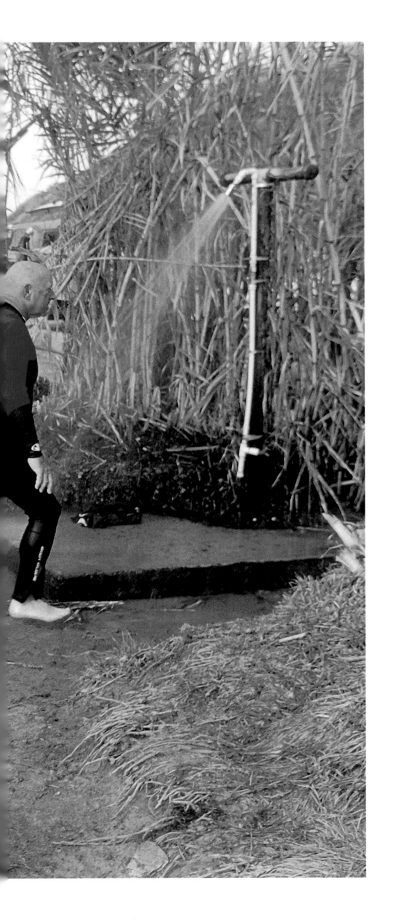

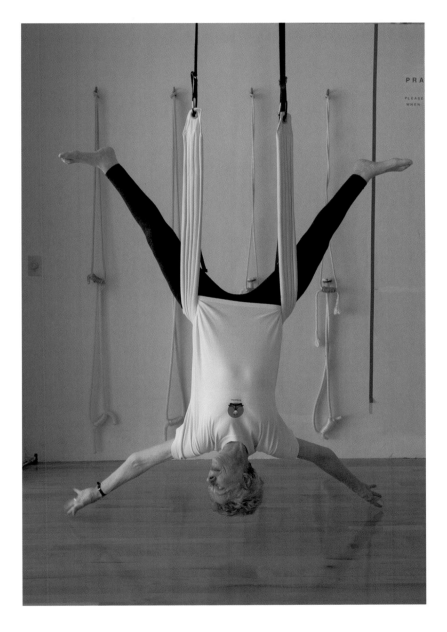

MADISON, WISCONSIN
Hanging hatha-style—as demonstrated by Mound Street Yoga Center instructor Nicole Plaut, 73—increases circulation and stimulates the brain. The word "yoga" means "union with the supreme spirit" in Hindi.
Photo by Jeff Miller

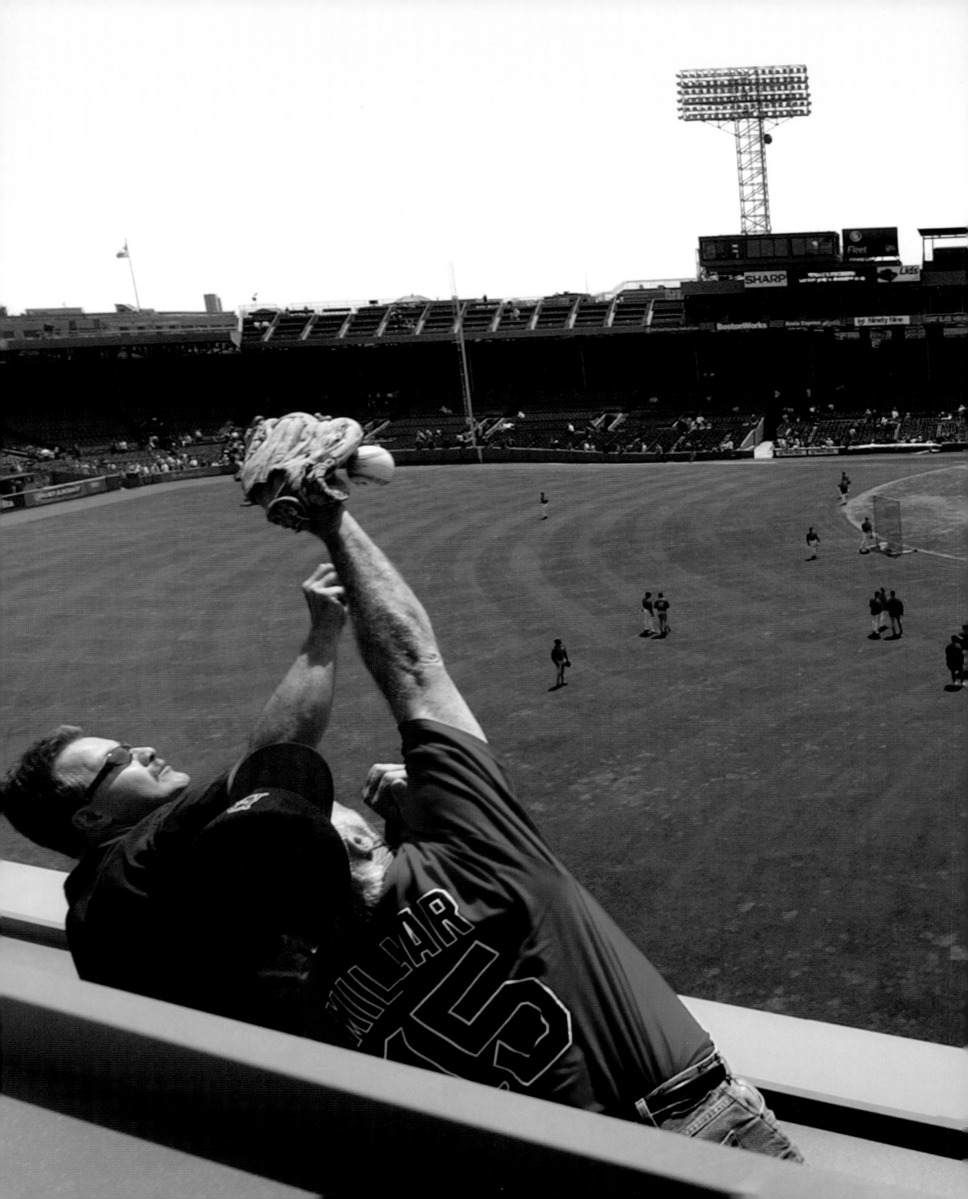

BOSTON, MASSACHUSSETTS
Monster hit: During pregame batting practice, barehanded Mark Paradis of Falmouth, Maine, and Larry Hurley of Groton, Massachusetts, stretch for a dinger smacked over "The Green Monster," Fenway Park's infamous left field fence. Red Sox fans can now sit above the historic 37-foot behemoth in new "Monster Seats," which replaced the 23-foot screen that once kept long balls from pelting pedestrians on Lansdowne Street below.
Photo by Jim Davis

WATERBURY, CONNECTICUT
The fast and the studious: Students from
Yeshiva Gedolah in Waterbury rally
participants at the Tour of Connecticut, a
three-day, three-stage pro bicycle race
running 220 miles from New Haven to
Danbury. The *yeshiva bochers* hail from New
York City.
Photo by Bob Falcetti

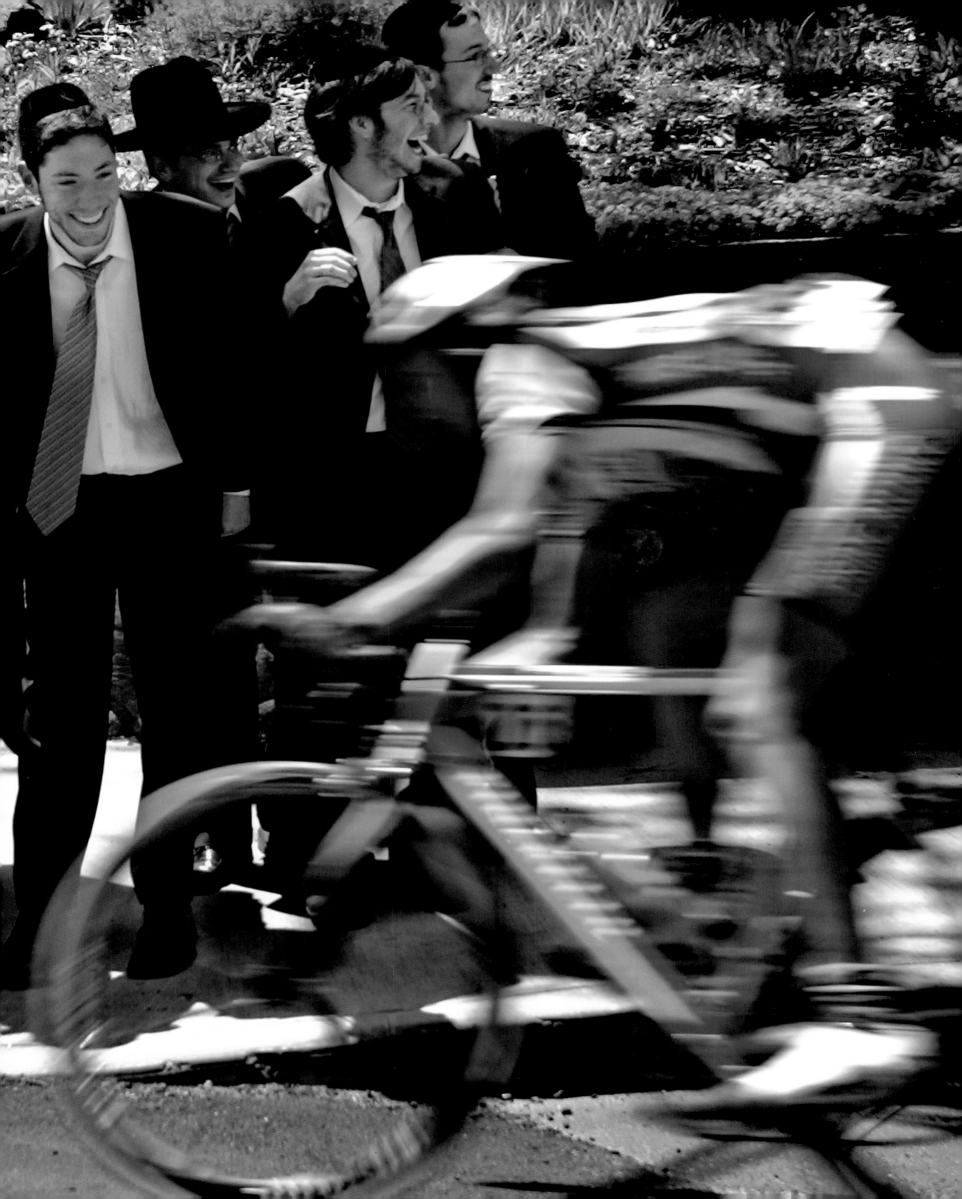

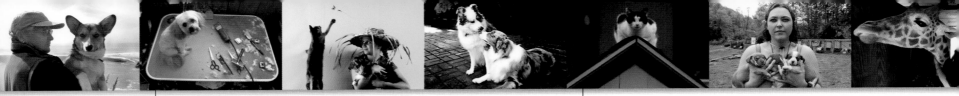

BOWLING GREEN, KENTUCKY
Drizzit feels half his normal 27-pound weight after Kim Doolin of Wags-N-Whiskers takes a little—okay, a lot—off the top.
Photo by Jeanie Adams-Smith,
Western Kentucky University

BRIDGEPORT, CONNECTICUT
Rescued from drug dealers when he was a kitten, Bumby lives with Gwendolyn Lord and takes his role as house gargoyle very seriously, only venturing inside to eat.
Photo by Christian Abraham

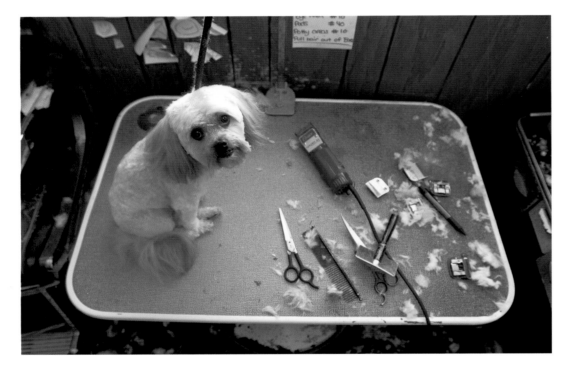

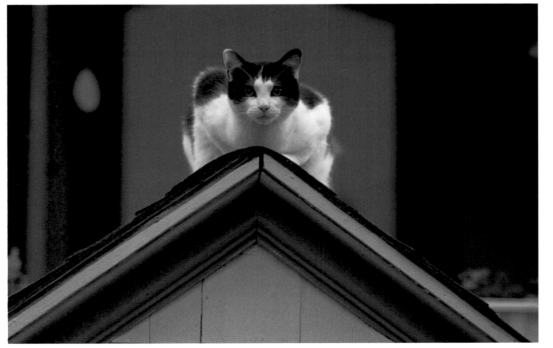

MANHATTAN, KANSAS
Drake does his labwork at the Tuttle Creek
Reservoir, where diving for quail dummies takes a
keen eye and a soft mouth. Kip Etter works Drake
daily for hunting, and nothing could be more
exciting for the three-year-old sporting dog.
Photo by Kelly Glasscock

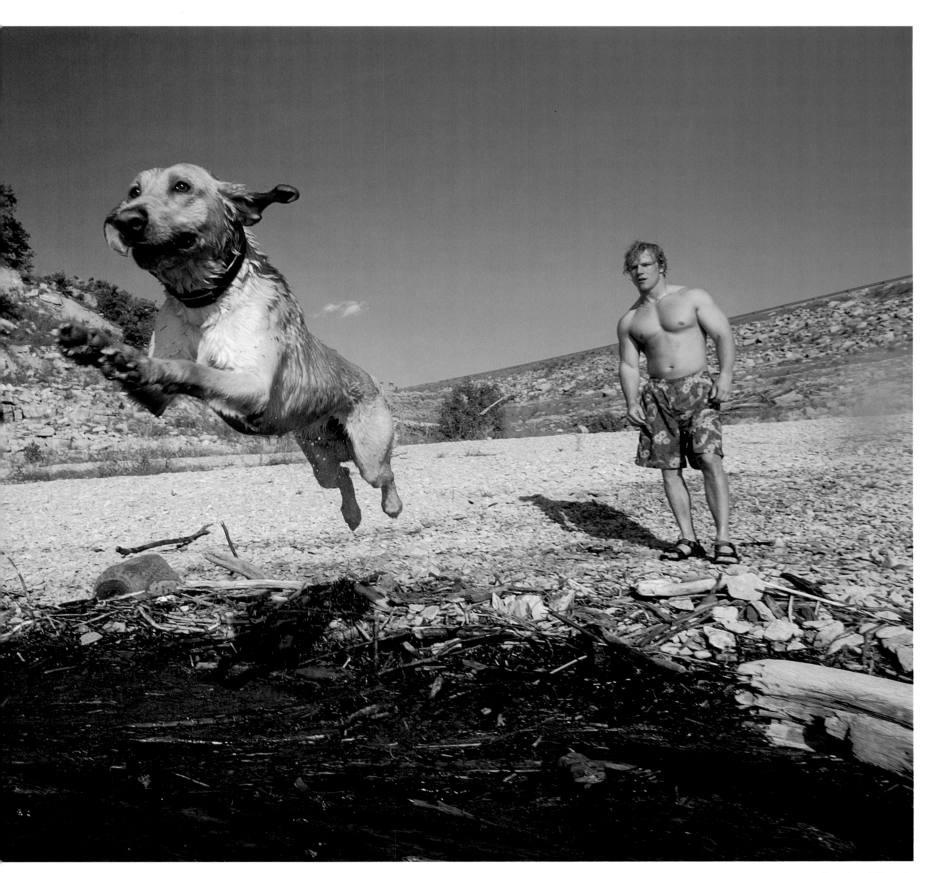

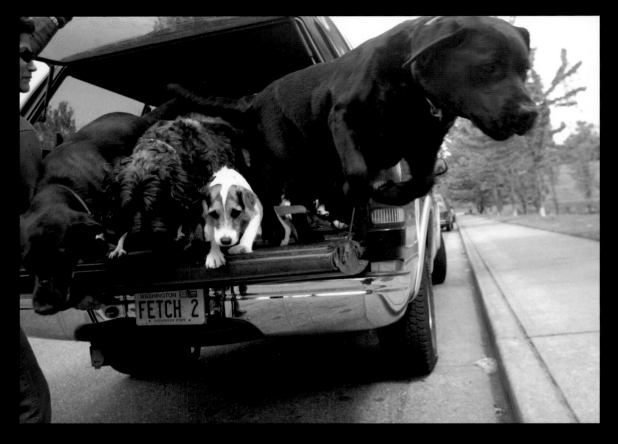

SEATTLE, WASHINGTON Dog walker Marie Emery takes the gang to the Blue Dog Pond Off-Leash Area. (Look for the big statue of a blue dog near I-90.) Emery, co-owner of Best Friends, cares for up to 20 dogs a day at $18 a romp. *Photo by Alan Berner*

ORLANDO, FLORIDA Real estate investor/waiter Gary Baron trains his six-month-old Sphinx cat, Anubis, at the Lake Davis home he shares with life-partner Rich Szadek . *Photo by Ben Van Hook*

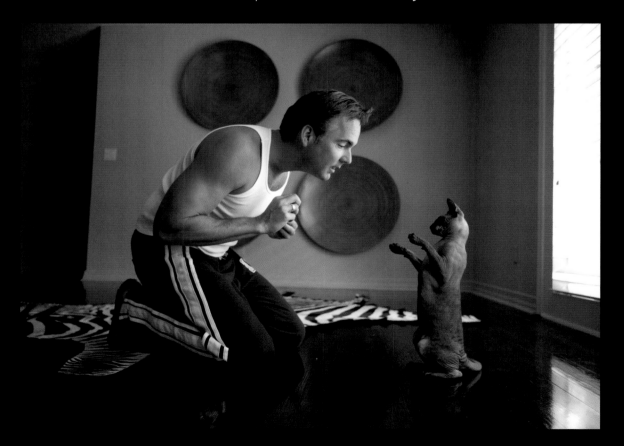

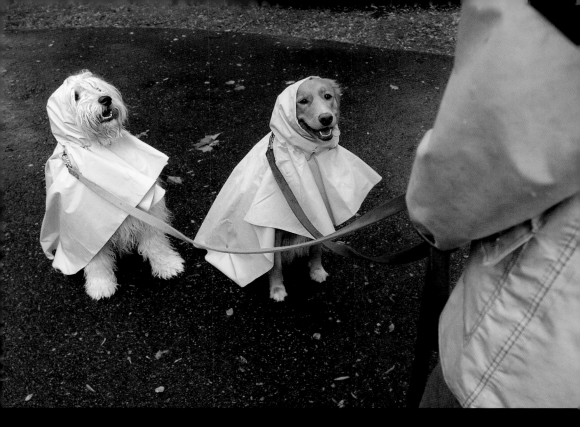

PENN VALLEY, PENNSYLVANIA Matsi (left) and Sophie's yellow slickers make walks in the park a much drier affair. Besides rain gear, this fashionable duo also have Halloween costumes and snow boots. *Photo by Sharon Gekoski-Kimmel*

MANCHESTER, NEW HAMPSHIRE The Nye family's new puppy, Twozee, teethes on sneaker laces during an evening little league game. *Photo by Don Himsel, The Telegraph*

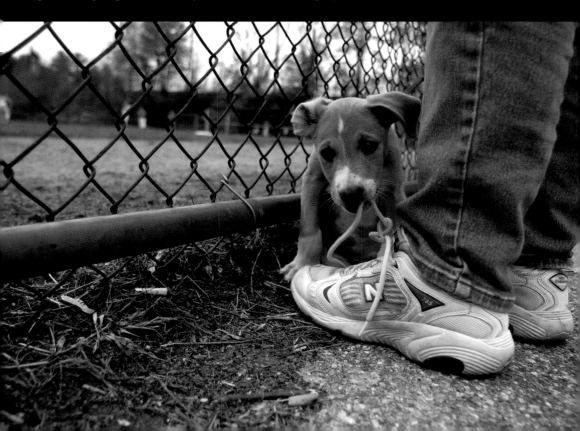

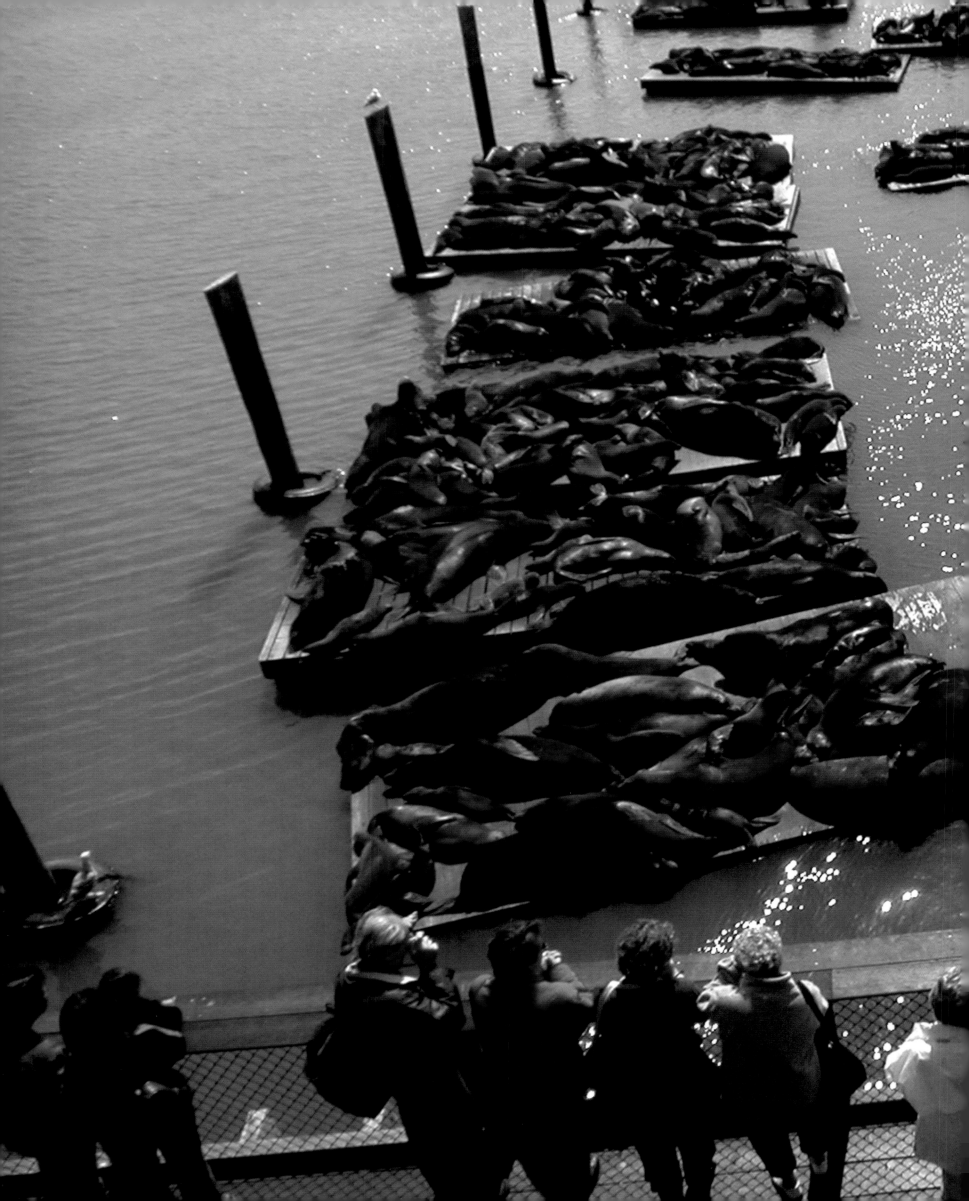

SAN FRANCISCO, CALIFORNIA
Fourteen years ago, a few sea lions showed up on a boat dock at San Francisco's bustling Pier 39—to take naps. Their chutzpah surprised everyone. Within months, there were 150. Boaters abandoned the docks, and now as many as 1,000 of the mammals show up at once. Scientists explain the invasion by noting there are no great white sharks and lots of fish in San Francisco Bay.
Photo by Pep Ventosa

NEW YORK, NEW YORK
When it opened in 1909, the two-deck,
$31 million Manhattan suspension bridge,
just north of the Brooklyn Bridge, carried
four trolley tracks, four subway tracks, and a
pedestrian walkway. Serious cracks caused by
trains were found in the steel superstructure
in 1978. Ongoing reconstruction has so far
cost $646 million.
Photo by Philip Greenberg

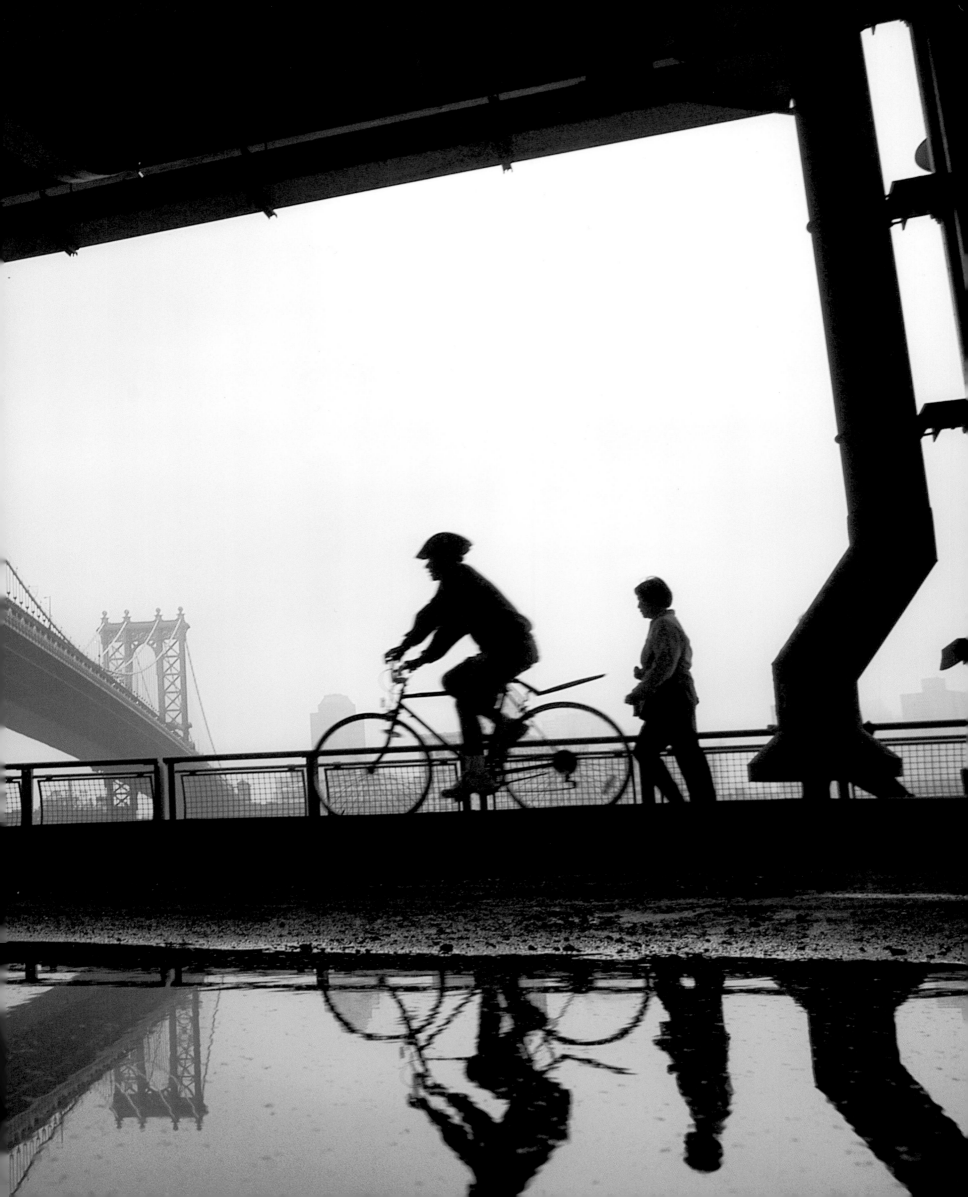

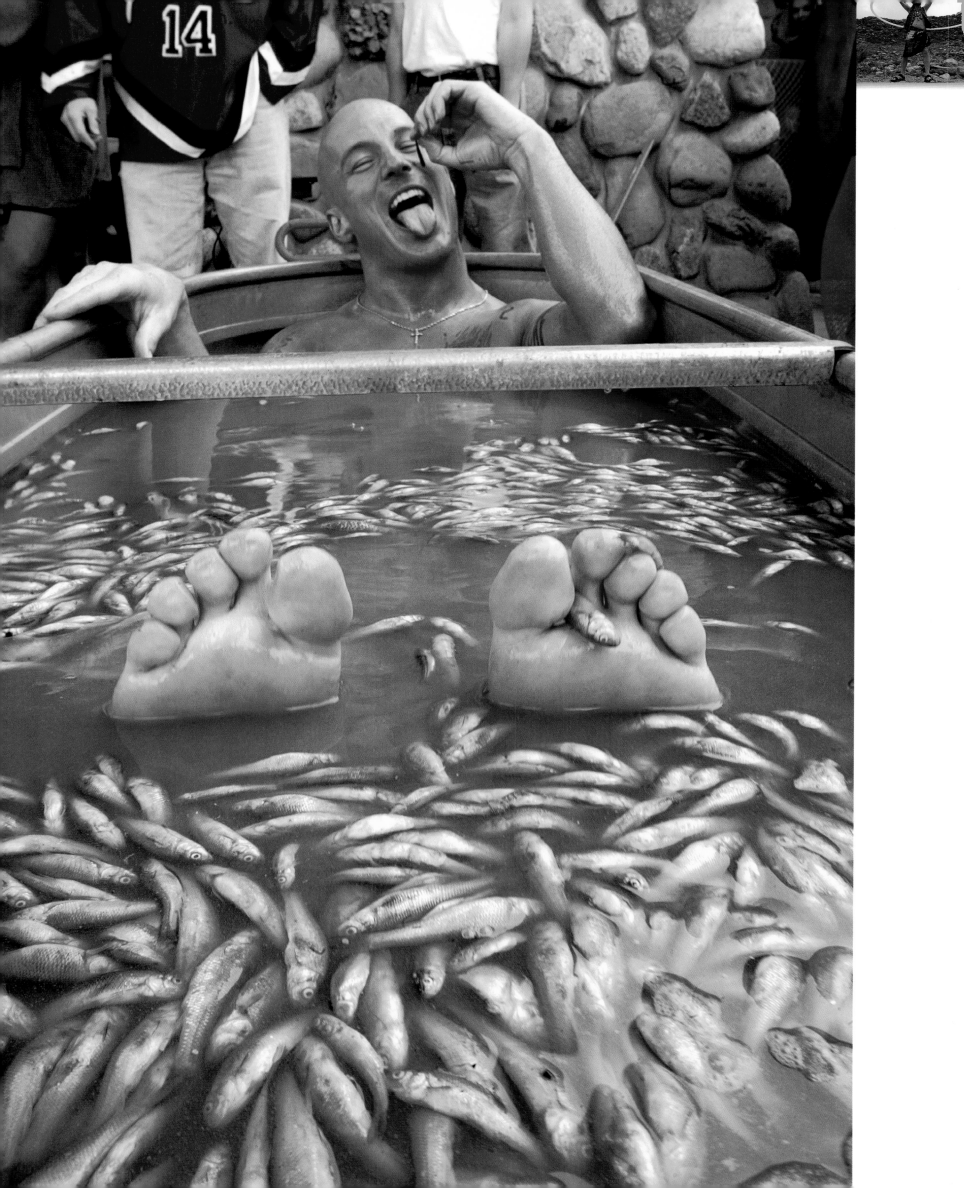

EAST GRAND, MINNESOTA

Give a man a fish, and he'll eat for a day. Give a man a tryout for NBC's prime-time reality gross-out show *Fear Factor*, and he'll bathe in a pool of cow's blood, live leeches, minnows, and ground catfish. Brian LaChance also ate a cow's stomach lining and a bull's testicle on a bed of live night crawlers, but he still didn't make the cut.

Photo by Eric Hylden, Grand Forks Herald

DALLAS, TEXAS

True blue: Dallas Mavericks superfans Morgan Ream, 14, and Audra May, 13, make a colorful attempt to win tickets to an upcoming play-off game. The duo competed against other Mavericks zealots at a pregame contest in the American Airlines Center (where the Mavs take it to the hoop) and won.

Photo by Barbara Davidson,
The Dallas Morning News

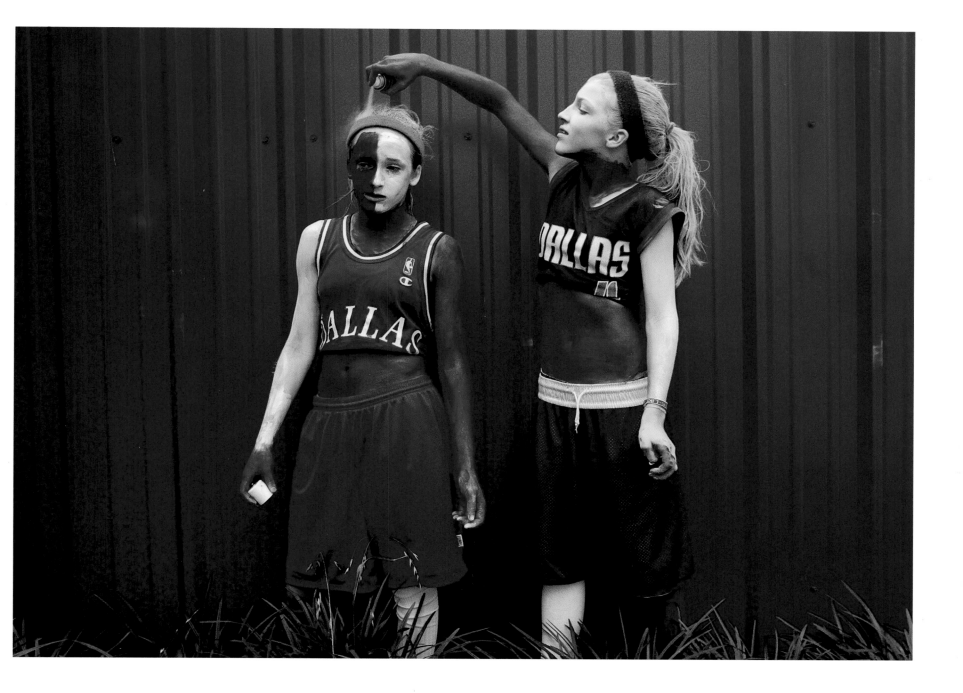

BOONE, NORTH CAROLINA
In extreme tubing, the cheaper the raft and rougher the river—the bigger the rush. Will Hagna, hangs on for dear life on the wily Watauga near the Tennessee border. During the winter months he pulls equally risky snowboard stunts on the frozen stuff.
Photo by Jason Arthurs

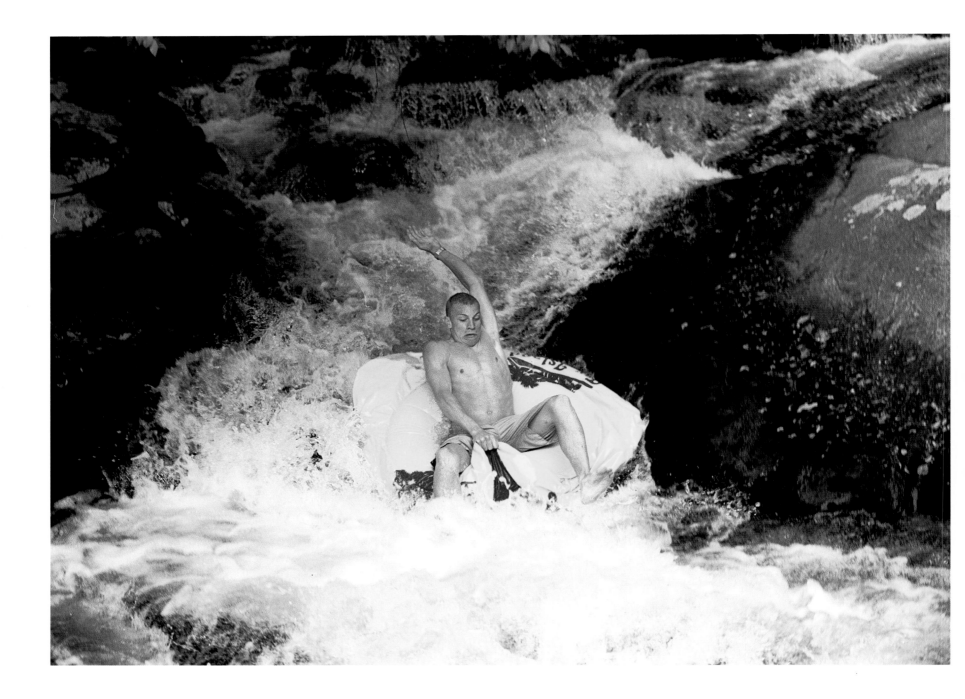

BLUE RIVER, OREGON
B-ass-ketball: Students from Mohawk and McKenzie High Schools compete in their annual "donkey basketball" fundraiser for athletic programs. The mounts were provided by Donkey Sports, Inc., which trucks donkeys around the Pacific Northwest for games and exhibitions. According to Donkey Sports, the cost of training donkeys to play basketball is "food and a whip."
Photo by Thomas Boyd

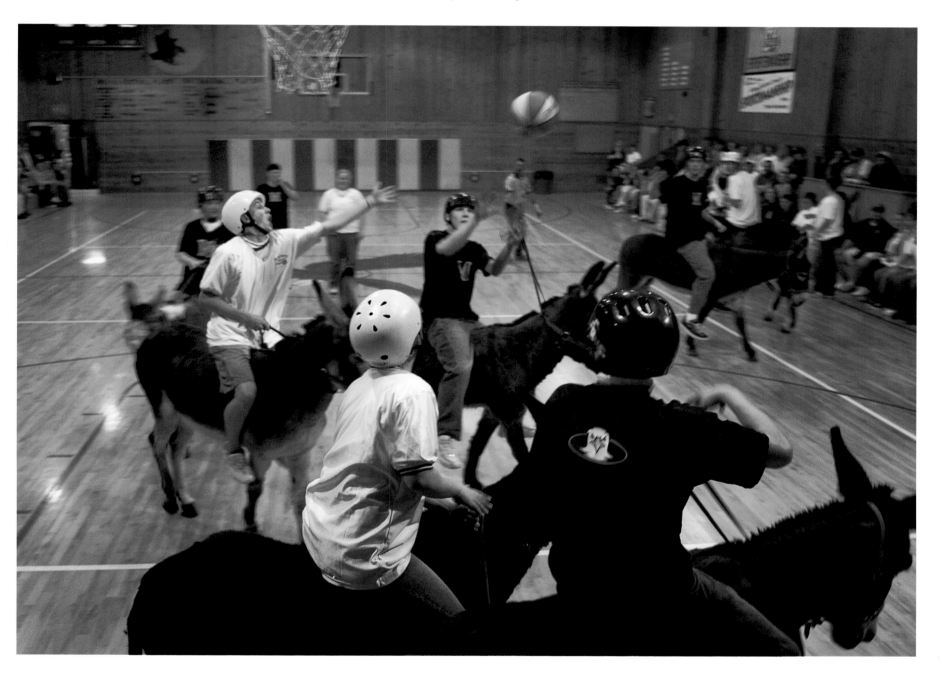

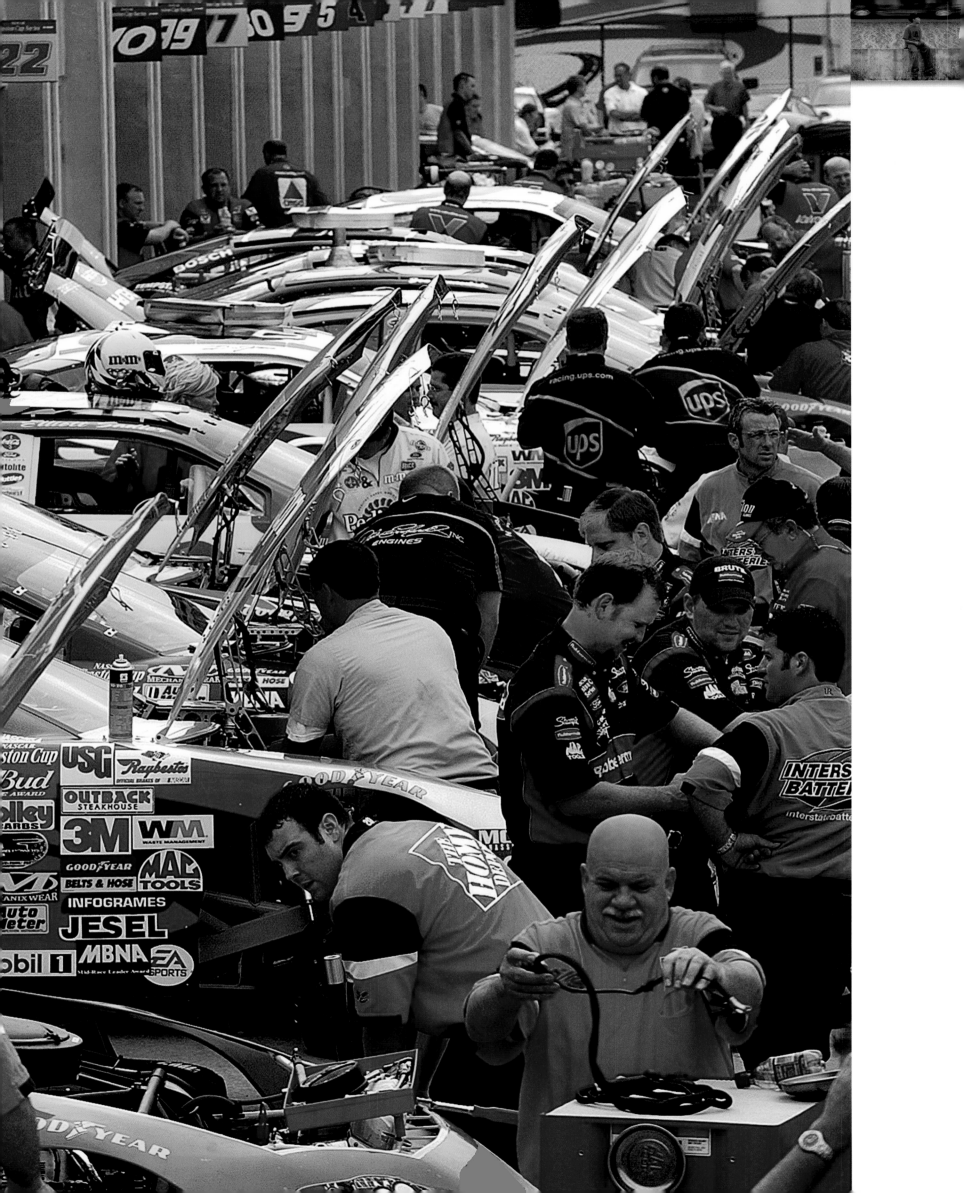

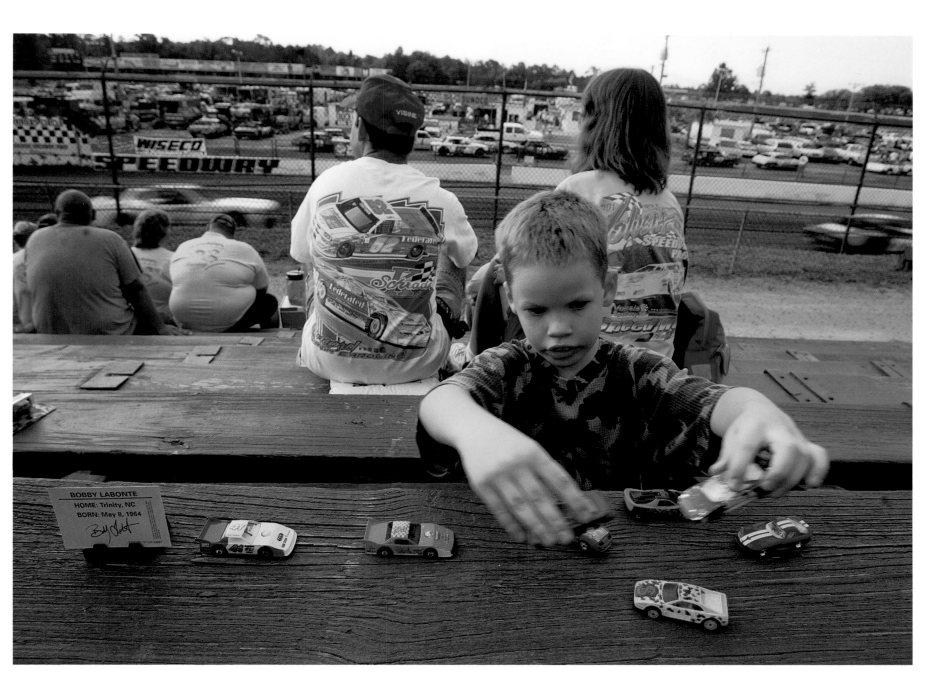

CONCORD, NORTH CAROLINA
At the NASCAR Winston Cup qualifying series at Lowe's Motor Speedway, race cars line up for prerace assembly and inspection. A month later, R. J. Reynolds, maker of Winston cigarettes, announced it would end its 32-year sponsorship of the series; telecom giant Nextel stepped in with a cool $700 million deal for the high-octane, ten-year NASCAR sponsorship.
Photo by Patrick Schneider, The Charlotte Observer

BARBERVILLE, FLORIDA
While Mom and Dad watch the stock cars on the half-mile dirt track at Volusia Speedway east of Daytona Beach, Mark Houle, eight, configures his own Matchbox race in the bleachers.
Photo by Kelly Jordan,
Daytona Beach News-Journal

CONCORD, NORTH CAROLINA
Driver Terry Cook (#29) gets set to pass #66,
Donnie Neuenberger (#66). Cook went on to
place 14th in NASCAR's Hardee's 200, the first
truck race ever held at Lowe's Motor Speedway.
Neuenberger fell back and finished 25th.
Photos by Patrick Schneider,
The Charlotte Observer

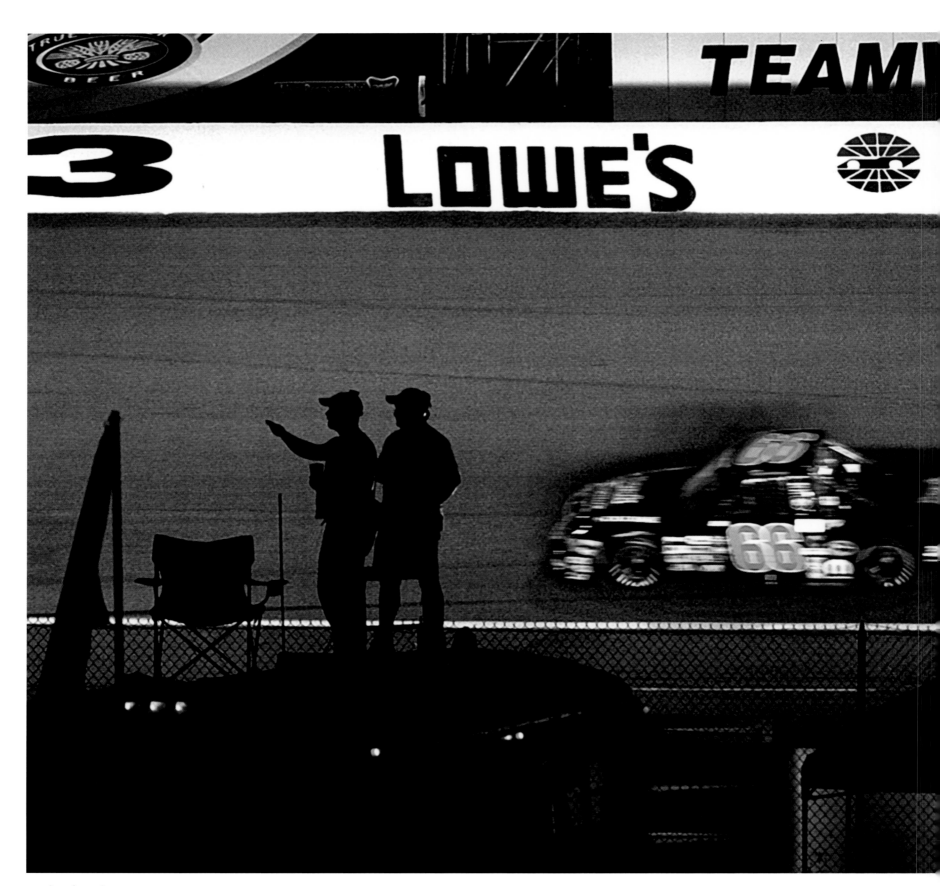

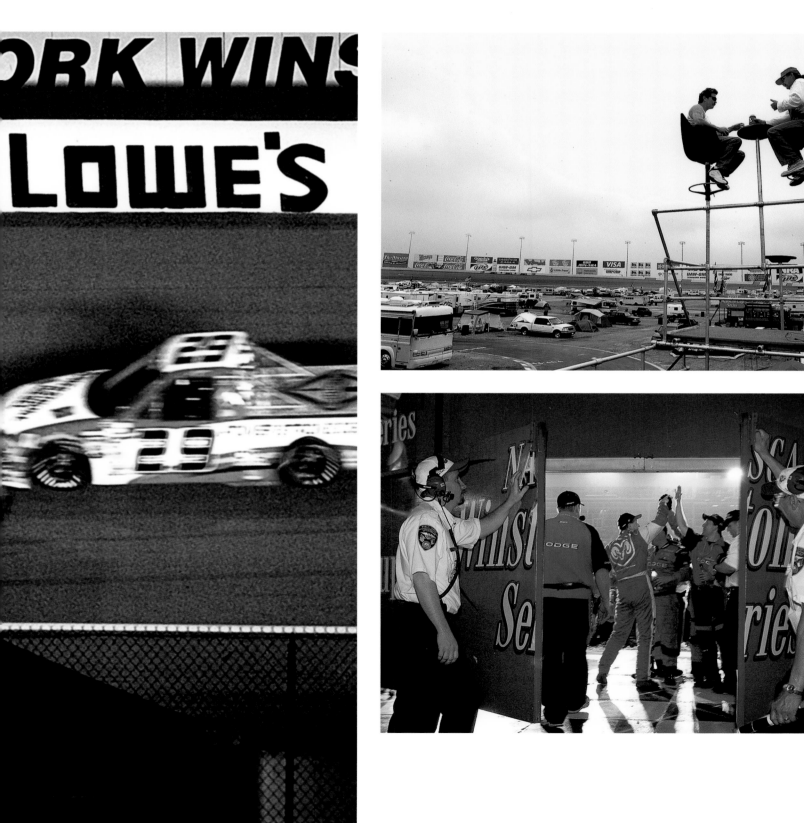

CONCORD, NORTH CAROLINA
Mark Delany and John Allen sit 23 feet up in the Lowe's Motor Speedway infield to watch Winston Cup qualifying races. Their perch is a makeshift scaffolding set on an old church bus. NASCAR claims 75 million of the most loyal sports fans in America.

CONCORD, NORTH CAROLINA
Security officers Bryan Stephens and Doug Allman close the gates as veteran NASCAR Winston Cup driver Bill Elliott and his team—part of the Coca-Cola racing family—celebrate after posting the fastest qualifying time of the day.

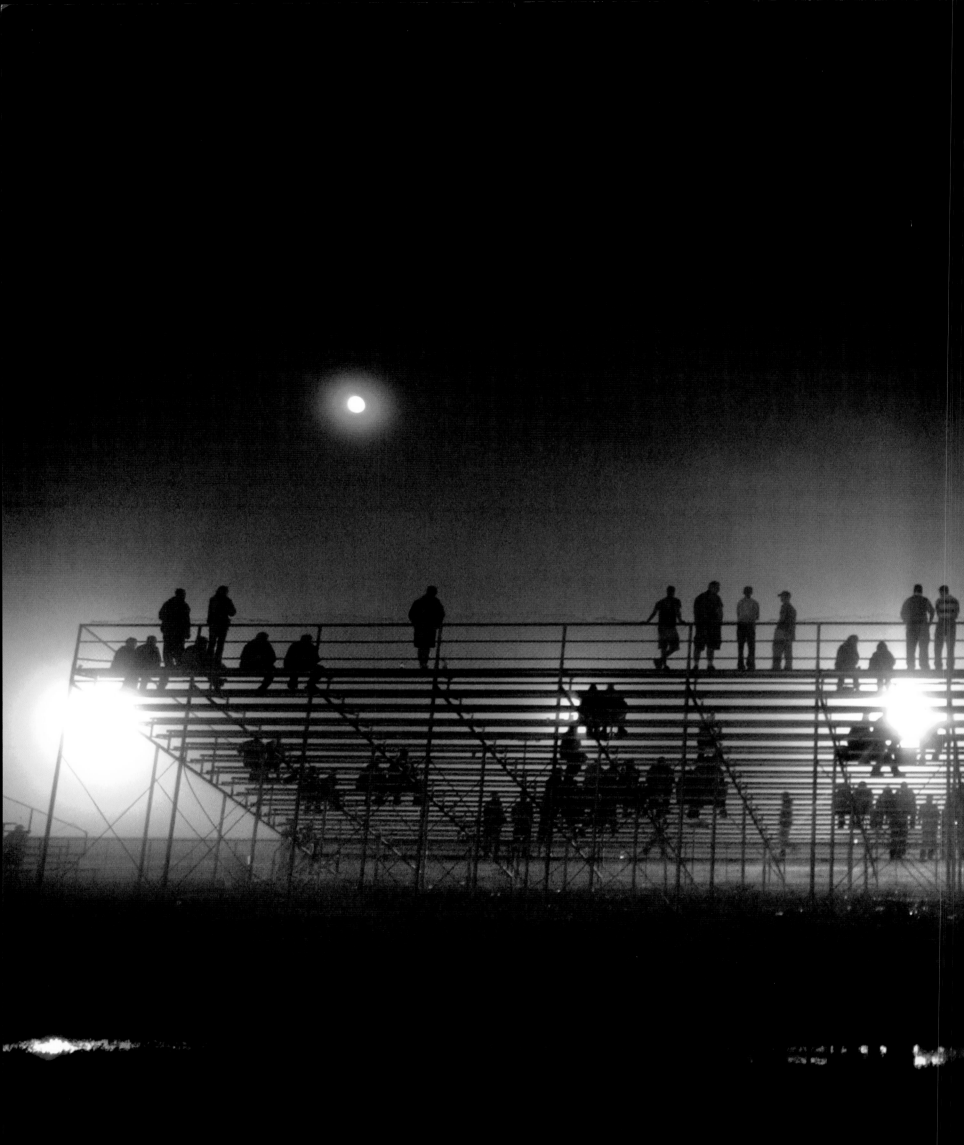

TULSA, OKLAHOMA
The wide-open Midnight Drag show at the
new Tulsa International Raceway has a little
of everything: unscored grudge matches
between bikes, trucks, and cars; the "Hour of
Power" when the scoreboard reports speed
and elapsed time; and "Badboy" races with
nitrous-powered and blower-motor cars that
can do the quarter-mile strip in under nine
seconds. The winnings? Maybe cash, maybe a
win light, and, always, bragging rights.
Photo by Paul Taggart

KAILUA, HAWAII

The bride and groom and their guests paddled seven outrigger canoes one mile to a sandy getaway beach on a little offshore islet. There, in the blazing morning sun, 38-year-old Robert Myint was wedded to Angelina Campos, 34. After the ceremony, the couple swam back to the mainland. Love is crazy!

Photo by Sergio Goes

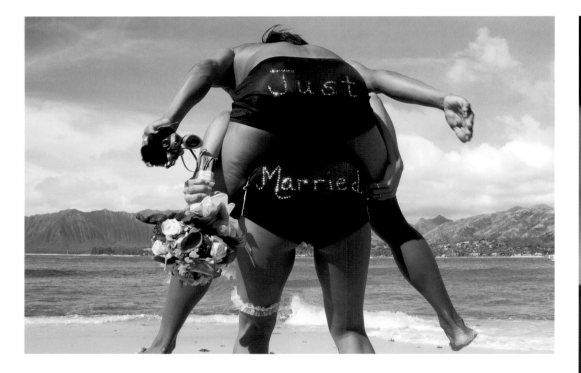

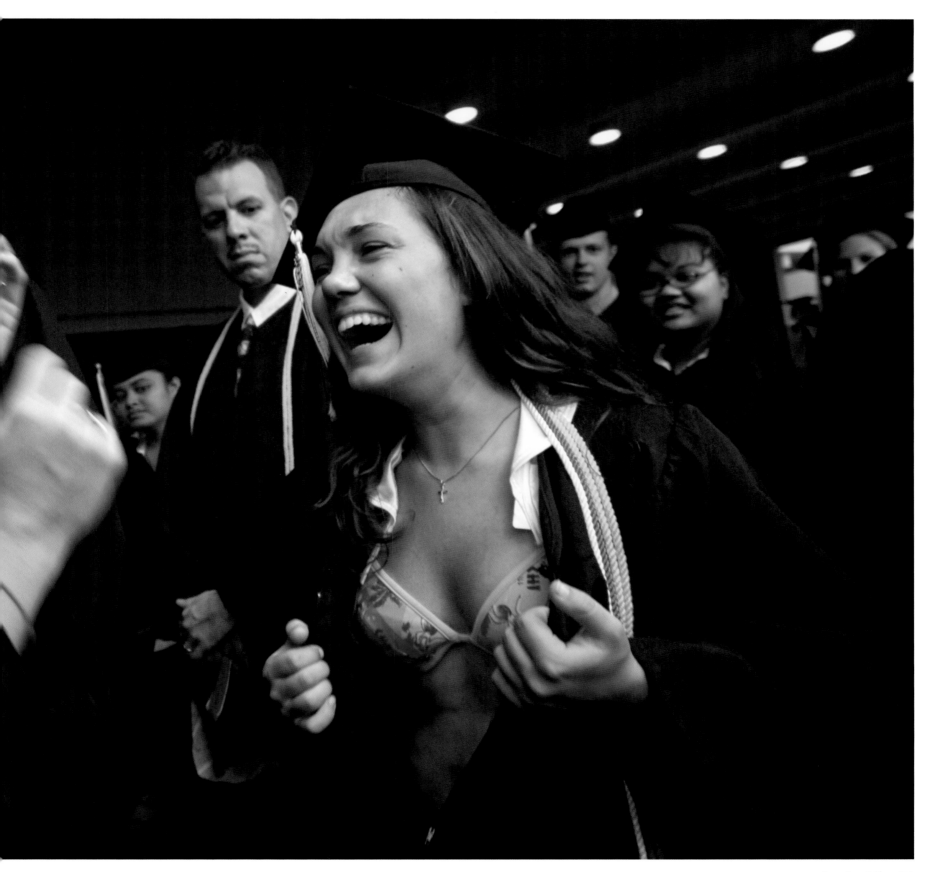

HONOLULU, HAWAII
Pomp and circumstance, Hawaiian-style: Kathryn Dolac makes good on a graduation-day dare, flashing her bikini top to friend Adrienne Uecker. A few moments later, the two women and 408 other seniors and postgraduates were awarded degrees from Chaminade University, a Marianist Catholic school founded in 1955.
Photo by George F. Lee

TALLAHASSEE, FLORIDA
Practice makes perfect: When a knee injury
sidelined him from after-work basketball games,
Mike Ewen decided to do something he'd always
wanted to do—learn to play the saxophone. He
bought a secondhand baritone sax, taught him-
self to play, and now he performs every Tuesday
evening with the Tallahassee Swing Band. Ewen's
son, Nathanael, four, matches him note for note
in a bathroom jam session.
Photo by Craig Litten

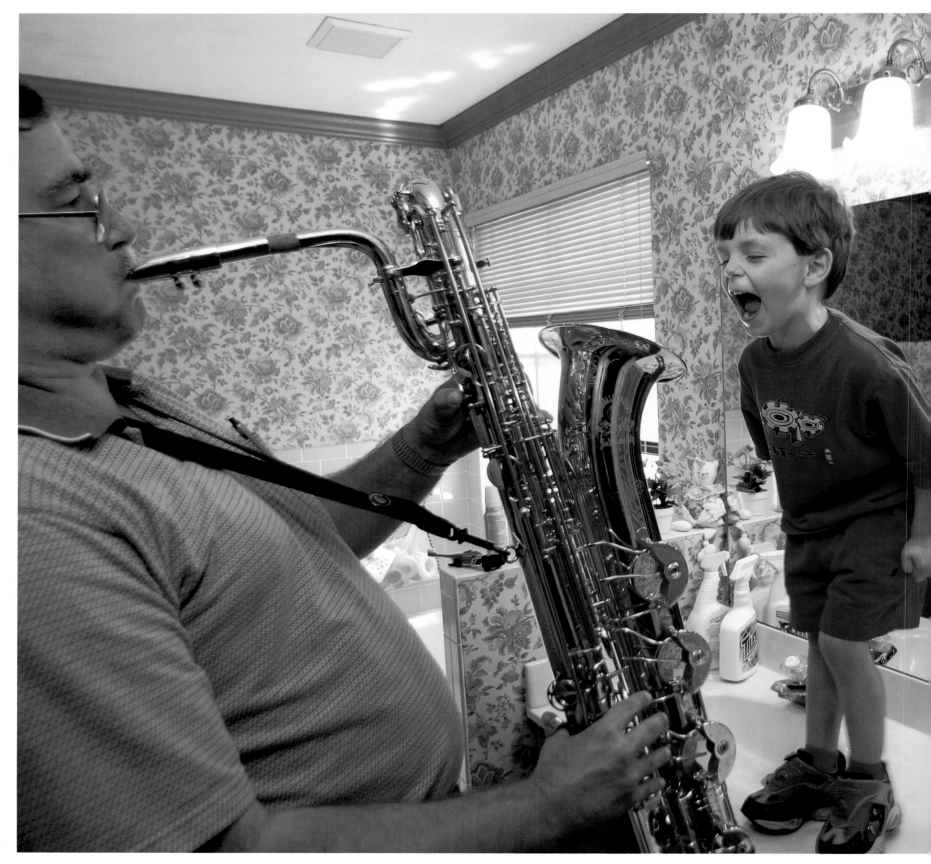

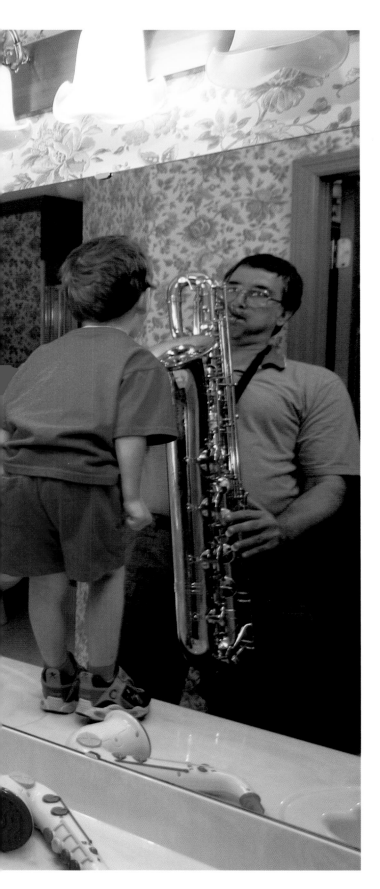

Squaring the knot: During the Baltimore Boychoir Festival at Goucher College, a Cleveland BoyChoir chaperone fine-tunes Marcus White's outfit. The choir's repertoire that night included "Sanctus" by Leonard Bernstein and an American-Indian travel song.
Photo by Kevin T. Gilbert, Blue Pixel

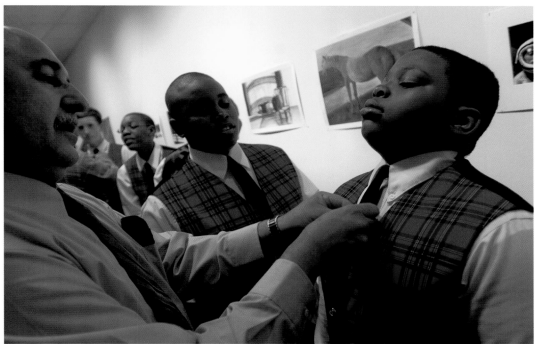

Fountain of youth: Botox injections are the fastest-growing procedure in the medical-cosmetic biz. Derived from botulinum toxins, Botox has been in use since 1973 to treat crossed eyes and facial tics, and is now in clinical trials for a broad range of conditions, including migraines. When doctors noticed that Botox temporarily softened frown lines between the eyebrows, it sparked a coast-to-coast half-billion-dollar vanity industry. Botox parties, where food and drinks are served while guests undergo treatment, are taking place across America—sort of the 2003 equivalent of Tupperware parties.

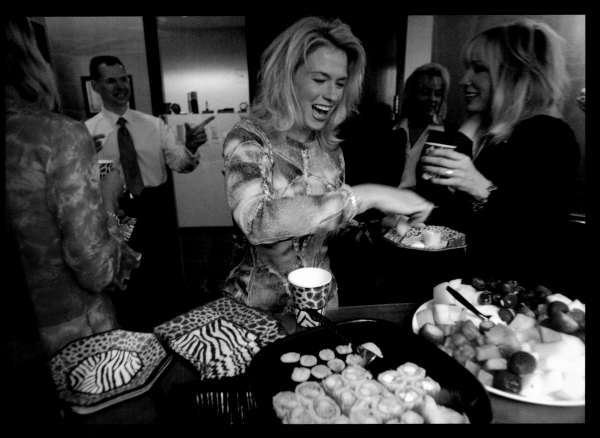

EDINA, MINNESOTA Invited to observe Botox treatments firsthand, women from the Minneapolis suburbs gather at Dr. Edward Szachowicz's Facial Plastic Surgery office. Botox injections now make up 40 percent of his business. *Photos by Carlos Gonzalez*

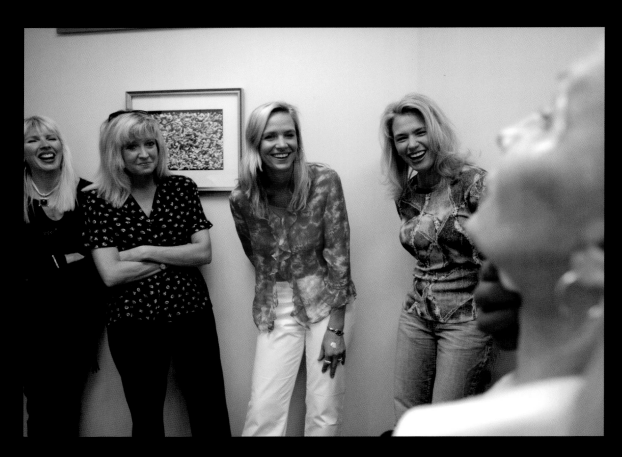

EDINA, MINNESOTA Donna Bakkum, Ann Marie Holland, Kimberly Anne Holland, and Amy Bonjean (L–R) watch Dr. Szachowicz inject Botox into Sharon's face. Donna signed up.

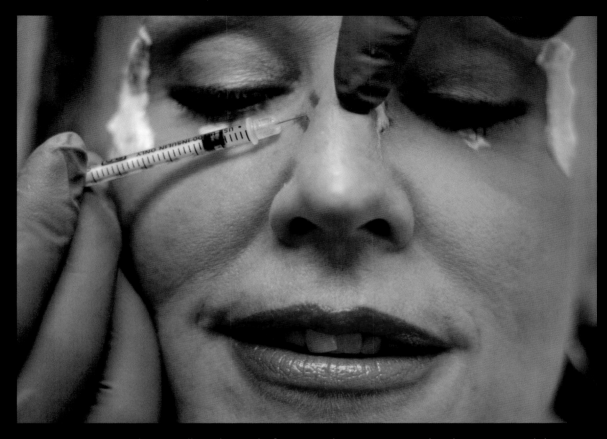

EDINA, MINNESOTA Sharon Miller, who works for Dr. Szachowicz, is injected with Botox around the nose and eyes to reduce laugh and squint lines. Less pain and no post-op recovery time make Botox an attractive alternative to face-lifts for many American women.

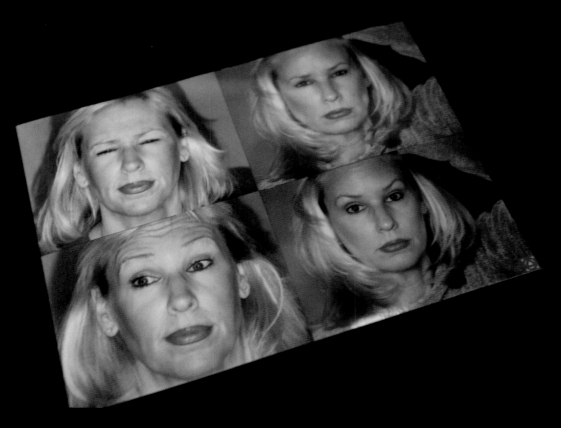

EDINA, MINNESOTA Before and after: The procedure is considered safe, but there have been a few reports of adverse side effects, including a high-profile Hollywood malpractice suit.

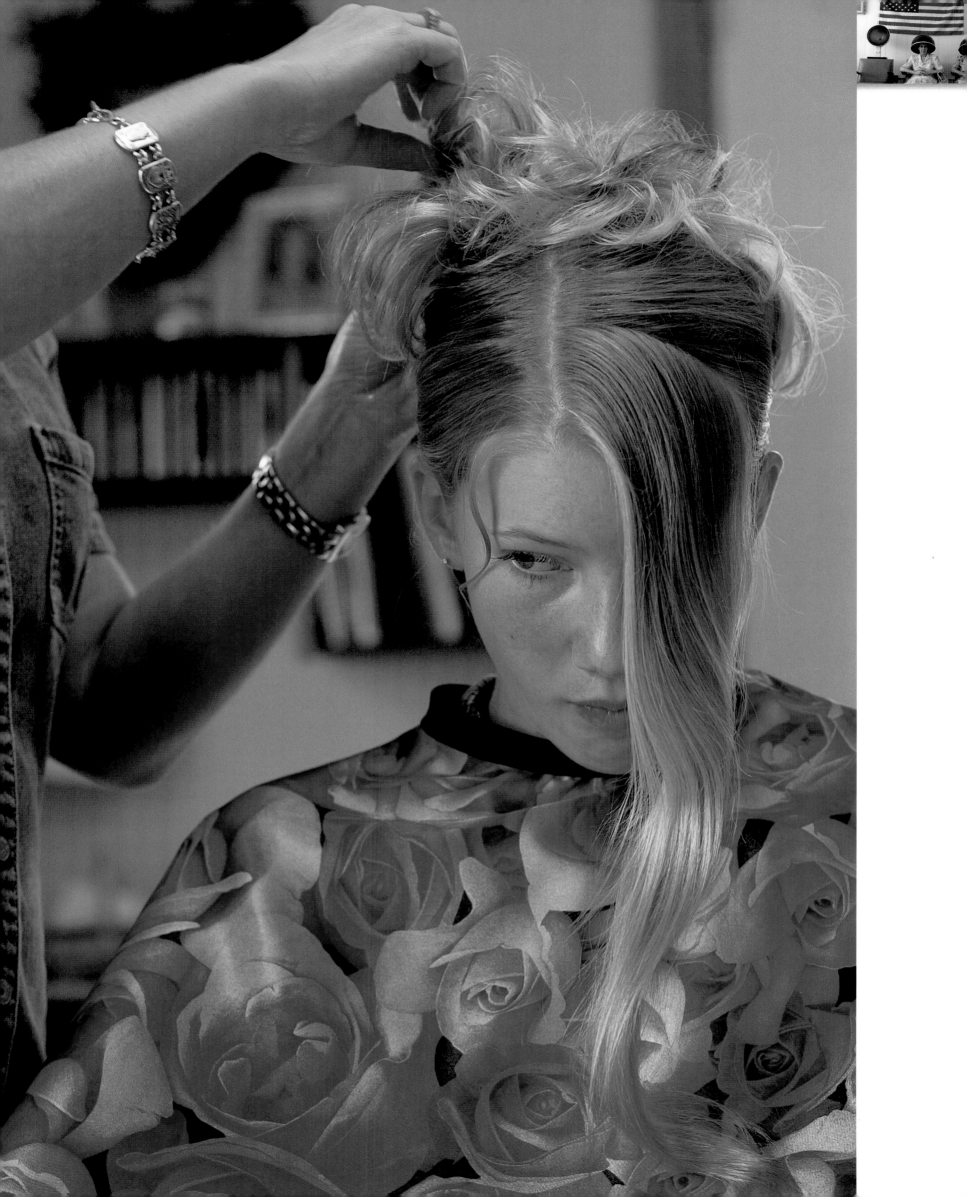

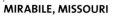

MIRABILE, MISSOURI

Graduating from the eighth grade and getting an "up-do" are both important milestones in a girl's life. Danielle Leeper was one of just four graduates of Mirabile Elementary School—and the only girl. With 28 students enrolled in K–8, Mirabile is the smallest public school district in the state of Missouri.

Photo by Robert Cohen, St. Louis Post-Dispatch

NEW YORK, NEW YORK

At the Toto Beauty Salon on Hester Street in New York's Chinatown, you can get a dozen different varieties of facial, including a crystal peel treatment, neck and double-chin special treatment, oxygen plasma potion treatment, and crystal goat living-cell treatment (don't ask). Facials account for half of the $10.7 billion annual spa business nationwide.

Photo by Kristen Ashburn, Contact Press Images

BALTIMORE, MARYLAND

Women will do almost anything to look good, including dyeing, teasing, and spraying their hair into submission. Evelyn Bartkowiak goes to Phyllis' Hair Design on Conklin Street in Baltimore every other week for "the masterpiece," as she calls it, and she isn't alone. The salon is packed from 6 A.M. to 6 P.M. six days a week.

Photo by Jim Burger

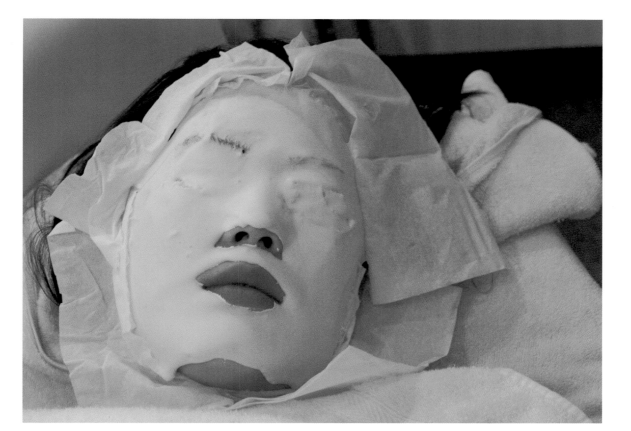

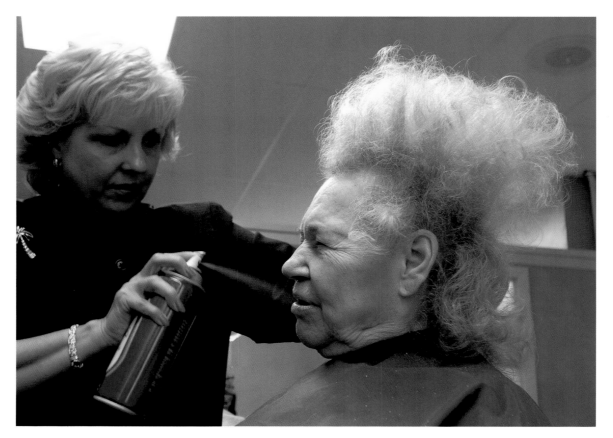

Ten years ago, a Pennsbury High School student hitched a helicopter ride to the prom. Arriving in style has become a tradition for Pennsbury kids ever since. Among the more famous modes of arrival during prom night in Fairless Hill (pop. 9,026): a cement mixer, a forklift, and a dragster race car. Heather Raudenbush and friends prove that bigger isn't always better.
Photos by E.A. Kennedy 3rd, Image Works

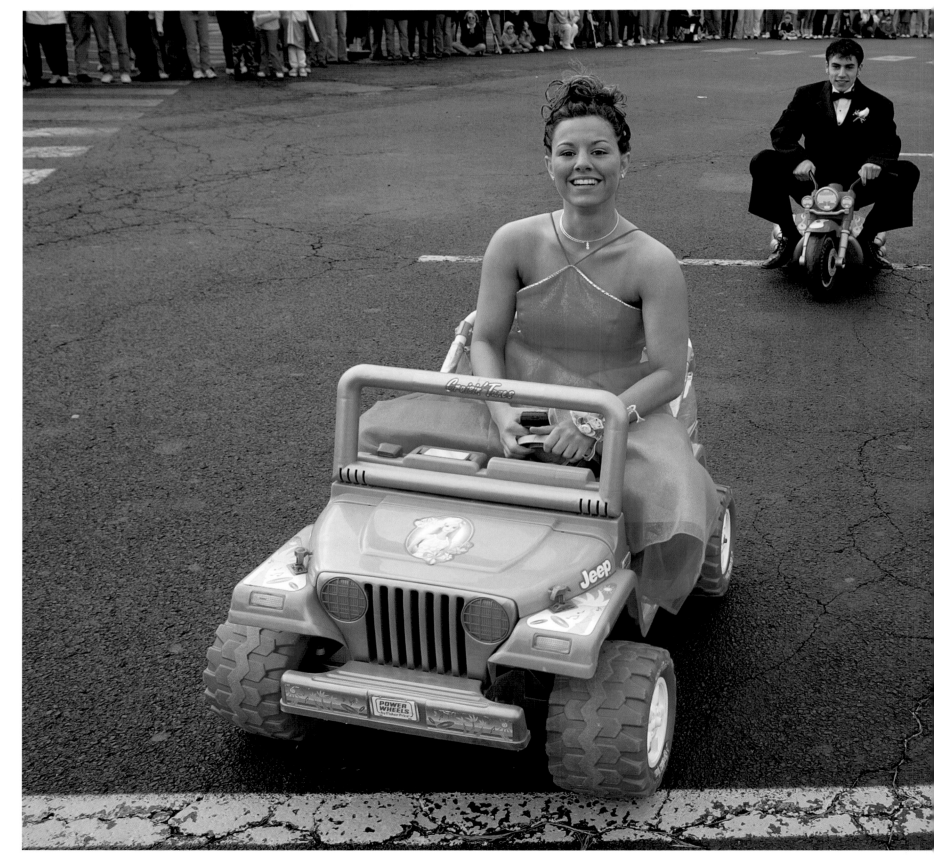

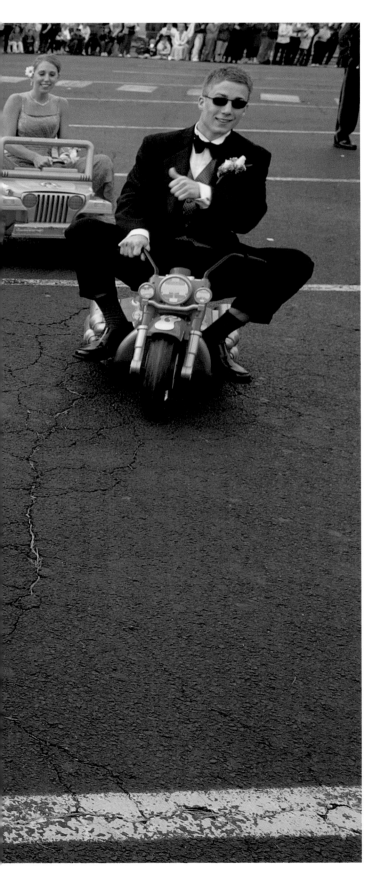

FAIRLESS HILL, PENNSYLVANIA
Special delivery: Angie Perini and Ashley Rochanchou step down to join dates Joe Tobias and Doug Sarver, amidst a throng of amused onlookers. The boys didn't have to sign for the packages.

FAIRLESS HILL, PENNSYLVANIA
Land of the lost: Shannon Horn and Ryan White ride retro, astride a motorized stegosaur.

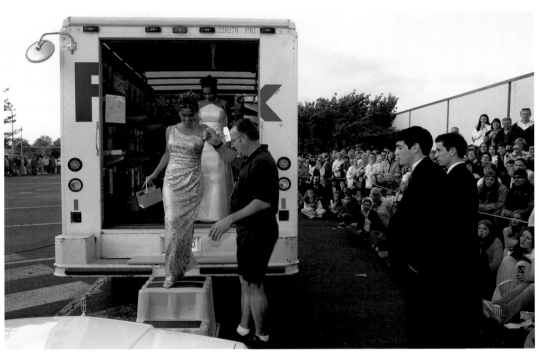

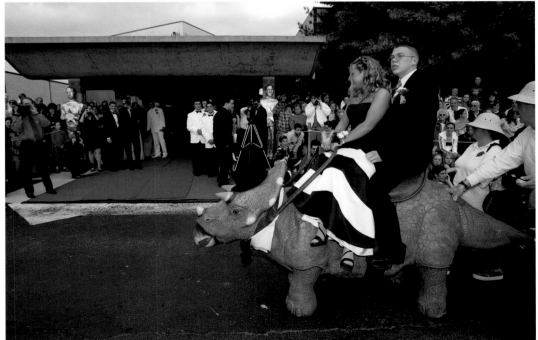

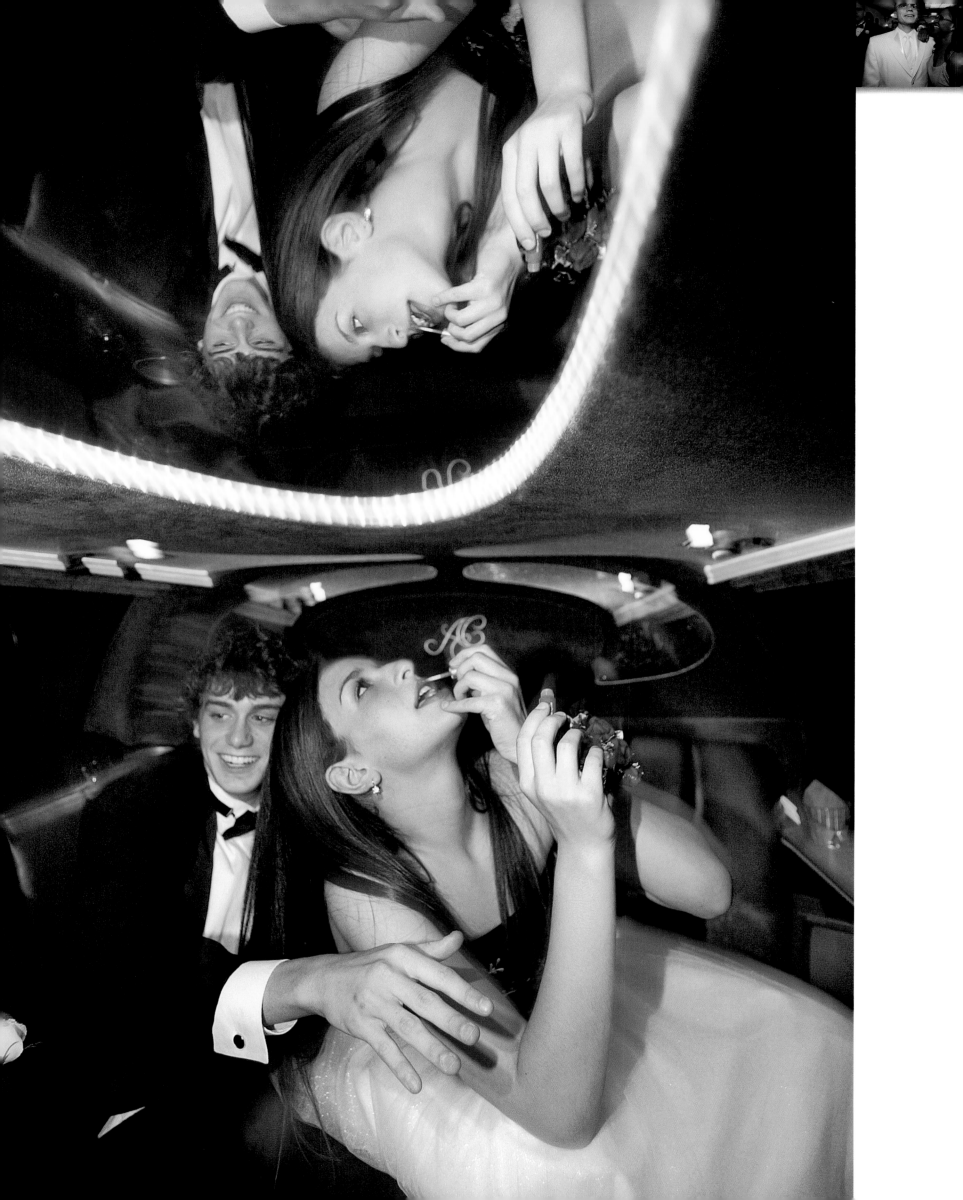

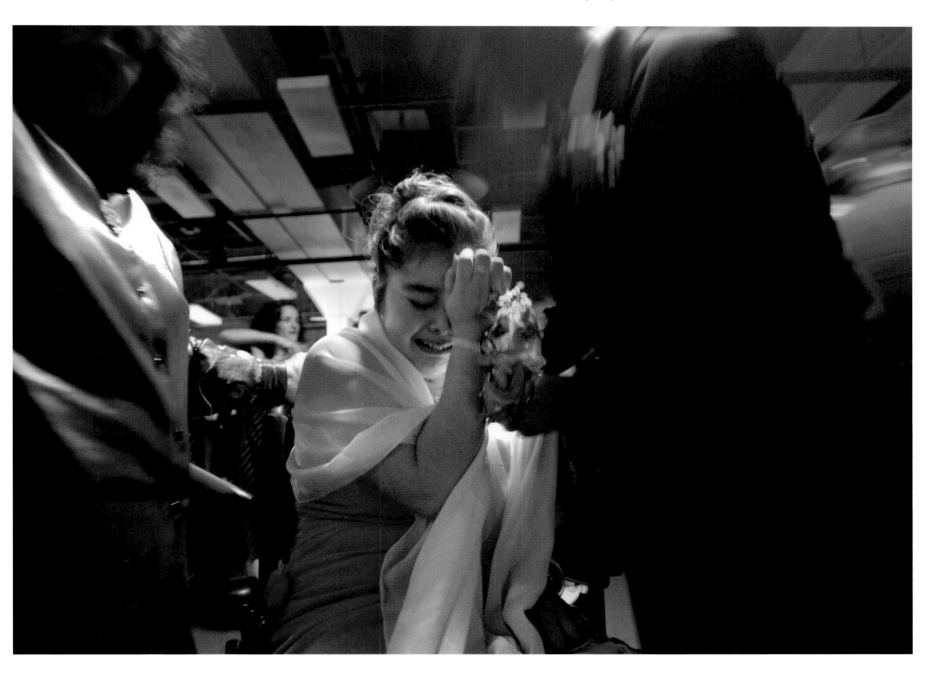

LITTLE ROCK, ARKANSAS

Mirror, mirror on the ceiling: The threat of tornadoes canceled Dina Epstein and Stephen Schroeder's dinner plans, but nothing could keep them from traveling in style to the main event—the Little Rock Central High School Prom.

Photo by Benjamin Krain

LONG BEACH, CALIFORNIA

Tears of joy: Angelina Lopez, 17, may not look happy, but in fact she was overwhelmed by the kindness of others. Hospitalized numerous times while battling multiple sclerosis, Angie dreamed of attending her prom. Carol Walker and Dr. Warren Chin, members of her medical team, suprised her with a new dress, makeover, and limousine, and accompanied Angie to her prom at Lakewood High School.

Photo by Stephen Carr

LITTLE ROCK, ARKANSAS

In an age-old ritual, prom-bound seniors from Little Rock Central High School surreptitiously fill water bottles with liquor in a friend's bathroom. Tornado warnings nixed their dinner plans and kept the girls stuck in the house until 9 P.M., when a limo finally ferried them to the prom.

Photo by Benjamin Krain

DUBUQUE, IOWA

Are we having fun yet? Seniors Ryan Cosgrove and Erin Heim shout it out at the Wahlert High School Prom. "Just friends," Ryan and Erin partied down with their classmates on the Loras College Alumni Campus Center dance floor.

Photo by Clint Austin

WOOD-RIDGE, NEW JERSEY

Something to talk about: Hudson Catholic senior Patrick Sidhom cools down while his hot date, Sophia Rodriguez, checks in. The high school held its 2003 prom "Heaven" at the Fiesta Banquet Rooms, overseen—in oil at least—by their late founder, Rose Landry.

Photo by Aristide Economopoulos,
The Star-Ledger

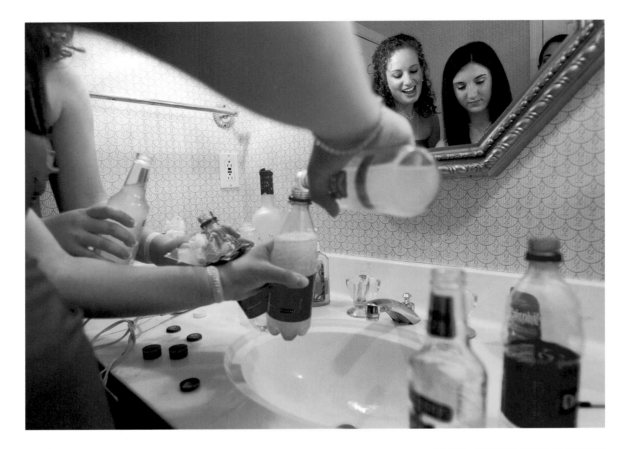

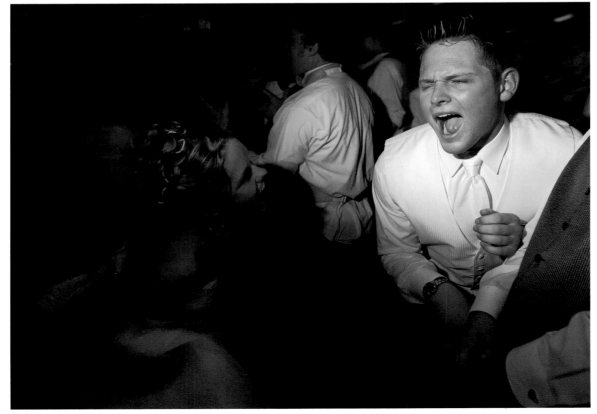

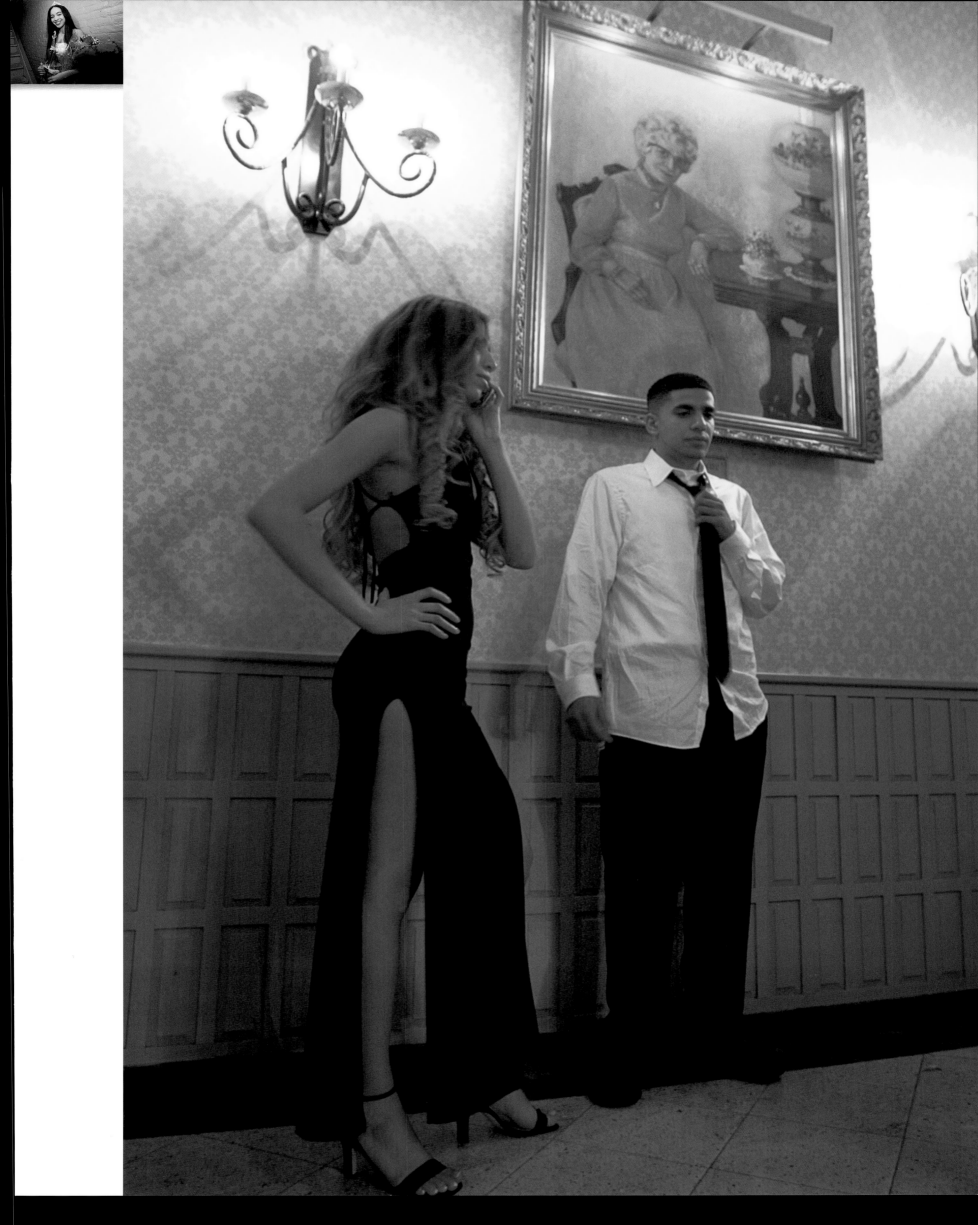

PITTSBURGH, PENNSYLVANIA
At Pittsburgh's Andy Warhol Museum, an enchanted evening winds down for exhausted prom couple Tabatha Recker and Harry Caskey (left), seniors at Pittsburgh's Creative and Performing Arts High School.
Photo by Annie O'Neill

DENVER, COLORADO
Open all night: According to a sign outside, it's "Denver's most exciting landmark." Smiley's Laundromat on Colfax Avenue also claims to be the largest Laundromat in America, with 190 washers and 190 dryers, three coin changers, five detergent dispensers, four video machines, two snack machines, and three pay phones. Here, night attendant Sammy Mojica polishes the floor.
Photo by Trevor Brown, Jr.,
Rich Clarkson & Associates

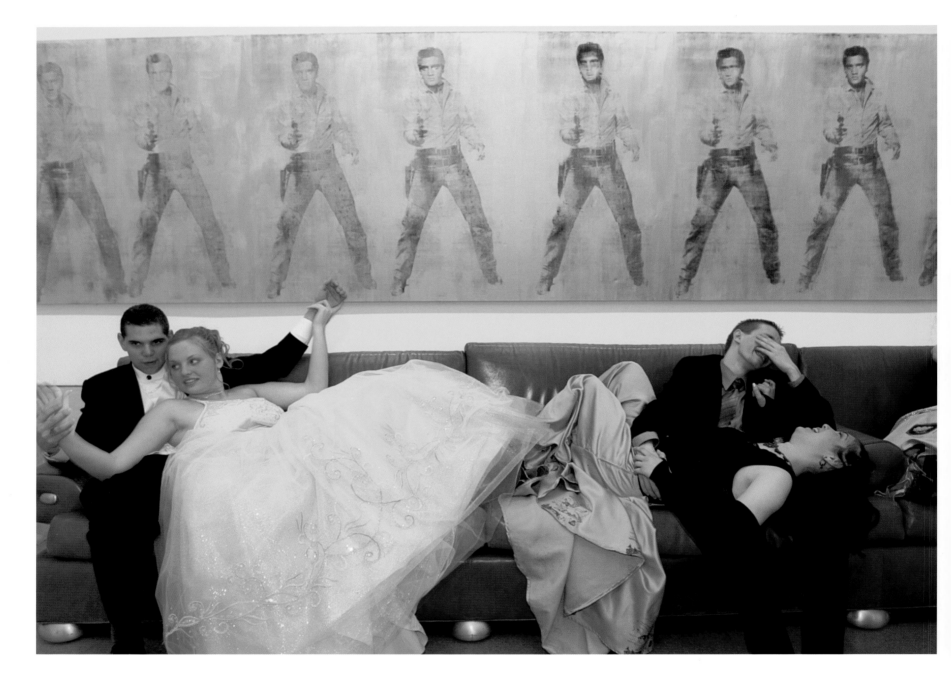

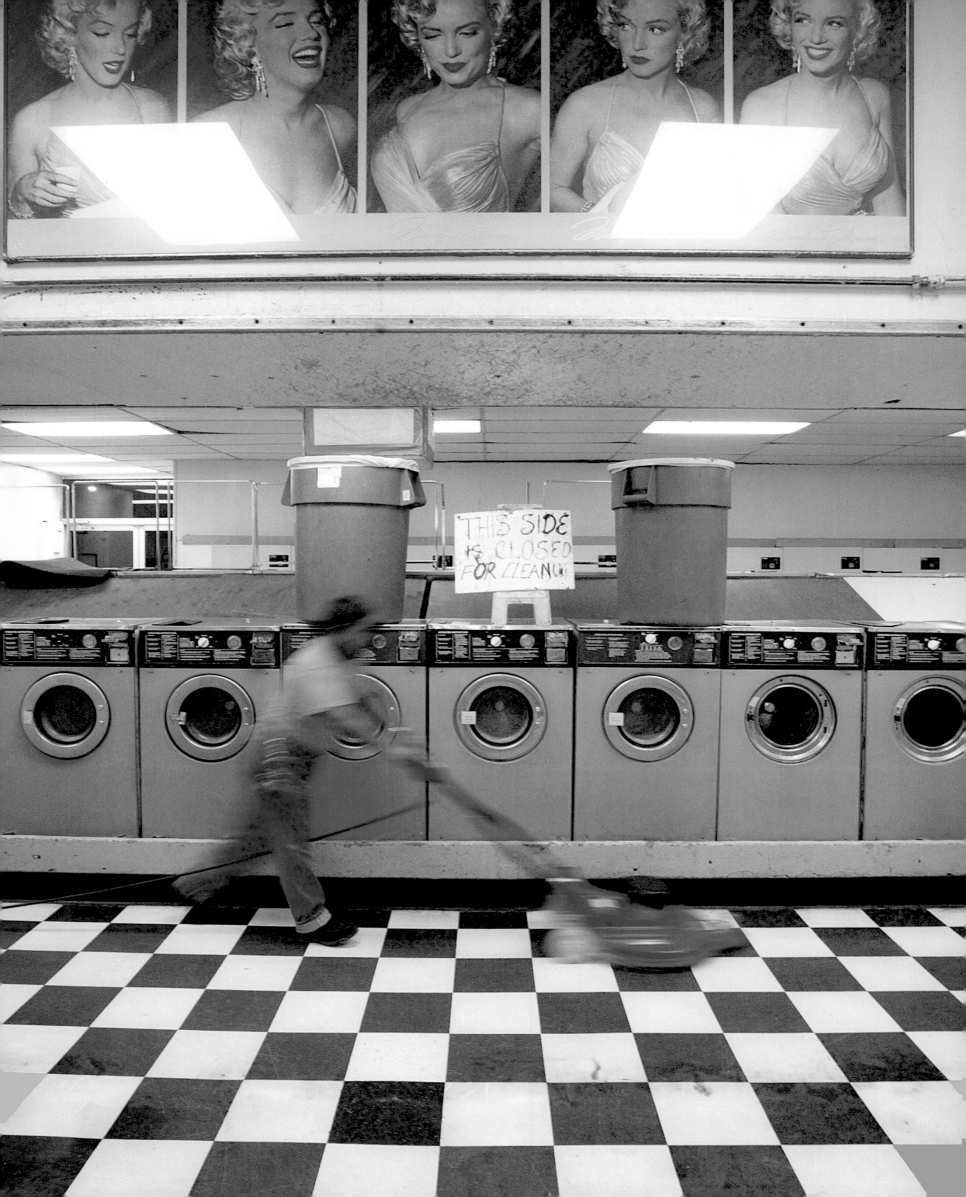

PITTSBURGH, PENNSYLVANIA
Tradition and baseball go together hand in glove
at the Pirates' PNC Park, which opened in 2001. Its
design pays homage to classic ballyards such as
Wrigley and Fenway, and Pittsburgh's own Forbes
Field (1909 – 1970). At any big-league stadium in
America, kids (and their parents) can still enjoy
cotton candy, a sticky tradition started in the
early 1900s.
Photo by Scott Goldsmith

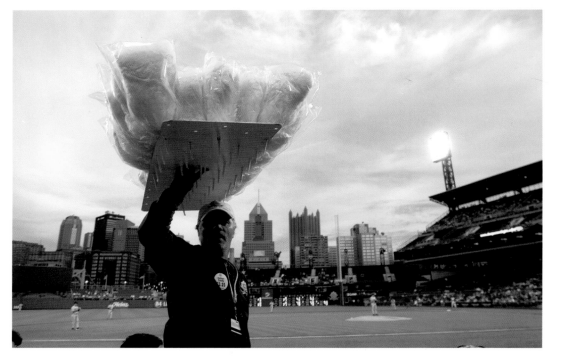

ST. PAUL, MINNESOTA
Out in left field: Midway Stadium holds 6,329
fans, but the best seats in the house may be in
the left field hot tub. Fans of the Northern League
Saint Paul Saints (team motto: "Fun is Good") can
also root, root, root for the home team from the
outfield Fishing Hut or the paddleboat
SS *Porkchop*.
Photo by Richard Marshall

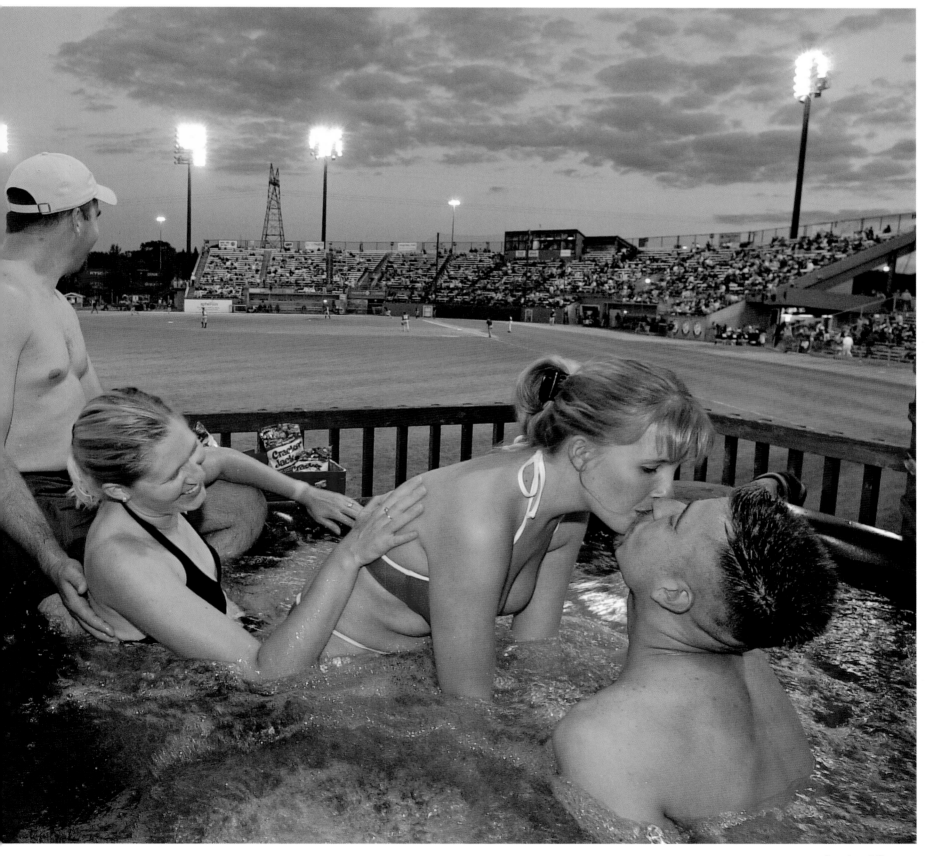

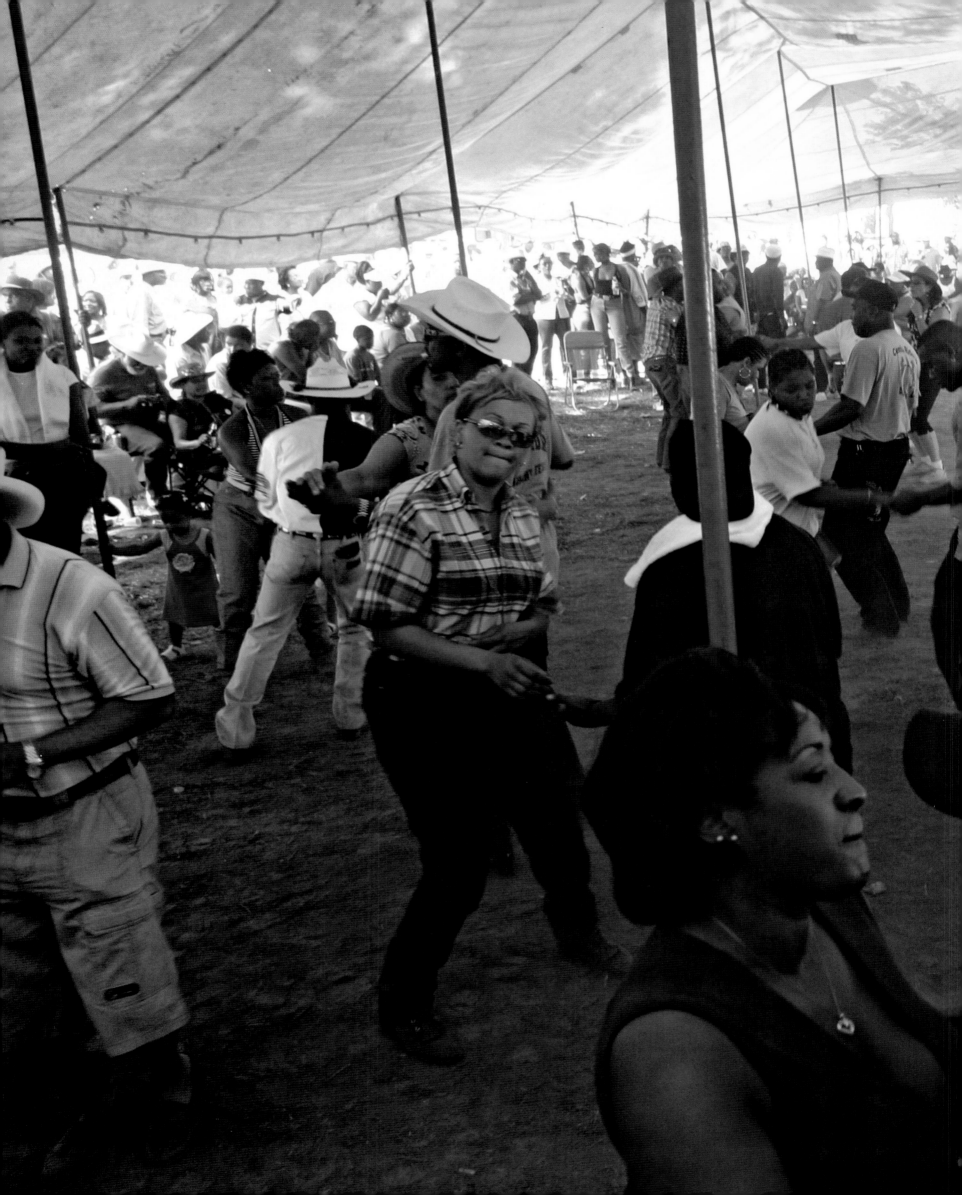

GRAND MARAIS, LOUISIANA
After two long, hot days riding horseback through Creole country, Zydeco Trail Riders let loose on the dance floor. Named for the distinctive music style of the region, the weekend Zydeco Trail Ride is very popular with southern Louisiana's African-American community—attracting more than 1,000 participants every May.
Photo by Philip Gould

EUGENE, OREGON
"Delta Gamma, yes I amma!" At a nightclub near the University of Oregon campus, Delta Gamma sorority sisters Emily Perkins, Pamela Hobson, Megan Dobson, Lindsay Wood, and Jen Guptil sing along to the Olivia Newton-John and John Travolta duet "Summer Nights" from the musical *Grease*. The movie was released in 1978, five years before these women were born.
Photo by Sol Neelman, The Oregonian

OWATONNA, MINNESOTA

Teenage couch potatoes Jessica Schwartz, Shalaine Thomson, John Klotz, and Matt Berghoff stopped for fries after the police pulled them over, declaring the sofas in the back of their pickup unsafe. The gang drove from Waterville to cruise Owatonna's Cedar Avenue strip but ended up spending the evening in a McDonald's parking lot instead.

Photo by Renée Jones, Owatonna People's Press

ST. CLAIR SPRINGS, ALABAMA

White's Mountain Bluegrass Park keeps traditional bluegrass music and buck dancing alive and kicking in the hills of northeast Alabama. Tommy and Sybil White host two festivals yearly on their 40-acre property. Replete with foot-stomping music, old-fashioned dancing, and homemade victuals, the White's down-home extravaganzas draw more than 1,200 folks from all over the country.

Photo by Joe Songer, The Birmingham News

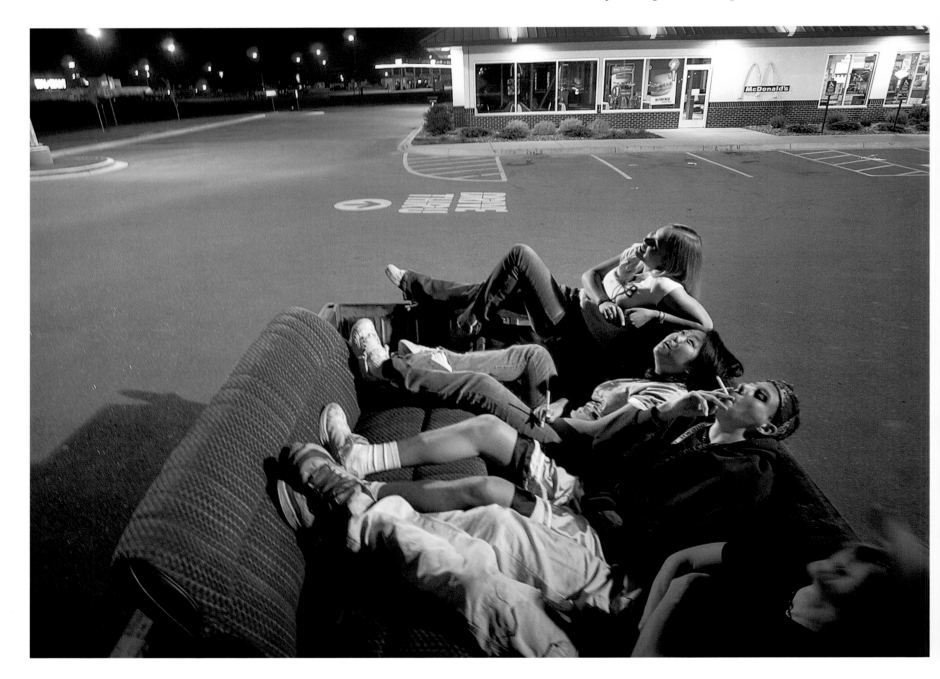

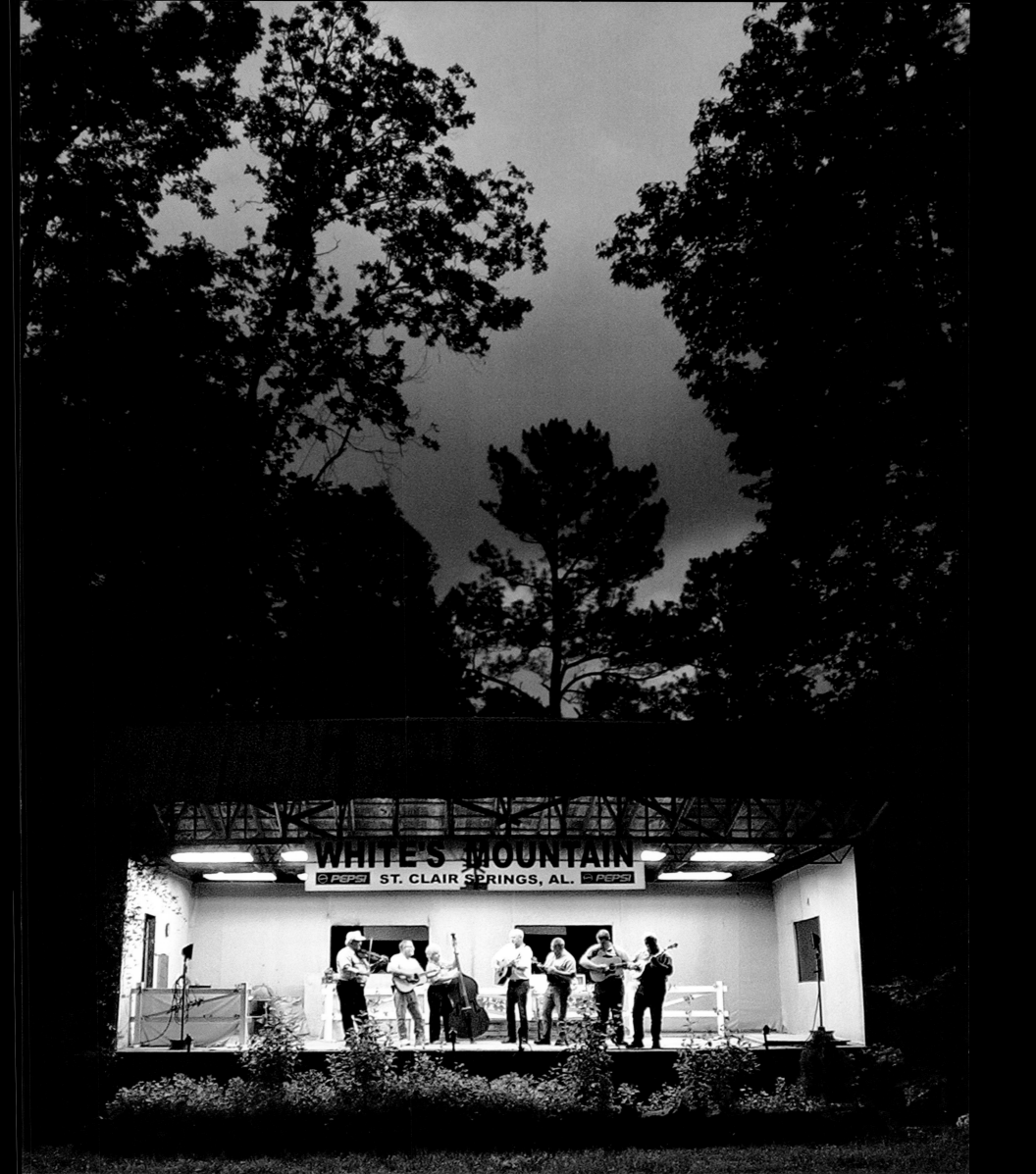

MARYSVILLE, KANSAS

In the wake of a passing thunderstorm, the 24-hour Penny's Diner on US 36 promises refuge. Inside, waitress Sharon Marx gets ready to go home while cook/waiter James Curtis hunkers down 'til 11 P.M. US 36, running east-to-west across northern Kansas, roughly traces the route of the short-lived, if fabled, Pony Express.

Photo by Mike Yoder,
The Lawrence Journal-World

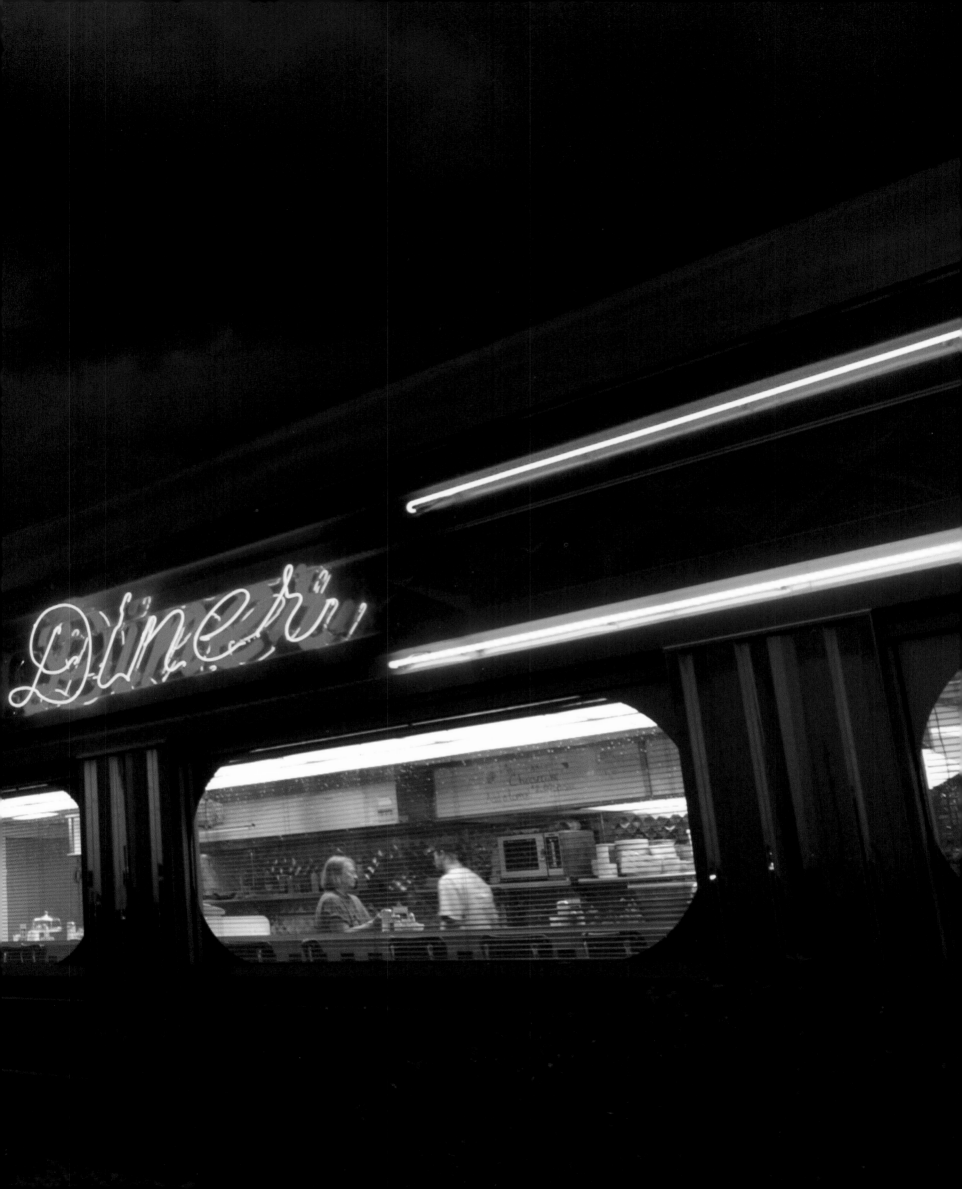

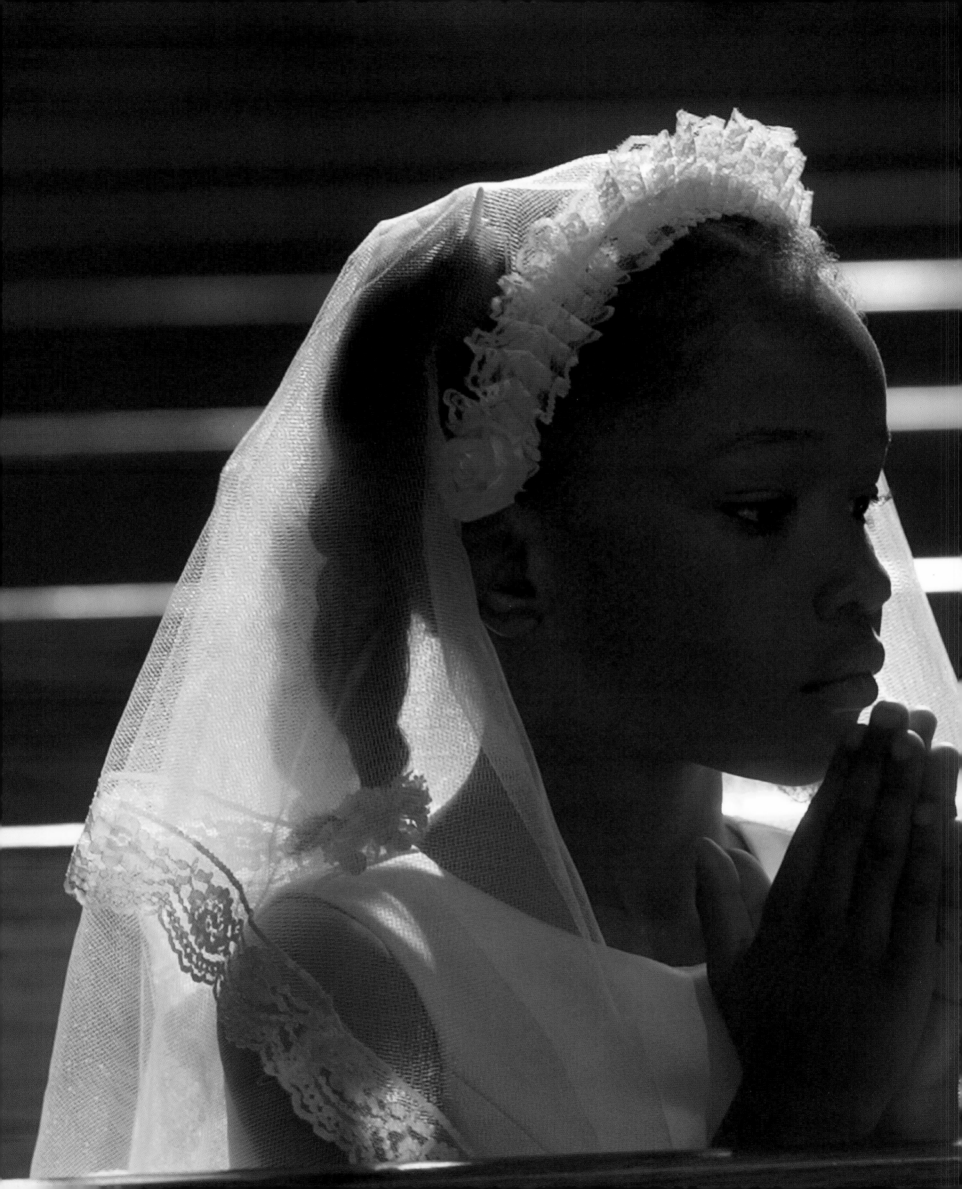

Reason to Believe

A
merica is the most religious country in the industrialized world, and the most shook-up about it. Ever since Jefferson and Madison separated church from state, it freed Americans to be as religious as they wanted. And we wanted.

We have old-line churches and store front churches. We have liberal and conservative Catholicism, at least three levels of Judaism, and countless Protestant variations. We have Muslims, Buddhists, Shintos, and Native American religions. We have cults, sects, people who set themselves up as gods. We pledge allegiance under God. In God we trust. We go to court, so help us God. We go to war with God on our side. When a President becomes a President, God is at hand.

With all that, the national nerves get jangled every time religion is spoken of publicly. Everybody seems to be doing that these days. Some of the reasons are obvious. The rise of evangelical churches with the absence of mediation between God and the individual has made it more inviting for people to declare their

MEMPHIS, TENNESSEE Angelic Lisa Betserai honors Our Lady of Africa during a May Crowning at St. Augustine Catholic Church, where the priest encourages children to focus on the peace and awareness of their own culture.
Photo by Karen Pulfer Focht

WORCESTER, MASSACHUSETTS If Boy Scouts of
America founder W. D. Boyce were alive today,
he might be interested to learn that Troop 77 in
Worcester, Massachusetts, is made up almost
entirely of Hispanic and Vietnamese boys.
Photo by Sean Dougherty

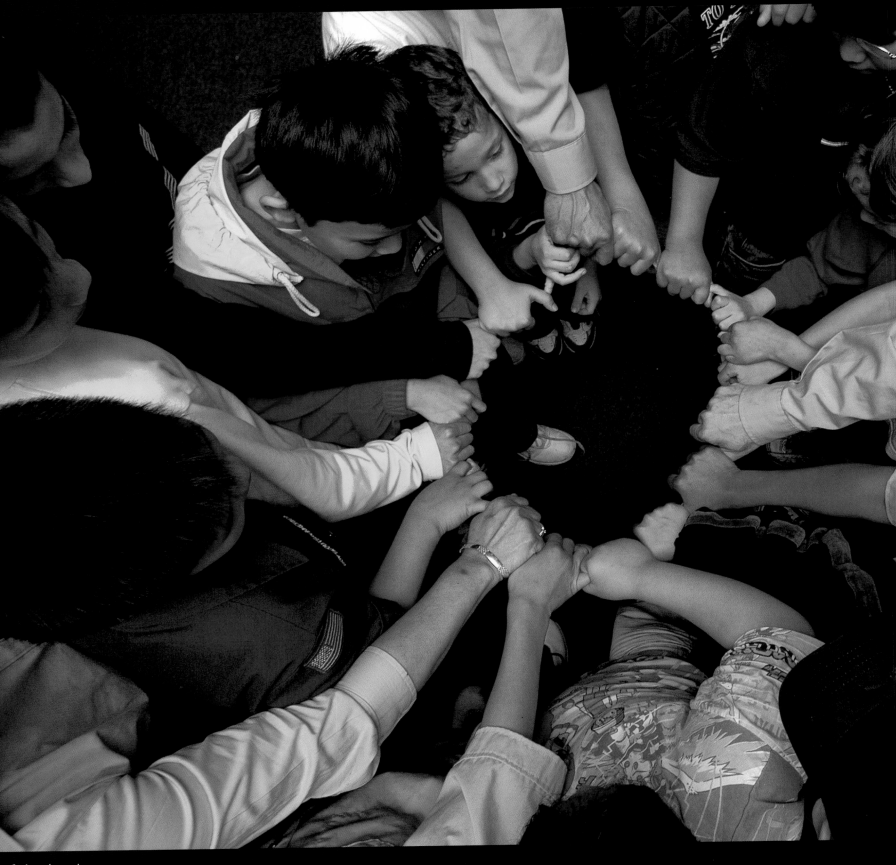

faith. During the 2000 campaign, candidate George W. Bush claimed Jesus as his favorite philosopher. His opponent, Al Gore, spoke of finding his personal savior. And America's first Jewish Vice Presidential candidate, Senator Joseph Lieberman, publicly quoted the Old Testament. At John Ashcroft's confirmation hearings, the prospective Attorney General's conservative Christian beliefs came up repeatedly...and the country bristled.

Forty or fifty years ago, Presidents invoked God as national guide and protector, but that's about as far as it went. Then President Jimmy Carter told us about being born again, and suddenly lots of people decided to do the same. On TV, in megachurches with basketball arena seating, vast choirs sang religion loud and clear. And Christian television and radio networks sprang up and filled the air.

Then, too, there was the end of the Cold War, which many Americans saw as the victory of God over the godless. And there was the emergence of new medical ethics issues, such as abortion and fetal tissue research, cloning and assisted suicide, that impinge on religion. In recent years, we've also seen the emergence of a cultural atmosphere in which people are taking the spirit world as fact. On Broadway, there was *Angels in America*. On television, *Touched by an Angel*. In movies, *The Sixth Sense*, where it was announced matter-of-factly, "I see dead people."

All this adds to our consistent turmoil about religion, which at different times in American history has taken distinctly different emotional turns. Sometimes we're fearful and doubtful about religion, thus *The Scarlet Letter*, thus the figure of the sinful clergyman (buttressed, of course, by the recent sex scandals in the Catholic Church). Sometimes we apologize for people of the cloth and so create the figure of the battling

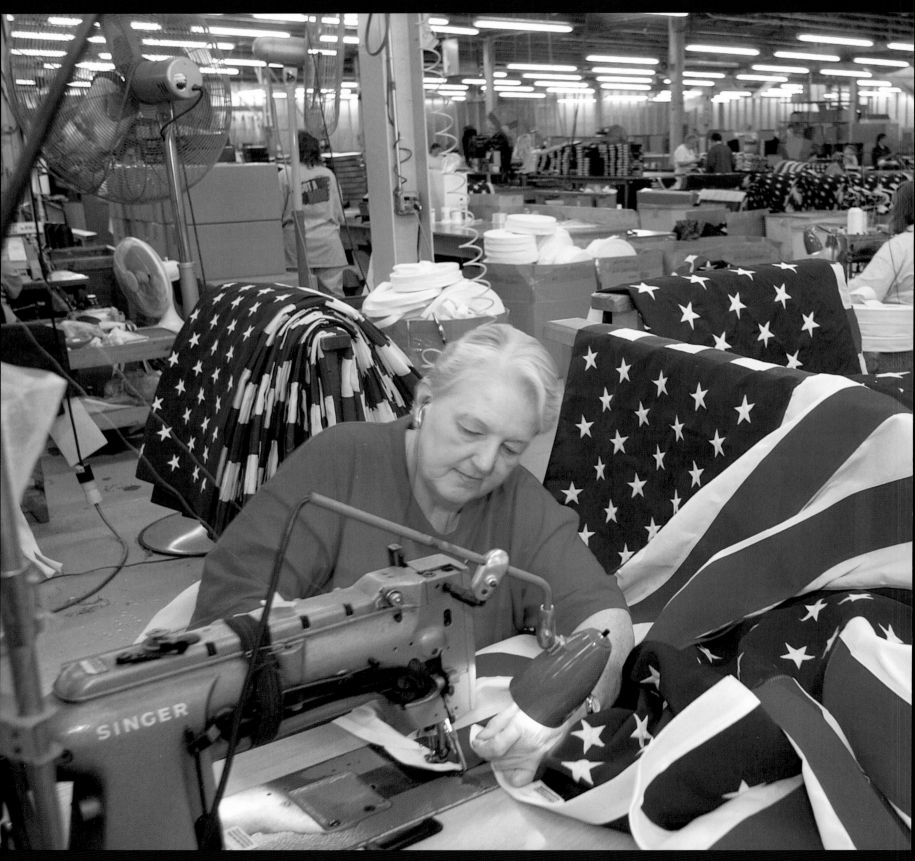

America: For the past seven years, Rosalie Best has sewn 750 flags weekly for the Valley Forge Flag Company. But it wasn't until the September 11, 2001, terrorist attacks that she appreciated the importance of her job. Americans bought 100 million flags nationwide in the 12 months after the attack—a 100 percent increase from the year before.
Photo by Michael Bryant, Bryant Photo

priest, or the priest or nun or rabbi who plays detective. Sometimes we make fun of religion. Remember the great satirical songwriter Tom Lehrer, who sang about brotherhood week—

> "Oh the Protestants hate the Catholics and the Catholics
> hate the Protestants and the Hindus hate the Muslims
> and everybody hates the Jews..."

Sometimes we embrace religion with the deepest devotion, sometimes we regard it with the deepest suspicion. Usually, we regard religion with a little of both.

We've always gone this way, because America is sort of a religion itself. So we are always operating in a semi-mystical state of mind that includes belief and disbelief in ourselves, thoughts of heaven and hell, salvation and redemption, and the prayer of starting over again cleansed, baptized, reborn. America derives from one or another house of bondage. The hopes people have in the country have to do with their souls. No wonder those old boys separated church and state on a technicality. They may have sensed that the country did not need an established faith. America itself was already an established faith, full of all the beauty and trouble and ecstasy and doubt religion provides, and always ready to throw a fit when anyone brings up the subject.

By Roger Rosenblatt

ROGER ROSENBLATT'S *essays for* Time *magazine and The NewsHour with Jim Lehrer have won two George Polk Awards, a Peabody Award, and an Emmy Award. He is the author of 10 books, including* Children of War *which won the Robert F. Kennedy Book Prize, the national bestseller* Rules for Aging *and his most recent,* Anything Can Happen.

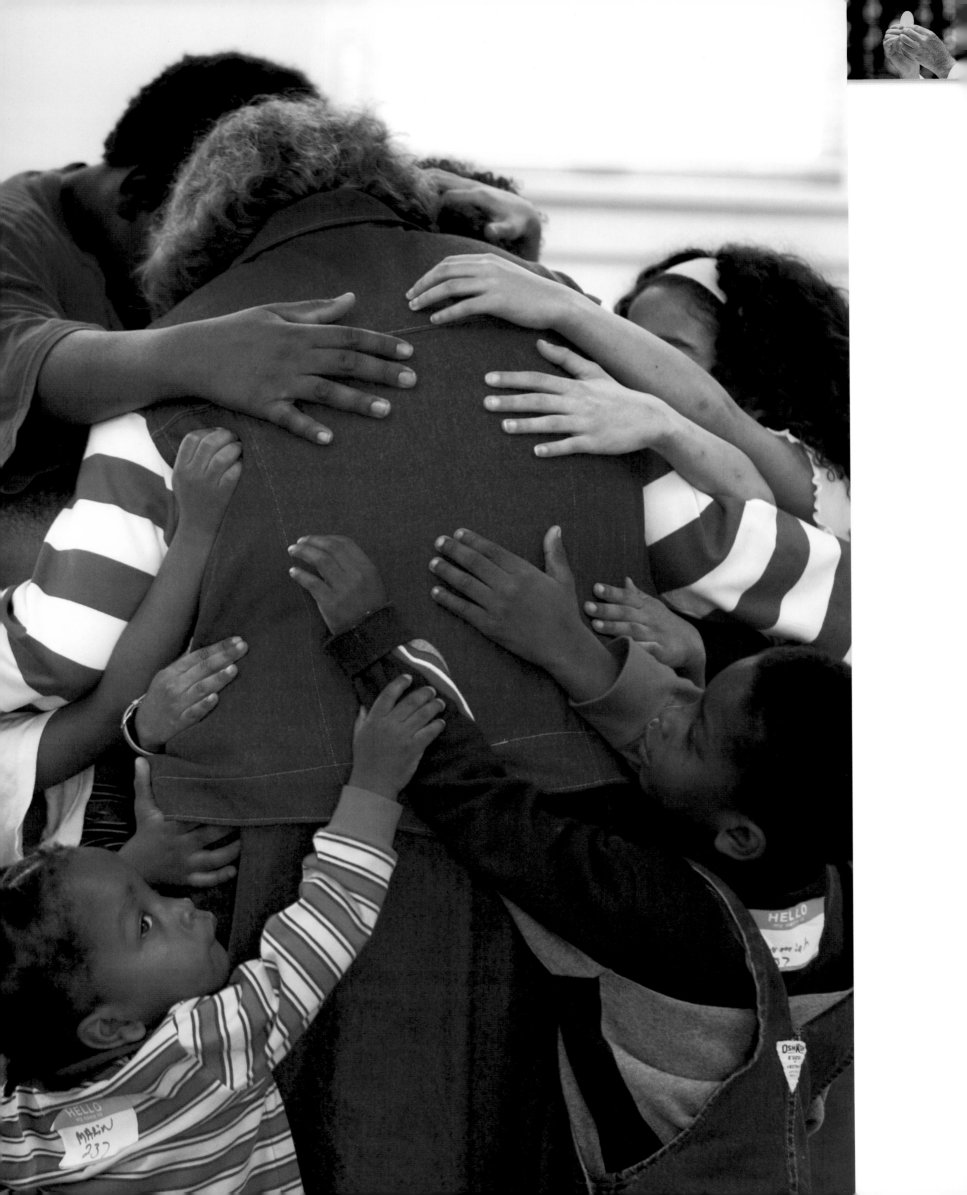

BROOKLYN CENTER, MINNESOTA

Helping hand: Mary Jo Copeland started the nonprofit Sharing and Caring Hands in 1985 with just $2,000 and no public funds. Sharing and Caring Hands runs a daycare center; medical and dental clinics; homeless shelters; clothing and food banks; and employment, legal aid, and tutoring services. "Anything we can do for people, we do," says Minnesota's own Mother Theresa.
Photo by Stormi Greener

SAN FRANCISCO, CALIFORNIA

Hallelujah! Tracy Noriega feels the rapture during Sunday services at Glide Memorial Church. Renowned for its electrifying, gospel-belting services and many outreach programs (more than a million free meals served each year) Pastor Cecil Williams's 10,000-member church has been ground zero for San Francisco's multicultural ecumenical fervor for 37 years.
Photo by David Paul Morris

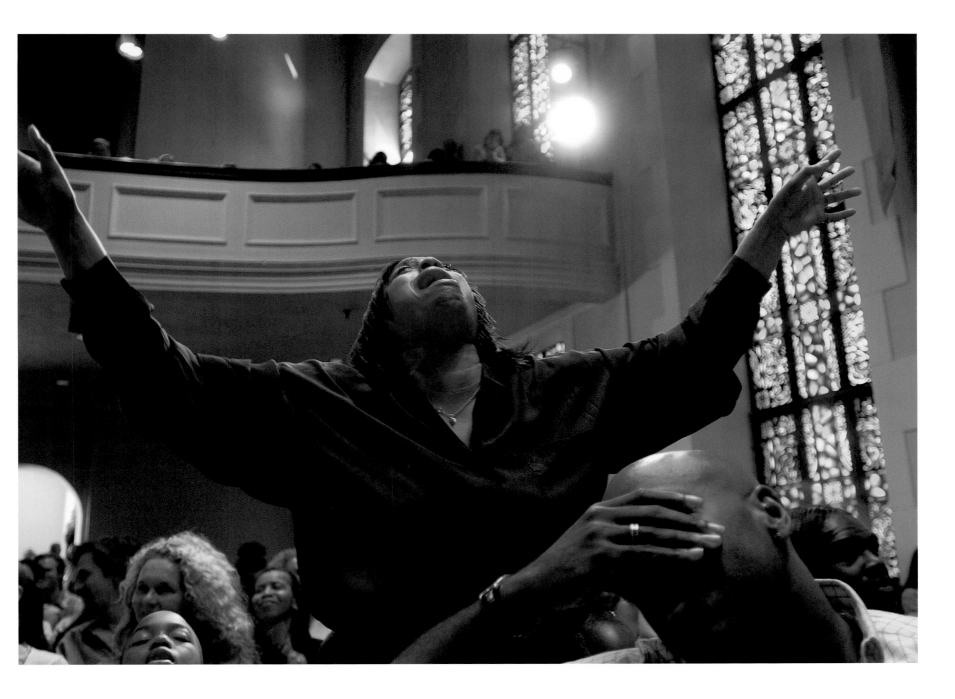

Father Jacob Myers baptizes newborn Luke
Avaliani during a Sunday morning service at the
Eastern Orthodox St. John the Wonderworker
Church. The parish is the first in the world named
for St. John Maximovitch of San Francisco and
Shanghai, who was canonized in 1994, 28 years
after his death. The Orthodox missionary was an
ascetic known as a loving father of orphans.
Photo by Steven Schaefer

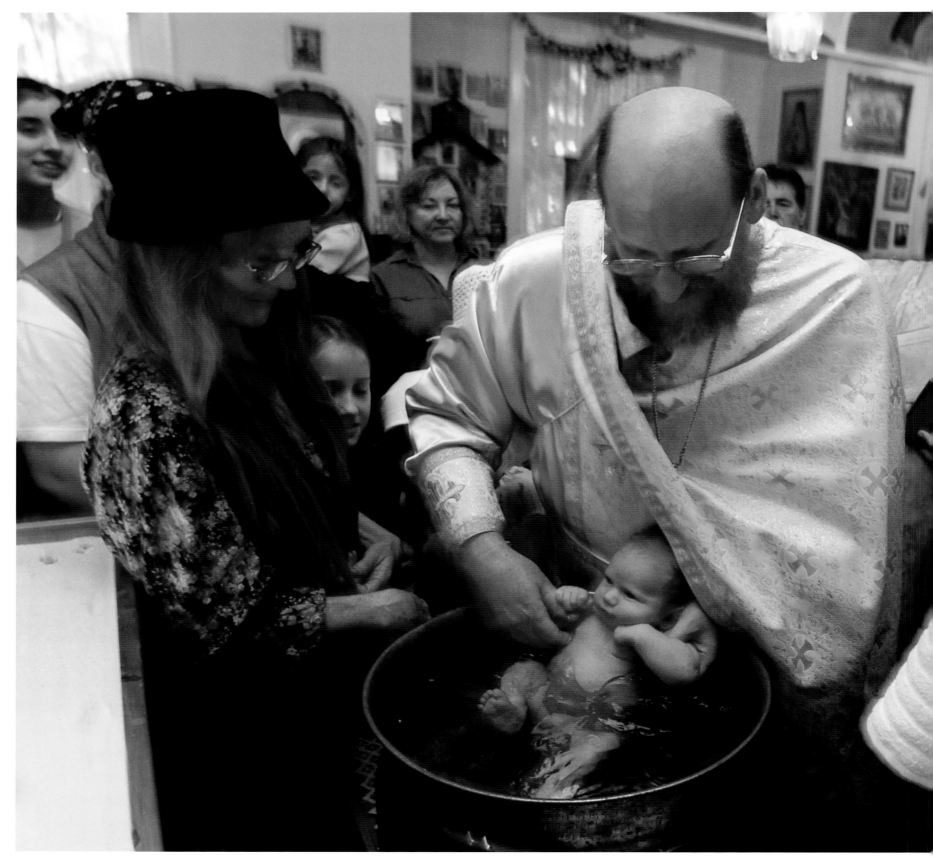

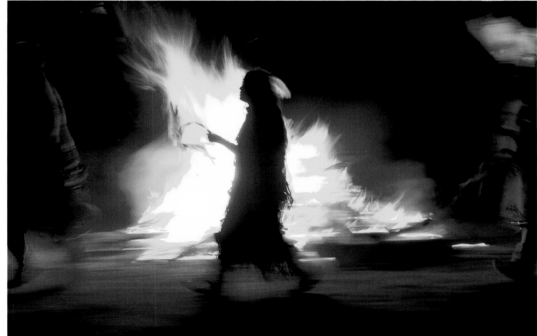

ASH CREEK, ARIZONA
Eleven-year-old Leslie Stevens walks the path to womanhood during the Sunrise Celebration, an ancient ceremony of the San Carlos Apaches. The tribe and its spirits will escort the girl through the entire four-day ritual, where long hours of singing, chanting, and dancing commemorate her transformation from child to adult.
Photo by Mark Henle, The Arizona Republic

ROCHESTER, NEW YORK

Saliha Hacibektasoglu, daughter Busra, 10, and son Burak Tarik, 8, recite Surah Fatiha (verses that reaffirm the right path) at the Islamic Center of Rochester. Originally from Turkey, Saliha works as an administrative assistant but still finds time to observe the Muslim practice to pray five times a day.

Photo by Carlos Ortiz, Democrat and Chronicle

NEW SQUARE, NEW YORK

Life in the Orthodox Hasidic Jewish community in New Square, 30 miles outside New York City, is devoted to study and prayer. As part of their daily ritual, the men don prayer shawls called *tallit,* and leather straps with little boxes containing bits of scripture called *teffilin.* The community is growing rapidly; more than a quarter of its 8,000 members are under the age of five.

Photo by Mark Greenberg, WorldPictureNews

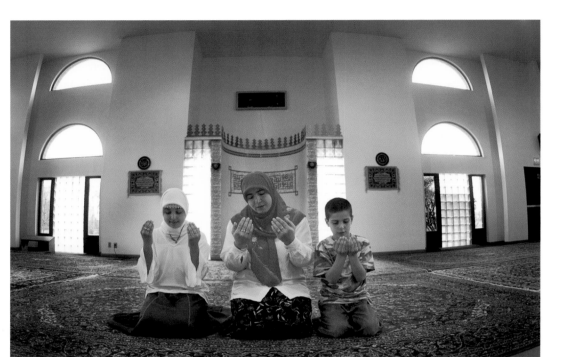

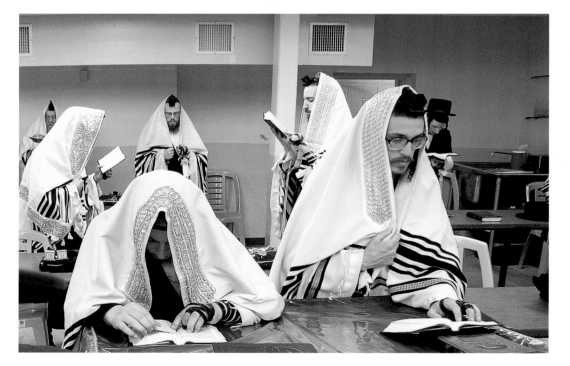

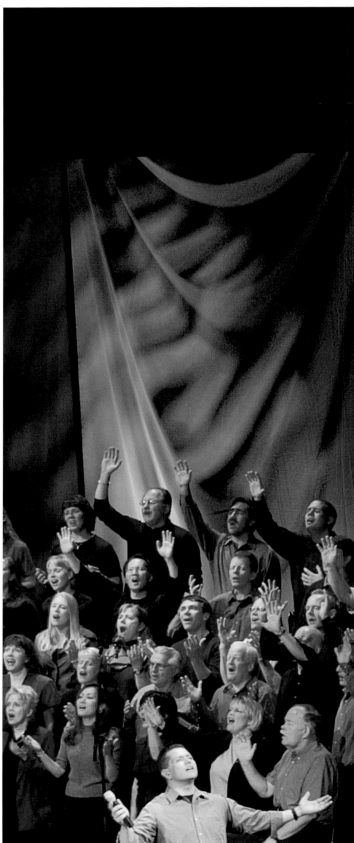

SOUTH BARRINGTON, ILLINOIS

Worship leader Rene LeDesma brings the message of Christ to the big screen during a service at the Willow Creek Community Church. The interdenominational megachurch and its nearly 100 subministries lead some 17,500 Christians in song and prayer every weekend, making it one of the largest in the country. Started in the 1970s by a handful of teenagers, the church now receives $20 million annually in donations.

Photo by Alex Garcia

VICKSBURG, MISSISSIPPI
When he married his wife, Margaret, the Reverend H.D. Dennis promised her a castle "that would be a monument to God." So over the years, he slowly converted an old grocery store on the banks of the Mississippi into a traffic-stopping jumble of towers, signs, biblical verse, and cryptic scrawls, most inspired by his "visions." Margaret calls it "a spiritual place."
Photo by J.D. Schwalm

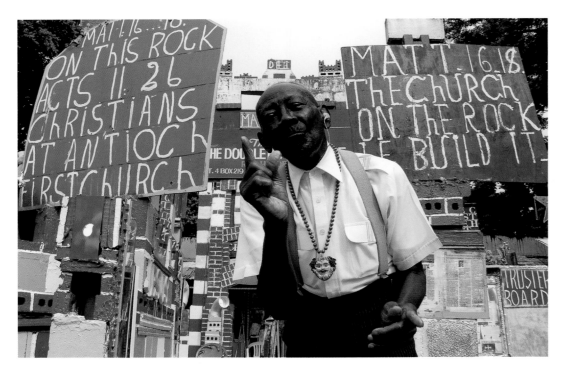

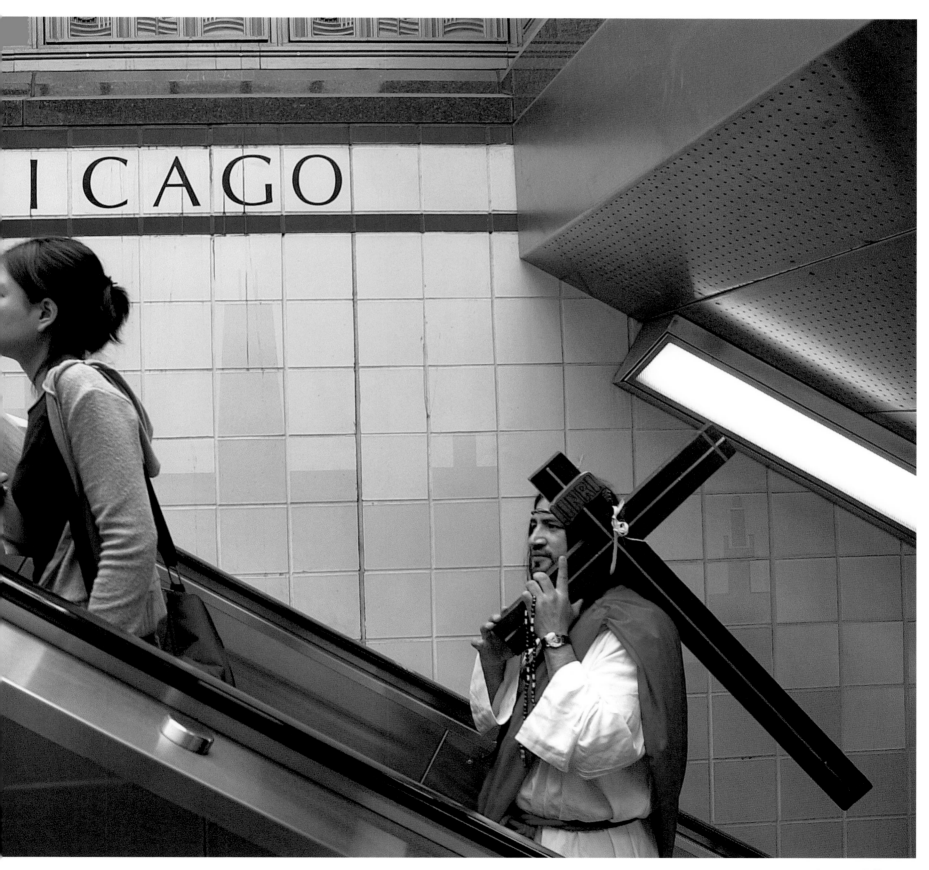

Stairway to heaven: Every day after work Gustavo Aguilar, 39, carries a cross around the city to "help keep Christ's image alive." A former fan of satanic rock, Aguilar now begins his daily transformation from maintenance man to holy man listening to the music of *Jesus Christ Superstar.*
Photo by Robert A. Davis, Chicago Sun-Times

NEW ORLEANS, LOUISIANA
After 9 years together, the 17 graduating eighth-graders at St. Louis Cathedral, a private school in the French Quarter, have formed tight bonds. The students come from different areas, so they will not attend the same high schools, making this moment bittersweet.
Photo by Jennifer Zdon

NEWBURGH, INDIANA
Kindergarteners belt out country singer Lee Greenwood's "The Pledge of Allegiance" song during their graduation ceremony from Kindergate Child Development Center. From left to right: Hannah Kasun, Dana Rust, Elliott Quinn, Meredith Campbell, Nick Rudisill, and Christopher Blanford.
Photo by Denny Simmons

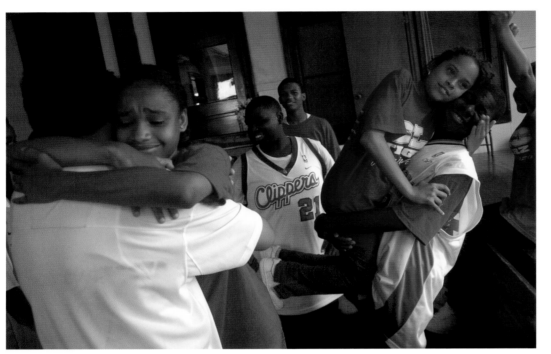

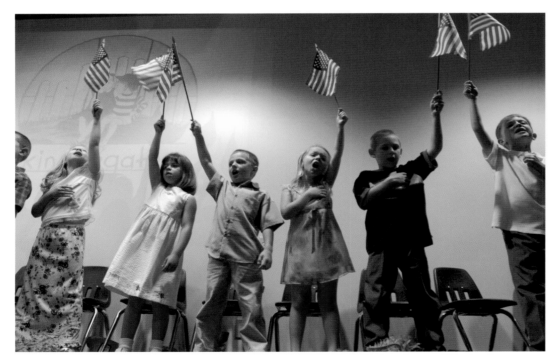

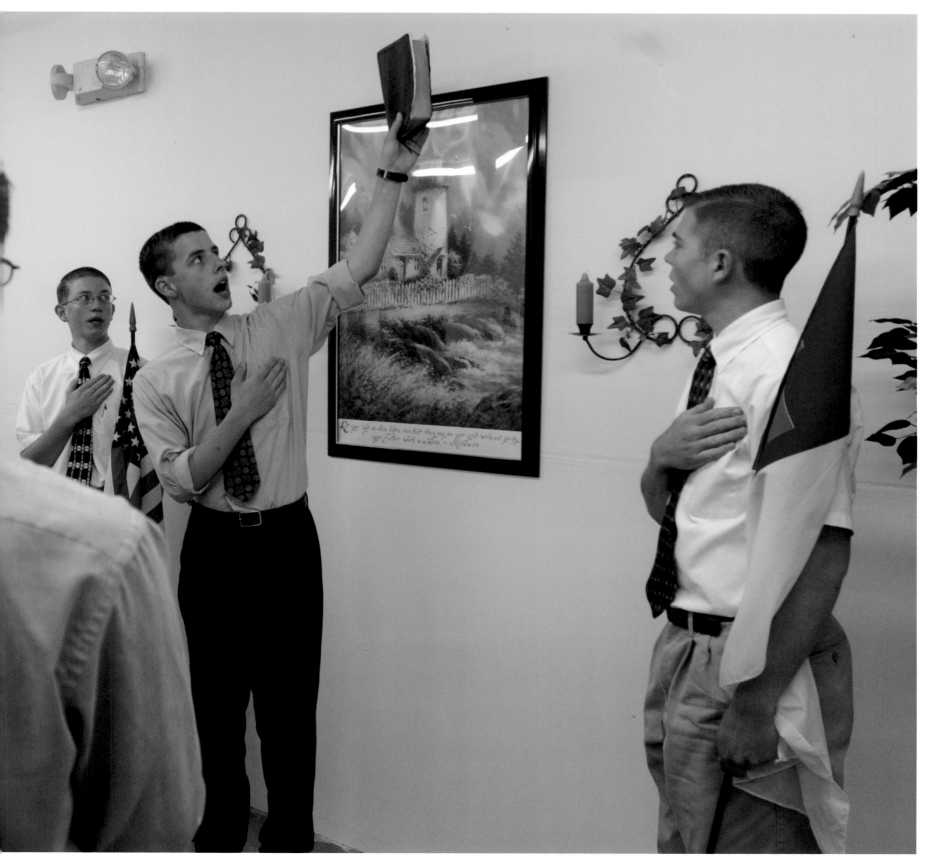

LAWRENCE, KANSAS
"I pledge allegiance to the Bible, God's Holy Word. I will make it a lamp unto my feet and a light unto my path. I will hide its words in my heart that I might not sin against God." Each morning 70-some students at the Heritage Baptist Christian School recite the Bible Pledge along with pledges to the American and Christian flags. Of America's 5.1 million K–12 private-school students, 85 percent attend religious schools.
Photo by Mike Yoder, Lawrence Journal-World

CHICAGO, ILLINOIS
Ericka Simpson contemplates her family's future from her home in Chicago's infamous Cabrini-Green Housing Project. The Chicago Housing Authority tagged Simpson's building and seven others (1,324 units) in the high-rise public housing complex for demolition but plans to build only 700 new ones. Simpson, who cannot afford to move, will have to rely on family, friends, and neighbors if she is forced to relocate.
Photo by Alex Garcia

GREENVILLE, SOUTH CAROLINA
Led by Rev. Jesse Jackson, 8,000 citizens march up Church Street to pressure Greenville County into recognizing Martin Luther King, Jr. Day. The action followed a county council decision to let the county's 1,600 workers choose their own holiday rather than establish a countywide MLK holiday. In 1983, King's birthday was made a federal holiday, but many municipalities, particularly in the South, don't recognize the celebration.
Photo by Patrick Owens

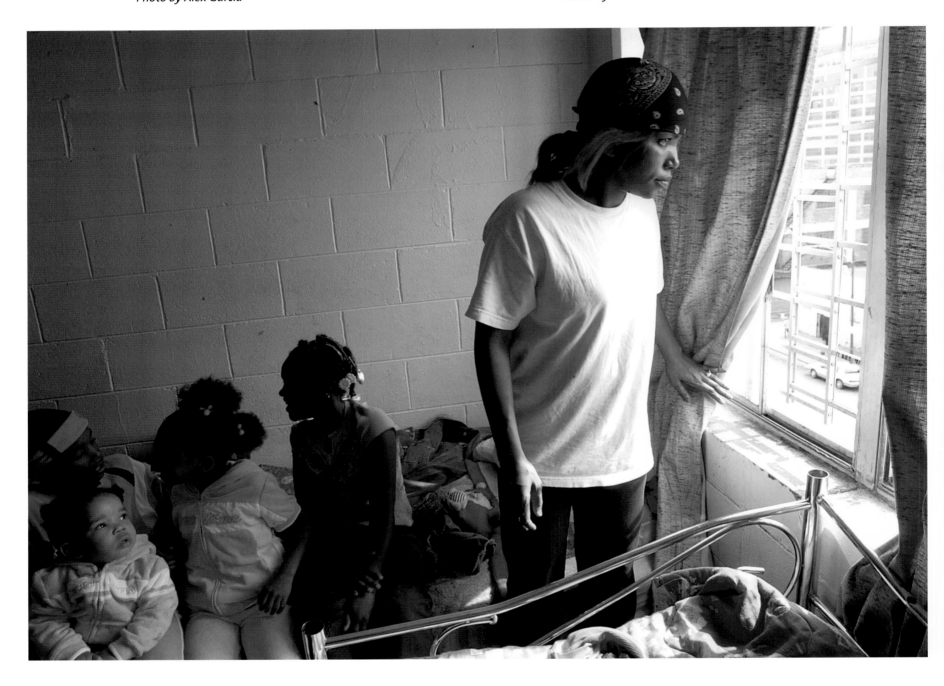

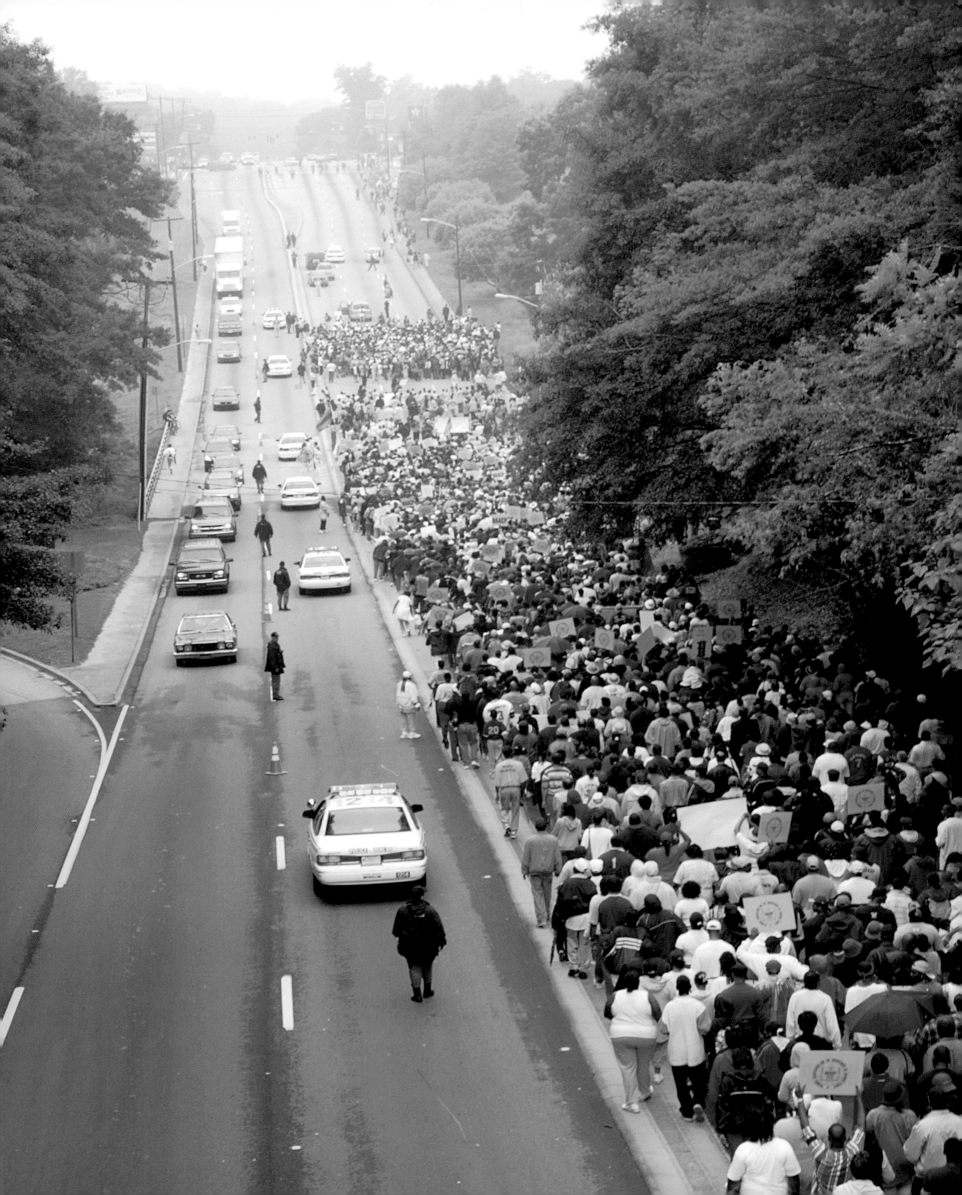

ATLANTA, GEORGIA
Star linebacker John Grant wants to go pro after graduating from Morehouse College, an all-male, African-American school founded in 1867. Its most famous alumnus, Dr. Martin Luther King, Jr., was an ordinary student until he met Professor Walter R. Chivers, a sociologist and outspoken critic of segregation who wrote articles about the role of black leaders in the struggle against oppression.
Photo by Joey Ivansco

MEMPHIS, TENNESSEE

The 2003 graduating class of St. Mary's Episcopal School accumulated a whopping $3.6 million in merit scholarships to help the girls live up to their potential. The class of 64 young women was the largest in the school's 156-year history.

Photo by Lisa Waddell Buser

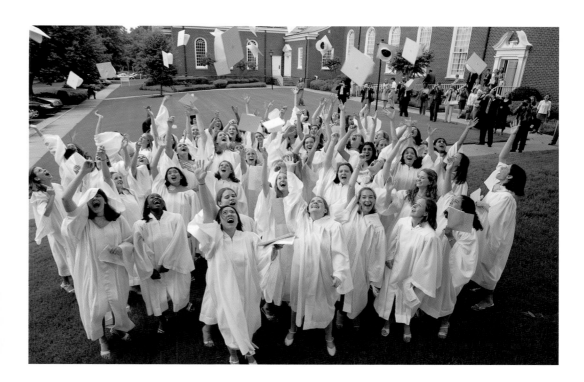

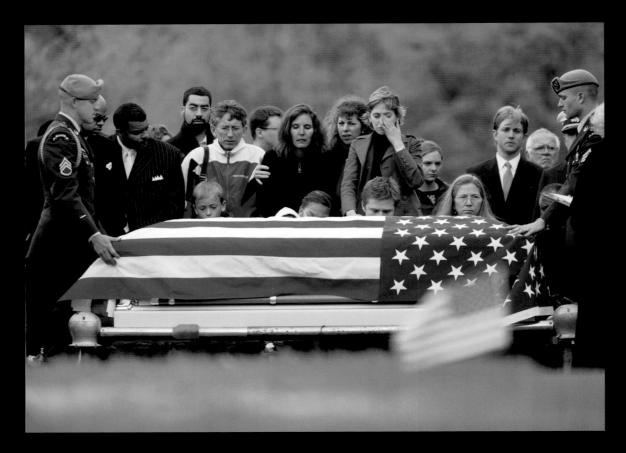

BERKLEY, MICHIGAN Family and friends gather graveside to honor Army Sgt. Sean Reynolds at Roseland Park Cemetery. Reynolds, 25, died during operation Iraqi Freedom.
Photo by J. Kyle Keener, Detroit Free Press

ORLANDO, FLORIDA At the Whirl & Twirl Square & Round Dance Club, people of all ages come dressed to the nines to learn their do-si-dos. *Photo by Julian Olivas*

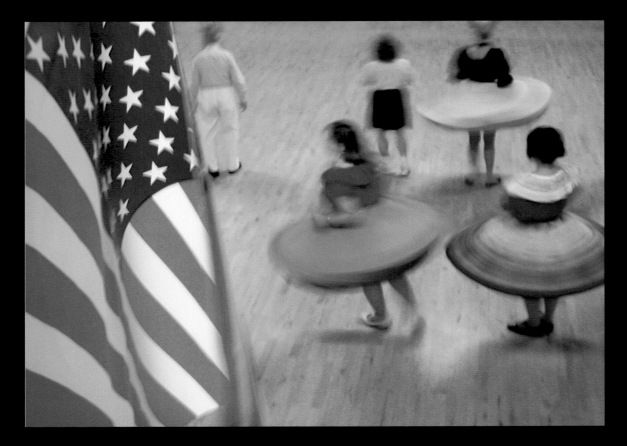

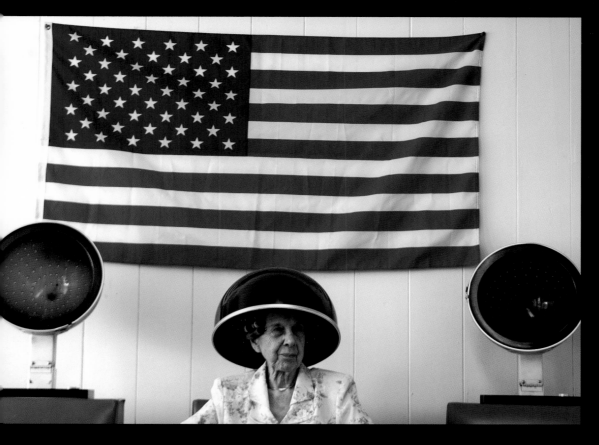

ORLANDO, FLORIDA Ninety year old Rose Juliana knows a good deal when she sees one. In her 30 years of Saturday afternoon appointments at Danny's Family Barber, the price of style has risen only from $7 to $15. *Photo by Gary Bogdon*

CODY, WYOMING Forrest Allen, 77, provides a red, white, and blue beacon for passing motorists on State Highway 14. Allen, who lives on the land he homesteaded in 1948, lit his neon flag in late 2001 to honor the victims of the September 11 terrorist attacks. *Photo by Devendra Shrikhande*

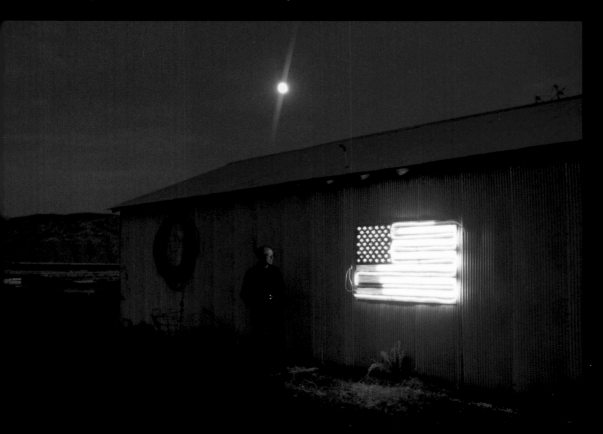

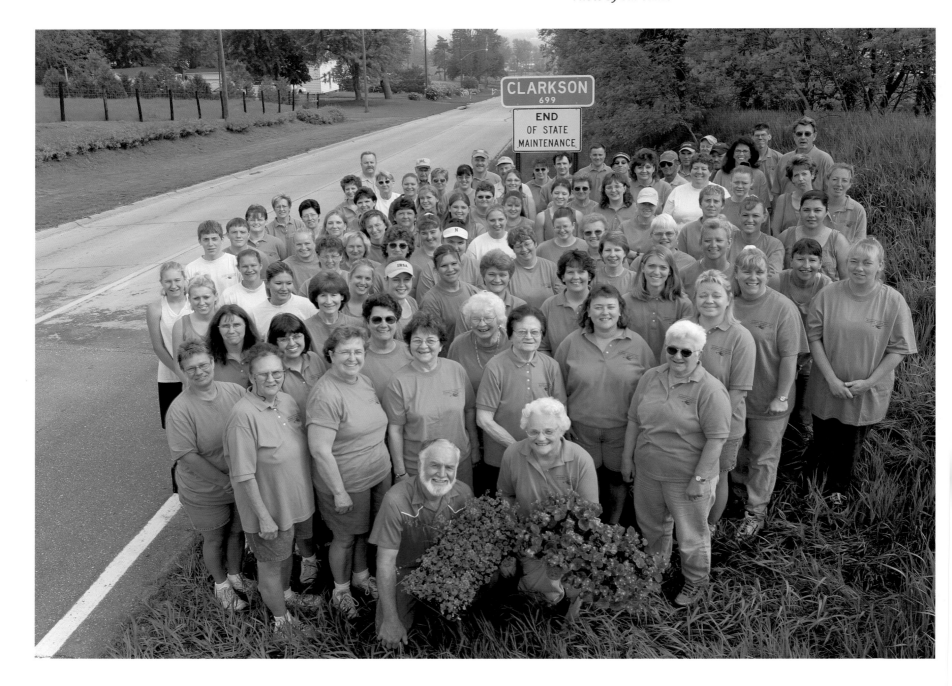

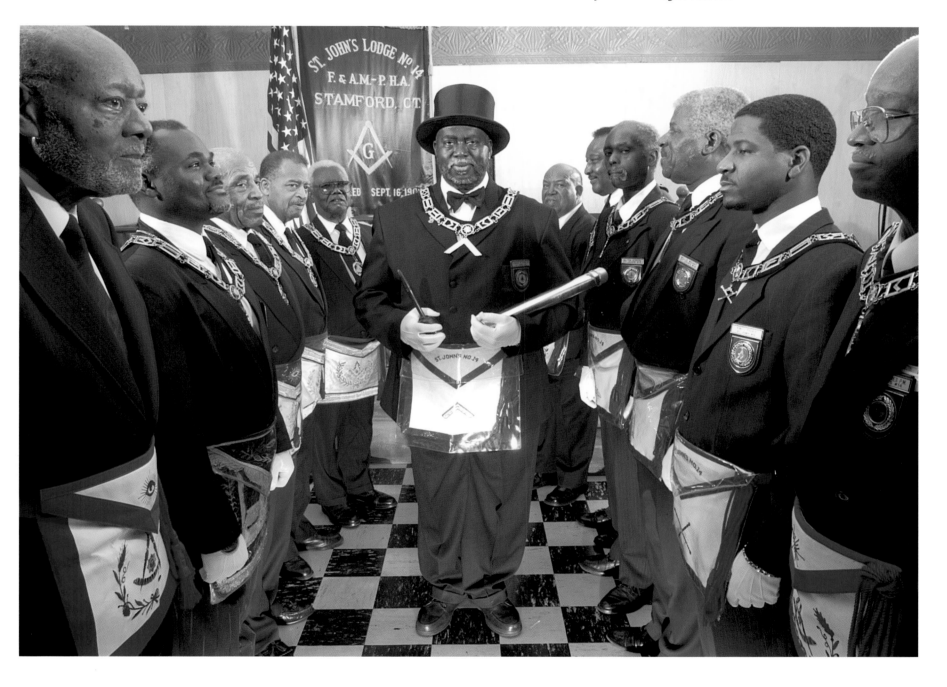

STAMFORD, CONNECTICUT

The Most Worshipful Prince Hall Grand Lodge of Free and Accepted Masons (St. John's Lodge #14) is the oldest African-American organization in Stamford. Lodge Master Charles Paris (center) is proud that his branch of the largest charitable fraternal organization in the world (five million members strong) provides college scholarships for dozens of needy students each year.

Photo by Andrew Douglas Sullivan

SHREVEPORT, LOUISIANA
As in many Southern homes, the front porch provides a cool evening gathering spot for the Kalogeris kids. John, 11, engages siblings Christina, 6, and Paul, 3, with *McElligot's Pool*—a Dr. Suess favorite from 1947.
Photo by Laura L. Coe

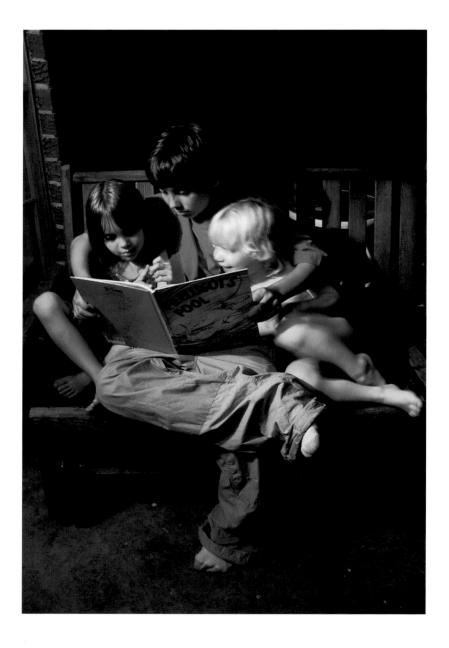

PINEHURST, GEORGIA

Howard "Curly" Borders loves old houses and old cars. He's restored both his prized '29 Buick and the 100-year-old Victorian house he shares with wife Elaine. After a day of errands, Curly relaxes in his living room with the new issue of *Hemmings Motor News*.

Photo by Rich Addicks,
The Atlanta Journal Constitution

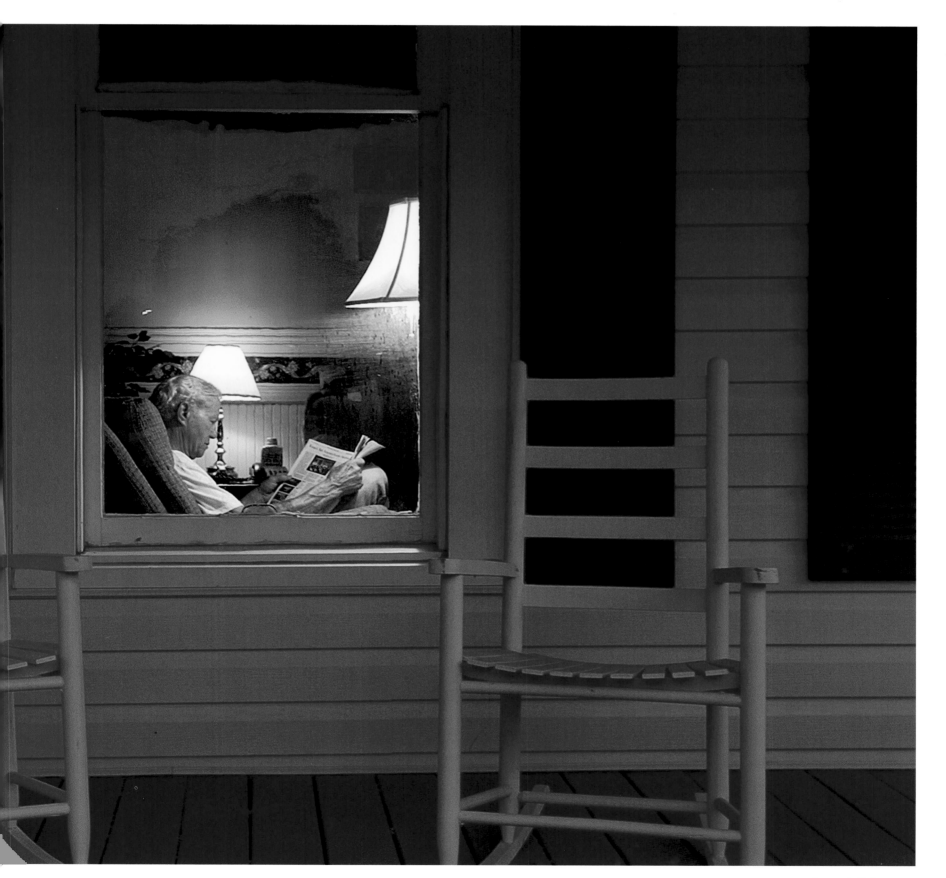

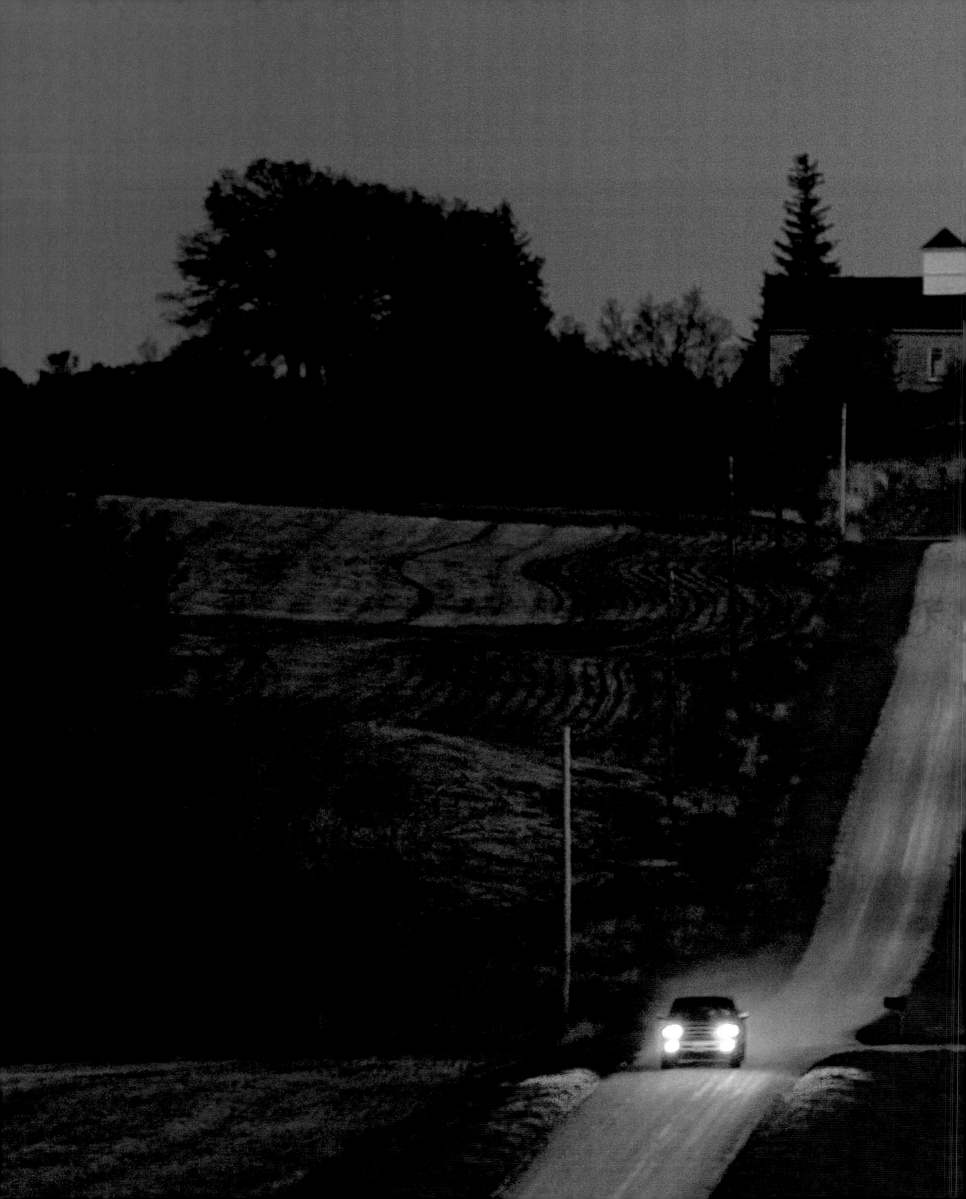

NERSTRAND, MINNESOTA
In 1862, four years after Minnesota achieved
statehood, a band of Norwegian immigrants
chose a windswept prairie hillock for their
house of worship. The first Valley Grove
Lutheran Church was made of stone.
In 1894, the congregants built a second,
larger church—this one of wood—to
accommodate their growing numbers.
Photo by Brian Peterson,
The Minneapolis Star-Tribune

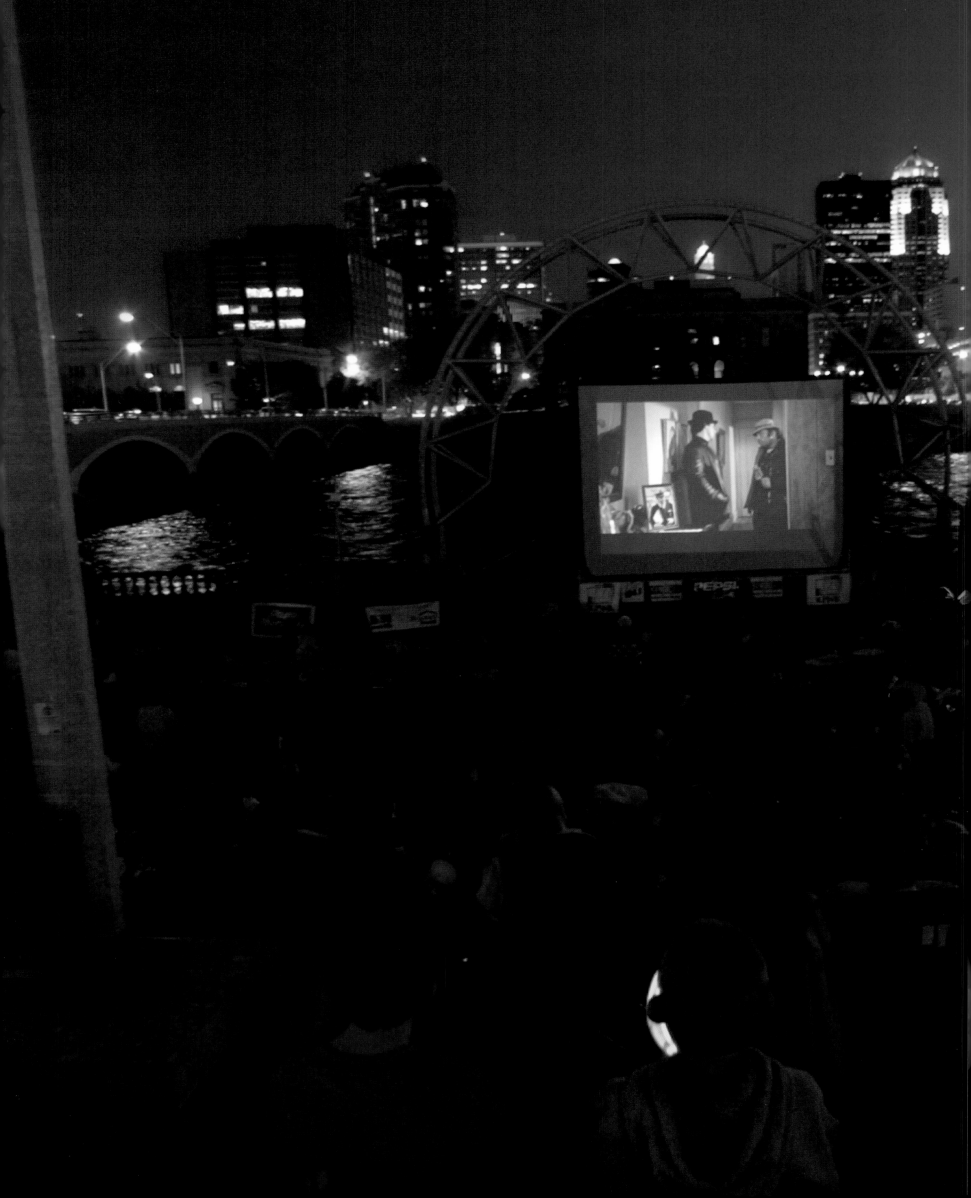

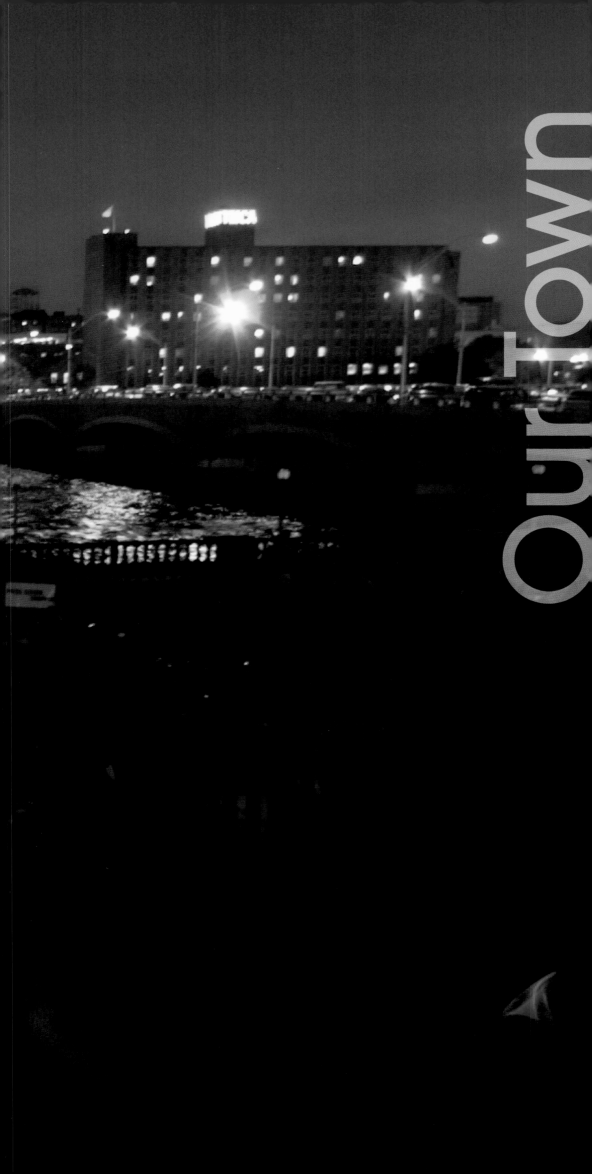

us while the neighbor-

loved the United States

had welcomed millions of

erican home with a strict

vent to art school and

oth century. She took us

where we loved Swami

m on his birthday for

h called Unity that said

isited these halls of

uslim.

issues—there were many

s. Anyone who said a

e" was delusional and

themselves together by

uld learn to respect

n't just like us. It was

place, that fragrant

well, trading news, imag-

ne. No one had much

By Naomi Shihab Nye

ntown San Antonio. Her

st was a National Book

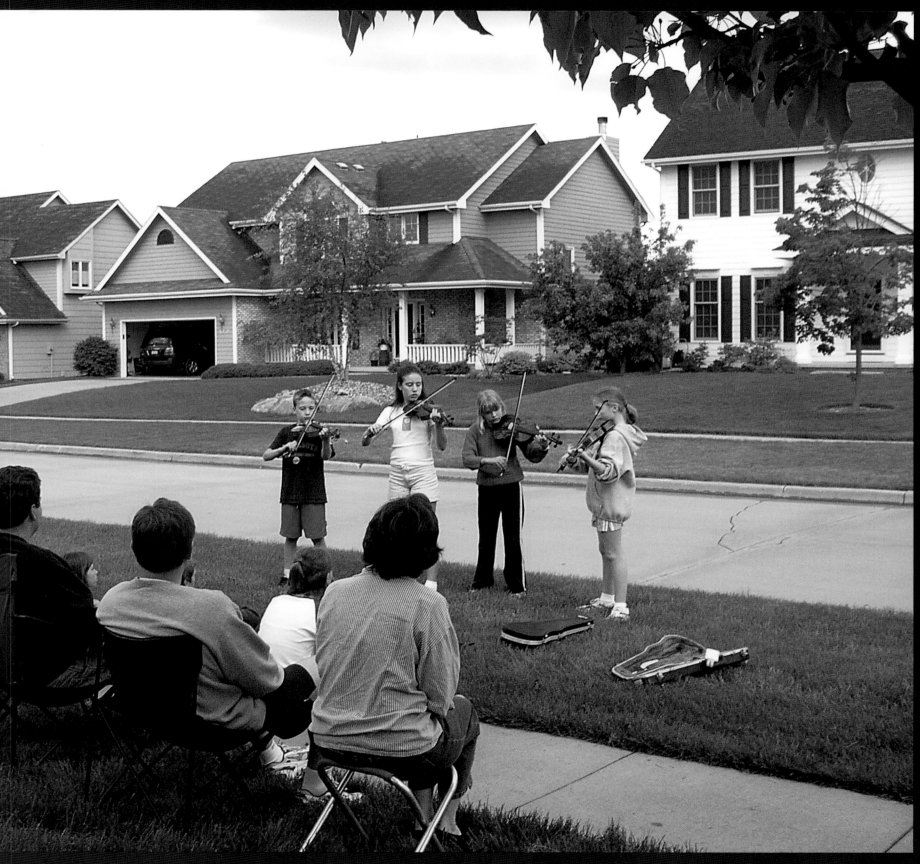

WEST DES MOINES, IOWA The Northview Drive Quartet (sort of) includes (L-R): Will Fandel, 10, on viola; Sarah Fandel, 12, on violin; Allison Pestotnik, 9, on viola; and Nicole Becker, 10, on violin. Whenever there are enough kids with enthusiasm, the neighborhood mounts alfresco song and dance performances.
Photo by Gary Fandel

SANBORN, NEW YORK

In a routine that hearkens back to a gentler-paced America, Tom Hoover delivers freshly bottled milk to customers on his Friday morning route. The Hoover Dairy, a family-owned business, has been in operation since 1920. During the course of a year, the delivery routes cover roughly 42,000 miles and serve more than 40,000 customers.
Photo by Michael Groll

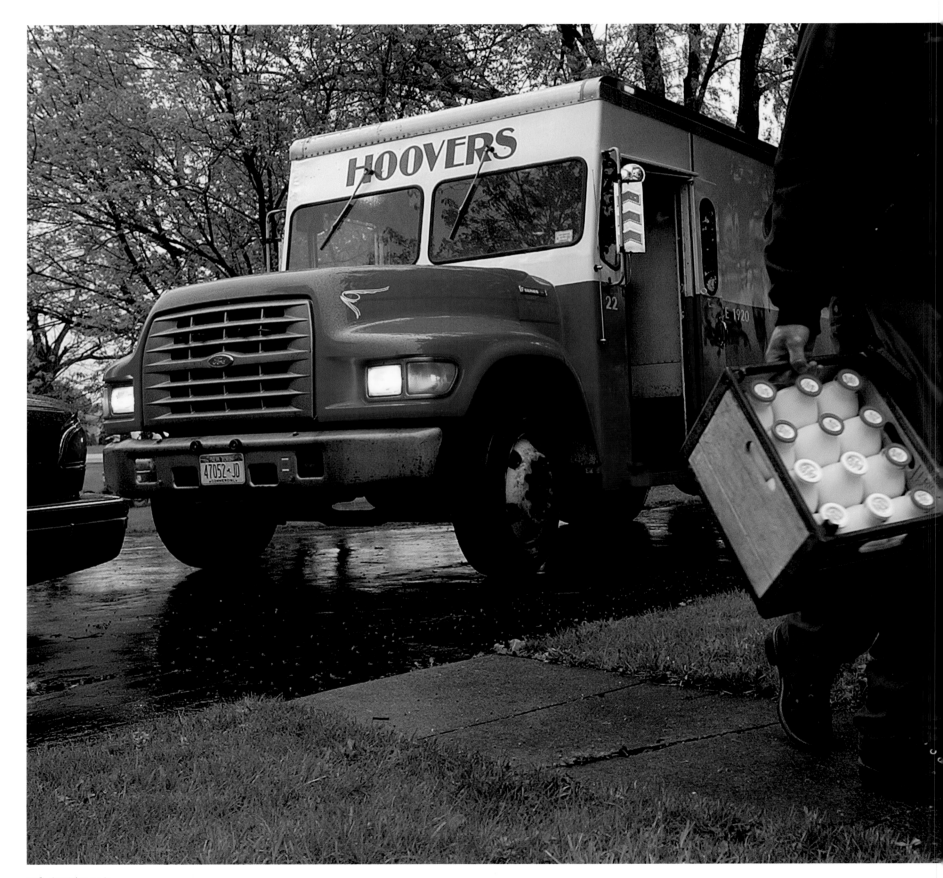

PITTSBURGH, PENNSYLVANIA
West Highland Terriers Gertrude and Alice wait eagerly for owner Bill Kaiser to come home. The Westies are named for Lost Generation author Gertrude Stein—born only a few blocks away in Pittsburgh's Mexican War Streets—and her partner Alice B. Toklas.
Photo by Annie O'Neill

DETROIT, MICHIGAN

As a kid, band director John Wilkins, 48, learned to play the trumpet to Doc Severinson records. After college, he covered Herb Alpert and Chicago tunes at weddings and bars. Now, backed by the hot cadences and cool moves of his Mumford High School Band, Wilkins struts his stuff at the 27th annual Broad Street Parade, which lines up most of Detroit's middle and high school bands.

Photo by Hugh Grannum

NEW YORK, NEW YORK

He got a *Baywatch* walk-on in Hollywood and
waited tables in Nashville, but Cincinnati native
Robert John Burck didn't find real fame 'til he
stripped down to his skivvies and started
strumming a guitar. In 2000, the Naked
Cowboy switched coasts permanently, and
now he's a Times Square fixture. (To see the
Naked Cowboy really naked, pick up the May '98
issue of *Playgirl*.)
Photo by Lynn Goldsmith

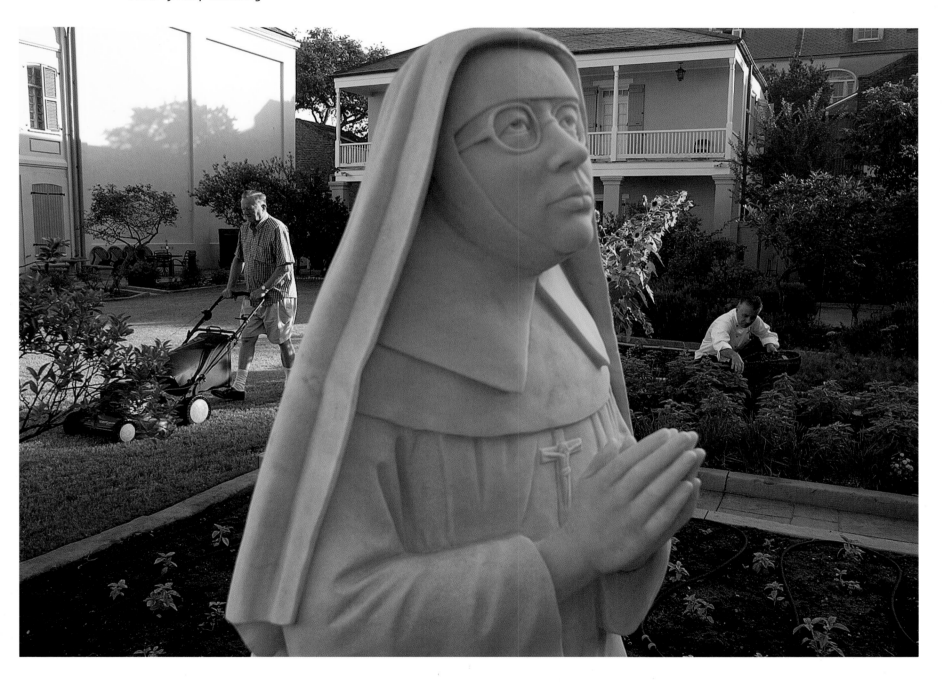

NEW YORK, NEW YORK

Head gardener Eric Pauze is proud of his seventh-floor gardens at Rockefeller Center. Under his care, his lawn was named one of the 10 best in America in 1998 by lawnmower manufacturer Briggs & Stratton. The Rockefeller Center gardens are designated state landmarks and cannot be changed, so every year Pauze and staff must plant pink geraniums and painstakingly measure and trim the hedges to their proper height.
Photo by Philip Greenberg

NEW ORLEANS, LOUISIANA

Nine years ago, Horst Pfeifer (right), chef of Bella Luna restaurant, had a divine inspiration. He needed fresh herbs for his cuisine, and the nearby Ursulines Convent was flanked by an unused parking lot. Pfeifer and Father Alvin O'Railly, left, created a serene courtyard garden full of herbs, lavender, and fig trees, blessed by a statue of American saint and missionary Katharine Drexel.
Photo by Jennifer Zdon, The Times-Picayune

PHILADELPHIA, PENNSYLVANIA

Hail Holy Queen, enthroned above! Oh, Maria!
Our life, our sweetness here below. Oh, Maria!
The Blessed Mother leads the Procession of
Saints down 7th Street. The annual parade is
sponsored by St. Paul's parish, including St. Paul
Church and St. Mary Magdalene de Pazzi, the
oldest Italian Roman Catholic church in America,
consecrated in 1852.
Photo by David Maialetti,
Philadelphia Daily News

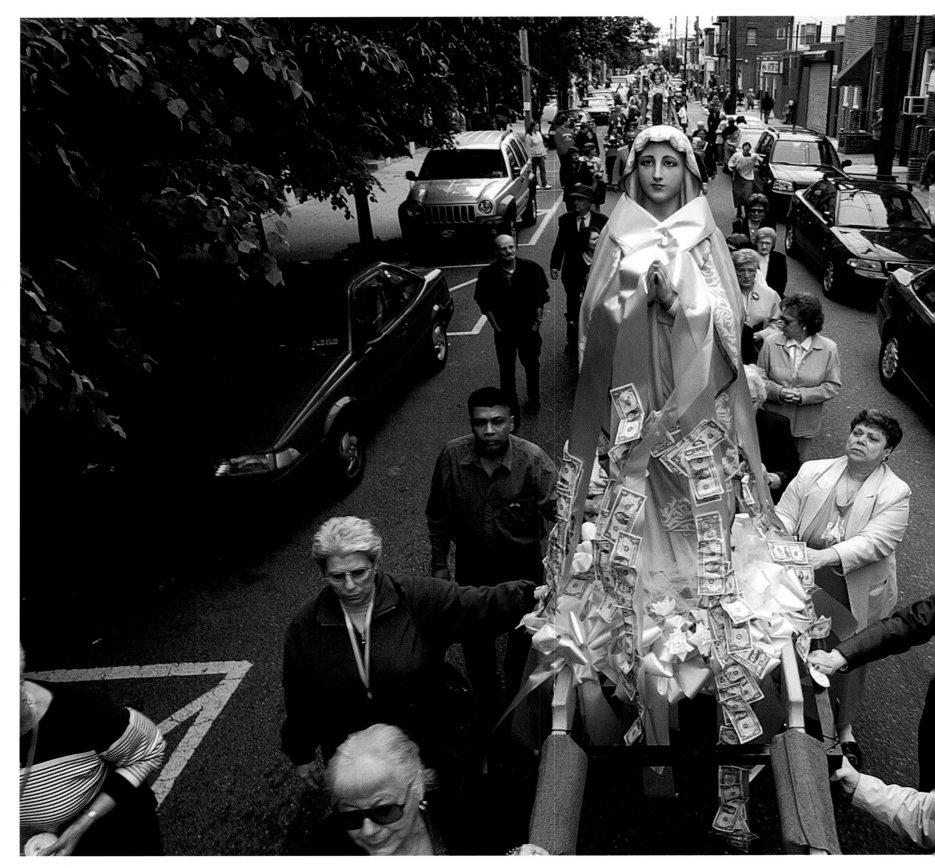

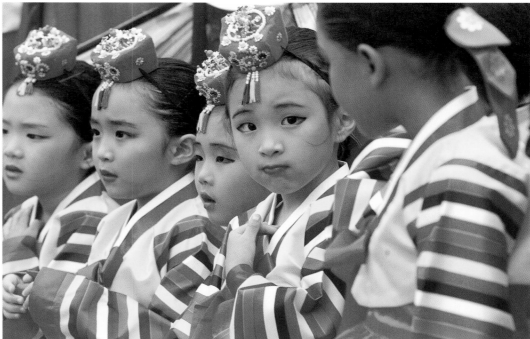

OKLAHOMA CITY, OKLAHOMA
These girls from the Korean Society of Oklahoma are about to perform a modern *kkoktu kaksi* puppet dance during the Asian Festival, held annually at the Myriad Botanical Gardens in downtown OKC.
Photo by Lisa Rudy Hoke

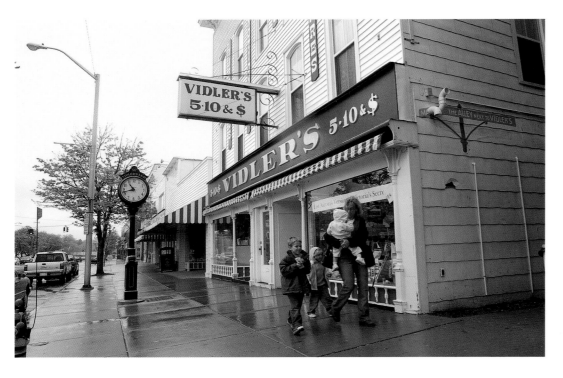

EAST AURORA, NEW YORK

Martha McLaughlin and her children walk home from Vidler's 5 & 10. Dime stores sprung up during the Depression when entrepreneurs like Robert Vidler, Sr. saw the need for low prices and utilized the availability of cheap goods and labor to provide them. Intent on retaining its small-town atmosphere, East Aurora (pop. 7,000) united to defeat a proposed megastore, which could have put Vidler's out of business.
Photos by Michael Groll

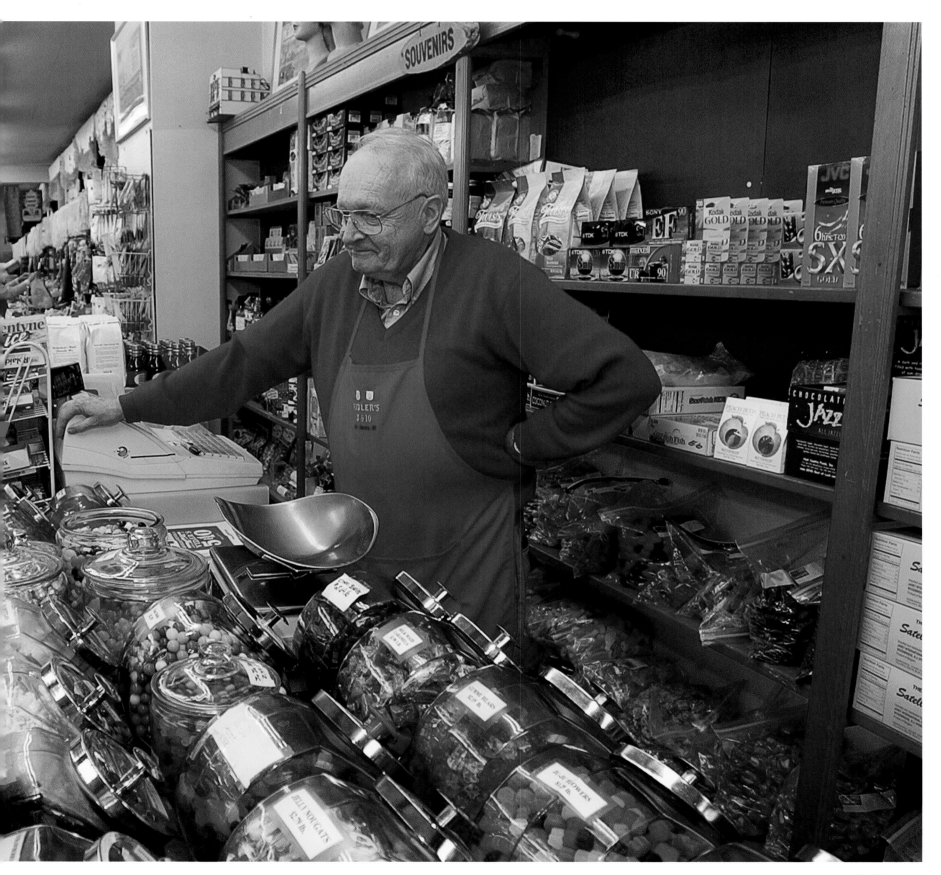

EAST AURORA, NEW YORK
The candyman can: Since 74-year-old Ed Vidler took over the business more than 50 years ago, he has been an idol to kids like Christian Zieger, seen here picking treats for his upcoming sixth birthday party.

AUSTIN, TEXAS

Legislators on the lam: The Texas House of Representatives ground to a halt after 51 Democratic legislators fled the Capitol rather than allow the Republican-controlled body to redistrict the state to Republican advantage. House Speaker Tom Craddick ordered state troopers to apprehend the quorum busters, but they had all decamped to an Oklahoma motel, outside the reach of Texas law.
Photos by Ralph Barrera, Austin American-Statesman

AUSTIN, TEXAS

Four days after they bolted, the 51 Texas Democrats walked back into the House chamber victorious. In the gallery, Democratic partisans cheered while a few Republicans pointedly turn their backs. The hurried-up lawmakers played catch-up on a host of bills before the stormy 78th Texas Legislature drew to a close.

PRINCETON, MINNESOTA

Under Minnesota state law, eight-year-old Jon Vock can't own a firearm for 10 more years. But that doesn't stop him from enjoying the automatic weapons demo at the Machine Gunners Association Spring Machine Gun Shoot. Jon couldn't pull the trigger, but more than 100 grown-up enthusiasts fired rounds from new and vintage weapons from all eras of gunmaking.
Photo by Thomas Whisenand

DEARBORN, MICHIGAN

Bretton Barber, 16, doesn't beat around the bush. When he wore his controversial tee shirt to Dearborn High during the build up to Operation Iraqi Freedom, school officials told him to take it off, turn it inside out, or go home. Barber went home, then created a little war of his own by contacting the American Civil Liberties Union and filing a lawsuit against the school.
Photo by Jeffrey Sauger, Reflex News

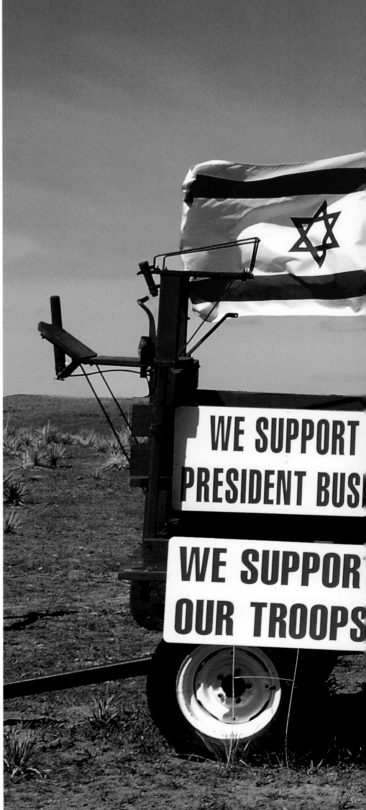

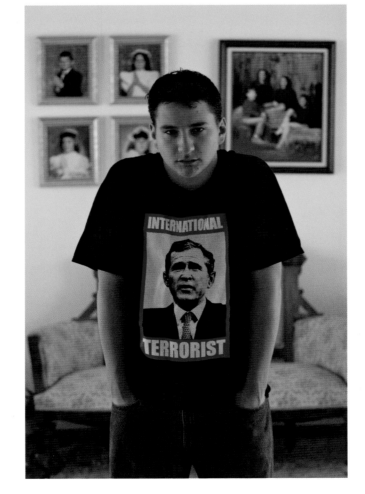

PARKER, COLORADO

On Hilltop Road, 20 miles south of Denver, an unnamed American leaves no doubt about his support for America's 2003 invasion of Iraq.
Photo by Cliff Lawson

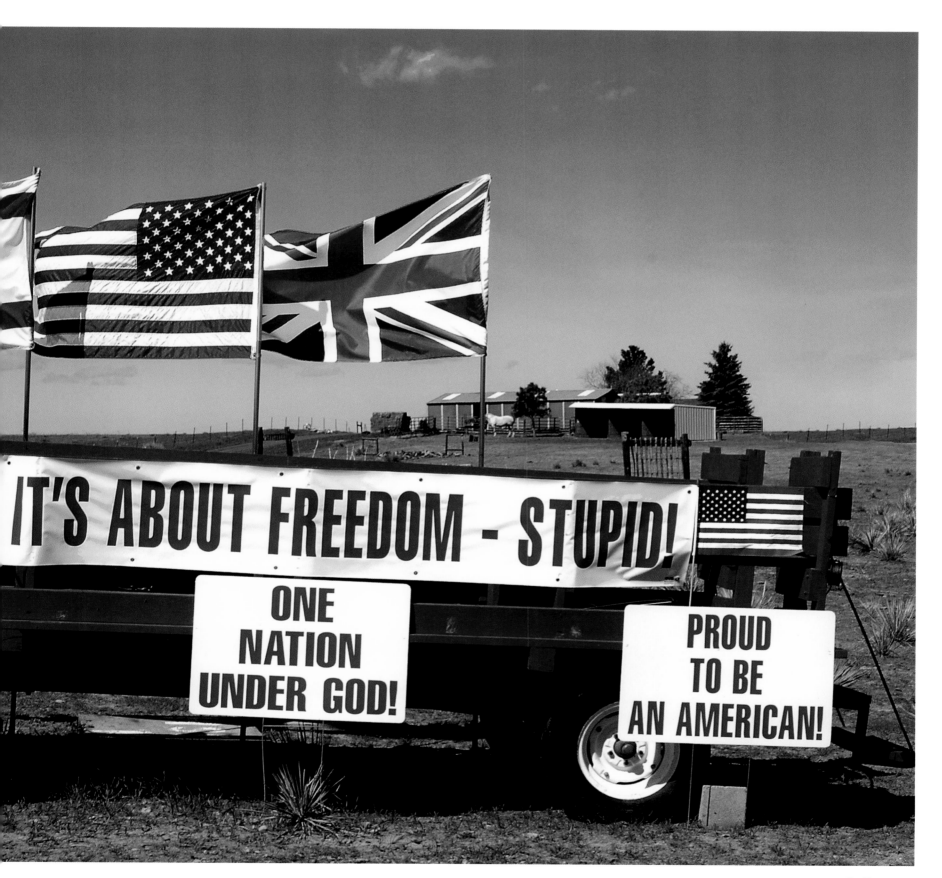

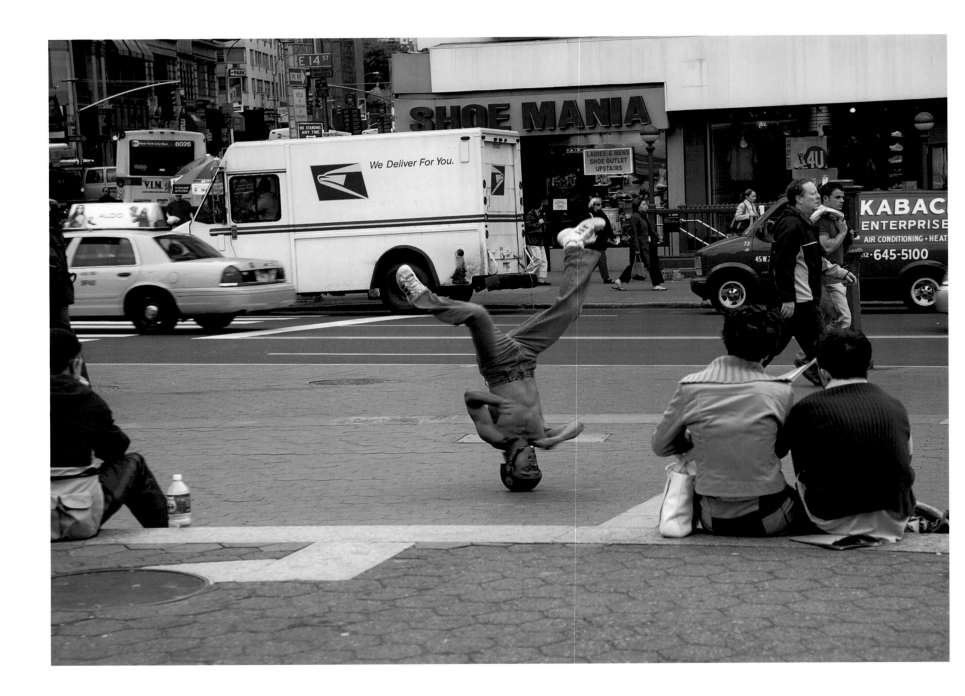

NEW YORK, NEW YORK
B-boys eschew Union Square's paving stones
to bust some smooth moves on 14th Street's
asphalt. Break dancing, born as a form of mock
battle among South Bronx gangs more than 20
years ago and the original physical expression of
hip-hop, is once again a New York sideshow.
Photo by Susan Liebold

PORTLAND, OREGON
It's recess at Grout Elementary, and six-year-old Aidan Finnegan is running with it. The 248 Grout students benefit from the school's rich assortment of cultural programs, including a Khmer-language program for the school's handful of young Cambodian Americans.
Photo by L.E. Baskow, Portland Tribune

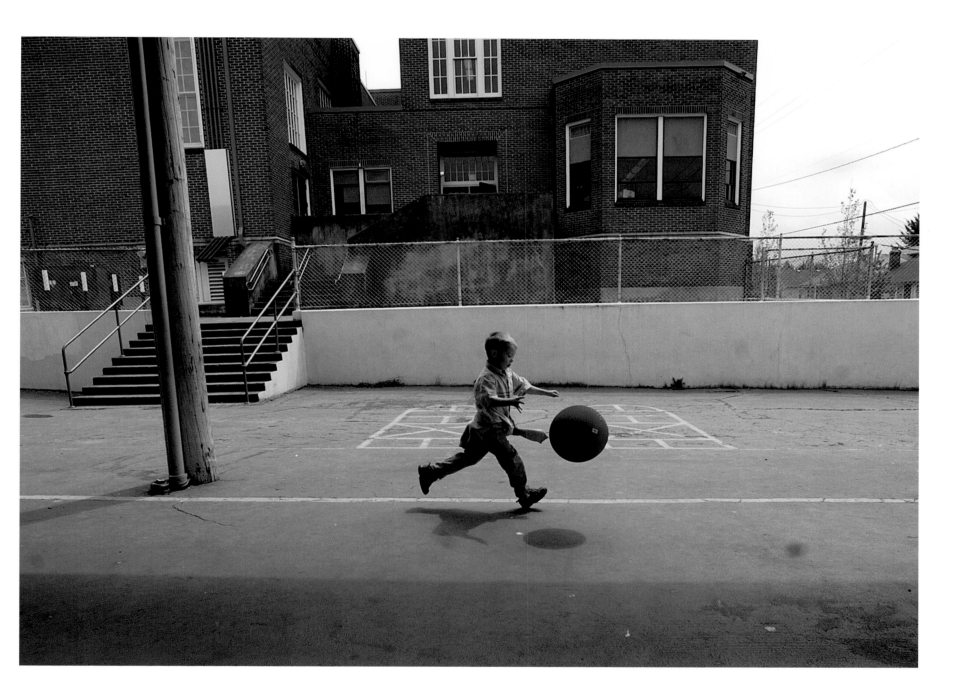

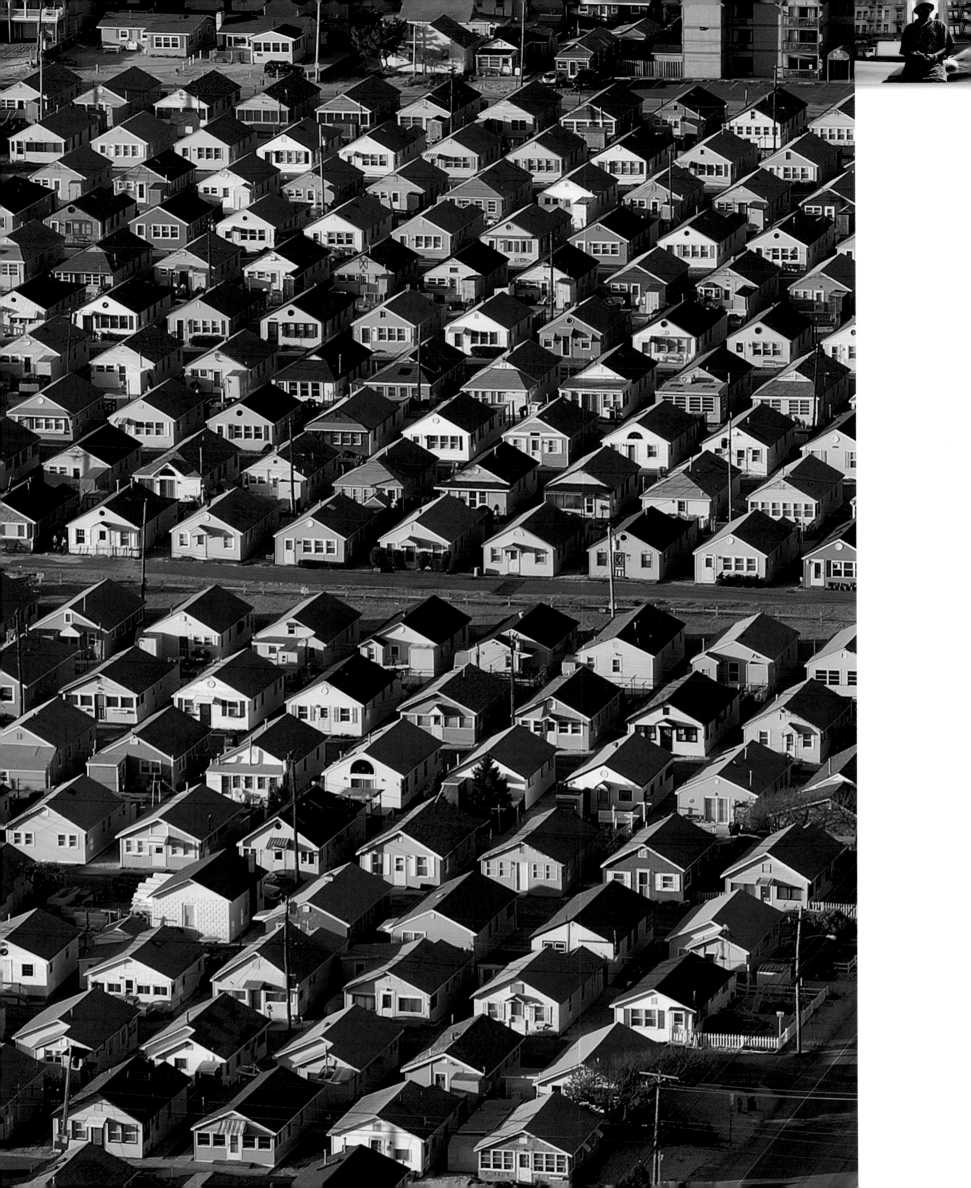

BERKELEY, NEW JERSEY

Unlike most suburban developments, which grew up around company towns as commuter communities, these Midway Beach bungalows were built strictly for summer fun—open floor plans with no insulation or heating. Developed between 1920 and 1960, the 500-square-foot bungalows originally sold for $2,500 and now go for more than $200,000.

Photo by Dennis McDonald,
Burlington County Times

COLUMBUS, OHIO

About 100 men bed down nightly at the Open Shelter in the Franklinton section of Columbus. The 20-year-old shelter welcomes men in need regardless of their condition. Two years ago, when Open Shelter's managers refused to relocate for redevelopment, they forfeited a half-million-dollars of annual funding from the city and the United Way. About 3.5 million Americans will likely experience homelessness in a given year.

Photo by Doral Chenoweth, The Columbus Dispatch

PORTLAND, OREGON

Face of homelessness: After living on the streets for a year in Arkansas, Robert, 41, moved to Oregon to find work fishing. He searched in vain. Oregon's fishing industry is depressed, and the state has an 8.5 percent unemployment rate. Portland provides food and shelter for the homeless, but Robert prefers his independence and panhandles for the $13 a night he needs to stay at a hotel.

Photo by Stephen Voss

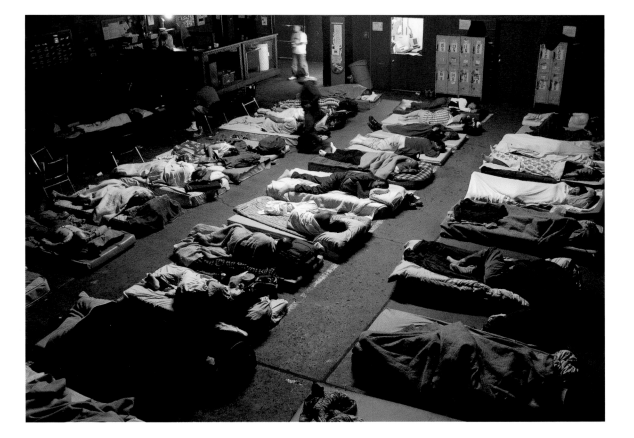

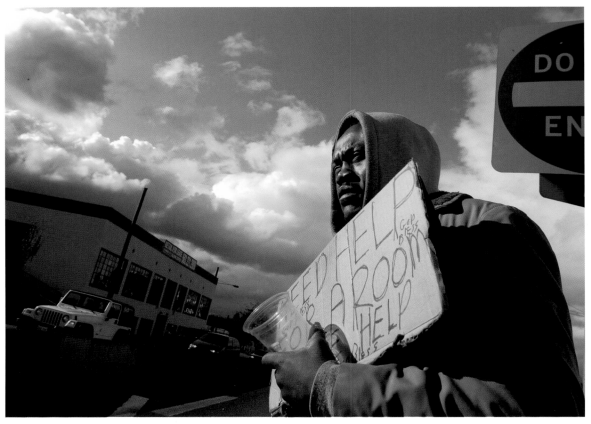

NEWARK, OHIO

Their work may not always be a picnic, but for the employees at the Longaberger Company, it sure looks like one. The family business is headquartered in a seven-story replica of the "Medium Market Basket." A nearby factory in Frazeysburg employs thousands of craftspeople who handweave wooden splints into baskets that can only be purchased from Longaberger "consultants" at basket parties nationwide.
Photo by Steve Hoskinson

BYRON, ILLINOIS

About a hundred miles west of Chicago, Byron Generating Station's twin 496-foot towers cool two nuclear reactors that can produce enough electricity to juice two million American households. Illinois has 14 nuclear reactors at seven sites.
Photo by Alex Garcia

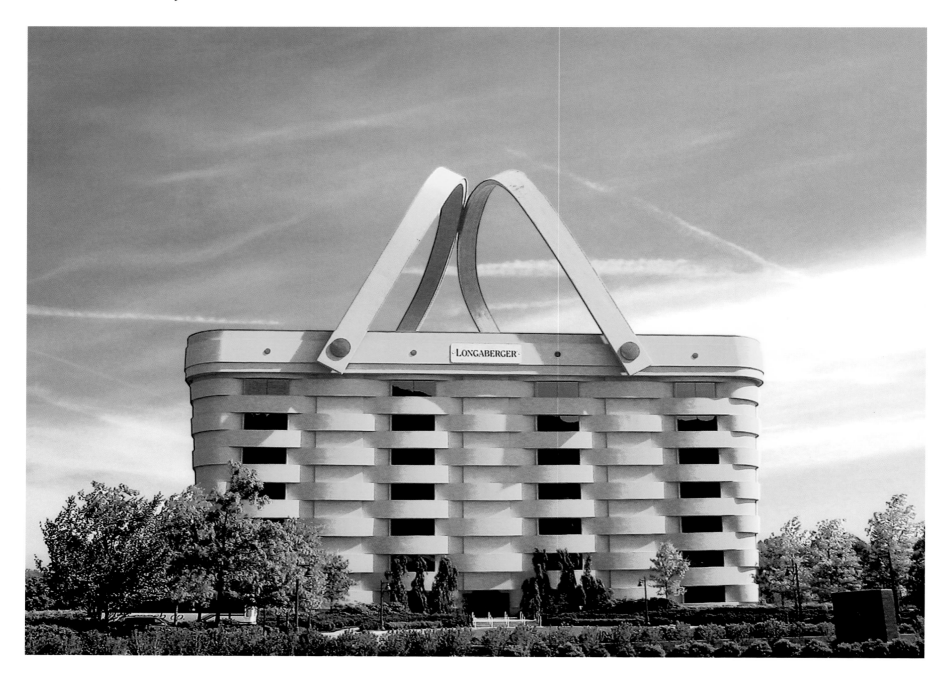

HONOLULU, HAWAII

7:22 P.M., 5/15/03: Temperature, 79 degrees; humidity, 60 percent; NE tradewinds, 14 mph; surf, 4 to 6 feet on the eastside, 2 to 4 feet on the south; sunset, 19 minutes ago. Forecast: more of the same. Zel Boddie takes a swim at King Manor Apartments on South King Street in downtown Honolulu.
Photo by Jeff Widener

SEATTLE, WASHINGTON
Looking for some after-dinner fun, Carl Tweeten, 25 (left), cruises Post Alley where local bands advertise upcoming shows and events. The Alley is adjacent to Seattle's Pike Place Market, which has a lively nightlife scene. Tweeten didn't know what the other guy was doing with the bicycle—and didn't wait to find out.
Photo by John Fischer

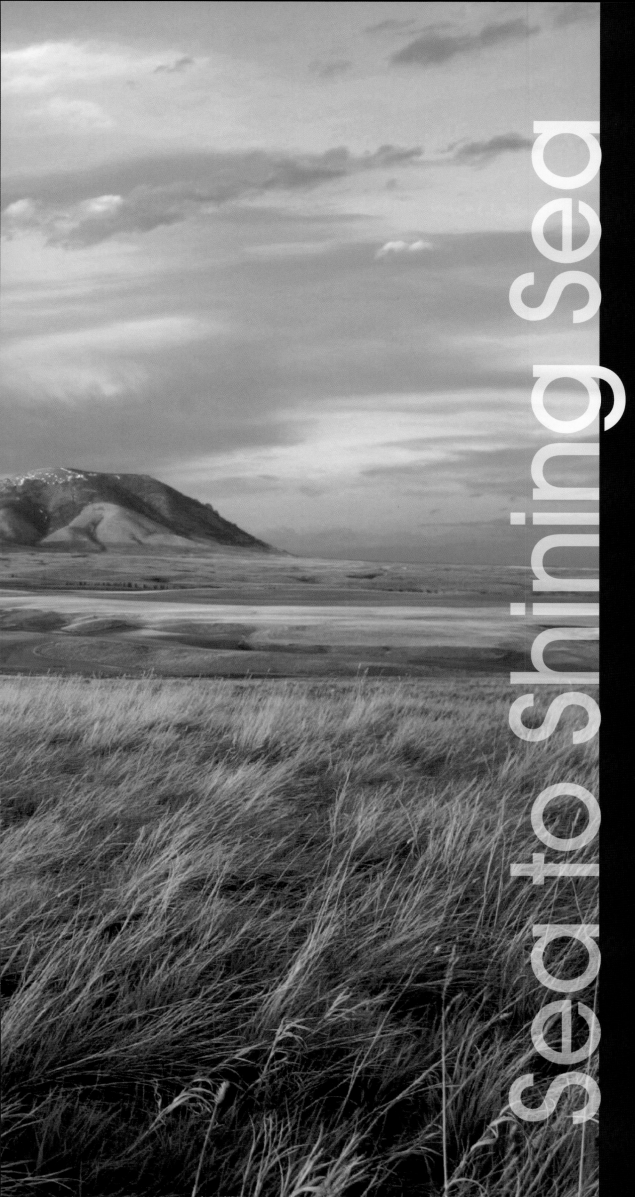

In the summer of 1996 human habitation on earth made a subtle, uncelebrated passage from being mostly rural to being mostly urban. More than half of all humans now live in cities. The natural habitat of our species, then, officially, is steel, pavement, streetlights, architecture, and enterprise—the hominid agenda.

With all due respect for the wondrous ways people have invented to amuse themselves and one another on paved surfaces, I find that this exodus from the land makes me unspeakably sad. I think of children who will never know, intuitively, that a flower is a plant's way of making love, or what *silence* sounds like, or that trees breathe out what we breathe in. I think of the astonished neighbor children who huddled around my husband in his tiny backyard garden, in the city where he lived years ago, clapping their hands to their mouths in pure dismay at seeing him pull carrots from the ground. (Ever the thoughtful teacher, he explained about fruits and roots, and asked, "What other food do you think might grow in the ground?" They knit their brows, conferred, and offered brightly, "Spaghetti?") I wonder what it will mean for people to forget that food, like rain,

SWEETGRASS, MONTANA Wide open spaces: Home to the Blackfeet, Chippewa-Cree, Gros Ventre, Salish, Kootenai, and Assiniboine tribes, Sweetgrass Hills is designated one of the 11 Most Endangered Places by The National Trust. *Photo by Todd Korol*

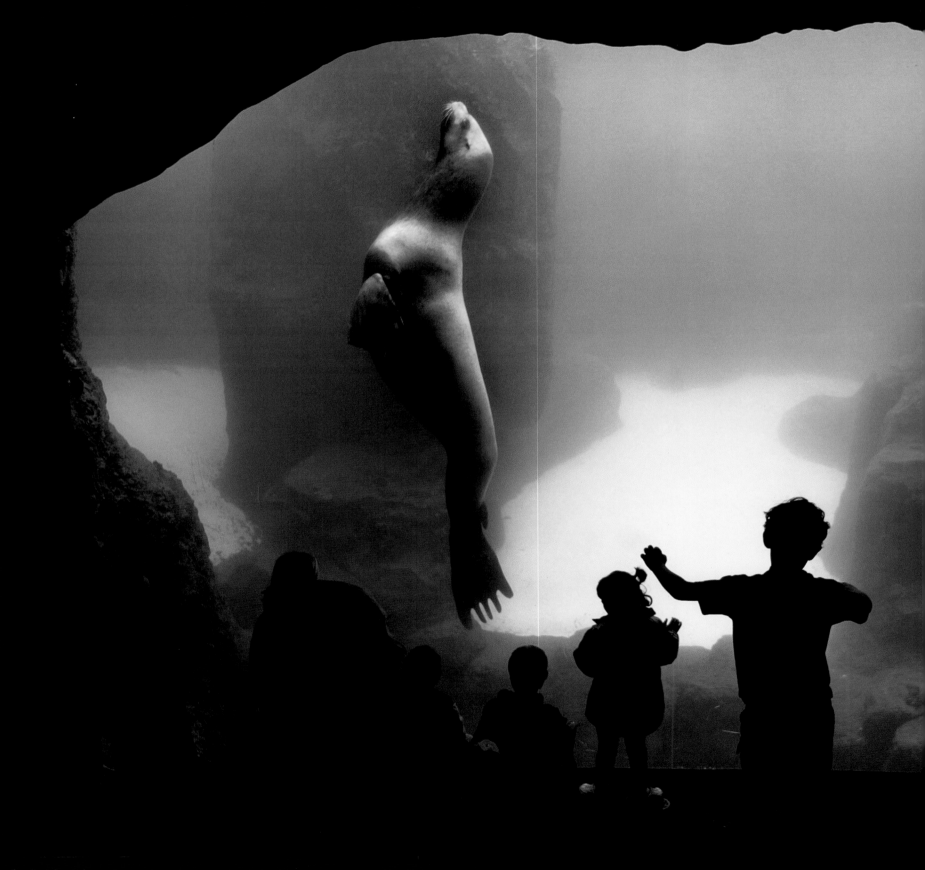

PORTLAND, OREGON Sea lion ballet: The Stellar Cove Exhibit is a prime attraction at the Oregon Zoo, which attracts more than 1.3 million kids and adults each year.
Photo by L.E. Baskow, Portland Tribune

is not a product but a process. I wonder how they will imagine the infinite when they have never seen how the stars fill a dark night sky. I wonder how I can explain the heartbreaking beauty of a wood-thrush song to a populace for whom wood is a construction material and thrush is a tongue disease.

What we lose in our great human exodus from the land is a rooted sense, as deep and intangible as religious faith, of why we need to hold onto the wild and beautiful places that once surrounded us. We seem to succumb so easily to the prevailing human tendency to pave such places over, build subdivisions upon them, and name them The Willows, or Peregrine's Roost, or Elk Meadows, after whatever it was that got killed there. Apparently it's hard for us humans to doubt, even for a minute, that this program of plunking down our edifices at regular intervals over the entire landmass of planet earth is overall a good idea. To attempt to slow or change the program is a tall order.

Barry Lopez writes that if we hope to succeed in the endeavor of protecting natures other than our own, "It will require that we reimagine our lives.... it will require of many of us a humanity we've not yet mustered, and a grace we were not aware we desired until we had tasted it."

And yet no endeavor could be more crucial at this moment. Protecting the land that once provided us with our genesis may turn out to be the only real story there is for us. The land still provides our genesis, however we might like to forget that our food comes from dank, muddy earth, that the oxygen in our lungs was recently inside a leaf, and that every newspaper or book we may pick up (including this one...) is made from the hearts of trees that died for the sake of our imagined lives. What you hold in your hands right now, beneath these words, is consecrated air and time and sunlight and, first of all, a place. Whether we are leaving it or coming into it, it's *here* that matters, it is place. Whether we understand where we are, or don't, that is the story: To be here or not to be. Storytelling is as old as

our need to remember where the water is, where the best food grows, where we find our courage for the hunt. It's as persistent as our desire to teach our children how to live in this place that we have known longer than they have. Our greatest and smallest explanations for ourselves grow from place, as surely as carrots grow in the dirt. I'm presuming to tell you something that I could not prove rationally but instead feel as a religious faith. I can't believe otherwise.

A world is looking over my shoulder as I write these words; my censors are bobcats and mountains. I have a place from which to tell my stories. So do you, I expect. We sing the song of our home because we are animals and an animal is no better or wiser or safer than its habitat or its food chain. Among the greatest of all gifts is to know our place.

Oh, how can I say this: People need wild places. Whether or not we think we do, we do. We need to be able to taste grace and know once again that we desire it. We need to experience a landscape that is timeless, whose agenda moves at the pace of speciation and glaciers. To be surrounded by a singing, mating, howling commotion of other species, all of which love their lives as much as we do ours, and none of which could possibly care less about our economic status or our running day calendar. Wildness puts us in our place. It reminds us that our plans are small and somewhat absurd. It reminds us why, in those cases in which our plans might influence many future generations, we ought to choose carefully. Looking out on a clean plank of planet earth, we can get shaken right down to the bone by the bronze-eyed possibility of lives that are not our own.

By Barbara Kingsolver

Barbara Kingsolver *has published books of essays, poetry, and fiction including the bestselling novel* The Poisonwood Bible. *Her work is translated and read throughout the world. She lives with her husband and two daughters.*

America clocks in at 32 pounds per person per week, up from 18 pounds in 1960. Northampton County Director of Solid Waste Ronald Rowe jockeys a Caterpillar D-5M at the county's landfill. At capacity, the facility will close at the end of 2003, and the county's solid waste will travel to neighboring Accomack County for disposal.
Photo by Scott Neville, Eastern Shore News

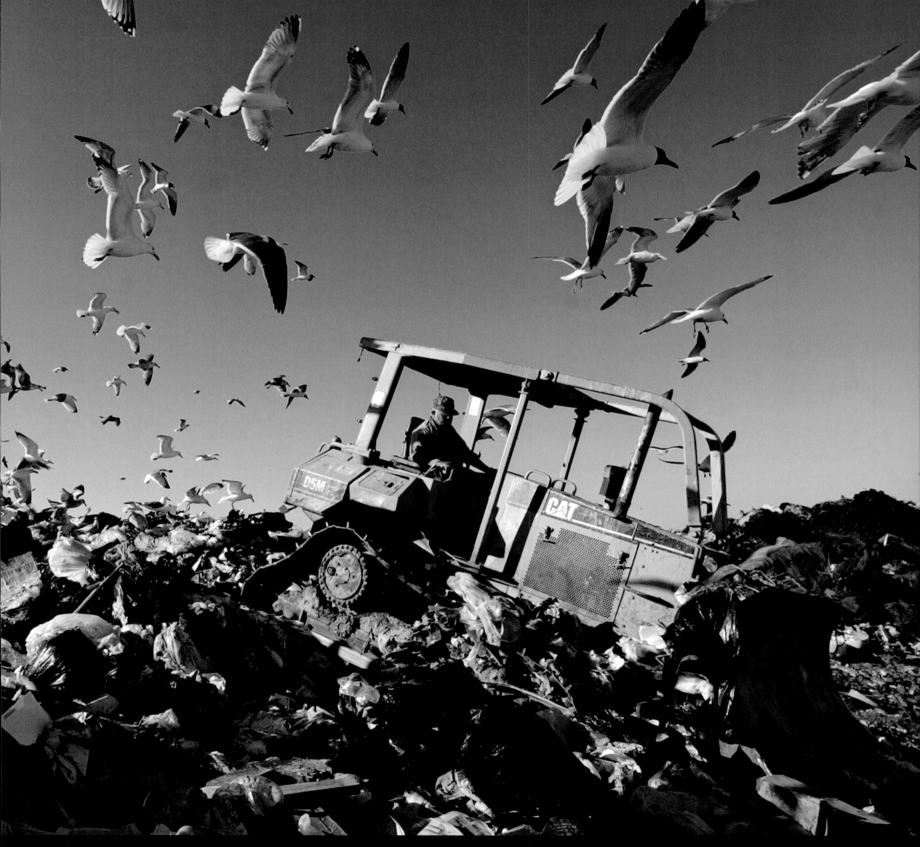

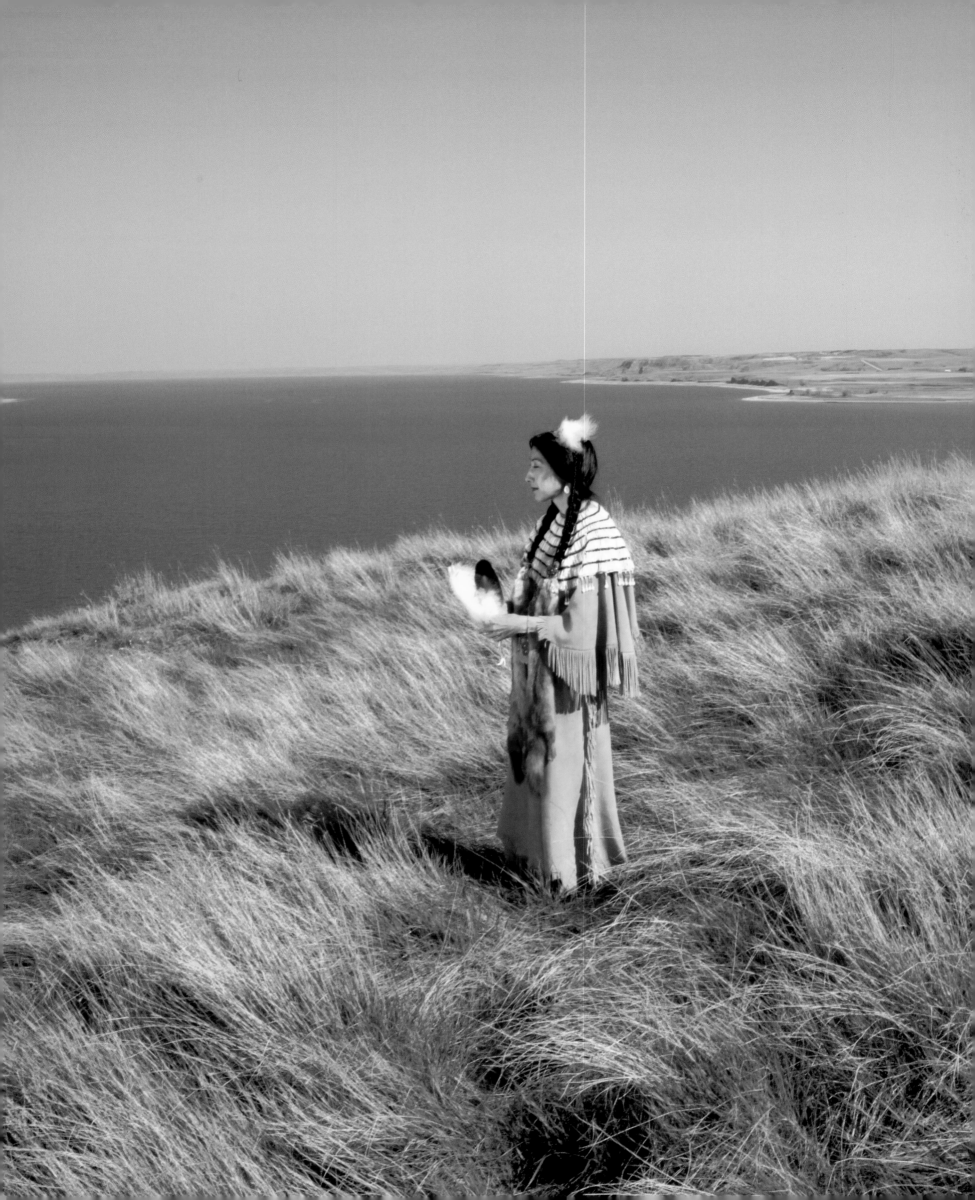

NEW TOWN, NORTH DAKOTA
Amy Mossett, a Mandan Indian and director of Tourism for the Three Affiliated Tribes at the Fort Berthold Indian Reservation feels a deep connection to Indian guide Sacagawea. In 1804, when Lewis and Clark wintered on the Missouri River in North Dakota on their way west, they met Sacagawea, who was living with Amy's relatives. It was there that Sacagawea joined the celebrated expedition.
Photo by Jason Lindsey, JasonLindsey.com

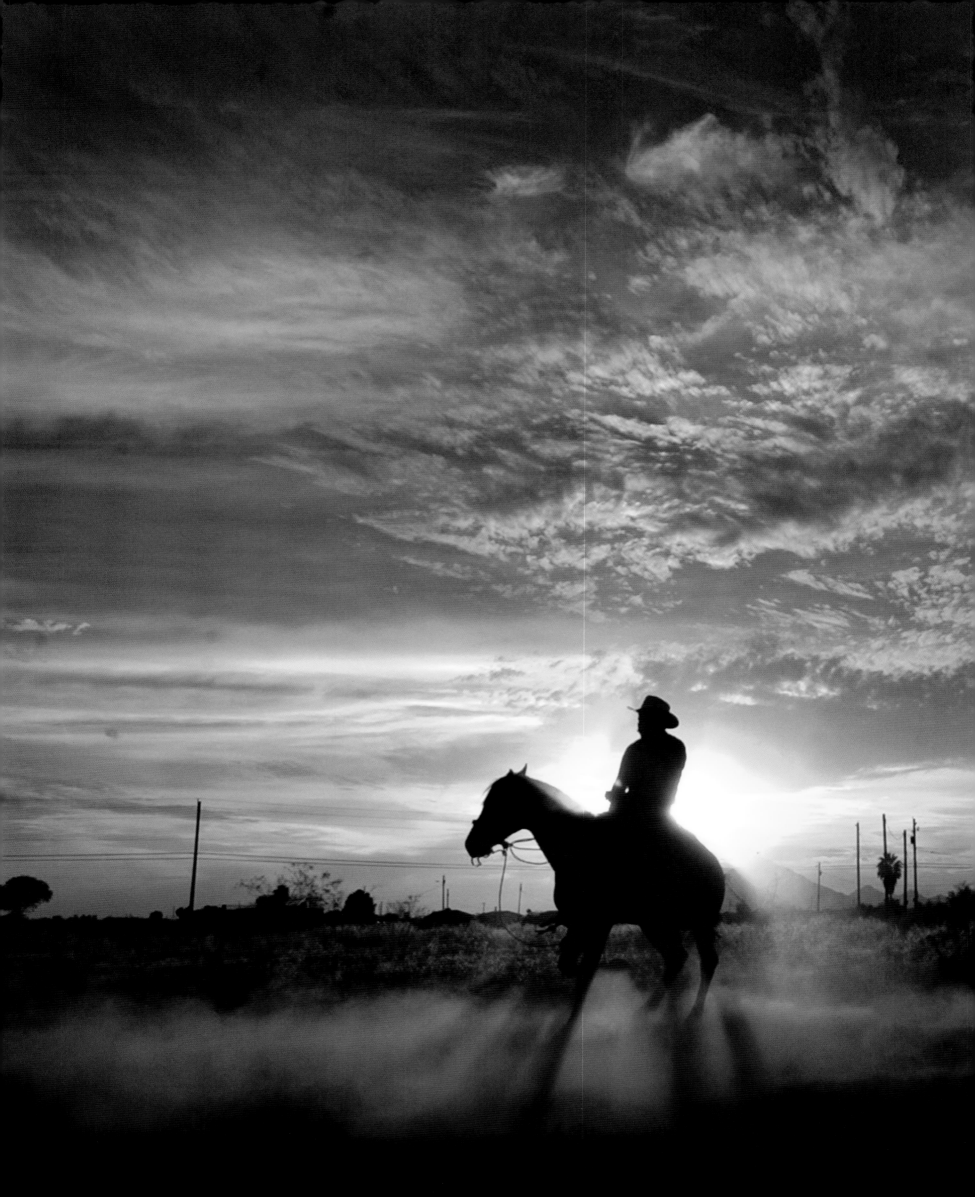

SALT RIVER, ARIZONA
Pascual Valadez, 35, trains two-year-old Thunderfoot at his brother's place at the Salt River Pima-Maricopa Indian Community near Phoenix. The community, created by Executive Order of President Rutherford B. Hayes in 1879, counts 7,000 people and 53,600 acres of land.

Photo by Michael Chow, The Arizona Republic

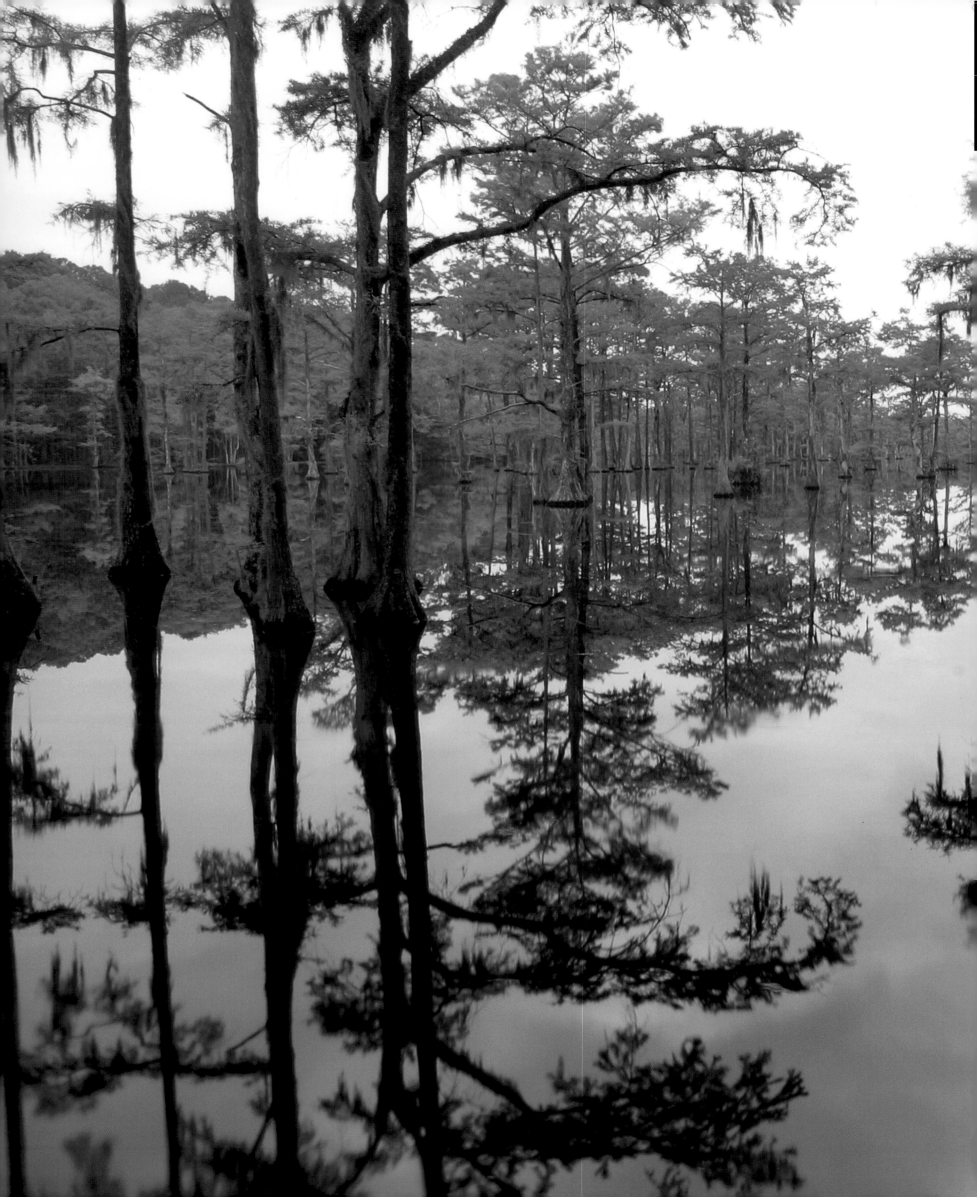

LAKE VIEW, SOUTH CAROLINA
In 1792, Zarv Ford built an earthen dam across Bear Swamp and created a 257-acre millpond. The banked waters powered mills that ground corn, bolted wheat, and milled lumber. The pond's current owners, Wade Huss and sister Alice Bost, allow fishing but no hunting in the cypress-dotted, unofficial preserve, called Page's Mill Pond since the Civil War.
Photo by Benton Henry

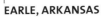

EARLE, ARKANSAS
Heavy rains drenched the rural town of Earle,
damaging or destroying at least 95 houses. The
flood waters wander through Derrick Edgerton's
living room, while friend Tyrone Nelson (looking
out the window) helps with the salvage effort.
Photo by Jim Weber

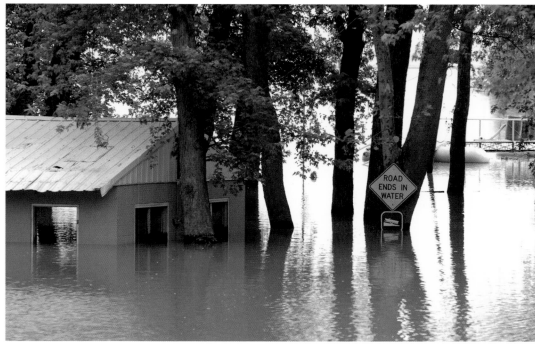

EVANSVILLE, INDIANA

Along the Ohio River, floods are a regular event, and residents go with the flow. For members of the Evansville Boat & Ski Club, located on a backwater by a bend in the river, heavy spring rains usually mean a few missed pleasure cruises. A memorable exception was the flood of 1997, which cost millions in property damage and killed at least 20 people.
Photo by Denny Simmons

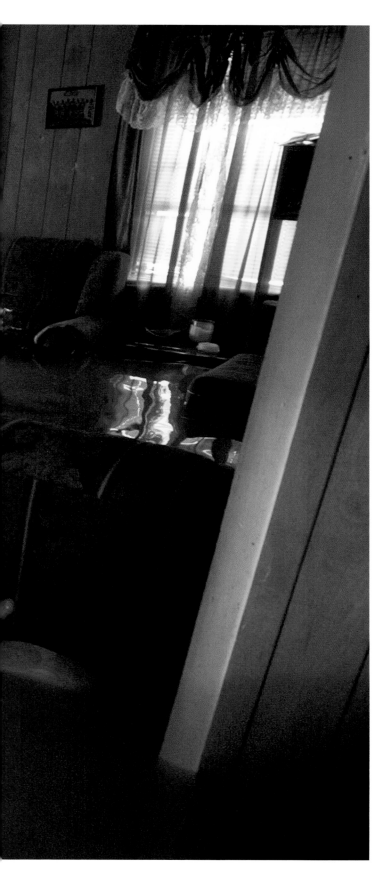

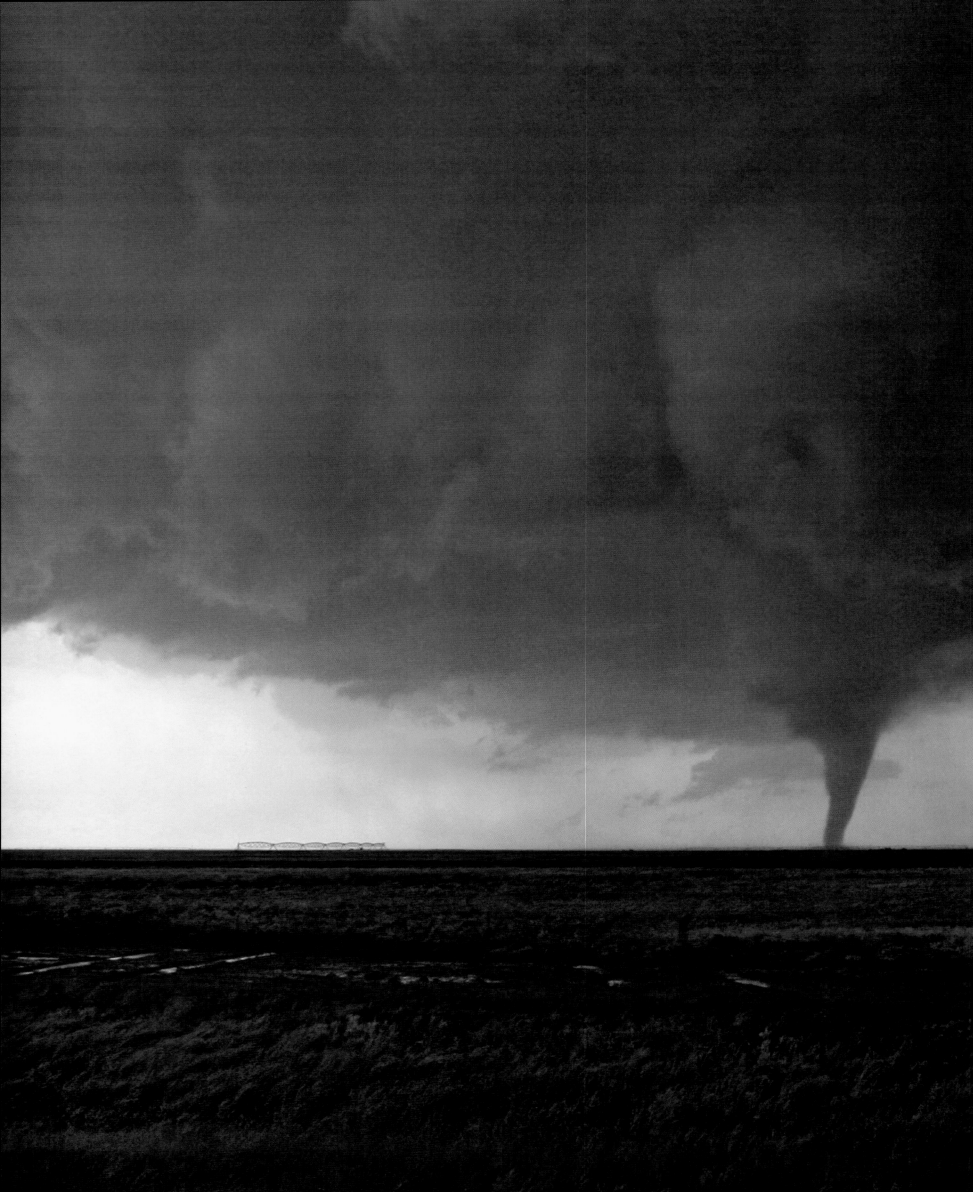

CONLEN, TEXAS
Thunderstorms, softball-sized hail, and
tornados work their way across northern
Texas into Oklahoma on May 15. Over a span
of nearly eight hours, a record 26 tornadoes
appeared in the Texas and Oklahoma
panhandles, surpassing the previous 1995
record by three funnels. On average,
tornadoes cost the country nearly 100 lives
and more than $290 million each year.
Photo by Kyle Gerstner

SOUTH PEKIN, ILLINOIS
Clara Jones tenderly touches the piano—all that's left of the Bible Holiness Church her parents founded 17 years ago. In four minutes, a severe funnel storm wreaked havoc in South Pekin (pop. 1,162), destroying homes and the church. The tornado cut a swath across central Illinois, damaging more than 178 homes in 20 towns before stopping 100 miles short of Chicago.
Photos by Fred Zwicky

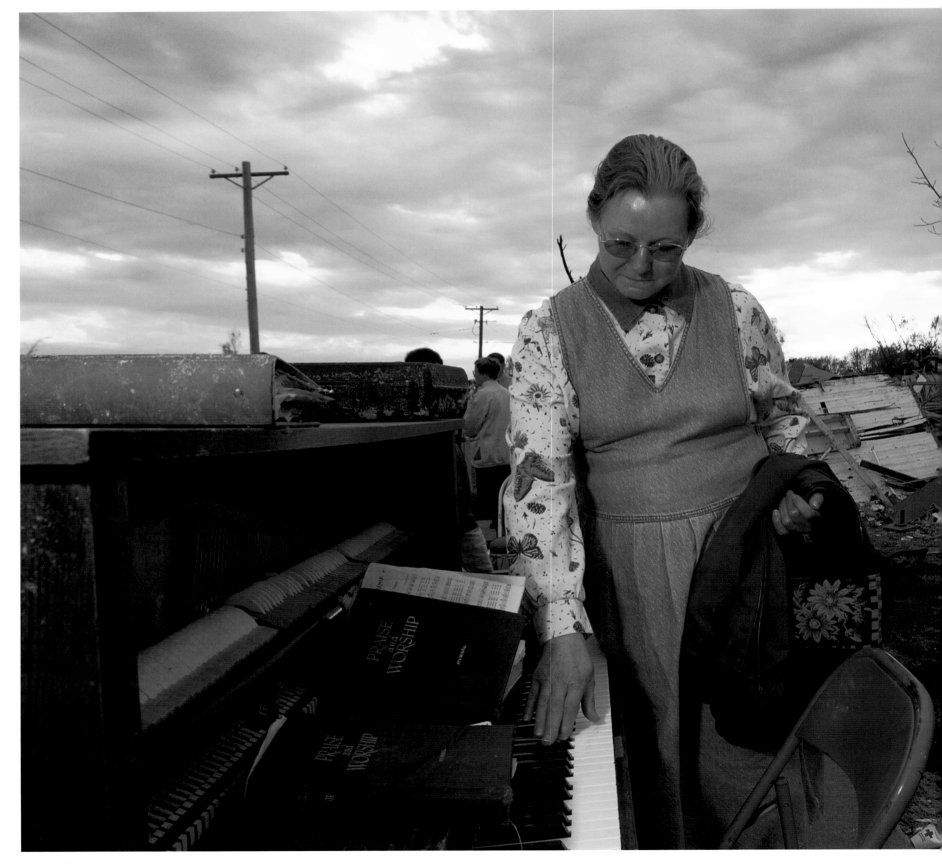

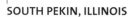

SOUTH PEKIN, ILLINOIS
Three days after a devasting F3 tornado,
(winds of up to 200 mph) battered the town of
South Pekin on May 10, the Reverend Wayne
Knipmeyer led a final service on his church's
foundations. Pledging to rebuild, the pastor
noted that despite the terrifying ordeal, "God is
good and we have survived."

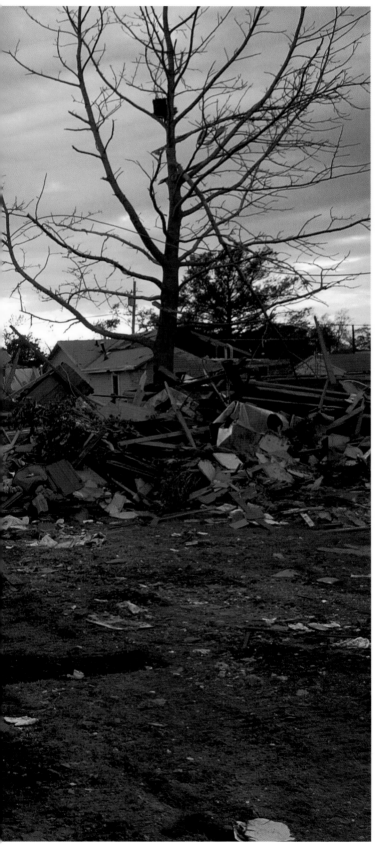

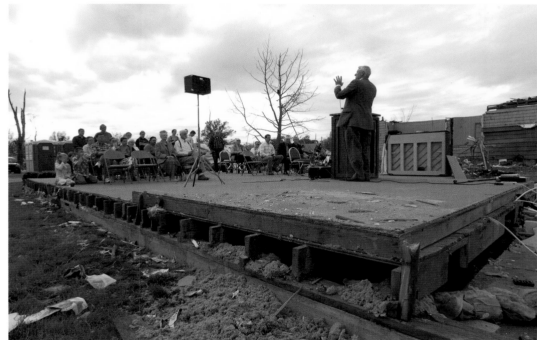

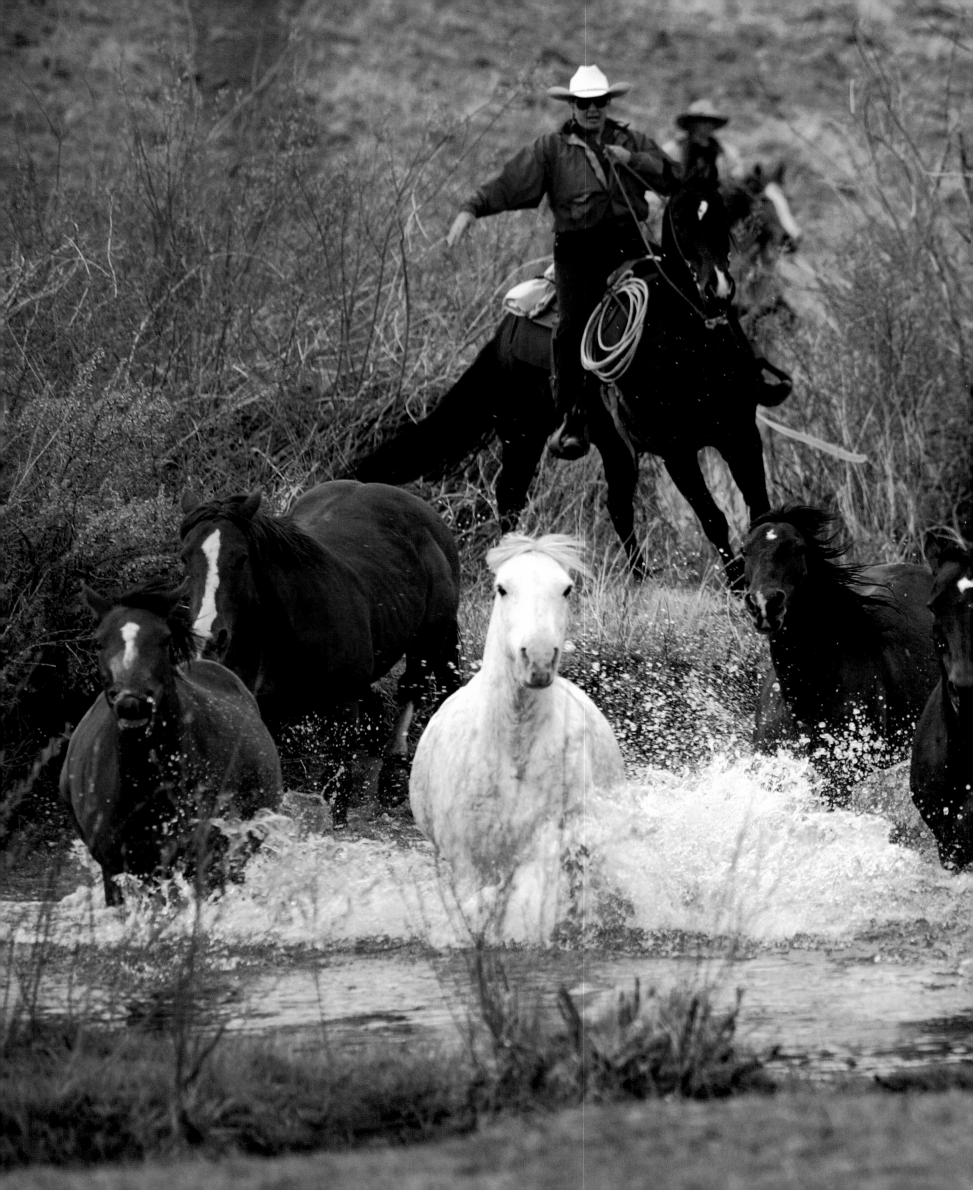

SPRINGERVILLE, ARIZONA
Cowgirl Wink Crigler and her sister are the only two women in eastern Arizona's White Mountains who own and run large ranches. Crigler, seen here driving her horses back to the barn, inherited the land from her grandparents, who started ranching in 1880. She raises horses and cattle, rents cabins to city slickers, and has built a log-cabin museum to teach schoolchildren local history.
Photo by Don B. Stevenson, www.arizonapix.com

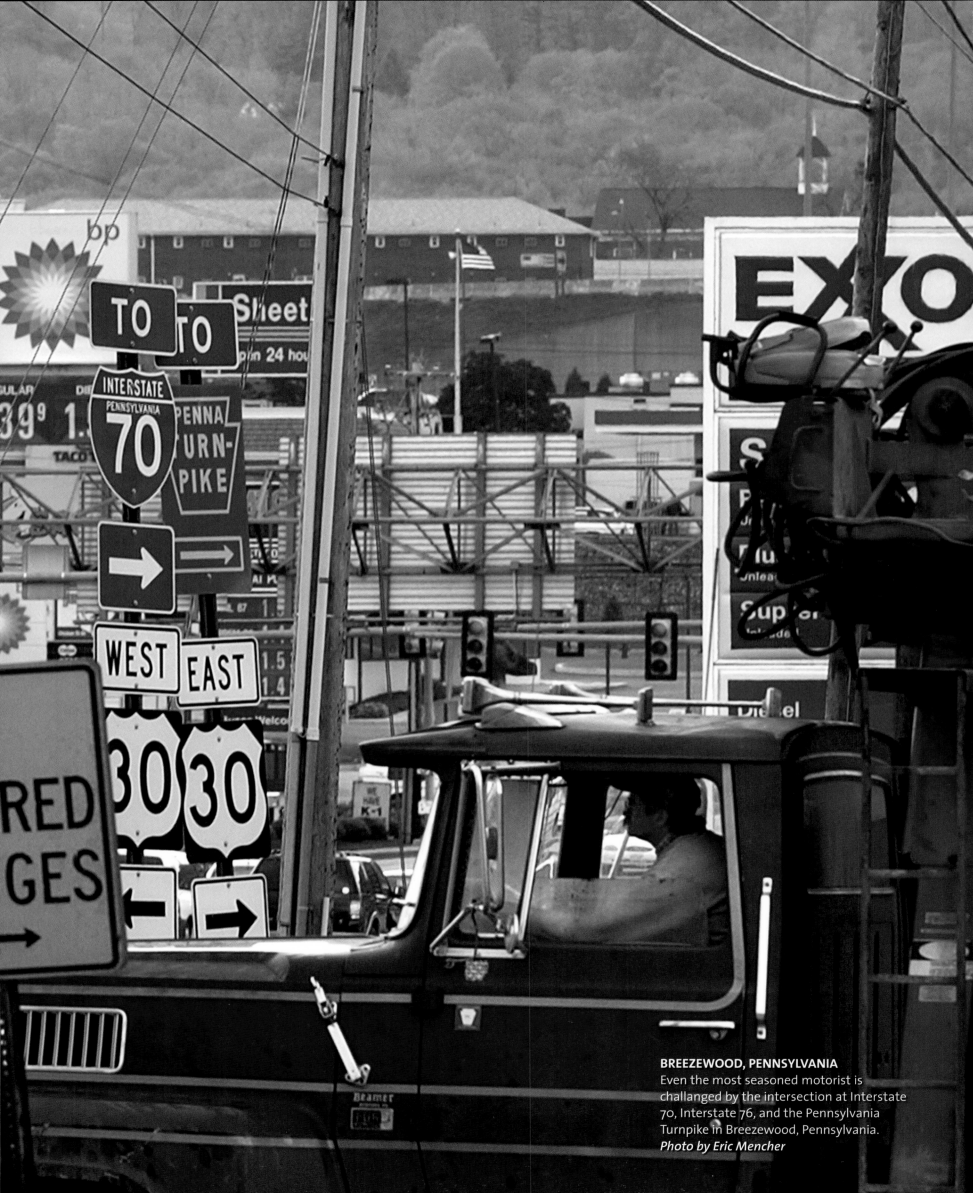

BREEZEWOOD, PENNSYLVANIA
Even the most seasoned motorist is challanged by the intersection at Interstate 70, Interstate 76, and the Pennsylvania Turnpike in Breezewood, Pennsylvania.
Photo by Eric Mencher

MT. RAINIER, WASHINGTON
According to volcanologists, 14,409-foot
Mount Rainier is the most dangerous volcano
in the Cascades. It's steep, swathed in a thick
blanket of ice and snow, and looms above the
densely populated Seattle-Tacoma metro-
politan area (pop. 3.5 million). Its most recent
eruption: 2,200 years ago, a geological blink
of the eye.
Photo by Nathan Myhrvold

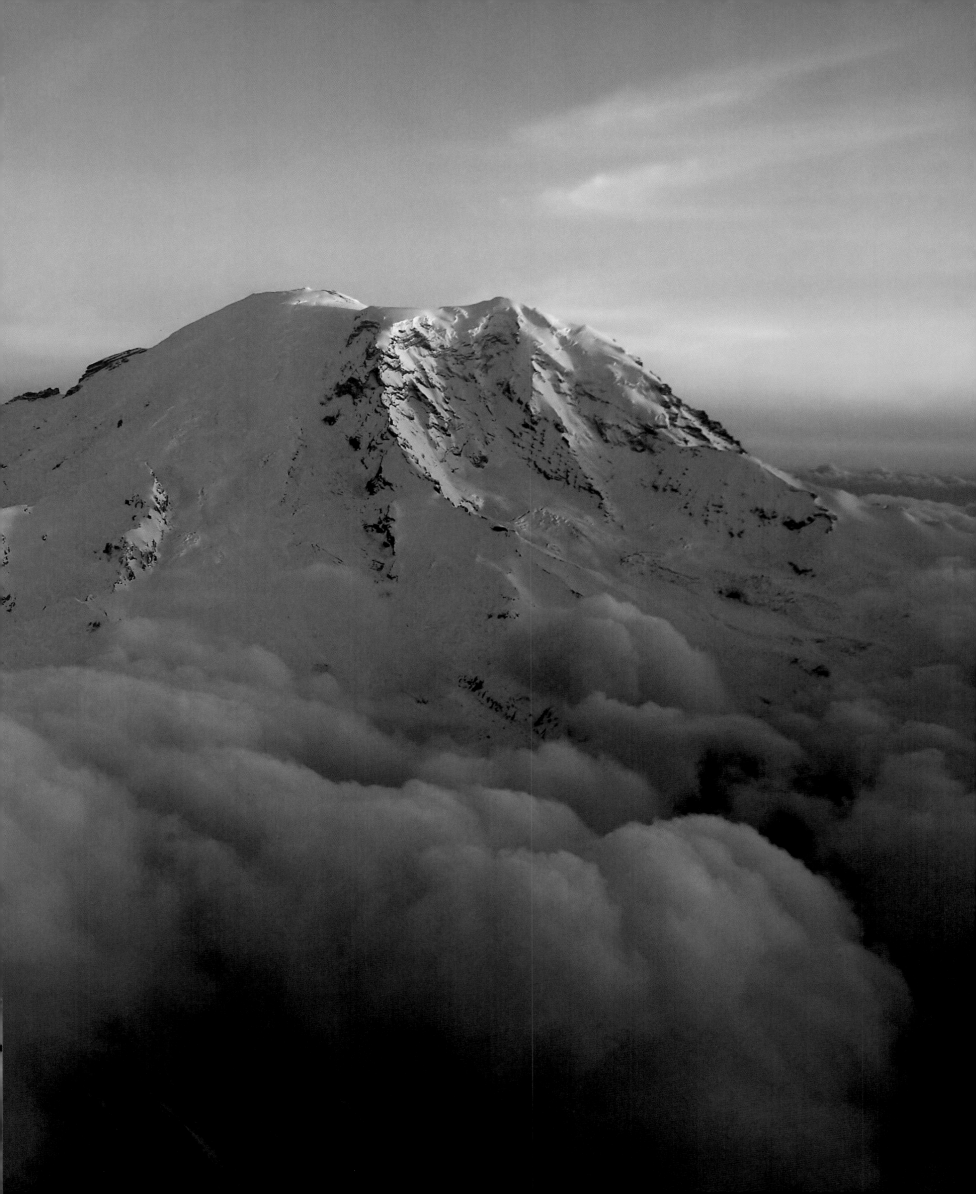

FORT LEE, NEW JERSEY
High above the Hudson River, painters
apply 35,000 gallons of gray paint to the
72-year-old George Washington Bridge, one
of the busiest in the country. The three-year,
$54 million project is part of a post-9/11,
$9.5 billion investment in metropolitan
New York's transportation systems.
Photo by James W. Anness

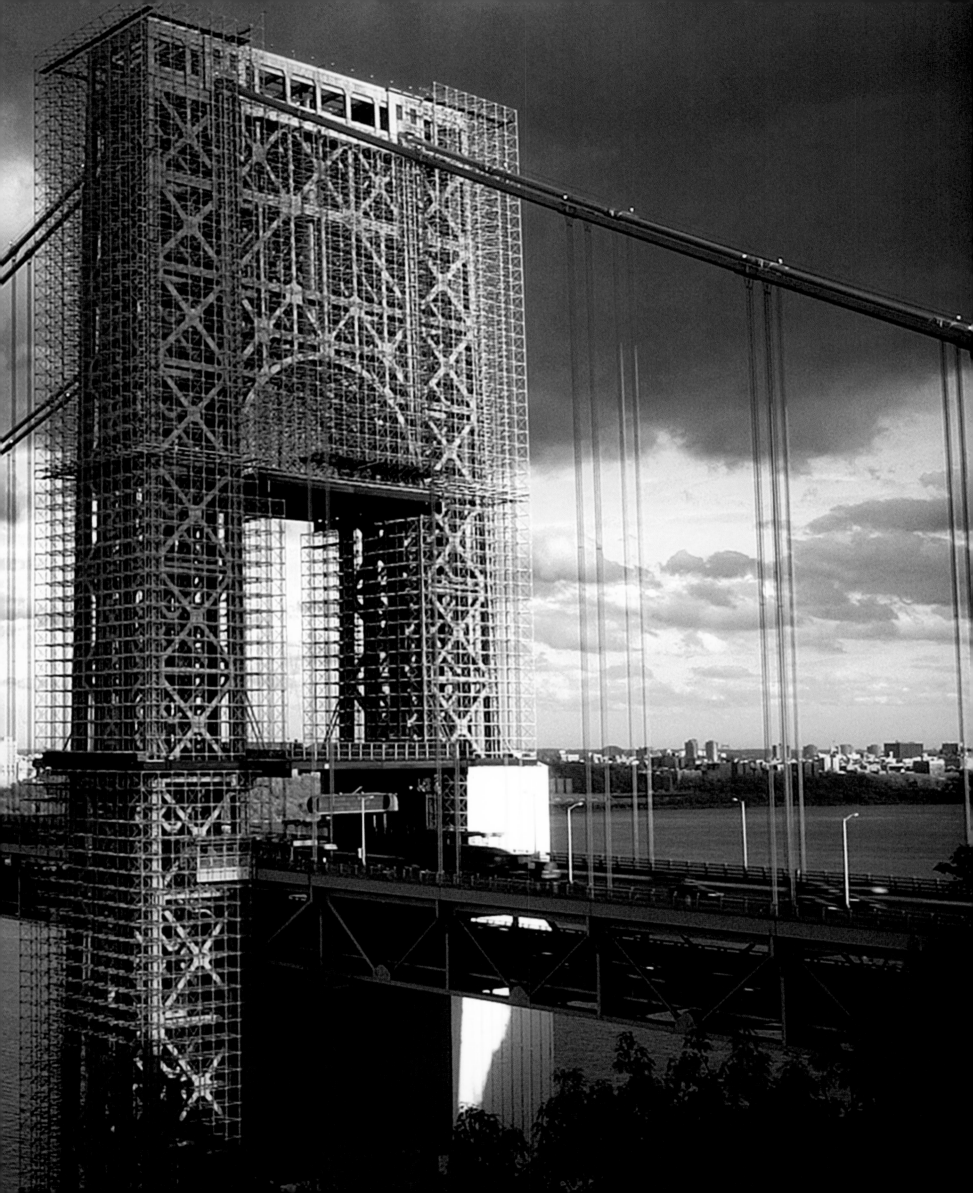

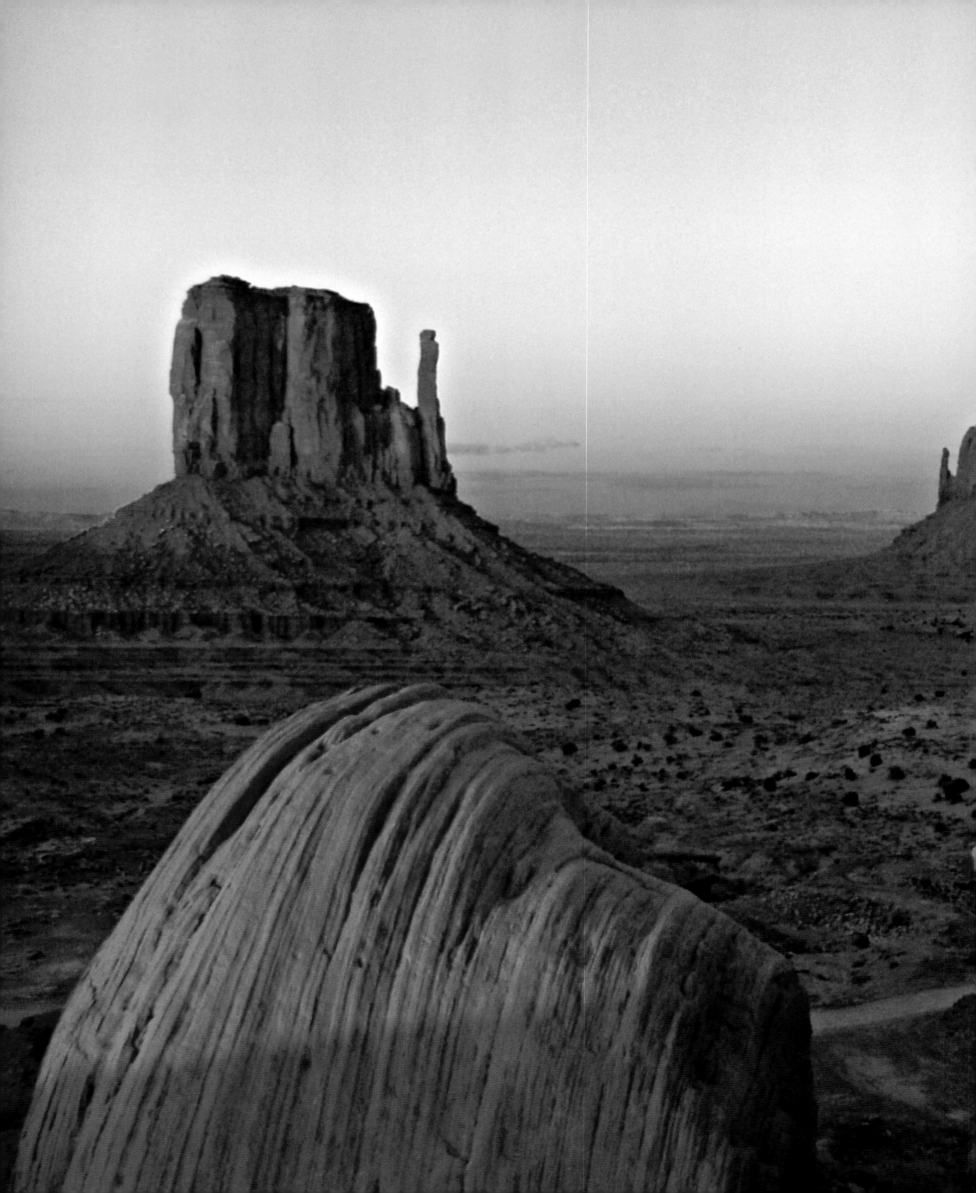

MONUMENT VALLEY, ARIZONA
The Dine'h (Navajo) people call the lands of
Monument Valley Tse' Bii'nidzisgai. Now a
tribal park operated under the auspices of
the Navajo Nation, the area's dramatic mesas
and buttes are primal shapes in the American
consciousness. Lorna Daniels, a Dine'h woman
who has lived in the area her entire life says,
"You should see the place after a snowfall."
Photo by Larry C. Price

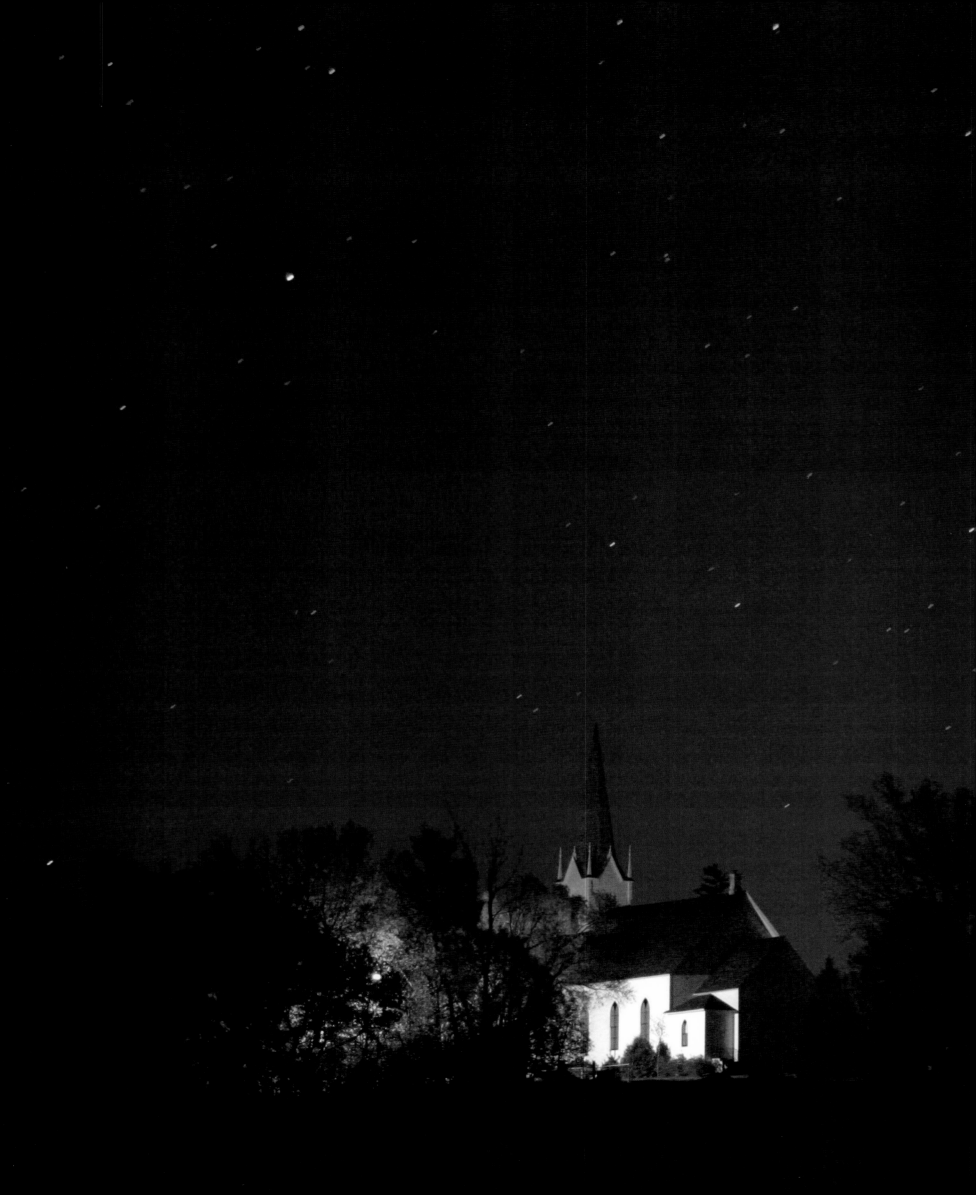

NERSTRAND, MINNESOTA
Celestial spectacle: The prairie sky glows with starlight and a full moon, just as the blurry shadow of the earth begins to darken the moon's face, on its way to a full eclipse.
Photo by Brian Peterson,
The Minneapolis Star-Tribune

The week of May 12-18, 2003, more than 25,000 professional and amateur photographers spread out across the nation to shoot over a million digital photographs with the goal of capturing the essence of daily life in America.

The professional photographers were equipped with Adobe Photoshop and Adobe Album software, Olympus C-5050 digital cameras, and Lexar Media's high-speed compact flash cards.

The 1,000 professional contract photographers plus another 5,000 stringers and students sent their images via FTP (file transfer protocol) directly to the *America 24/7* website. Meanwhile, thousands of amateur photographers uploaded their images to Snapfish's servers.

At *America 24/7*'s Mission Control headquarters, located at CNET in San Francisco, dozens of picture editors from the nation's most prestigious publications culled the images down to 25,000 of the very best, using Photo Mechanic by Camera Bits. These photos were transferred into Webware's ActiveMedia Digital Asset Management (DAM) system, which served as a central image library and enabled the designers to track, search, distribute, and reformat the images for the creation of the 53 books, foreign language editions, web and magazine syndication, posters, and exhibitions.

Once in the DAM, images were optimized (and in some cases resampled to increase image resolution) using Adobe Photoshop. Adobe InDesign and Adobe InCopy were used to design and produce the 53 books, which were edited and reviewed in multiple locations around the world in the form of Adobe Acrobat PDFs. Epson Stylus printers were used for photo proofing and to produce large-format images for exhibitions. The companies providing support for the *America 24/7* project offer many of the essential components for anyone building a digital darkroom. We encourage you to read more on the following pages about their respective roles in making *America 24/7* possible.

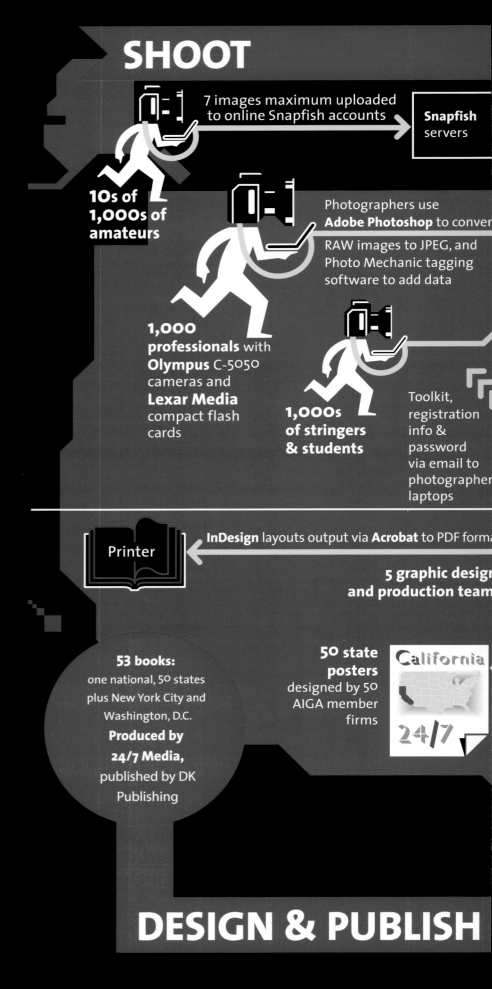

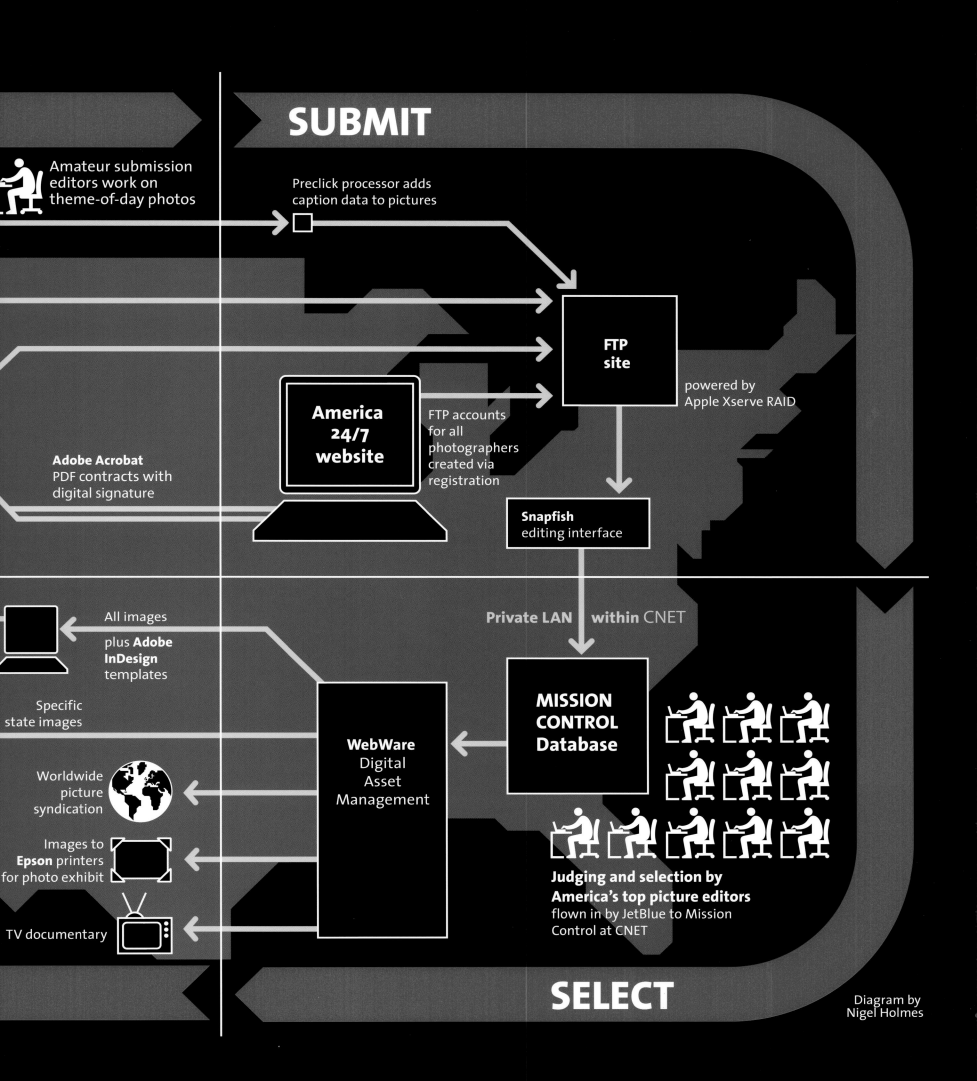

SUBMIT

Amateur submission editors work on theme-of-day photos

Preclick processor adds caption data to pictures

FTP site

powered by Apple Xserve RAID

America 24/7 website

FTP accounts for all photographers created via registration

Adobe Acrobat PDF contracts with digital signature

Snapfish editing interface

All images plus **Adobe InDesign** templates

Specific state images

Private LAN within CNET

Worldwide picture syndication

WebWare Digital Asset Management

MISSION CONTROL Database

Images to **Epson** printers for photo exhibit

Judging and selection by America's top picture editors flown in by JetBlue to Mission Control at CNET

TV documentary

SELECT

Diagram by Nigel Holmes

About the Sponsors

Adobe

America 24/7 gave digital photographers of all levels the opportunity to share their visions of what it means to live in the United States. This project was made possible by a digital photography revolution that is dramatically changing and improving picture-taking for professionals and amateurs alike. And an Adobe product, Photoshop®, has been at the center of this sea change.

Adobe's products reflect our customers' passion for the creative process, be it the photographer, graphic designer, layout artist, or printer. Adobe is the Publishing and Imaging Software Partner for *America 24/7* and products such as Adobe InDesign®, Photoshop, Acrobat®, and Illustrator® were used to produce this stunning book in a matter of weeks. We hope that our software has helped do justice to the mythic images, contributed by well-known photographers and the inspired hobbyist.

Adobe is proud to be a lead sponsor of *America 24/7*, a project that celebrates the vibrancy of the American spirit: the same spirit that helped found Adobe and inspires our employees and customers to deliver the very best.

Bruce Chizen
President and CEO
Adobe Systems Incorporated

OLYMPUS

Olympus, a global technology leader in designing precision healthcare solutions and innovative consumer electronics, is proud to be the official digital camera sponsor of *America 24/7*. The opportunity to introduce Americans from coast to coast to the thrill, excitement, and possibility of digital photography makes the vision behind this book a perfect fit for Olympus, a leader in digital cameras since 1996.

For most people, the essence of digital photography is best grasped through firsthand experience with the technology, which is precisely what *America 24/7* is about. We understand that direct experience is the pathway to inspiration, and welcome opportunities like this sponsorship to bring the power of the digital experience into the lives of people everywhere. To Olympus, *America 24/7* offers a platform to help realize a core mission: to deliver and make accessible the power of the digital experience to millions of American photographers, amateurs, and professionals alike.

The 1,000 professional photographers contracted to shoot on the *America 24/7* project were all equipped with Olympus C-5050 digital cameras. Like all Olympus products, the C-5050 is offered by a company well known for designing, manufacturing, and servicing products used by professionals to perform their work, every day. Olympus is a customer-centric company committed to working one to one with a diverse group of professionals. From biomedical researchers who use our clinical microscopes, to doctors who perform life-saving procedures with our endoscopes, to professional photographers who use cameras in their daily work, Olympus is a trusted brand.

The digital imaging technology involved with *America 24/7* has enabled the soul of America to be visually conveyed, not just by professional observers, but by the American public who participated in this project—the very people who collectively breath life into this country's existence each day.

We are proud to be enabling so many photographers to capture the pictures on these pages that tell the story of who we are as a nation. From sea to shining sea, digital imagery allows us to connect to one another in ways we never dreamed possible.

At Olympus, our ideas have proliferated as rapidly as technology has evolved. We have channeled these visions into breakthrough products and solutions to meet the demands of our changing world—products like microscopes, endoscopes, and digital voice recorders, supported by the highly regarded training, educational, and consulting services we offer our customers.

Today, 83 years after we introduced our first microscope, we remain as young, as curious, and as committed as ever.

LEXAR *Media™*

Lexar Media has grown from the digital photography revolution, which is why we are proud to have supplied the digital memory cards used in the *America 24/7* project. Lexar Media's high-performance memory cards utilize our unique and patented controller coupled with high-speed flash memory from Samsung, the world's largest flash memory supplier. This powerful combination brings out the ultimate performance of any digital camera.

Photographers who demand the most from their equipment choose our products for their advanced features like write speeds up to 40X, Write Acceleration technology for enabled cameras, and Image Rescue, which recovers previously deleted or lost images. Leading camera manufacturers bundle Lexar Media digital memory cards with their cameras because they value its performance and reliability.

Lexar Media is at the forefront of digital photography as it transforms picture-taking worldwide, and we will continue to be a leader with new and innovative solutions for professionals and amateurs alike.

EPSON

Photography is not just about carrying a camera and capturing images. Photography gives people the chance to relive their memories. The best way to do that is to show and share the final product, which is the print. Epson's digital technology helps photographers of all skill levels realize their passion for photography by giving them not only stunning image quality but also control that they never had with a lab. The newest Epson technology also provides longevity that exceeds most traditional photographic technology, enabling photographers to preserve their photos for generations. So, while you can enjoy other photographers' work in this book, Epson printers enable you to enjoy your own work for years to come.

Special thanks to additional contributors: Digital Pond, FileMaker, Apple, Camera Bits, LaCie, Now Software, Preclick, Outpost Digital, Xerox, Microsoft, WoodWing Software, net-linx Publishing Solutions, Radical Media, and Hilton Tokyo.

Online support provided by: AmericanPhotojournalist.com, BET.com, DigitalJournalist.org, DigitalPhotoContest, Gay.com, Military.com, OnRequest Images, OutbackPhoto.com, pcphotoREVIEW.com, PhotographyREVIEW.com, PhotoSource International, PlanetOut.com, TakeGreatPictures.com, ThirdAge.

The San Francisco photo edit—"Mission Control"—was generously hosted by CNET Networks Inc.; The Savoy Hotel, San Francisco; The Pan Pacific, San Francisco; Four Seasons Hotel, San Francisco; XYZ Restaurant; Ponzu; Café Pescatore; Tommy's Joynt; SKYY Vodka; *San Francisco Chronicle*; Mez Design; Odwalla, Inc.; and Debbie Does Dinner.

snapfish

Snapfish, which developed the technology behind the *America 24/7* amateur photo event, is a leading online photo service, with more than 5 million members and 100 million photos posted online. Snapfish enables both film and digital camera owners to share, print, and store their most important photo memories, at prices that cannot be equaled. Digital camera users upload photos into a password-protected online album for free. Users can order film-quality prints on professional photographic paper, for as low as 25¢. Film camera users get a full set of prints, plus online sharing and storage, for just $2.99 per roll.

jetBlue AIRWAYS

JetBlue Airways is proud to be *America 24/7*'s preferred carrier, flying photographers, photo editors, and organizers across the United States.

Winner of Condé Nast Traveler's Readers' Choice Awards for Best Domestic Airline 2002, JetBlue provides friendly service and low fares for travelers in 22 cities in nine states across America.

On behalf of JetBlue's 5,000 crew members, we're excited to be involved in this remarkable project, and for the opportunity to serve American travelers each and every day, coast to coast, 24/7.

Google

Google's mission is to organize the world's information and make it universally accessible and useful.

With our focus on plucking just the right answer from an ocean of data, we were naturally drawn to the *America 24/7* project. The book you hold is a compendium of images of American life distilled from thousands of photographs and infinite possibilities. Are you looking for emotion? Narrative? Shadows? Light? It's all here, thanks to a multitude of photographers and writers creating links between you, the reader, and a sea of wonderful stories. We celebrate the connections that constitute the human experience and are pleased to help engender them. And we're pleased to have been a small part of this project, which captures the results of that interaction so vividly, so dynamically, and so dramatically.

WEBWARE

WebWare Corporation is pleased to be a major sponsor of the *America 24/7* project. We take pride in being part of a groundbreaking adventure that is stretching the boundaries—and the imagination— in digital photography, digital asset management, publishing, news, and global events.

Our ActiveMedia Enterprise™ digital asset management software is the "nerve center" of *America 24/7*, the central repository for managing, sharing, and collaborating on the project's photographs. From photo editors and book publishers to 24/7's media relations and marketing personnel, ActiveMedia provides the application support that links all facets of the project team to the content worldwide.

WebWare helps Global 2000 firms securely manage, reuse, and distribute media assets locally or globally. Its suite of ActiveMedia software products provide powerful media services platforms for integrating rich media into content management systems marketing and communication portals; web publishing systems; and e-commerce portals.

Contributors, Advisors, and Friends

Alexandra Able
James Able
Sophia Able
Zachary Able
Valeria Accioly
Eddie Adams
Dan Adler
Hassan Ahdab
David Akin Vin Alabiso
Nick Alesandro
Pam Alexander
Karen Allen
Liz Allen
Monica Almeida
Stewart Alsop
Craig Anderson
Jane Anderson
Mark Anderson
Chris Angerame
Bob Angus
Lark Anton
Jeff Appleman & Suzanne Engleberg
Kay Arentsen
Sam Arkin
Joe G. Armstrong
Dorothy & Herb Asherman
Mark Atchley
Marie-Francoise Audouard
Jessica Bak
Tim Bajarin
Corinne Baldassano
Kipp Baratoff
Pam Barnett
Brigitte Barkley
John Battersby
Jane Bay
Rob & Erin Becker
Bob Beckerle
Eve Beckerle
Scott Beechuk
Brigitte Belanger
Keith Bellows
Ron Berg
Amy Bernstein
Roger Bessmeyer
Tom Bettag
Christy Betts
Jeff Bezos
Bipin & Bharti Bhayani
Carol Bidnick
Susie Biehler
Mark & Gogo Bierdon
Helen & Peter Bing
Meredith Birkett
Nanette Bisher
Roger Black
Martha Blanchfield
Larry Bleiberg
Donna & Web Blessley
Brigid Breen
Mayor Michael R. Bloomberg
Margaret Blumen
Amy Bonetti
Annie Boulat
Michael Bourne
Russell Brady
Stewart Brand
Toni Brayer, M.D. & Craig Patterson
Barbara & Stew Brenner
Jill Brevda
Sergey Brin
Fred Brink
Doug Brooks

Brian Browdie & Karen Loew
Lois & Jerry Browdie
Sandy & Leonard Browdie
Bruce Brown
James Brown
JoBeth Brown
Bruce Brownstein
Matt Bruno
Chuck Burgess
Matt Burgess
Mike Burgess
Kathy Bushkin
Rick Byers
Christina Cahill
Kathleen Cairney
Woodfin Camp
Natalie Carpenter
Chris Carstens
Todd Carter
Tork Carver
Frank Casanova
Steve Case
Dylan Casey
Jeffrey Cassaro
Jason Cavalli
Fiona B. Chambers
Ani Chamichian
Eric Chinje
Bruce Chizen
Jeannie & Saul Chosky
Arta Christiansen
Dale & June Christiansen
Tom & Barbara Christopher
Gary Christophersen
Alfred Chuang
Helen Churko
Vincent Cimino
George Clack
Leigh Claxton
Bethany Clement
Steve Coate
William Coblentz
Wren Coe
Dan & Stacy Cohen
Kara Cohen
Lucas Cohen
Norman & Hannah Cohen
Steve Cohen
William G. K. Cohen
Rick Colcock
Johnny & Shannon Colla
Chuck & Paula Collins
Jimmy Colton
Carol Cone
Seamus Conlan
Kevin Connor
Heather Cooney
Guy Cooper
Elizabeth Corcoran
W. Don Cornwell
Adam, Jamie & Josh Costello
Janake & Heine Costello
Saner Cotte Acosta
Anne-Marie Couderc
Don Crabb
George Craig
Scott Crist
Richard & Bettina Cullen
Andy Cunningham
Richard Curtis
Ari Cushner
Judith & John Cushner
Yogen Dalal

Bahman Dara
Ann Day & Spencer Reiss
Sky Dayton
Ariane de Bonvoisin
Steve de Bonvoisin
Michele de Jonghe
Marielle Dean
Manuel Antonio DeCastro
Teresa DeCastro
Cliff Deeds
Jay DeFoore
Yasmine Delawari
Helene DeLillo
Ray & Barbara DeMoulin
Wendie Demuth
Joy DiBenedetto
Bob & Gene Dickman
Rebecca Dietz
Katherine Dillon
Walter Dods
John Doerr
Sharon Doherty
Liz Dolan
Debbie Donnelly Robinson
Sheila Donnelly
Bill Douthitt
Debbie & Burtch Drake
Arnold Drapkin
Donna Dubinsky
Chris Dubuque
Hank Duderstadt
Dan Dunbo
Bryn Dyment
Melissa Dyrdahl
Esther Dyson
Oscar Dystel
Lois & Mark Eagleton
Kevin Eans
Ayperi Ecer
Gareth Edmondson-Jones
Doug Edwards
Lemur Efelyan
Ruth Eichorn
Dick & Mina Eisenberg
Jeff Elias
Brian Elliott
Nick Ellis
Luke Ellison
Katherine Ely
Emotion Studios
Rohn & Jeri Engh
Michela English
Debbie Epstein
Jeff & Sue Epstein
Andrew Erlichson
CJ & Erik Erwitt
David & Sherri Erwitt
Ellen Erwitt
Elliot Erwitt
Sasha & Amy Erwitt
Kim Evans
John & Joice Fairchild
James Fallows
Daniel & Elinore Farber
Joe Farber
Gabriele & Aubrey Federal
Mike Federle
Phil & Lisa Feldman
Julie Felner
Skip Ferderber
Carrie Ferguson
Marcie Ferias
Vicki Ferrando

Laurie Finch
George & Ann Fisher
Kathy & Michael Fitzgerald
Jerry Flanagan
Ben Fong-Torres
Steve Forbes
Lilibet Foster
John Fox
Steve Fowler
Michael Fragnito
Tom Frank
Shoshana Friedman
Zhenya & Yury Friedman
David Friend
Peter & Margot Friend
Fabien Fryns
Rachel Fudge
Jason Fujii
Dale Fuller
Mary Furlong
Johnny Furr
John Gage
Ezra Galbraith
Lisa Gansky
Alicia Garcia
Oscar Garcia
Nate Garhart
Mathieu Gasquy
Betty Ann Gathard
Gene Gathard
Jackson Gathard
Scott Geffert
Tricia Gellman
Hans Gerhardt
Pheme Geyer
Alex Gigante
Miles Gilburn
Stephen Gillett
Dan Gillmore
Alexis Girard
John Girard
Hope Gladney
Bill Gladstone
Annie Gladue
Rob Glaser
Kiva & Ari Gluck
Peter Goggin
Bette Jean Goldblum
Dr. John & Asmita Goldblum
Philip & Lauren Goldblum
Tracey Goldblum
Steven Goldenberg
David Gonski
Maria Gonzalez Mabutt
Eric Goodstadt
Andrew Gore
Bill & Mary Agnes Grant
Chris Grant
Pat & Mary Grant
Taylor Gray
Becky Green
Heather Green
Jeff Greenwald
Richard Grefé
Julie Grist
Joshua Grossnickle
Louise Gubb
Lisa Guidetti
Chris Gulker
Jim Gustke
John Hagel III
David Hagerman
Brad Hajim

Corey Hajim
Deron Haley
Maggie Hallahan
Charles Hamilton
Doug Haner
Beverly Hanly
Takashi Hara
Sarah Harbutt
Mary Clyde Hardin
Charles Hardwick
Acey Harper
Jay Harris
John Harrison
Linda Hart
Russell Hart
Andrew & Ellen Hathaway
Selma Hauser
Steve Hawksworth
Mike Hawley
Nigel Healy
Will Hearst
Jim Heeger
Kate Heery
Jim Heiser
Terri Henderson
Dan Hennes
Linda Herrera
Carolyn Herter
James Higa
Bill Higgins
Danny Hillis
Paul Hilts
Peter Hirschberg
Steve Holms
Robert Hood
Nick & Linda Hoppe
Justin Horner
Ron & Cheryl Howard
John Huey
Steve Huey
Holly Hughes
Loopy Hughson
Jeff Hunter
Bill Hutton
Lindsey & Paul Iacovino
Dr. Clyde Ikeda
Christopher Ireland
Kim Isola
Shel Israel
Vern & Pigeon Iuppa
John E. Jacob
Rita Jacobs
Veronique Jacobs
Lauren Jaeger
Ariel Jakobovits
Kia Jam
Mary Jamie
Glen Janssens
Peter Jennings
Lisa Jervis
Garrett Jewett
James Joaquin
Steve Jobs
AJ Johnson
Allison Johnson
Judith & Richard Johnson-Marsano
Marsha & Dennis Johnson
Audrey Jonckheer
Eric Jones
Randy Jones
Vyomesh Joshi
Bill Joy
Dorothy Kalins
Anna Kamdar & Todd Simmons
Devyani Kamdar
Dipu, Dipti & Usha Kamdar
Ketan, Shilpa & Amit Kamdar
Paresh & Viren Kamdar

Prabhakar P. Kamdar
Pravin Kamdar
Vinoo & Chitra Kamdar
Mira Kamdar & Michael Claes
Jill & Steve Kantola
Raj Kapoor
Mitchell Kapor
Ivan Kashinski
Donald Katz
Merlee Katzman
Ann & Jim Kauffman
Guy & Beth Kawasaki
Dr. Alan Kay
Midge Keator
Larry Keeley
Wendy Keller
Kevin Kelly
Thomas Keneally
Rob Kenneally
Heather Kennedy
Tom Kennedy
Paul Kent
Mike Kesl
Elizabeth Kieszkowski
Vinod Khosla
Reuel Khoza
Heather King
Mervyn King
Douglas & Francoise Kirkland
Robert Kirschenbaum
Laurence Kirshbaum
Michael Kleeman
Harlan & Sandy Kleiman
Neal Klein
Carol Klinger
John Knaur
Kent Kobersteen
Jamie Kohler
Eli Kollman
Janet Kornblum
Jesse Kornbluth
Julieanne Kost
Kristin Kovacic
Lisa Kovner
Tony Krantz
Kevin Kratzberg
Tom Kunhardt
Kaku & Sumiko Kurita
Scott Kurnit
Nicole & Rich Kutchai
Mark Kvamme
Lizellen La Follotte
Stephanie Laffont
Michael Lai
Terrell Lamb
Michael Lambert
Bryan Lamkin
Mario Lamorte
Jerry Lamprecht
Sonia Land
Judy Lang
Arthur Langhaus
Mickey Lass
Ken Lassiter
Bronwen Latimer
Sheldon & Nancy Laube
Andy Lax
Geraldine Laybourne
Kit Laybourne
Rosemarie Layton
Martin Lee
Suzette Lee
Sarah Leen
Stephanie LeGras
Joe & Marney Leis
Thomas Leistiko
Joel Leivick
Amy Lemley

Peter Leon
Ted Leonsis
Rick LePage
Jean-Francois LeRoy
David Levin
Lori Levin
Bob Levitus
Steve Levy
Dan'l & Susan Lewin
Barry Lewis
Cathy Lewis
Huey Lewis
Mary Lewis
Jay Lewis-Kraitsik
Josh Liberman
Marlane Liddell
David Liddle
Dan Liebowitz
Martin Light
Ann Lloyd
Tom and Brenda Lloyd
John & Susan Lloyd-Karrel
John Loengard
Don Logan
Henry S. Long, Jr.
Arty Longhaus
Julie Look
Joe Lorenz
Tim Lovett
Sharon Lucas
Gerd Ludwig
Paul Lundahl
Walter & Mari Lurie
Eric Lustman
David Lyman
Dan Lynch
Kelly Lyon
Diane Macdonald
John & Diana Mack
Sandy Mackie
Michelle Madden
Michael Madrid
Larry Magid
Michael & Michelle Magnus
Eric Magnusson
Maureen Mahon Egen
Josh Mailman
Meir Malinsky
Robert Mallet
Kevin J. Mallon
Michael Malone
Lacey Mamak
Ian Manasco
Alan Mandell
Roger Mandle
Martin Manley
Al Manzello
Gerald Margolis
Van Maroevich
Brenda Marsh
Sallie Martin
Tom Masland
Nadja Masri
Davis Masten
Joe Matsau
Minoru Matsuzaki
Lucienne & Richard Matthews
CJ Maupin
John McAlester
Cindy McCaffrey
Andy & Holloway McCandless Belt
John McChesney
Robert McCullough
Linda McCutcheon
Maria McDonald
Nion McEvoy
Diane McGarry
Ric McGredy

Regis McKenna
Trigg McLeod
Roger McNamee
Scott McVay
Kevin McVea
Jack McWilliams
Mary Meeker
Charlie & Jessica Melcher
Jim & April Melcher
Liz Melcher
Tom Melcher
Alex Melnyk
Doug & Tereza Menuez
Pedro & Trisha Meyer
Norm Meyrowitz
Liz Michaels
Sharon Middendorf
Michael Miller
Nicole Miller
Pam Miller
Rand Miller
Robert & Barbara Miller
Robyn Miller
Didier & Marie Claude Millet
Valérie Millet
Rich Miner
Kamran Mohsenin & Laura Sackett
Tiffany Mok
Scott Molinaroli
David & Lisa Monetta
Carlos Montalvo
Manny Monterrey
David Moody
Kathleen Moody
Paula Moore
Paul Moreno
Fiona Morrison
Vanessa Morrison
Ann Moscicki
Mary Moslander
Larry Moss
Murray Moss
Nora Lee Moss
Christopher Mulhauser
Dennis & Zora Muren
Randal T. Murray
Jason Murtha
Dave Nagel
Corinne Nagy
Hiroshi Nakamura
Lisa Naopoli
Graham Nash
Raymond Nasser
Eileen Naughton
Susan Naythons
Eric Nee
George Neill
Bill & Darrell Nelson
Grazia Neri
Michael Newler
Mark Nichols
Meredith Nicholson
Bambi Nicklen
Leonard Nimoy
Evan Nisselson
Chris Noble
Francesca Noli
Alan Norman
Alex Notides
Phillip & Jan Noyce
Brian & Lori Nuss
Erin O'Connor
Fearghal O'Dea
Dolores O'Donoghue
Joseph & Virginia O'Keefe
William O'Keefe
Peggy O'Leary
Dan O'Shea

Participating Photographers

Alabama
Coordinator: Walt Stricklin, Director of Photography, *The Birmingham News*

Philip Barr, *The Birmingham News*
Bob Farley, *Birmingham Post-Herald*
J. Mark Gooch
E. Vasha Hunt
Steven T. King
Jamie Martin
Michael Mercier, *The Huntsville Times*
Christine Prichard
Kiichiro Sato
Karim Shamsi-Basha, *Portico Magazine*
Joe Songer, *The Birmingham News*
Bill Starling, *Mobile Register*
Gary Tramontina
Patrick Witty
Hal Yeager, *The Birmingham News*

Alaska
Coordinator: Richard J. Murphy,* Director of Photography, *Anchorage Daily News*

Hall Anderson
James H. Barker
Fran Durner,* *Anchorage Daily News*
Mark Farmer, topcover.com
Robert Hallinen,* *Anchorage Daily News*
Jim Lavrakas,* *Anchorage Daily News*
Marc Lester, *Anchorage Daily News*
Charles Mason Photo, Corbis
Clark James Mishler
Stephen Nowers, *Anchorage Daily News*
Judy Patrick
Michael Penn*
David Predeger
Anne Raup, *Anchorage Daily News*
Bill Roth,* *Anchorage Daily News*
Jeff Schultz
Robert Stapleton, Jr.
Evan R. Steinhauser, *Anchorage Daily News*
Luciana Whitaker

Arizona
Coordinator: Mary Ann Nock, *The Arizona Republic*

John Annerino
Max Becherer, *Arizona Daily Star*
Michael Chow, *The Arizona Republic*
James Garcia
Adriel Heisey
Mark Henle, *The Arizona Republic*
Christine Keith
Tim Koors, *The Arizona Republic*
Stephen Marc, *Olympus Camedia Master*
Edward McCain, www.mccainphoto.com
Tricia McInroy, *Tucson Citizen*
Bob Rink
Ken Ross
David Sanders
Rob Schumacher, *The Arizona Republic*
Pat Shannahan, *The Arizona Republic*
Don B. Stevenson, www.arizonapix.com

Arkansas
Coordinator: Barry Arthur, Assistant Managing Editor, Photos, Electronic Media, *Arkansas Democrat-Gazette*

Alex Brandon
Robert T. Coleman
Chris Dean
Lori L. Freeze, *Stone County Leader*
Matt Hoyle
Ashlyn Jones
Benjamin Krain
Freddy Lea
John Loomis
Rick McFarland
Michelle Posey, *Arkansas Democrat-Gazette*
Russell Powell, *Arkansas Democrat-Gazette*
Richard Rasmussen, *The Sentinel-Record*
Karen E. Segrave, *Arkansas Democrat-Gazette*
Aaron Street
Stephen B. Thornton, *Arkansas Democrat-Gazette*
Mark Wilson

California
Coordinator: Susan Gilbert, Director of Photography, *San Francisco Chronicle*

PF Bentley, PFPIX.com
Nadia Borowski Scott, *The San Diego Union-Tribune*
Sisse Brimberg
Stephen Carr
Courteney Coolidge
Anna Marie Dos Remedios, *The Pinnacle*
Victor Fisher
Deanne Fitzmaurice, *San Francisco Chronicle*
Jim Gensheimer, *The San Jose Mercury News*
Paul F. Gero
Arthur Grace
Michael Grecco Photography, Icon International
Maggie Hallahan, Network Images
Josh Haner
Kurt Hegre
Robert Holmes
Jean Jarvis
Stephen Johnson
Ed Kashi
Paul Kitagaki, Jr.*
Laura Kleinhenz
Kim Komenich*
David Krider
Michael Lambert
Frans Lanting, www.lanting.com
Sheila Masson
William Mercer McLeod
Jim Merithew

David Paul Morris
Charles O'Rear
Darcy Padilla
Peggy Peattie, *The San Diego Union-Tribune*
Alon Reininger, Contact Press Images
Rick Rickman*
Brian D. Schultz
Meri Simon
Jan Sonnenmair, Aurora
H. Chris Stocker, Olympus Camedia Master
Patrick Tehan
Pep Ventosa
George Wedding, GEOPIX
Sean Williams

Colorado
Coordinator: Trevor Brown, Jr., Rich Clarkson & Associates

Jeffrey Aaronson, Network Aspen
Glenn J. Asakawa,* *The Denver Post*
Jay Dickman*
Barry Gutierrez,* *Rocky Mountain News*
David Harrison
Patrick Kramer, *Longmont Daily Times-Call*
Cliff Lawson
Michael S. Lewis
Peter Lockley
Ryan McKee
Andrea Modica, Marilyn Cadenboch Association
Kevin Moloney, Aurora
Larry C. Price*
Mark Reis, *The Colorado Springs Gazette*
Jamie Schwaberow, Rich Clarkson & Associates
Carl Scofield
Neal Ulevich*
Emily Yates-Doerr

Connecticut
Coordinator: Stephanie Heisler, Picture Editor, *The Hartford Courant*

Christian Abraham
Wendy Carlson
Peter Casolino
Anne Day
Sean D. Elliot, *The Day*
Bob Falcetti
John Kane, Silver Sun Studio
Catherine Karnow
Jonathan Olson
Cloe Poisson, *The Hartford Courant*
Patrick Raycraft
Marc-Yves Regis II, *The Hartford Courant*
George Ruhe
Jean Santopatre, Fairfield University
Andrew Douglas Sullivan
Rikki Ward

Delaware
Coordinator: Oswaldo Jimenez, Editor, Worldfoto.org

Jonathan Blair
William Bretzger
Monique Brunsberg
Fred Comegys
Jennifer Corbett
Pat Crowe II, *The News Journal*
Gary Emeigh, *The News Journal*
Kevin Fleming
Joey Gardner
Chuck McGowen, Freelance
Scott Nathan
Tom Nutter
Ginger Wall, *The News Journal*

District of Columbia
Coordinator: Pete Souza, National Photographer, *Chicago Tribune*

Susan Biddle
Khue Bui*
André F. Chung, Iris PhotoCollective
Stephen Crowley
Cameron Davidson
Chuck Kennedy, Knight Ridder/Tribune
Jim Lo Scalzo, *U.S. News & World Report*
Marie Poirier Marzi
Stephanie Maze, Maze Productions, Inc.
Paul Morse, The White House
Andy Nelson
Jonathan Newton
Robert A. Reeder, *The Washington Post*
Peter Steinhauer
Chris Usher, Apix

Florida
Coordinator: Sherman Zent, Photo Editor, *St. Petersburg Times*

Bruce R. Bennett
Gary Bogdon
Cheryl Anne Day-Swallow
Jon M. Fletcher, *The Florida Times-Union*
Jamie Francis, *St. Petersburg Times*
Jacek Gancarz, *Palm Beach Daily News*
Red Huber, *Orlando Sentinel*
Kelly Jordan, *Daytona Beach News-Journal*
Andrew Kaufman, Contact Press Images
Lisa Krantz, *Naples Daily News*
Chip Litherland, *Sarasota Herald-Tribune*
Craig Litten
Melissa Lyttle
Preston Mack
Gary McCracken, *Pensacola News Journal*
John Moran
Julian Olivas
Beth Reynolds, The Photo-Documentary Press, Inc.
Phil Sears, *Tallahassee Democrat*
David Spencer, *The Palm Beach Post*

Angel Valentin,*
South Florida Sun-Sentinel
Nuri Vallbona, *The Miami Herald*
Ben Van Hook
Dan Wagner

Georgia
Coordinator: Rich Addicks, Staff
Photographer,
The Atlanta Journal-Constitution

Tova R. Baruch
Rob Carr
Flip Chalfant
Tami Chappell
Curtis Compton
Gene Driskell
Jonathan Ernst
Greg Foster
Karekin Goekjian
Ben Gray
Joey Ivansco
Rachel LaCour Niesen
Stephen Morton, stephenmorton.com
Andrew Niesen
Laura Noel
Dot Paul
Steven Schaefer
Jean Shifrin
Jamie Squire
Sunny H. Sung,
The Atlanta Journal-Constitution

Hawaii
Coordinator: David Ulrich, Pacific New
Media, University of Hawaii

Warren Bolster, Getty Images
Deborah Booker, *Honolulu Advertiser*
David S. Boynton
Richard A. Cooke III
Monte Costa
Ron Dahlquist
Tami Dawson, Photo Resource Hawaii
Peter French
Michael Gilbert
Sergio Goes
Ed Greevy
Randy Hufford, www.visualimpact.org
Sabra Kauka
George F. Lee
Wayne Levin
G. Brad Lewis
Val Loh
Dennis Oda, *Honolulu Star-Bulletin*
Phil Spalding
Brett Uprichard
Jeff Widener

Idaho
Coordinator: Kim Hughes,
Photojournalist, *The Idaho Statesman*

Steve Bly, Bly Photography
Rajah Bose
Robert Bower, *Post Register*
Chris Butler
Chad Case, Idaho Stock Images
Geoff Crimmins,
Moscow-Pullman Daily News
Randy G. Hayes, *Post Register*

Jason Hunt, *Coeur d'Alene Press*
Katherine Jones, *The Idaho Statesman*
Barry Kough, *Lewiston Tribune*
Troy Maben
Gerry Melendez
Kyle Mills
William H. Mullins
Glenn Oakley, www.oakleyphoto.com
Darin Oswald
Bruce Shields
Thomas W. Volk

Illinois
Coordinator: Steve Warmowski, Photo
Editor, *Jacksonville Journal-Courier*

Chuck Cass
Chris Curry, *Journal Star*
Robert A. Davis, *Chicago Sun-Times*
Heather Edwards
Alex Garcia*
Troy T. Heinzeroth
Greg Hess
Michael Hettwer
Michael Hudson
Steve Jahnke
Denise Keim
Tim Klein
Juli Leonard
Joel N. Lerner
Jon Lowenstein, Aurora
Devin Miller, *The Courier*
Todd Mizener
T.J. Salsman, *The State Journal-Register*
Tom Sistak
Clayton Stalter
Scott Strazzante, *Chicago Tribune*
Stuart Thurlkill
Fred Zwicky

Indiana
Coordinator: Mike Fender, Director of
Photography, *The Indianapolis Star*

Tim Bath, *Kokomo Tribune*
Ellie Bogue
Matt Detrich, *The Indianapolis Star*
Michael Heinz
Jeremy Hogan
Kurt Hostetler, *The Star Press*
Steve Linsenmayer,
The Fort Wayne News-Sentinel
Jeffrey D. Nicholls
Frank Oliver
David Pierini, *The Herald*
Vincent Pugliese
Steve Raymer
Jeri Reichanadter
Denny Simmons
Tom Strickland
Dan Uress

Iowa
Coordinator: John Gaps III, Director of
Photography, *The Des Moines Register*

Clint Austin
Harry Baumert, *The Des Moines Register*
Mike Brunette
Jeff Bundy, *Omaha World-Herald*

Alex Dorgan-Ross
Gary Fandel
John Gaines, *The Hawk Eye*
Mark Hirsch, *Telegraph Herald*
Dave Kettering, *Telegraph Herald*
Charlie Neibergall, Associated Press
Buzz Orr
David Peterson
Brian Ray, *The Gazette*
Jeff Storjohann
Rodney White
Danny Wilcox Frazier
Kevin R. Wolf
Heidi Zeiger

Kansas
Coordinator: Bill Snead, Senior Editor,
The Lawrence Journal-World

Thad Allender
David Doemland
Kyle Gerstner
Kelly Glasscock
Steven Hausler
Reed Hoffmann, Freelance
Tim Janicke
Jill Jarsulic, *The Wichita Eagle*
Nick Krug, *The Topeka Capital-Journal*
Chris Landsberger,
The Topeka Capital-Journal
Karen Lee Mikols
Sandra J. Milburn
Chris Ochsner, *The Kansas City Star*
Jaime Oppenheimer, *The Wichita Eagle*
Earl Richardson
Charlie Riedel, Associated Press
Rich Sugg
Dan White*
Mike Yoder, *The Lawrence Journal-World*

Kentucky
Coordinator: Bill Luster,* Senior
Enterprise Photographer, Associate
Photo Editor, *The Courier-Journal*

Jeanie Adams-Smith, Western Kentucky
University
Charles Bertram
Tim Broekema,* Western Kentucky
University
David Coyle
Dan Dry
Ron Garrison
John Isaac
James H. Kenney, Western Kentucky
University
David R. Lutman
Pat McDonogh*
Patrick L. Pfister, pfoto.com
David Robertson
Jim Roshan, jimroshan.com
Pam Spaulding
David Stephenson
Chad Allen Stevens, Western Kentucky
University
Sam Upshaw, Jr.
Ken Weaver
Janet Worne, *Lexington Herald-Leader*

Louisiana
Coordinator: David Grunfeld, Staff
Photographer, *The Times-Picayune*

Neil Alexander, neilphoto.com
Kathy Anderson
Laura L. Coe
Michael Dunlap
Terri Fensel
Philip Gould
Chris Granger
Ted Jackson,* *The Times-Picayune*
Arthur D. Lauck
Andy Levin
Kristy May
Tim Mueller
Sanford Myers
Leslie Parr, Loyola University New
Orleans
Frank J. Relle
Mark Saltz
Mike Silva, *The Times*
David G. Spielman
Dave Stueber
Jennifer Zdon, *The Times-Picayune*

Maine
Coordinator: José Azel, Aurora

Kevin Bennett
Bridget Besaw Gorman, Aurora
Robert F. Bukaty*
John Paul Caponigro
Thatcher Hullerman Cook, Thatcher
Cook Photography
Alexandra C. Daley-Clark
Jim Daniels
Stephen M. Katz
Alison Langley
James Marshall, Corbis
David McLain, Aurora
Shawn Patrick Ouellette
Chris Pinchbeck, Pinchbeck Photography
Gregory Rec
Michele Stapleton
Jeffrey Stevensen
Amy Toensing
Nance S. Trueworthy
Carl D. Walsh, Aurora
Shoshannah White, Aurora

Maryland
Coordinator: Jim Preston, Assistant
Managing Editor for Photography,
The Baltimore Sun

Shannon Bishop
Jim Burger
Mary F. Calvert
Amy Deputy
Laurie DeWitt
Dennis Drenner
John Ficara
Kevin T. Gilbert, Blue Pixel
David Harp, Chesapeake Photos
Nanine Hartzenbusch,*
The Baltimore Sun
Craig Herndon
Judy Herrmann, Herrmann & Starke
Jerry Jackson

Doug Kapustin, *The Baltimore Sun*
Chiaki Kawajiri
Gunes Kocatepe
Rick Kozak, kofoto
Matt Mendelsohn
James W. Prichard
Susana Raab
Scott Robinson
Michael Starke, Herrmann & Starke
Perry Thorsvik

Massachusetts
Coordinator: Steve Haines, Assignment Editor, *The Boston Globe*

Sarah Brezinsky
Jim Davis
Vincent DeWitt, *Cape Cod Times*
Sean Dougherty
Geoff Forester Photography
Bill Greene, *The Boston Globe*
Steve Heaslip, *Cape Cod Times*
Jodi Hilton
Cheryl Koralik
Michele McDonald
Arnold Miller, *Cape Cod Times*
Amy Newman, Freelance
Nancy Palmieri
Peter Pereira
Arthur Pollock, *Boston Herald*
Evan Richman, *The Boston Globe*
Ron Schloerb
Essdras M. Suarez,* *The Boston Globe*
Matt Suess, Freelance
Laurie Swope

Michigan
Coordinator: Steve Jessmore, Chief Photographer, *The Flint Journal*

Nancy Andrews, *Detroit Free Press*
Mark Bugnaski, *Kalamazoo Gazette*
Lisa DeJong, *The Flint Journal*
Bruce Edwards, *The Flint Journal*
J. Carl Ganter, MediaVia
Hugh Grannum
Andrew Johnston
Sylwia Kapuscinski
J. Kyle Keener, *Detroit Free Press*
Brian Masck, *The Flint Journal*
Kent Miller, *The Bay City Times*
Cory Morse, *Muskegon Chronicle*
Barbara Neller
David Olds
Jeffrey Sauger, Reflex News
Jeff Schrier
Chip Somodevilla, *Detroit Free Press*
Ken Stevens, *Muskegon Chronicle*
Donna Terek, *The Detroit News*
Leisa Thompson, *The Ann Arbor News*
Chad Warner
Ryan Wood, *Midland Daily News*
Lance Wynn, *The Grand Rapids Press*

Minnesota
Coordinator: Christina Paolucci

Bill Alkofer
Kimm Anderson
Raoul Benavides
John L. Cross, *The Free Press,* Mankato

Carlos Gonzalez
Stormi Greener
Judy Griesedieck
Richard Hamilton Smith
Kyndell Harkness
Renée Jones, *Owatonna People's Press*
Andy King
Ken Klotzbach
Richard Marshall
Ann Arbor Miller
Brian Peterson,
The Minneapolis Star-Tribune
Darlene Pfister Prois
Dean Riggott, www.riggottphoto.com
Joe Rossi
Dawn Villella
Thomas Whisenand

Mississippi
Coordinator: Chris Todd,* Photo Director, *The Clarion-Ledger*

Jonathon Alford
Steve Coleman
Melanie Duncan Thortis,
The Vicksburg Post
Ben Hillyer, *The Natchez Democrat*
Greg Jenson, *The Clarion-Ledger*
Stephen Kirkpatrick
Mike McEwen
Leilani H. Pope
J.D. Schwalm
Marianne Todd
Thomas Wells
Taylor Wilson

Missouri
Coordinator: Larry Coyne, Director of Photography, *St. Louis Post-Dispatch*

David M. Barreda, University of Missouri
Lisa Waddell Buser
Robert Cohen, *St. Louis Post-Dispatch*
Dean Curtis
Sara Andrea Fajardo
Eric Keith
Brian W. Kratzer, University of Missouri
Ival Lawhon, Jr.
Bob Linder
Tammy Ljungblad
Dawn Majors, *St. Louis Post-Dispatch*
L.G. Patterson
Teak Phillips
Andrea Haley Scott,
St. Louis Post-Dispatch
Sherry Skinner
Laurie Skrivan, *St. Louis Post-Dispatch*
Chris Stanfield
Jessica A. Stewart
Todd Weddle
Seth Wenig

Montana
Coordinator: Keith Graham, Professor, University of Montana

Daniel Armstrong, New Rider Print
Tom Bauer
William Campbell
Dudley Dana, Dana Gallery
Jennifer DeMonte

David Grubbs
Kenneth Jarecke, Contact Press Images
Todd Korol
John W. Liston, *Great Falls Tribune*
Doug Loneman, Loneman Photography
Robin Loznak
Jeremy Lurgio
Larry Mayer
Erik Petersen
Derek Pruitt, *The Montana Standard*
Steven G. Smith*
Teresa L. Tamura, University of Montana
John Warner, *Billings Gazette*
Kurt Wilson

Nebraska
Coordinator: George Tuck, College of Journalism and Mass Communications, University of Nebraska–Lincoln

Jeff Beiermann, *Omaha World-Herald*
Bob Berry
Ken Blackbird
George Burba
Doug Carroll
Crystal Corman
Kiley Cruse
Darin Epperly
Bill Ganzel
Lane Hickenbottom
Laura Inns
Mikael Karlsson, arrestingimages.com
Scott Kingsley
Matt Miller
Gerik Parmele
Kent Sievers
Josh Wolfe
Richard Wright
Randy Zuke

Nevada
Coordinator: Jim Laurie, Director of Photography, Stephens Press

Lin Alder, alderphoto.com
Larry Angier
Amy Beth Bennett
Jessica Brandi Lifland
Dan Burns, nofearfotos.com
Joe Cavaretta
Jim K. Decker, *Las Vegas Review-Journal*
Misha Erwitt
John Gurzinski
Naomi Harris
Lindsay Hebberd, Cultural Portraits Productions, Inc.
John Locher
Sam Morris
Marilyn Newton, *Reno Gazette-Journal*
Scott Sady, *Reno Gazette-Journal*
Scott T. Smith

New Hampshire
Coordinator: Ben Garvin, Staff Photographer, *The Concord Monitor*

Deb Cram, *Portsmouth Herald*
Laura DeCapua
Bill Finney
Jamie Gemmiti, Cross Road Studio
Dan Habib, *The Concord Monitor*

Bob Hammerstrom
Jennifer Hauck
Don Himsel, *The Telegraph*
Steve Hooper
Nancy G. Horton
Lloyd E. Jones, *The Conway Daily Sun*
Jim Korpi
Bob LaPree, *The Union Leader*
Kathy Seward MacKay
Carrie Niland
Tom Rettig
Ken Williams, *The Concord Monitor*

New Jersey
Coordinator: Pim Van Hemmen, Assistant Managing Editor for Photography, *The Star-Ledger*

Peter Ackerman, *Asbury Park Press*
James W. Anness
Aristide Economopoulos,
The Star-Ledger
Najlah Feanny
Thomas E. Franklin
Sarah J. Glover, *The Philadelphia Inquirer*
Scott Lituchy, *The Star-Ledger*
Ellie Markovitch, *The Herald News*
Dennis McDonald, *Burlington County Times*
Ed Murray
Noah K. Murray
Danielle P. Richards
April Saul*
Shaul Schwarz, Corbis
Mia Song, *The Star-Ledger*
Daryl Stone, *Asbury Park Press*
Akira Suwa, *The Philadelphia Inquirer*
Jason Towlen
David M. Warren,
The Philadelphia Inquirer

New Mexico
Coordinator: Mark Holm, Director of Photography, *The Albuquerque Tribune*

Brett Butterstein
Esha Chiocchio
Carole Devillers
Phillippe Diederich
Michael J. Gallegos,
The Albuquerque Tribune
Miguel Gandert
Toby Jorrin, *The Albuquerque Tribune*
Marcia Keegan
Douglas Kent Hall
Karen Kuehn
Steve Northup
Wes Pope, *The Santa Fe New Mexican*
Eli Reed, Magnum Photos, Inc.
Jake Schoellkopf
Richard Scibelli, Jr.
Stacia Spragg, *The Albuquerque Tribune*
Jamey Stillings
Sterling Trantham, New Mexico State University
Barbara Van Cleve
Pat Vasquez-Cunningham
Jennah Ward

New York
Coordinator: David Frank, Deputy Picture Editor, *The New York Times*

Nancie Battaglia
John Bigelow Taylor
Jay Brenner, Brenner Lennon Photo
Douglas Dubler III
Jill Enfield
Paulo Filgueiras
Peter Freed
Mark Garten
Al Gilbert, C.M.
Lynn Goldsmith
Michael Groll
Patrick Harbron
Irene Horrigan
Lyn Hughes
Chava Kenny
Greg Kinch
Douglas Kirkland
Ian Macdonald-Smith
Lou Manna, Olympus Camedia Master
Doug Menuez, C.M.
Joel Meyerowitz
Michael J. Okoniewski
Carlos Ortiz, *Democrat and Chronicle*
Laurie Owens
Chris Ramirez
Kevin Rivoli
Rick Sammon
Shepard Sherbell, Corbis/SABA
Susan Stava
Will Yurman

New York City
Coordinator: Michele McNally, Picture Editor, *Fortune Magazine*

Associate Coordinators from *Fortune* magazine:
Sarah Beth Barnett
William Nabers
Scott Thode
Janene Outlaw
Alix Colow
Nakyung Han
Meaghan Looram
Mia Diehl
Courtenay Dolan

Gwen Akin
Alyson Aliano
Barbara Alper
Kristen Ashburn, Contact Press Images
Nina Berman
David Burnett, Contact Press Images
Martha Cooper
Lauren Fleishman
Frank Fournier, Contact Press Images
Jason Fulford
Elizabeth Gilbert
Craig Gordon
Mark Greenberg, WorldPictureNews
Philip Greenberg
Lori Grinker, Contact Press Images
Alicia Hansen
Eric Johnson
J-P Laffont
Andre Lambertson
Kristine Larsen

Gillian Laub
Michael Lee
Andrew Lichtenstein
Susan Liebold
Roxanne Lowit
Lauri Lyons
Joe McNally
Mark Peterson
Sylvia Plachy
Robert Polidori
Gus Powell
Jenny Schulder
Frank Schwere, BRANSCH INC.
Joseph Sywenkyj
Joyce Tenneson
Scott Thode
Jonathan Torgovnik
Nathaniel Welch

North Carolina
Coordinator: Patrick Davison,* Assistant Professor, Visual Communication, The University of North Carolina

Jason Arthurs
Cindy Burnham, Nautilus Productions
Bruce DeBoer
Ethan Hyman
Janet Jarman, Contact Press Images
Melody Ko
Scott Lewis
Corey Lowenstein
Logan Mock-Bunting
Susie Post Rust, Aurora
Christopher Record
Ted Richardson, *Winston-Salem Journal*
Patrick Schneider, *The Charlotte Observer*
Scott Sharpe
Gayle Shomer Brezicki
Ross Taylor
Ami Vitale
John L. White
Coke Whitworth

North Dakota
Coordinator: Colburn Hvidston III, *The Forum*, Fargo

Jerry Anderson
Dave Arntson
Susan Beehler
Sandee Gerbers
Darren Gibbins
Wayne Gudmundson
Ludvik Herrera
Eric Hylden, *Grand Forks Herald*
Chuck Kimmerle
Will Kincaid
Dan Koeck
Jason Lindsey, JasonLindsey.com
Jackie Lorentz
Mike McCleary
David Samson
John Stennes
Tom Stromme
Amy Taborsky, *Bismarck Tribune*
Heidi Weiss, *Minot Daily News*

Ohio
Coordinator: Larry Nighswander, School of Visual Communication, Ohio University

Eric Albrecht, *The Columbus Dispatch*
Stan Alost, Ohio University
Doral Chenoweth, *The Columbus Dispatch*
Bruce Crippen, *The Cincinnati Post*
Allan E. Detrich
Carolyn Drake
Terry E. Eiler, Ohio University
Albert P. Fuchs, Fuchs & Kasperek Photography
Lawrence Hamel-Lambert
Steve Hoskinson
Eustacio Humphrey
Larry Kasperek, Fuchs & Kasperek Photography
Dale Omori
Skip Peterson, *Dayton Daily News*
Patrick Reddy, *Cincinnati Enquirer*
Bill Reinke, *Dayton Daily News*
Uma Sanghvi
Bruce Strong, LightChasers
Jim Witmer, *Dayton Daily News*

Oklahoma
Coordinator: Doug Hoke, Director of Photo Technology, *The Daily Oklahoman*

Jaconna Aguirre, *The Daily Oklahoman*
Robert Billings
Nate Billings, *The Daily Oklahoman*
David Crenshaw
Anibal Cuervo
Michael Downes, *The Daily Oklahoman*
David G. Fitzgerald
Dan Hoke
Lisa Rudy Hoke
Stephen Holman
Kelly Kerr
R. E. Lindsey, Lindsey Enterprises, Inc.
Fred W. Marvel
David McNeese
Sarah Phipps
Paul Rutherford
Hugh Scott
Steve Sisney
Brandon Snider
Randy Stotler, *The Lawton Constitution*
Paul Taggart
Bryan Terry
Mark Zimmerman

Oregon
Coordinator: Michael Lloyd, *The Oregonian*

L.E. Baskow, *Portland Tribune*
Thomas Boyd
Gary Braasch
Stephen Brashear
Andy Bronson
Faith Cathcart, *The Oregonian*
Michael Durham, www.DurmPhoto.com
Bruce Ely

Rob Finch, *The Oregonian*
C. Bruce Forster
Dean Guernsey
Joni Kabana
Julie Keefe
John Klicker
Brian Lanker*
Karl Maasdam
Sol Neelman, *The Oregonian*
Susan Ochoa
Lou Sennick, *The World*
Stephen Voss
Ron Winn
Stephanie Yao, *The Oregonian*
Carol Yarrow

Pennsylvania
Coordinator: Clem Murray, Director of Photography, *The Philadelphia Inquirer*

John Beale, *Pittsburgh Post-Gazette*
Yoni Brook
Michael Bryant, Bryant Photo
Jason Cohn, www.jasoncohn.com
Butch Comegys, *The Scranton Times*
Gary Dwight Miller
Arturo Fernandez, *The Morning Call*
Sharon Gekoski-Kimmel
Christopher Glass, *York Daily Record*
Scott Goldsmith
Tom Gralish,* *The Philadelphia Inquirer*
Jack Hanrahan, *Erie Times-News*
Nick Kelsh
E.A. Kennedy 3rd, Image Works
Yischon Liaw
David Maialetti, *Philadelphia Daily News*
Steve Mellon, *Pittsburgh Post-Gazette*
Eric Mencher
Jennifer Midberry, *Philadelphia Daily News*
Annie O'Neill
Robin Rombach
Sean Simmers, *Harrisburg Patriot-News*
Vicki Valerio,* *The Philadelphia Inquirer*
Frank Wiese, *The Morning Call*
Michael S. Wirtz, *The Philadelphia Inquirer*

Rhode Island
Coordinator: Kevin Dilley, Creative Circle Media Consulting

Billy Black
Bob Breidenbach
Kris Craig
William K. Daby
John Forasté, ASMP & Creative Eye
John Freidah
Peter Goldberg
Erik Gould
Dave Hansen
Scott Kingsley
Mary Beth Meehan
Stew Milne
Jason O'Neal
Ruben W. Perez, *The Providence Journal*
Rob Pike
David H. Wells, www.davidHwells.com

*Pulitzer Prize winners

South Carolina
Coordinator: Anne McQuary, Photo Editor, *The Sun News*

Mark Adams
Travis Bell
Janet Blackmon Morgan
Tim Dominick, *The State*
Kim Kim Foster
Alan Hawes
Benton Henry
Jon Holloway
Takaaki Iwabu, *The State*
Keith Jacobs
Yalonda M. James
Keith Kenney
Diedra Laird, *Charlotte Observer*

South Dakota
Coordinator: Lloyd B. Cunningham, Senior Photographer, *The Argus Leader*

Steve Babbitt
Chad Coppess, South Dakota Tourism and State Development
Don Doll, S.J., Creighton University
Doug Dreyer, Dakota Images
Kevin Eilbeck
Val Hoeppner
Dick Kettlewell
Eric Landwehr
Greg Latza, peoplescapes.com
Steven McEnroe
Steven A. Page
Dave Sietsema
Johnny Sundby, Dakota Skies Photography
Mike Wolforth

Tennessee
Coordinator: Dennis Copeland,* Director of Photography, *The Commercial Appeal*

Jack Corn
Gary Heatherly
Mark Humphrey
Nancy Lee Andrews
Chad McClure
Lance Murphey
Patrick Murphy-Racey, pmrphoto.com
John Partipillo, *The Tennessean*
Karen Pulfer Focht
John Rawlston
John Russell, Maximum Exposure
Rusty Russell
Alan Spearman
Jim Weber
Billy Weeks
A.J. Wolfe

Texas
Coordinator: Joe Abell, Systems Editor, *San Antonio Express-News*

Henry Bargas, *Amarillo Globe*
Ralph Barrera, *Austin American-Statesman*
Vickie Belcher
Peter A. Calvin
Alicia Wagner Calzada
Lance S. Cheung

John Davenport, *San Antonio Express-News*
Barbara Davidson, *The Dallas Morning News*
Penny De Los Santos, *National Geographic*, Freelance
Louis DeLuca
Barbara DeMoulin
Brad Doherty
Ronald W. Erdrich, *Abilene Reporter-News*
Tim Fischer, *Midland Reporter-Telegram*
Rodolfo Gonzalez*
Amy Gullett
Rudy Gutierrez, *El Paso Times*
Dirck Halstead
Les Hassell
Cheryl Hatch
Shelly Katz Photo
Jerry Lara, *San Antonio Express-News*
Gary Lawson
Scogin Mayo
Sean Meyers Photography
Michael O'Brien
Craig Robinson
Joshua Trujillo
Todd Yates
Tim Zielenbach

Utah
Coordinator: Chuck Wing, Assistant Photo Editor, *Deseret Morning News*

Nick Adams
Lori Adamski-Peek
Jeffrey D. Allred, *Deseret Morning News*
Ravell Call, *Deseret Morning News*
Sallie Dean Shatz
Rick Egan, *The Salt Lake Tribune*
Jeremy Harmon
Leah Hogsten
Keith Johnson, *Deseret Morning News*
Robert Johnson, *The Standard Examiner*
Johanna Kirk, *Deseret Morning News*
Mitch Mascaro, *Herald Journal*
Kent Miles
Trent Nelson
Jason Olson, *Deseret Morning News*
Laura Seitz, *Deseret Morning News*
Michael West
Scott G. Winterton, *Deseret Morning News*

Vermont
Coordinator: Karen Pike, Karen Pike Photography, Hinesburg

Paul O. Boisvert
Jon Gilbert Fox
Geoff Hansen
Stefan Hard
Peter Huoppi
Craig Line
Peter Miller
Jon Olender
Alden Pellett
Alison Redlich
Adam Riesner
Jack Rowell

Glenn Russell, *The Burlington Free Press*
Jordan Silverman Photography, www.jordansilverman.com
Vyto Starinskas, *Rutland Herald*
Natalie Stultz, Location Photography, Burlington
Rob Swanson
Toby Talbot
Jeb Wallace-Brodeur

Virginia
Coordinator: Alex Burrows, Director of Photography, *The Virginian-Pilot*

Joe Amon, *The Free Lance-Star*
Lisa Billings
Regina H. Boone
Scott K. Brown, Scott K. Brown Photography, Inc.
Suzanne Carr
Leo Charette
Vicki Cronis
Bruce Dale Photography
Scott Elmquist
Bill Garrett
Kelly Hahn Johnson, *The Roanoke Times*
Heather S. Hughes, *Daily Press*
Gary C. Knapp
Reza A. Marvashti
Josh Meltzer, *The Roanoke Times*
Sangjib Min, *Daily Press*
P. Kevin Morley, *Richmond Times-Dispatch*
Scott Neville, *Eastern Shore News*
Genevieve Ross
Amy Rossetti
Stephen Salpukas, *Style Weekly*
Davis Turner, *The Free Lance-Star*
Chris Tyree, *The Virginian Pilot*

Washington
Coordinator: John Sale, Director of Photography, *The Spokesman-Review*

Christopher Anderson, *The Spokesman-Review*
Alan Berner
Al Camp, *The Omak Chronicle*
Laurence Chen, LChenphoto.com
Greg Ebersole, *Longview Daily News*
John Fischer
Natalie Fobes
Kevin German
Kirk Hirota
Torsten Kjellstrand
Colin Mulvany
Nathan P. Myhrvold
Tony Overman, *The Olympian*
Joanna B. Pinneo, Aurora
Roger Ressmeyer, Visions of Tomorrow
Mike Salsbury, *The Olympian*
Phil Schofield
Don Seabrook

West Virginia
Coordinator: Bob Lynn, former AME, Graphics, *The Virginian-Pilot*

Nina Barnett
Joel Beeson, West Virginia University
John Bright

Paul Corbit Brown
Stephanie S. Cordle
Craig Cunningham
Sam Dean
Chris Dorst
Melissa Farlow,* Aurora
F. Brian Ferguson
Raymond Gehman
Tom Hindman, *Charleston Daily Mail*
Karen Kasmauski
Benita Keller
M. K. McFarland
Steve Payne
Martha Rial*
Mat Thorne, Western Kentucky University
Guy Wathen

Wisconsin
Coordinator: Mark Hertzberg, Director of Photography, *The Journal Times*

Scott C. Anderson
Steve Apps, *Wisconsin State Journal*
Suzi Battin
Mark Derse Photography
Jeffery Foss Davis
Dale Guldan
Darren Hauck
Ron Kuenstler
Stephen D. Levin
Kris Lorentzsen
Tom Lynn
Andy Manis, manisphoto.com
Buck Miller
Jeff Miller
Gary W. Porter
Dan Reiland
Mike Roemer, Roemer Photography
Gregory Shaver
Jill Stolt Photography

Wyoming
Coordinator: Trevor Brown, Jr., Rich Clarkson & Associates

Sarah Beth Barnett
Cara Blessley Lowe, Images of Nature, The Cougar Fund
Dan Cepeda, *Casper Star-Tribune*
W. Garth Dowling
Lucas J. Gilman
Todd Heisler,* *Rocky Mountain News*
Jeff Henry, Roche Jaune Pictures, Inc.
Matthew Idler, Matthew Idler Photography
Bobby Model
Devendra Shrikhande
Mary Steinbacher
Angus M. Thuermer, Jr., *Jackson Hole News&Guide*
Morris Weintraub
Bob Woodall, Focus Productions, Inc.

Thumbnail Picture Credits

Credits for thumbnail photographs are listed by the page number and are in order from left to right.

26 Michael Chow, The Arizona Republic
Karl Maasdam
Glenn J. Asakawa, *The Denver Post*
Matt Detrich, *The Indianapolis Star*
Kent Miller, *The Bay City Times*
John W. Liston, *Great Falls Tribune*
Martha Cooper

27 Philip Greenberg
Lauri Lyons
Andrew Johnston
Steve Mellon, *Pittsburgh Post-Gazette*
Peter Goldberg
Anya M. Traisman
Adam Rendon

28 Katya Able
Karen Pike, Karen Pike Photography, Hinesburg
Bruna Stude
Dennis Oda, *Honolulu Star-Bulletin*
Brett Uprichard
Amy Deputy
Stormi Greener

29 Lori Duff
Michael Hettwer
Akira Suwa, *The Philadelphia Inquirer*
Jason Towlen
Dean Dixon
P. Kevin Morley, *Richmond Times-Dispatch*
Mike Roemer, Roemer Photography

33 Steve Jessmore, *The Flint Journal*
Gwen Akin
Josh Haner
José Azel, Aurora
Hal Yeager, *The Birmingham News*
Hugh Grannum
Greg Hess

34 Rick Rickman
Stormi Greener
Victor Fisher
Anne Day
David Grunfeld, *The Times-Picayune*
Jon M. Fletcher, *The Florida Times-Union*
Dawn Villella

35 Marianne Todd
Dawn Villella
Tim Klein
Ken Karlewicz
Travis Bell
Dean Dixon
Gary C. Knapp

36 Hal Yeager, *The Birmingham News*
Katya Able
Michael Hudson
Tanja DeHoff
Emily Yates-Doerr
Tamara Valdez
Michael Gilbert

37 Wayne Levin
Renée Jones, *Owatonna People's Press*
Hugh Allan Flick
Kelly Glasscock
Chiaki Kawajiri
David Simoni
Nick Adams

38 Emily Yates-Doerr
John Isaac
Darlene Pfister Prois
Dave Kettering, *Telegraph Herald*
Rick Smolan
Greg Kinch
Michael Lloyd, *The Oregonian*

39 Gary Dwight Miller
Carlos Ortiz, *Democrat and Chronicle*
Alan Spearman
Scott C. Anderson
Steve Jahnke
Kayla Linquist
Steven G. Smith

40 Jackie Lorentz
David Krider
Richard Marshall
Renée Jones, *Owatonna People's Press*
Marianne Todd
Corey Lowenstein
Ben Garvin, *The Concord Monitor*

41 April Saul
Ken Blackbird
Dean Dixon
Alan Spearman
Steven Noreyko

Eli Lucero
Colin Mulvany

42 Max Becherer, *Arizona Daily Star*
Sylwia Kapuscinski
Jacek Gancarz, *Palm Beach Daily News*
Melissa Lyttle
Todd Heisler, *Rocky Mountain News*
Susana Raab
Hugh Grannum

43 Ann Arbor Miller
Ann Arbor Miller
John Partipillo, *The Tennessean*
Richard Marshall
Kate Medley
Andre Maier
Andre Maier

44 Christine Prichard
Stuart Thurlkill
Jack Rowell
George Wedding, GEOPIX
PF Bentley, PFPIX.com
Alex Dorgan-Ross
John Gaps III, *The Des Moines Register*

45 Cy Jariz Cyr
Jim Gensheimer, *The San Jose Mercury* News
Dawn Villella
Scott Lituchy, *The Star-Ledger*
Jamey Stillings
John Gurzinski
Louis DeLuca

46 Jeffrey Aaronson, Network Aspen
Jeffrey Aaronson, Network Aspen
Jeffrey Aaronson, Network Aspen
Clark James Mishler
Phil Spalding
Sean Dougherty
Justin Kase Conder

47 Laurie Skrivan, *St. Louis Post-Dispatch*
Jason Towlen
Lauri Lyons
Eric Albrecht, *The Columbus Dispatch*
Stormi Greener
David Maialetti, *Philadelphia Daily News*
Michael Bryant, Bryant Photo

48 Kelly Jordan, *Daytona Beach News-Journal*
Jeri Reichanadter
Michael Hettwer
Jeremy Hogan
Reed Hoffmann, Freelance
Carlos Gonzalez
Jessica A. Stewart

49 Mike McEwen
Scott Thode
Jeremy Lurgio
Robert Caplin
Thomas Boyd
David Maialetti, *Philadelphia Daily News*
Erik Gould

50 Benjamin Krain
Andy Levin
Jacek Gancarz, *Palm Beach Daily News*
Jan Sonnenmair, Aurora
Pamela Einarsen
April Saul
J.D. Small

51 Alan Spearman
Todd Korol
Michael Lloyd, *The Oregonian*
Michael S. Wirtz, *The Philadelphia Inquirer*
Sheila Masson
Rodolfo Gonzalez
Rodolfo Gonzalez

52 Stephen B. Thornton,
Arkansas Democrat-Gazette
Courteney Coolidge
Brian Peterson, *The Minneapolis Star-Tribune*
Sandy Huffaker
Jeffrey Aaronson, Network Aspen
Marla Aufmuth
J. Carl Ganter, MediaVia

53 Jeff Schrier
Miguel Gandert
Peter Miller, The White House
Brian Peterson, *The Minneapolis Star-Tribune*
John E. May
Barbara Davidson, *The Dallas Morning News*
Kent Miles

68 Rich Addicks,
The Atlanta Journal-Constitution
PF Bentley, PFPIX.com

Chris Butler
Lori Grinker, Contact Press Images
Peter Ackerman, *Asbury Park Press*
James Salzano
Stephen Morton, stephenmorton.com

69 Stuart W Conway
PF Bentley, PFPIX.com
Paul Rutherford
Takaaki Iwabu, *The State*
Lori Grinker, Contact Press Images
Alicia Wagner Calzada
Frank Wiese, *The Morning Call*

70 Peggy Peattie,
The San Diego Union-Tribune
Kimm Anderson
Khue Bui
John Stennes
David M Warren, *The Philadelphia Inquirer*
Peter Ackerman, *Asbury Park Press*
Peter Ackerman, *Asbury Park Press*

71 Paul Rutherford
Eric Albrecht, *The Columbus Dispatch*
Pat Shannahan, *The Arizona Republic*
Alan Hawes
Barbara L. Johnston
Stephen Holman
Peter Huoppi

72 Deanne Fitzmaurice,
San Francisco Chronicle
Peggy Peattie, *The San Diego Union-Tribune*
Greg Hess
Alan Berner
David Simoni
PF Bentley, PFPIX.com
Andy Levin

73 Kathy Anderson
Chris Todd
Miguel Gandert
Andy Levin
Michael S. Wirtz, *The Philadelphia Inquirer*
Keith Kenney
Jeffery Foss Davis

74 Scott Sady, *Reno Gazette-Journal*
Charles O'Rear
Troy Maben
Josh Haner
Jamie Squire
Steve Coleman
Alex Garcia

75 Joe McNally
David H. Wells , www.davidHwells.com
Mark Peterson
Michael Heinz
Scott G. Winterton, *Deseret Morning News*
Lisa Billings
Bill Garrett

80 PF Bentley, PFPIX.com
PF Bentley, PFPIX.com
Neil Alexander, neilphoto.com
Thomas W. Volk
J. Carl Ganter, MediaVia
Evan Richman, *The Boston Globe*
Keith Graham, University of Montana

81 Robert Holmes
Thomas E. Franklin
Thomas E. Franklin
Lyn Hughes
Brian Lanker
Diedra Laird, *Charlotte Observer*
Alan Spearman

82 Bill Alkofer
Chuck Gathard
Kim Kim Foster
Arthur D. Lauck
Elizabeth M. McMillen
Dawn Villella
John L. Cross, *The Free* Press, Mankato

83 Kimm Anderson
David M. Barreda, University of Missouri
Gerry Melendez
Justin Kase Conder
J.D. Schwalm
Marianne Todd
Scott Elmquist

86 Brad Zweerink
Ed Kashi
Robert Bower, *Post Register*
Lea Garfield
Laura Kleinhenz
Paul Kitagaki, Jr.
Suzette Lee

87 Larry C. Price
Jamie Squire
Leslie Parr, Loyola University New Orleans

Marc-Yves Regis I, *The Hartford Courant*
Eli Reed, Magnum Photos, Inc.
Courtesy of Ariel Meyerowitz Gallery
Lou Manna, Olympus Camedia Master

90 Laura Kleinhenz
Craig Line
Seth Wenig
Peter Lockley
David S. Boynton
Laura Kleinhenz
Jon M. Fletcher, *The Florida Times-Union*

91 Dot Paul
Jeremy Lurgio
Noah K. Murray
Richard Marshall
Craig Fritz
Craig Fritz
Uma Sanghvi

94 Cheryl Anne Day-Swallow

95 Jennah Ward
George Wedding, GEOPIX
Patrick Davison,
The University of North Carolina
Stephen Voss
Greg Foster
Greg Hess
Jeffrey D. Allred, *Deseret Morning News*

96 Brad Zweerink
Jeffrey Aaronson, Network Aspen
Jim Gensheimer, *The San Jose Mercury* News
Maggie Hallahan, Network Images
Jeffrey Aaronson, Network Aspen
Michael Gellman
Louis DeLuca

97 Rick Wong

100 Karen E. Segrave,
Arkansas Democrat-Gazette
Chip Litherland, *Sarasota Herald-Tribune*
Chris Usher, Apix
David Pierini, *The Herald*
Paul Kitagaki, Jr.
Lori Bale
Warren Thompson

101 Michael C. Andrews
Jamey Stillings
Shirley Ware
Robert Caplin
Mark Hirsch, *Telegraph Herald*
David Maialetti, *Philadelphia Daily News*
J.D. Schwalm

102 James Garcia
Gary Tramontina
Nancy Palmieri
Maggie Hallahan, Network Images
Patrick Kramer, *Longmont Daily Times-Call*
Jon M. Fletcher, *The Florida Times-Union*
Pat Crowe II, *The News Journal*

103 Curtis Compton
Gene Driskell
Gary Fandel
Janet Jarman, Contact Press Images
Mark Derse Photography
Mark Bugnaski, *Kalamazoo Gazette*
Roy Feldman

104 Penny De Los Santos,
National Geographic, Freelance
Bob Hammerstrom
Matt Hoyle
Rena Cohen
Christine Prichard
Herrmann & Starke
Al Gilbert, C.M.

105 Ian Macdonald-Smith
Ami Vitale
Carol Yarrow
Mark Derse Photography
John Ater
Peter A. Calvin
Holli Hage

110 Rich Addicks,
The Atlanta Journal-Constitution

111 Rich Addicks,
The Atlanta Journal-Constitution
Stephen Morton, stephenmorton.com
Derek Anderson
Michael A. Pliskin
Doug Kapustin, *The Baltimore Sun*
Brien Aho
Alicia Wagner Calzada

112 John Annerino
John Annerino
John Annerino
John Annerino
John Annerino
John Annerino

Peggy Peattie, *The San Diego Union-Tribune*
Peggy Peattie, *The San Diego Union-Tribune*

113 John Annerino
Michael S. Wirtz, *The Philadelphia Inquirer*
Tricia McInroy, *Tucson Citizen*
Rudy Gutierrez, *El Paso Times*
Herrmann & Starke
Paulo Filgueiras
Rudy Gutierrez, *El Paso Times*

115 Lisa DeJong, *The Flint Journal*
Kurt Wilson
Cynthia Baldauf
Penny De Los Santos, *National Geographic*, Freelance
Mark Reis, *The Colorado Springs Gazette*
John Davenport, *San Antonio Express-News*
Bob Woodall, Focus Productions, Inc.

126 Karim Shamsi-Basha, *Portico* magazine
Dan Burns, nofearfotos.com
Danielle P. Richards
Douglas Kirkland
Lea Garfield
Chuck Gathard
Preston Mack

127 Patrick Davison, The University
of North Carolina
John Klicker
Erik Petersen
Michael Durham, www.DurmPhoto.com
Nick Kelsh
Greg Harris
Michael Good

128 Naomi Brookner
Douglas Kirkland
Michael Lambert
Gregory Stringfield
Dave Hansen
Jan Sonnenmair, Aurora
Michael S. Lewis

129 Rick McFarland
Bill Starling, *Mobile Register*
Brian Lanker
Jaime Oppenheimer, *The Wichita Eagle*
Dean Curtis
Rhoda Peacher
James P Camp

130 Greg Hess
Jacek Gancarz, *Palm Beach Daily News*
Carlos Ortiz, *Democrat and Chronicle*
Jean Shifrin
Anne Day
Randy Hufford, www.visualimpact.org
Jennifer Midberry, *Philadelphia Daily News*

131 Janet Jarman, Contact Press Images
Renée Jones, *Owatonna People's Press*
Patrick Davison,
The University of North Carolina
Patrick Davison,
The University of North Carolina
Lisa Waddell Buser
Rudy Gutierrez, *El Paso Times*
Craig Line

134 Ted Richardson, *Winston-Salem Journal*
Sean Simmers, *Harrisburg Patriot-News*
Jean Santopatre, Fairfield University
Yoni Brook
André F. Chung, Iris PhotoCollective
Jennifer Spear
Kathryn Nix

135 Michael Groll
Mark Bugnaski, *Kalamazoo Gazette*
Michael Groll
Scott Goldsmith
John Forasté, ASMP & Creative Eye
John Freidah
Kevin Eilbeck

136 Jay Dickman
Jim Weber
James H. Kenney,
Western Kentucky University
Leisa Thompson, *The Ann Arbor News*
Bill Alkofer
William Cohen
Aristide Economopoulos, *The Star-Ledger*

137 Jim Weber
Jim Weber
Sergio Goes
Jim Weber
Alicia Wagner Calzada
Lori Adamski-Peek
Lori Adamski-Peek

138 Nuri Vallbona, *The Miami Herald*
Marc Lester, *Anchorage Daily News*
Meri Simon
Andrew Kaufman, Contact Press Images

Staff

This project was imagined years ago by our friend Oscar Dystel, a publishing legend whose vision and enthusiasm have been a source of great inspiration.

We also want to express our gratitude to our truly visionary publisher, DK.

Rick Smolan, Project Director
David Elliot Cohen, Project Director

PROJECT STAFF
Katya Able, Operations Director
Tom Walker, Creative Director
Gina Privitere, Communications Director
Lael Weyenberg, Partnership Director
Chuck Gathard, Technology Director
Julio Garcia, Content Management Director
Kim Shannon, Photographer Relations Director
David Carriere, Publicity Director
Josh Haner, Photography and Technology Coordinator
Annie Polk, Office Manager
John McAlester, Administrative Assistant

Design and Editorial
Brad Zucroff, Art Director
Maggie Canon, Managing Editor
C. Thomas Hardin, Photography Director
Karen Mullarkey, Assignment Director
David Simoni, Production Artist
Sean T. Kelly, Senior Editor
Curt Sanburn, Writer
Elise O'Keefe, Copy Editor
Cara Blessley Lowe, BLAD Caption Writer
Bill Shore, Image Production Artist
Eric Sahlin, Image Production Artist
Peter Truskier, Workflow Consultant
Jim Birkenseer, Workflow Consultant

Infographic Design
Nigel Holmes

Literary Agent
Carol Mann, The Carol Mann Agency

Legal Counsel
Barry Reder, Coblentz, Patch, Duffy & Bass, LLP
Phil Feldman, Coblentz, Patch, Duffy & Bass, LLP
Gabe Perle, Ohlandt, Greeley, Ruggiero & Perle, LLP
Jon Hart, Dow, Lohnes & Albertson, PLLC
Mike Hays, Dow, Lohnes & Albertson, PLLC
Stephen Pollen, Warshaw Burstein, Cohen, Schlesinger & Kuh, LLP
Rick Pappas

Accounting and Finance
Rita Dulebohn, Accountant
Robert Powers, Calegari, Morris & Co. Accountants
Eugene Blumberg, Blumberg & Associates

Picture Editors
J. David Ake, Associated Press
Caren Alpert, formerly *Health* magazine
Simon Barnett, *Newsweek*
Caroline Couig, *San Jose Mercury News*
Mike Davis, formerly *National Geographic*
Michel duCille, *Washington Post*
Deborah Dragon, *Rolling Stone*
Victor Fisher, formerly Associated Press
Frank Folwell, *USA Today*
MaryAnne Golon, *Time*
Liz Grady, formerly *National Geographic*
Randall Greenwell, *San Francisco Chronicle*
C. Thomas Hardin, formerly *Louisville Courier-Journal*
Kathleen Hennessy, *San Francisco Chronicle*
Scot Jahn, *U.S. News & World Report*
Steve Jessmore, *Flint Journal*
John Kaplan, University of Florida
Kim Komenich, *San Francisco Chronicle*
Eliane Laffont, *Hachette Filipacchi Media*
Jean-Pierre Laffont, *Hachette Filipacchi Media*
Andrew Locke, MSNBC
Jose Lopez, *New York Times*
Maria Mann, formerly AFP
Bill Marr, formerly *National Geographic*
Michele McNally, *Fortune*
James Merithew, *San Francisco Chronicle*
Eric Meskauskas, *New York Daily News*
Maddy Miller, *People* magazine
Michelle Molloy, *Newsweek*
Dolores Morrison, *New York Daily News*
Karen Mullarkey, formerly *Newsweek, Rolling Stone, Sports Illustrated*
Larry Nighswander, Ohio University School of Visual Communication
Jim Preston, *Baltimore Sun*
Sarah Rozen, formerly *Entertainment Weekly*
Mike Smith, *New York Times*
Neal Ulevich, formerly Associated Press

Interns
Ilana Parmer
Grant Toeppen
Mike Connor
Naomi Brookner
Joe Stricker

Website and Digital Systems
Jeff Burchell, Applications Engineer
Luke Knowland, Phase 1, Website Design/ Development
Laird Popkin, Technology Advisor
Brian Smiga, Technology and Partnership Advisor
Greg Williams, Flash Animator

Participation
Jessica Lifland, Student Coordinator
Eva Selig, Community Development Director

Image Traffic
Sharon Garrett
Kathryn Howard
Joan Moriyama
Dominique Richard
Jean Scoutten

Website and Digital System Partners
@ Radical.Media
John Kamen
India Hammer
Rafael Esquer
Angela Fung
Jake Garcia
Heike Sperber

Snapfish
Sarah Bacon
Manas Chaliha
Anton Collins
Deanna Dawson
Vijay Gatadi
Dan Grishaver
Adina Nystrom
Bala Parthasarathy
Paul Schumer
Todd Skow
Lisa Sterling
Thomas Worster

Camera Bits
Dennis Walker
Bob Russell
Diana Ellison
Kirk A. Baker
Bill W. Kelly
Tracy Walker

Blue Pixel
Kevin Gilbert
Rob Galbraith

Television Documentary
Sandy Smolan, Producer/Director
Rick King, Producer/Director
Bill Medsker, Producer

Camera
Paul Holahan
Tamara Goldsworthy
Stephen Lighthill
Forest Thurman

Sound
Rick Prell
Phillip Palmer
Erik Magnus
Toby Barraud

Post Production—Outpost Digital
Ting Poo
Evan Schechtman
Christine Schneider
AJ Pyatak
Joe Faissal
Andy Zelada
Gilmar Iraheda
Eddie Arenas
Katya Kramer

Video News Release
Mike Cerre, Producer/Director
Bob Tracy
Mike Ellwell

Senior Advisors
Jennifer Erwitt, Strategic Advisor
Megan Smith, Technology Advisor
Jon Kamen, Media and Partnership Advisor
Mark Greenberg, Partnership Advisor
Patti Richards, Publicity Advisor
Cotton Coulson, Mission Control Advisor

Executive Advisors
Sonia Land
George Craig
Carole Bidnick

Advisors
Chris Anderson
Samir Arora
Russell Brown
Craig Cline
Gayle Cline
Harlan Felt
George Fisher
Phillip Moffitt
Clement Mok
Richard Saul Wurman

Mission Control, San Francisco
Andrea Smith, Site Manager
Carl Brown
Chris Oatey
Jennifer Herrera
Blair Roche

Mission Control Partners
CNET Networks
Shelby Bonnie
Barry Briggs
Cotton Coulson
Doug Woodrum
David Overmyer
Jeff Owider
Maria Caro
Dana Murphy

Digital Pond
Peter Hogg
Kris Knight
Roger Graham
Philip Bond
Frank De Pace
Lisa Li

DK Publishing
Andrew Welham
Christopher Davis
Dick Heffernan
Chuck Lang
Stuart Jackman
Therese Burke
Todd Fries
Cathy Melnicki
Eunice Paterson
Sarah Coltman
Joanna Bull
Jay Henry

Toppan Printing Company Ltd.
Paul Valerio
Toshi Uchida
Toru Moriyama

Photograph by Mark Wilson